*THE ART OF THE FIRST FLEET
AND OTHER EARLY
AUSTRALIAN DRAWINGS*

THE ART OF THE FIRST FLEET
& other early Australian drawings

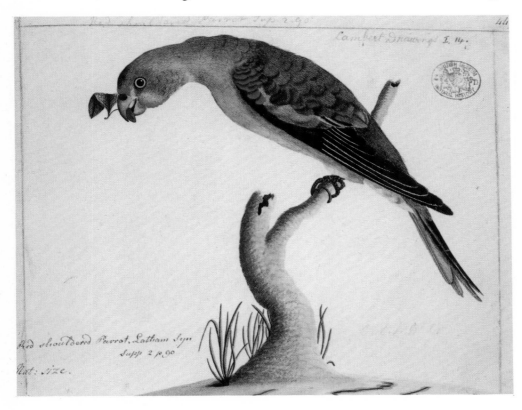

Edited by Bernard Smith & Alwyne Wheeler

Published for the Paul Mellon Centre for Studies in British Art by
YALE UNIVERSITY PRESS · New Haven and London · 1988
in association with the AUSTRALIAN ACADEMY OF THE HUMANITIES
and the BRITISH MUSEUM (NATURAL HISTORY)

Edited by Lee White Designed by Alison Forbes
Typeset by Meredith Typesetting
Colour separations by Scanagraphix Pty Ltd
Printed by Owen King Printers Australia Pty Ltd

Library of Congress catalog card number 87-51377
ISBN 0-300-04118-7

Contents

List of Plates

In this list of plates, identification numbers for drawings in the Watling collection [W], the Watling collection large series [WLS] and Raper collection [R], all located in the Zoology Library, Department of Library Services, British Museum (Natural History) and for the Banks Ms34 [Banks 34], located in the Botany Library, Department of Library Services, British Museum (Natural History), are given in square brackets. The source of other material appears in parentheses at the end of the descriptions. Full references are given in the captions.

Titles which appear on the drawings have been set in *italics*; identifying titles for untitled drawings have been set in roman. Natural history drawings are identified by their modern common names and, on the captions, by their scientific names, together with the original inscriptions and annotations. Where authorities and dates for zoological names are not enclosed within parentheses it indicates that the species still belongs in the genus in which it was first described by the original authority. Parentheses around the authority's name and date indicate that the species was subsequently transferred to another genus.

All measurements of paintings and drawings are in millimetres and except where specified all sizes given in the captions are the original sheet size. In reproduction, some margins and coloured borders have been trimmed slightly in order to reproduce the drawings as close as possible to the original size within the page format, and to show detail and texture with the maximum clarity.

1: ABORIGINAL LIFE AROUND PORT JACKSON, 1788–92

4: *THE NATURAL HISTORY DRAWINGS*

Acknowledgements

The production of a book of this kind requires the support and co-operation over a number of years of many individuals and institutions at the research, editorial and publishing levels. The editors wish to thank Mr Anthony P. Harvey, Head of the Department of Library Services, and Mr Robert Cross, formerly Head of Publications of the British Museum (Natural History), for their initial support of the proposal to publish in 1983, and also Mr Clive Reynard, the Museum's present Head of Publications, for his continued support and assistance. In the Department of Library Services of the British Museum (Natural History) we are indebted to Mr Rex Banks, the Acting Head of the Department, Miss Dorothy Norman, Assistant Archivist, and Mrs Ann Datta, Zoology Librarian, for their help, advice, and constant encouragement.

We are much indebted to the Council of the Australian Academy of the Humanities for its decision in 1984 to accept the project as one of its official projects for the Australian Bicentenary.

We are also indebted to a number of people for their help and advice and express our gratitude and thanks for their co-operation: D. J. Mulvaney, Emeritus Professor of Prehistory, Australian National University; Ms Elizabeth Imashev, Mitchell Library, State Library of New South Wales, Sydney; Ms Barbara Perry, Pictorial Librarian, National Library of Australia; Mrs Mary Lewis and Mr John Arnold, La Trobe Collection, State Library of Victoria, Melbourne; and Ms Emma Hicks for research conducted in London.

The staff of Oxford University Press have been most helpful in many ways, particularly Ms Ev Beissbarth and Ms Louise P. Sweetland who also drew our attention wisely from time to time to 1988's 'winged chariot hurrying near'. We wish also to express our thanks to Ms Alison Forbes for the care taken in designing this book and to Mrs Lee White for her scrupulous editing of the text.

B.S. A.W.

ALWYNE WHEELER

Preface / The Collections

The British Museum (Natural History) contains an enormous wealth of material relevant to the early exploration of Australia. Some of it is well known, like the notes and drawings of plants and animals made during James Cook's first voyage (1768–71), when the earliest significant discoveries of Australian natural history were made. Other eighteenth-century material is less well-known except in scholarly circles. It is this post-Cook material which has been drawn upon to form the nucleus of the present book, and from which most of the illustrations have been derived.

Three collections of drawings in the Museum have been used for illustrative purposes in this volume: the collection originally attributed to Thomas Watling, that made by George Raper, and that sometimes known as that of the Port Jackson Painter (which is properly known as the Banks Ms34). These collections came to the Museum over a long period of time and from various sources.

The identity of the artist or artists whose work is represented in the Banks Ms34 collection is uncertain. The artist was at one time alleged to be Edgar Thomas Dell. Thomas Watling has also been cited as the artist. As Bernard Smith points out the collection is a suite of drawings in which several styles are distinguishable. Most of the water-colours in the collection were made in the vicinity of Port Jackson but some were drawn from specimens in England and reproduced in John White's *Journal of a Voyage to New South Wales*. It is possible that some or indeed all (as Bernard Smith suggests) are by Watling.

This collection was part of the library of Sir Joseph Banks (1743–1820) which came to the British Museum in 1827. Because of the uncertainty concerning the artist, and because of its provenance, it became known as Banks Ms34 (34 being the number allocated to it in the catalogue of the Banksian manuscripts compiled by his librarian Jonas Dryander).

The Raper collection contains seventy-two water-colour drawings of naval topographical interest, natural history subjects and scenery. They were the work of George Raper (*c.*1767–97), midshipman on H.M.S. *Sirius*. Some of the drawings depict nautical views of landfalls and harbour entrances of places passed or visited on the outward voyage. Most were made in New South Wales, while others were drawn in Norfolk

Island where the *Sirius* was wrecked. The Raper collection was presented to the Museum by Miss Eva Godman in 1962.

The largest of the collections is that known as the Watling collection. Thomas Watling was a trained artist who was indicted of forgery in 1789 and sentenced to deportation to one or other of the colonies. After confinement in various hulks he left England in the custody of the commander of the *Pitt* in June 1791 but escaped in Cape Town, was recaptured, imprisoned and finally put aboard the *Royal Admiral* to arrive in Sydney in October 1792. His artistic abilities were quickly recognized and he was assigned to the service of John White, Surgeon General to the settlement in New South Wales, and later, it would seem, to David Collins for whom he recorded the development of Sydney.

Taken as a whole the Watling collection of charts and views, topographical drawings of Sydney, and the drawings of ethnographic and natural history interest form the largest and most detailed collection of the period. There appear to have been 512 drawings in the original collection but twenty-four bird drawings appear to have been separated from it prior to its acquisition by the Museum. Many drawings are signed by Watling but a considerable number is the work of at least one other artist and possibly more. The Watling collection was purchased by the Museum in 1902. The present selection of Watling's own work taken from this collection is the most extensive that has been published and vividly demonstrates the range and importance of his work.

All three collections are of historical interest. The topographical drawings are the earliest known representations of the developing community that Governor Phillip had named 'Sydney' shortly after his arrival. Similarly, the ethnographic drawings are historically important and form a pictorial record of the Aboriginal society which no longer exists, as well as the social interaction between that society and that of the European settlers. They also record graphically (and there are only written records otherwise) some of the memorable incidents of the early settlement, such as the wreck of the *Sirius* at Norfolk Island, and the spearing of Governor Phillip at Manly in 1790.

The plant and animal drawings are equally important as an historical record of an environment which has been changed dramatically by the creation of an urban society. As John Calaby shows in his essay many of the birds in particular, but other animals also, have disappeared from the Sydney region although still found elsewhere in New South Wales. However, some birds, especially the endemic species of Norfolk Island, are now extinct, so these drawings form a unique record of a fauna which has now been diminished irreversibly.

In addition to their aesthetic and historical value the drawings also have considerable scientific importance, especially in taxonomic zoology. Although Cook's *Endeavour* spent from April to August 1770 on the eastern coast of Australia, Joseph Banks and his team of naturalists and artists collected, illustrated or described very few animals. When the drawings by Watling and those of the artist now known as the Port Jackson Painter reached Europe they were the first significant representations of Australian animals to be seen. As a result the first detailed descriptions of many Australian animals were based on these drawings, or on copies of them. Some descriptions may have been made from the preserved specimens which had served as the basis of the drawing, but the vagaries of preservation and time have caused the specimen to perish, so that the drawing still remains the only original record.

The formal scientific naming, in Latin or Latinized form, of any animal or plant depends on the first published description. It follows from this that the material used

to compile the description, whether it be a specimen or a drawing, is the ultimate source of information about the animal or plant. Such specimens are termed type specimens in scientific nomenclature and although drawings used as the original and sole source of information have no official standing they nevertheless have to be referred to when doubt arises as to the species intended in the description.

Many early descriptions of Australian animals were based on the drawings comprised in the Watling, Raper and Banks Ms34 collections. These drawings therefore have the status, if not the terminology, of types for the names based on them. Their publication makes them widely available for the first time for the international community of naturalists to consult. This volume therefore represents an important resource for taxonomists concerned particularly with Australian fauna.

It is also an important new resource for historians. In the past, Australian historians writing about the first years of British settlement have tended to ignore the existence of the original visual material contained in the collections at South Kensington. When the material has not been ignored completely, it has been used mainly to illustrate modern interpretive history. The visual documents have rarely been interrogated in terms of their status as evidence or interpreted as visual material for the *kinds* of information they convey. Most historians have been content to make use of the engravings that embellished contemporary or near-contemporary texts. Natural historians have not made this mistake. They were the first to look closely at the visual material. But as Dr Calaby indicates there has remained, and remains, much to be done.

In presenting the wealth and variety of material held in the British Museum (Natural History) relating to the first decade of British settlement in New South Wales, it seemed desirable therefore to ask a small group of scholars – an ethnographer, a geographer, a social historian, a natural historian, and an art historian – to examine the relevant visual material available in the three collections, each from his own point of view. In this way we have sought to highlight the value of the material for historical, artistic and scientific research.

This book will also provide for the first time a comprehensive visual supplement to those very well-known publications relating to the beginnings of settlement: *The Voyage of Governor Phillip to Botany Bay* (1789); John White's *Journal of a Voyage to New South Wales* (1790), Watkin Tench's *Narrative of the Expedition to Botany Bay* (1789) and his *A Complete Account of the Settlement of Port Jackson* (1793), John Hunter's *An Historical Journal of the Transactions at Port Jackson and Norfolk Island* (1793), and David Collins's *An Account of the English Colony in New South Wales* (1798, 2nd volume 1802).

The publication of so many of these early Australian drawings is a major contribution by the British Museum (Natural History) to the Bicentenary celebrations in Australia. In thus reproducing so many of these first European impressions of the natural history, original inhabitants, and views of the first European communities in Australia, the Museum has made available to a wider audience some of its great historical and artistic treasures.

The publication of these essays by Australian scholars on natural history, ethnography, physical and geographic features, and the artists and their drawings, in conjunction with the reproduction of a large selection of these drawings, is a fitting collaboration for Australia's Bicentennial celebrations.

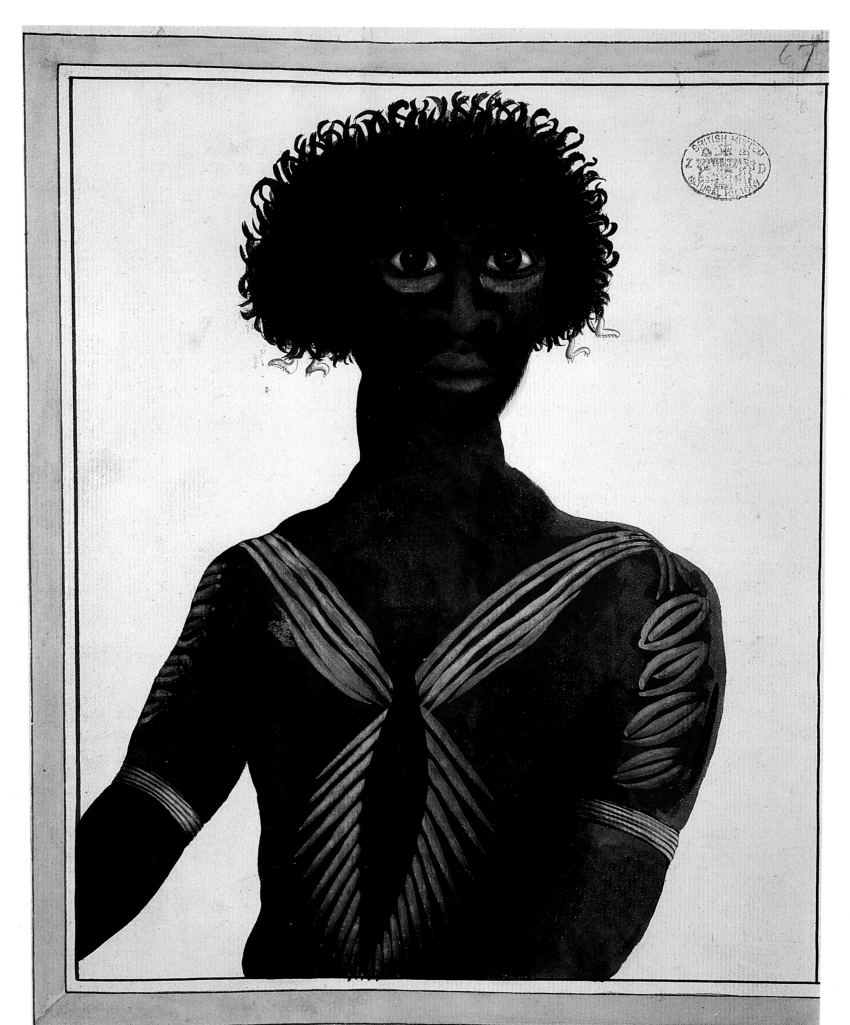

Balloderree.

R. J. LAMPERT

1 / Aboriginal Life around Port Jackson, 1788-92

Sydney, the first point of major impact by Europeans on Aboriginal society, was settled in 1788. In one migration the number of Europeans equalled about half the Aboriginal population of the entire Sydney district and probably exceeded the number of Aborigines around Port Jackson itself. The effect of this sudden influx on people with no previous contact with the outside world was catastrophic. Smallpox, brought by members of the First Fleet, was passed on to the Aborigines who succumbed at a rapid rate. Within a year people began dying of the disease, death becoming a daily occurrence. One Aboriginal band, whose territory was adjacent to the British settlement, was reduced in number from about fifty in 1788 to only three in 1790.

Smallpox spread rapidly between Aboriginal communities, reaching the Nepean River, some 60 kilometres west of Sydney, well before the first British expedition arrived there. Within two years of European settlement the Aboriginal population of the Sydney district had been halved; within three years it had been reduced to less than a third; fifty years later it was around one-tenth of its original estimate.[1] The traditional way of Aboriginal life around Sydney thus evaporated before the eyes of its first European observers. It had disappeared almost entirely by the time the first anthropologists began to record Aboriginal culture systematically towards the end of the nineteenth century.

Very few traditional artefacts from Sydney and nearby coastal regions found their way into the collections of the Australian Museum in Sydney. Although the museum was founded in 1827, it did not begin seriously to acquire Aboriginal artefacts until the latter part of the century, when traditional material was available no closer than western New South Wales. Those of us who seek to study traditional Aboriginal culture in the Sydney district must do so mainly from the texts of First Fleet diarists and from the works of the artists with whom they were associated. For this reason, the drawings by George Raper, the Port Jackson Painter and Thomas Watling, though not the only iconographies of Sydney's early Aborigines, are an invaluable source of information. They show not only traditional Aboriginal life but also changes resulting from European impact, as well as some of the social interaction between those two very different groups of people.

Plate 1 [Watling 58]
PORT JACKSON PAINTER
Balloderree
Ink and water-colour, 287 × 218
The portraits of *Balloderree* and
Gna.na.gna.na (plate 2) were
evidently divided and mounted
separately at an unknown date, prior
to their acquisition by the Museum.

Physical Appearance

First Fleet writers who commented on the physical characteristics of Aborigines often did so by comparing them with Europeans, noting the greater breadth of the nose, the beetling brows, the more forward-jutting teeth, shorter stature and generally slighter build. They noted also that the skin colour was of varying shades of dark brown and that the hair was straight rather than woolly. One of the more objective descriptions is given by Tench who supports his observations with measurements:

The tallest I ever measured, reached five feet eleven inches; and men of his height were rarely seen. Baneelon, who towered above the majority of his countrymen, stood barely five feet eight inches high . . . Instances of natural deformity are scarce; nor did we ever see one of them left-handed . . . Their muscular force is not great; but the pliancy of their limbs, renders them very active.[2]

The women were somewhat smaller than the men, having a median height of around 5ft 2in (157cm), the shortest being only 4ft 2in (127cm).[3] Several writers, all single men, recognized the attractiveness of many Aboriginal women.[4]

Many early artists, trained in depicting the human figure by using classical marbles as models, found difficulty in giving accurate renditions of Oceanic peoples.[5] Watling, Raper and the Port Jackson Painter, though not entirely free from their influence, have managed to avoid giving Aborigines the ridiculously statuesque torsos portrayed by some other artists, most notably the engravings in *The Voyage of Governor Phillip to Botany Bay* (1789). Only rarely does the Port Jackson Painter bring our attention to such Aboriginal facial characteristics as overhanging brow, breadth of nose and fullness of lips [plate 2] by over-emphasizing them sufficiently to produce a drawing with an element of caricature.

There are subtleties mentioned by writers but not visible in the drawings. The teeth of most people were badly damaged through biting artefacts of shell, wood and even stone into shape.[6] Most females underwent an operation early in life to remove the two upper joints from the little finger of the left hand, seen apparently in the portrait of Dirr-a-goa [plate 3]. This was performed by binding the finger tightly with a sinew or hair. According to Collins[7] this made it easier for a woman to wind a fishing line over her hand, although references collected much later by the anthropologist A.W. Howitt suggest the purpose was to mark a member of the 'fishing branch' of a tribe, and that it was a practice widespread along the east coast of Australia.[8]

The body was decorated in a variety of ways. On both men and women, cicatrices (raised scars) were made on upper parts of the torso 'by making two longitudinal incisions, with a sharpened shell, and afterwards pinching up with the nails the intermediate space of skin and flesh, which thereby becomes considerably elevated, and forms a prominence as thick as a man's finger'.[9] Cicatrices of this description can be seen clearly in many of the plates [2, 4–5, 22, 23, 27].

For ceremonial occasions, designs were painted on the body with natural ochres [plates 1, 5, 7, 10–13, 15, 28, 30, 46, 49, 51] in most cases red ochre being used by men in preparation for warfare and white by both sexes for peaceful ceremonies.[10] For funerals, some people in attendance painted themselves with both red and white ochre, while others smeared themselves with grease and charred wood as shown in plate 14. Possibly the grease was fish oil with which men, women and children frequently smeared their bodies to 'guard against the effects of the air and of musquitoes, and flies'.[11]

Plate 2 [Watling 60]
PORT JACKSON PAINTER
Gna.na.gna.na
Ink and water-colour, 286 × 208
Possibly a profile portrait of Balloderree (see plate 1). Another version with some differences in the positioning of the cicatrices and lacking the blue framing is in the National Library of Australia, Canberra, NK 144/D. No one by this name is mentioned in the early publications relating to the First Fleet. In his list of Aboriginal words David Collins (1798) gives *Gna-na* as the adjective for black. It has also been suggested that the man may be identified as 'Gnunga Gnunga' (see Collins, 1798, p. 299), the brother-in-law of Bennelong. Rhys Jones, 'Images of Natural Man', *Baudin in Australian Waters* (eds. J. Bonnemains, E. Forsyth and B. Smith) (1988), p. 63.

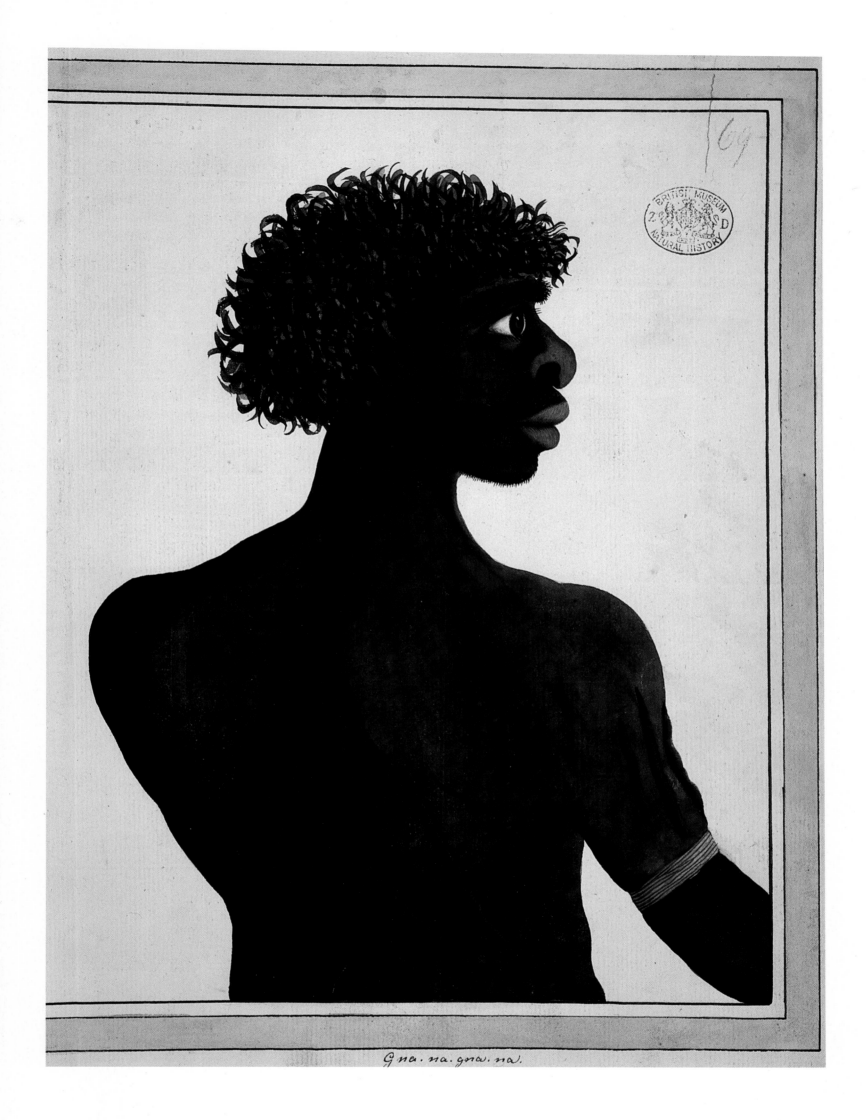

Gna. na. gna. na.

21

The hair, too, was adorned with a variety of objects including kangaroo incisors, fish jaws, feathers and pieces of wood, all attached directly to the hair with yellow gum obtained from the grass tree (*Xanthorrhoea resinosa*).[12] Such ornaments are to be seen in plates 1–3, 5, 7, 10, 12, 15, 46, 49. Occasionally the hair was matted with gum [plates 32, 37]. According to Collins this was a characteristic of people living on the southern shore of Botany Bay, who 'divide the hair into small parcels, each of which they mat together with gum, and form them into lengths like the thrums of a mop'.[13] Hair divided in this manner was drawn by Watling [plate 62].

The drawings at plates 5, 15 and 30 show men wearing nose bones. They were worn on ceremonial occasions by both sexes, but more often by men than by women, together with such other ornamentation as body painting. The bone was usually the small lower leg bone (fibula) of a kangaroo, sharpened to a point at one end. It was thrust through a hole made in the *septum nasi* at an operation called Gnah-noong, when boys and girls were between eight and fifteen years of age.[14]

Necklaces of various kinds were worn, including short sections of hollow reed strung together [plate 3], a fish hook suspended from a line [plate 22] and what appears to be string spun from possum fur [plates 17, 19]. Headbands, seen in plate 17 are probably nets made of fine string spun from possum fur.[15] Chaplets, consisting of a line to which several kangaroo incisors were attached with gum, were worn around

Plate 3 [Watling 35]
THOMAS WATLING
Dirr-a-goa
Pencil, 212 × 166
Apparently a young unmarried woman because she still wears the *barrin*, a waistband made of possum-fur string, other ornaments include a chaplet with attached kangaroo incisors and a necklace made of short sections of hollow reed. Note also that the joints of the little finger of the left hand appear to be missing.

Plate 4 [Watling 37]
THOMAS WATLING
Gur-roo-ee
Pencil, 198 × 168, signed in ink 'Watling del.'
Note the missing incisor, the mark of an initiated man.

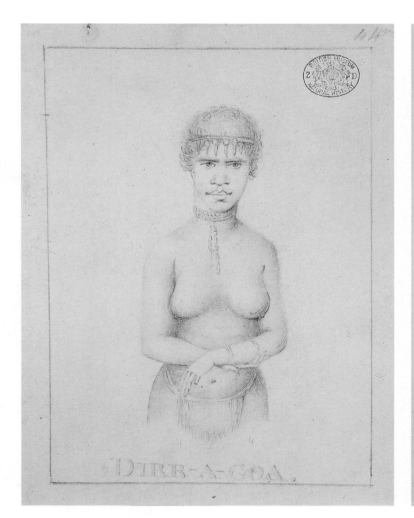

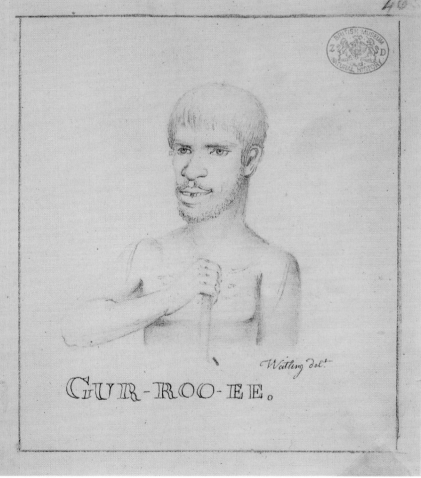

the forehead in a similar manner [plate 3]. Kangaroo incisors with gum still attached to the proximal end, suggesting such usage, were recovered during the excavation of an Aboriginal camp site at Durras North, on the coast some 230 kilometres south of Sydney.[16] Waistbands were made from possum fur string; when worn by men [plate 19] they were used to carry clubs and other weapons.[17] The waistband for a female [plate 3] was: 'a small line made of the twisted hair of the opossum, from the centre of which depend a few small uneven lines from two to five inches long, made of the same materials. This they term bar-rin, and wear it [from an early age] until they are grown into women and attached to men'.[18]

As all of the drawings indicate, clothing was not normally worn. Only rarely, usually during cold weather, were people seen wearing a cloak made of possum skins sewn together.[19] Near Broken Bay a man was seen in winter wearing a 'skin of reddish colour round his shoulders'.[20] Possibly this was a kangaroo skin, like the single kangaroo skin worn as a cape by Tasmanian Aborigines.[21]

Body postures were also noted by First Fleet artists and writers, particularly where these differed from those normally adopted by Europeans. Sitting with one foot drawn up towards the crutch [plates 18, 20, 27] is a posture common among Australian Aborigines and is used today by women in Arnhem Land, the foot serving to conceal the private parts.[22] Another common posture was squatting in the sartorial position

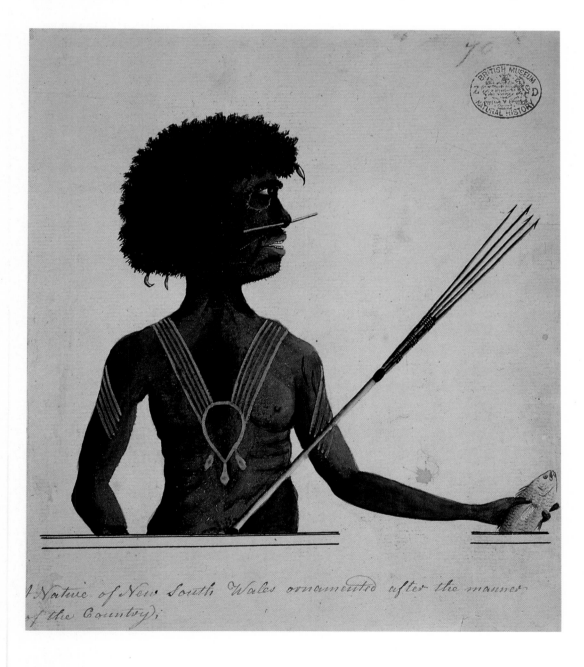

Plate 5 [Watling 61]
PORT JACKSON PAINTER
A Native of New South Wales ornamented after the manner of the Country
Ink and water-colour, 211 × 177
Another version, but with the body paint designed differently and lacking the nose bone, is in the National Library of Australia, Canberra, NK 144/C (see plate 51).

[plate 29], while another was the 'stork' posture adopted by men [plate 20] shown also for Tasmanians by Lesueur,[23] a standing position with one foot drawn up to the opposite knee, the body being further supported by a spear. Prolonged squatting leaves facets on both the distal end of the tibia and on the talus, which have been identified on early Aboriginal skeletal remains from South Australia.[24] Around Port Jackson, however, women spent more time kneeling in their canoes, with buttocks resting on the heels and knees braced against the sides of the canoe.[25] Whether this also leaves characteristic facets on the bones is unknown.

The way in which children were carried astride one shoulder aroused interest, being different from European practice [plates 21, 22]. Tench describes how a woman carried her small child when fishing from her canoe: 'the child is placed on her shoulders, entwining its little legs around her neck, and closely grasping her hair with its hands . . . An European spectator is struck with horror and astonishment, at their perilous situation: but accidents seldom happen.'[26]

The Social Order

From diarists of the First Fleet and later writers we can identify three major groups of Aboriginal people known as the Dharawal, Dharug and Kuringgai living in the Sydney district, each with its own language. The three languages had enough words in common to allow people in one group to communicate with those in another. The territory of the Dharawal was a coastal strip extending southward from Botany Bay and inland to the Georges River. The Dharug occupied the coast between Botany Bay and Port Jackson, and most of the Cumberland Plain westward as far as the Blue Mountains. North of Port Jackson, the Kuringgai lived between the coast and the Lane Cove River, reaching northward beyond Broken Bay [plate 6].

Within each major division were smaller groups, referred to by the writers as 'tribes' or 'families'. Today's anthropologists would call such a group a 'band', defined by them as the 'basic economic group', consisting of, perhaps, fifty or so closely related people who hunted, foraged and fished together daily. Although the artists often show groups described as man and wife [plates 36, 37] or man, wife and children [plates 33, 34, 38], the groupings and/or descriptions appear to result from the European concept of a nuclear family rather than the Aboriginal one of an extended family, seen perhaps in Watling [plate 20].

The name of some bands around Sydney was made up of the name of the place of residence and the suffix 'gal'. Thus the Cammeraigal occupied the north shore territory called Cammeray, and the Gweagal resided at Gwea on the southern shore of Botany Bay. A fuller list of band names is given by Kohen and Lampert.[27]

The Port Jackson Painter identifies one of his portraits as being 'Cameragal the chief of the most powerful tribe that we at present know of in New South Wales' [plate 30] suggesting that an important senior man may have taken the name of his band. Certainly the Cammeraigal appear to have been the most influential band around the harbour, being responsible for conducting initiation ceremonies and for settling disputes among the other local bands.[28]

The 'rites of passage' were as important to the Aboriginal people of Sydney as they are to all other societies. As soon as a child's hair was long enough to be taken hold of it was ornamented with such items as fish bones and kangaroo incisors fastened with gum [plate 1]. The body was decorated with white clay, and at about the age of six weeks the child was given a name, usually the name of a local bird, mammal or fish.[29]

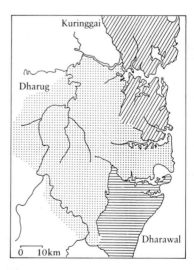

Plate 6
Aboriginal tribes of the Sydney area in 1788
Reproduced with the permission of Mr J. Kohen.

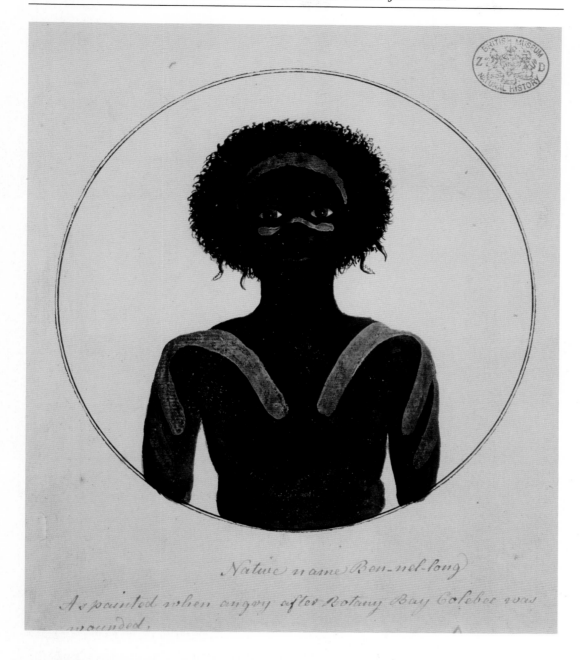

Plate 7 [Watling 41]
PORT JACKSON PAINTER
Native name Ben-nel-long. As painted when angry after Botany Bay Colebee was wounded
Ink and water-colour, tondo frame 148 diameter, sheet size 204 × 172
The incident referred to in the inscription may possibly be that which took place in December 1797 and is described at length by Collins (1802) ii, 65–9. If this is so however, the portrait could not be by Henry Brewer who died in July 1796 (see section on Brewer in chapter 5).

Children played a variety of games, boys learning to throw the spear, and how to defend themselves from it, by throwing reeds at each other [plate 24]. At about the age of puberty, boys not only had the septum of the nose pierced to accommodate a nose bone, but also went through a more elaborate ceremony called Yoo-lahng, initiating them into manhood. Watling made a series of eight remarkable drawings depicting various stages of a Yoo-lahng ceremony held at Farm Cove in February 1795. These were published, together with written descriptions by Collins [plate 8]. The climax of the ceremony was the evulsion of an upper incisor from each initiate, the result of which can be seen in a portrait of an initiated man named Gur-roo-ee [plate 4]. One of the initiates at the 1795 ceremony was Nan.bar.ree (Nanbree, Nanberry) [plates 9, 58, 67] whose sore gum was attended to after the ceremony by his relation Colebee [plates 13, 19].

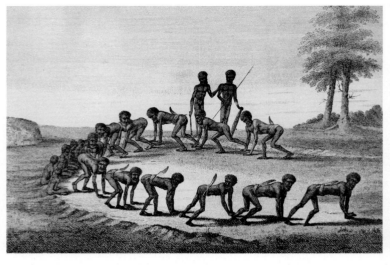

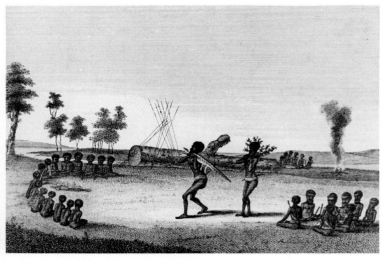

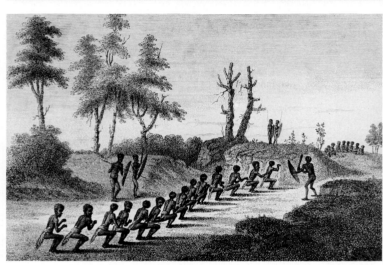

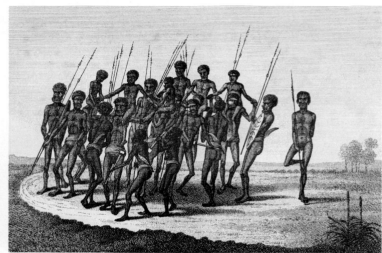

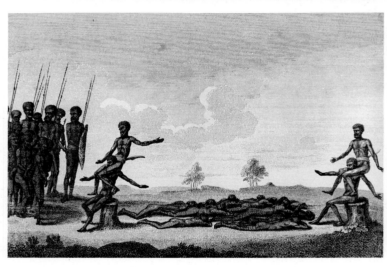

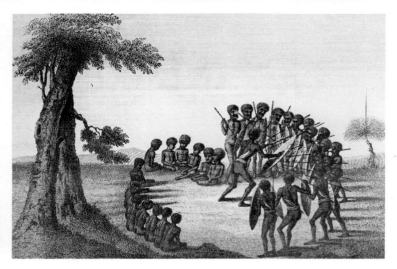

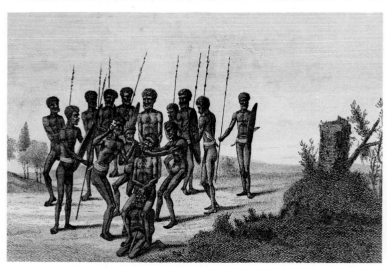

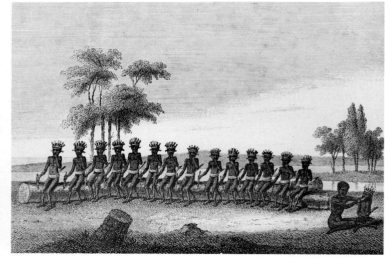

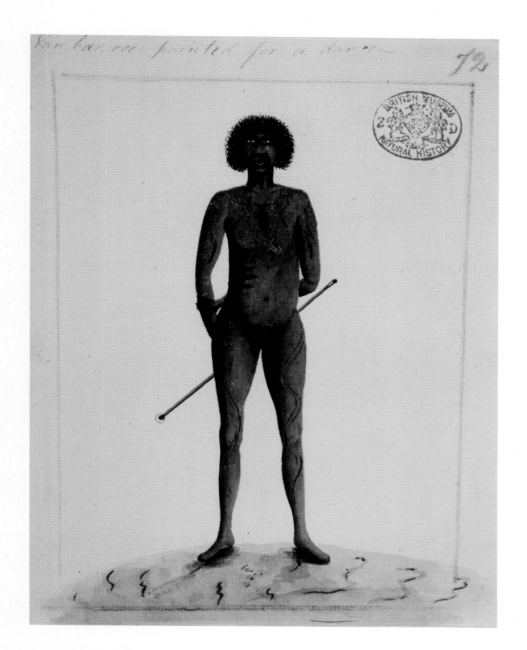

Plate 9 [Watling 63]
PORT JACKSON PAINTER
Nan.bar.ree painted for a dance
Ink and water-colour, 164 × 127
Orphaned by the smallpox epidemic,
Nan.bar.ree was unofficially adopted
by John White in 1789 at about the
age of eight, but did not lose touch
with Aboriginal culture, undergoing
the rites of initiation some six years
later.

Plate 8
Yoo-long Erah-ba-diang
A sequence of eight engravings (to be
read left to right and top to bottom)
by J. Neagle after Thomas Watling,
illustrating the Yoo-lahng ceremony,
from David Collins, *An Account of
the English Colony in New South
Wales* (1798) I, Appendix vi,
between 566–81.

Plate 10 [Watling 44]
PORT JACKSON PAINTER
*A Moobee Ornamented after a
Burial with a Club of great size over
the shoulder*
Ink and water-colour, tondo frame
142 diameter, sheet size 179 × 150
A similar but not identical figure is in
the National Library of Australia,
Canberra, NK 144/C (see plate 51).

Plate 11 [Watling 45]
PORT JACKSON PAINTER
*Abbarroo a moobee af'. Balloderrees
funeral*
Ink and water-colour, tondo frame
120 diameter, sheet size 167 × 141
The title appears to be in John
White's hand.

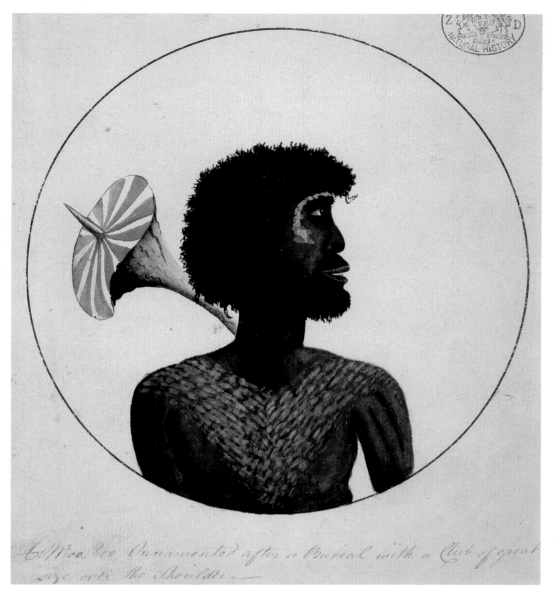

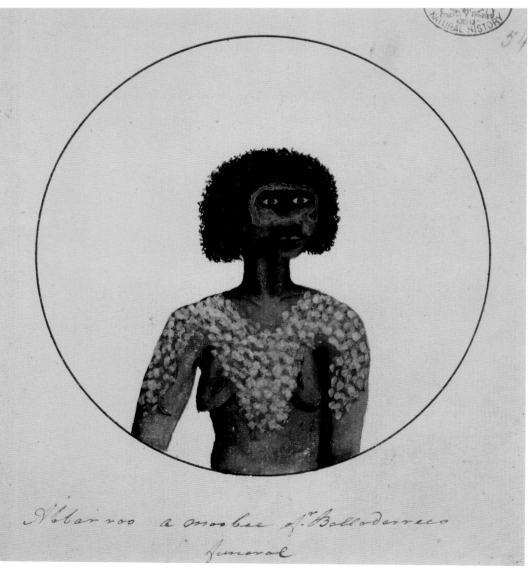

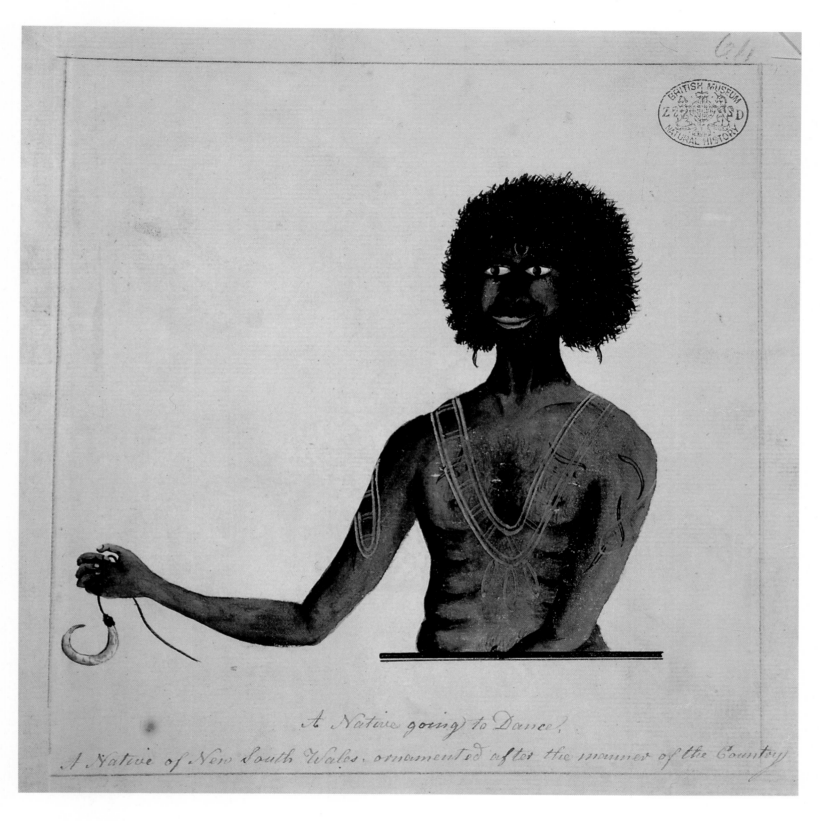

A Native going to Dance.

A Native of New South Wales, ornamented after the manner of the Country

Plate 12 [Watling 55]
PORT JACKSON PAINTER
*A Native going to Dance. A Native
of New South Wales ornamented
after the manner of the Country*
Ink and water-colour, 214 × 208
A similar drawing but with the head
in profile is held in the National
Library of Australia, Canberra,
NK 144/C (see plate 51).
Note the fish hook and line in the
right hand and the ornaments
gummed to the hair.

Plate 13 [Watling 67]
PORT JACKSON PAINTER
Colebee when a Moobee after
Balloderrees Burial
Ink and water-colour, tondo frame
119 diameter, sheet size 130 × 124
For what is probably a back view of
the same man see the drawing held
by the National Library of Australia,
Canberra, NK 144/A.

Plate 14 [Watling 66]
PORT JACKSON PAINTER
Dorringa his Wife smeared over with
burnt stick & Grease
Ink and water-colour, tondo frame
119 diameter, sheet size 136 × 134
Dorringa (Daringa) was the wife of
Colebee (see also plate 17).

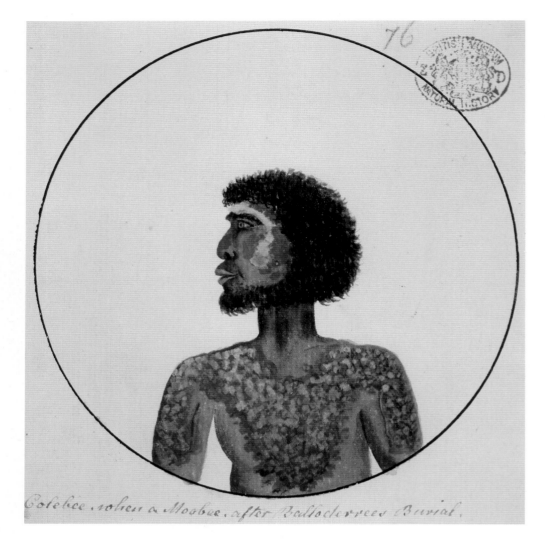

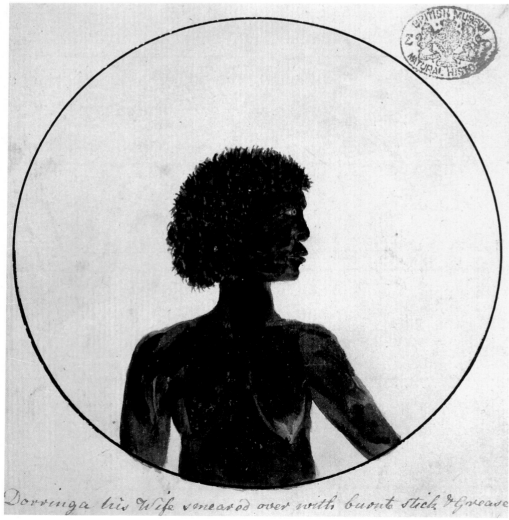

30

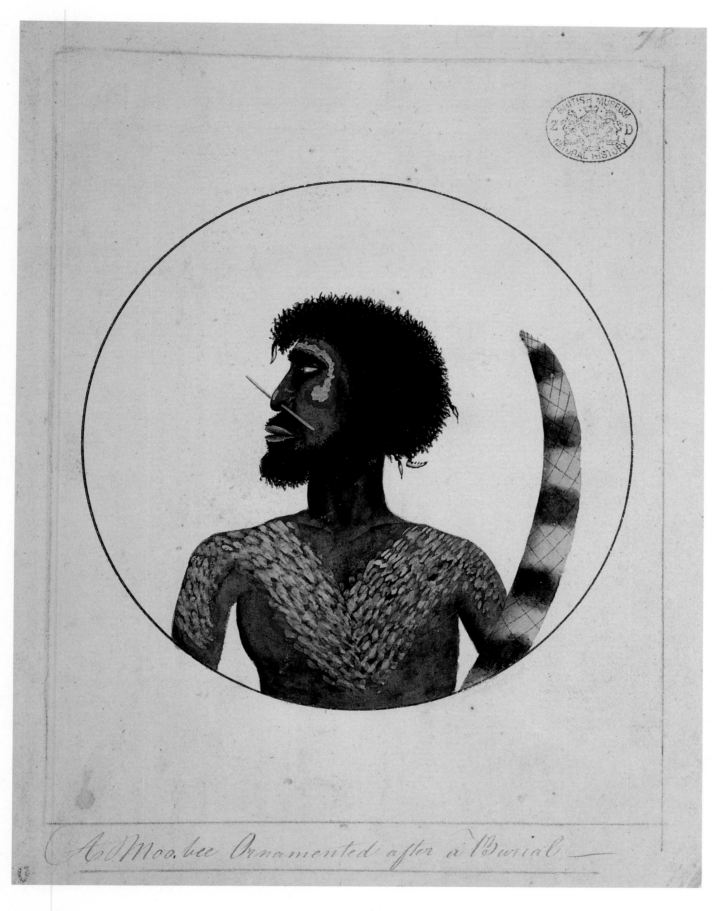

A Moobee Ornamented after a Burial

Plate 15 [Watling 69]
PORT JACKSON PAINTER
A Moobee Ornamented after a
Burial
Ink and water-colour, tondo frame
143 diameter, sheet size 236 × 181
For a similar portrait but with
different body paint designs see
plate 51.

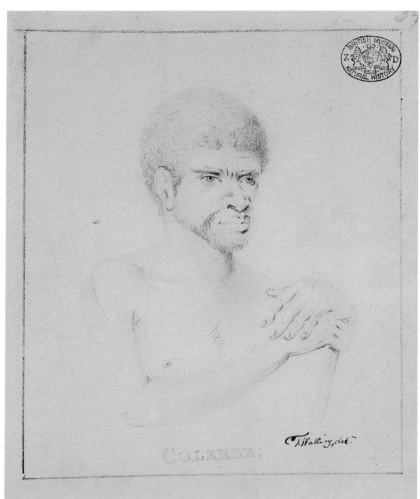

COLEBEE.

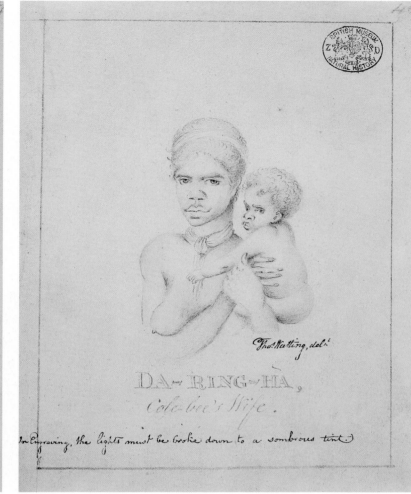

DA~RING~HA,
Cole-bee's Wife.

In Engraving, the lights must be broke down to a sombrous tint.

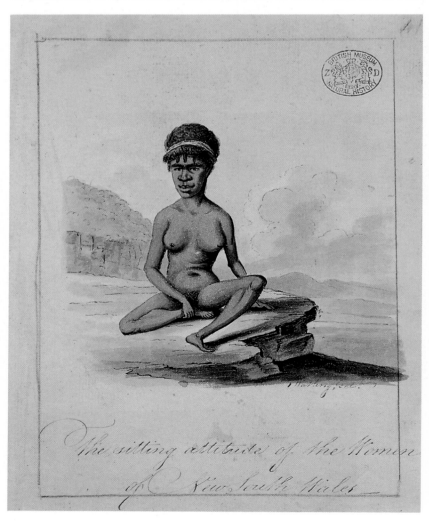

The sitting attitude of the Women
of New South Wales

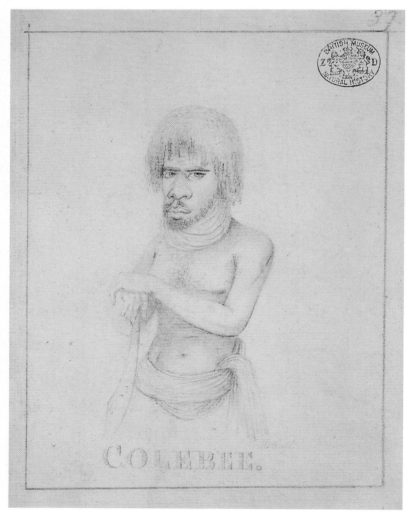

COLEBEE.

32

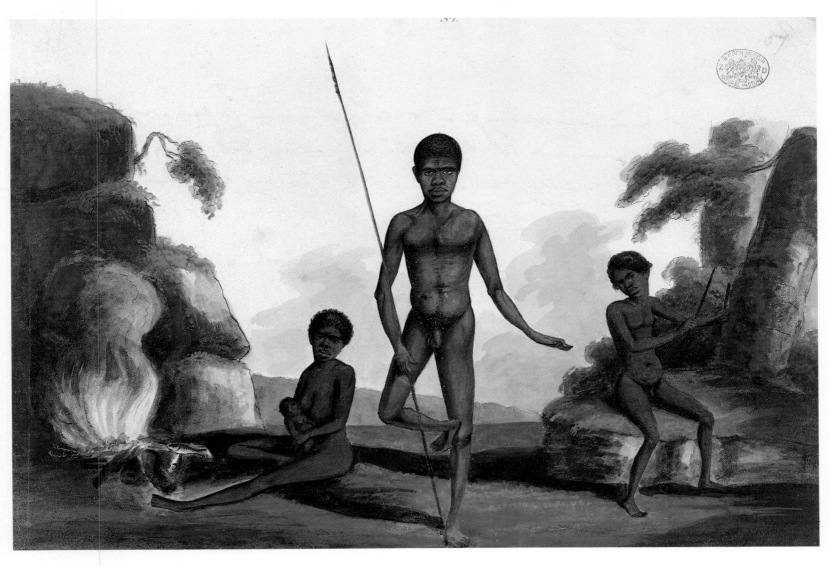

Plate 16 [Watling 30] *top left*
THOMAS WATLING
Colebee
Pencil, 207 × 172, signed in ink
'T. Watling del.'

Plate 17 [Watling 31] *top right*
THOMAS WATLING
Da-ring-ha, Cole-bee's Wife
Pencil, 204 × 160, signed in ink,
'Tho‡ Watling del.'
The inscription 'In Engraving the
lights must be broke down to a
sombrous tint' is in Watling's
'informal' hand.

Plate 18 [Watling 32] *bottom left*
THOMAS WATLING
*The sitting attitude of the Women
of New South Wales*
Pencil, ink and wash, 205 × 165,
signed in ink 'T. Watling del.'
The title is inscribed in Watling's
'copperplate' hand.

Plate 19 [Watling 28] *bottom right*
THOMAS WATLING
Colebee
Pencil, 202 × 160, signed (l.r.)
faintly in pencil 'T. Watling d!'
The waistband and neckband were
possibly made from possum-fur
string; the weapon is a wooden club
shaped like a sword.

Plate 20 [Watling 48]
THOMAS WATLING
*Native Man standing in an attitude
very common to | them all. A
Woman with her child on her lap
broiling | Fish while a Boy is beating
two Sticks together and | dancing to
the sound*
Wash and water-colour, 250 × 366
The title as above inscribed on verso
and on a separate label mounted
beneath the drawing. Also inscribed
'No. 1' above the drawing.

33

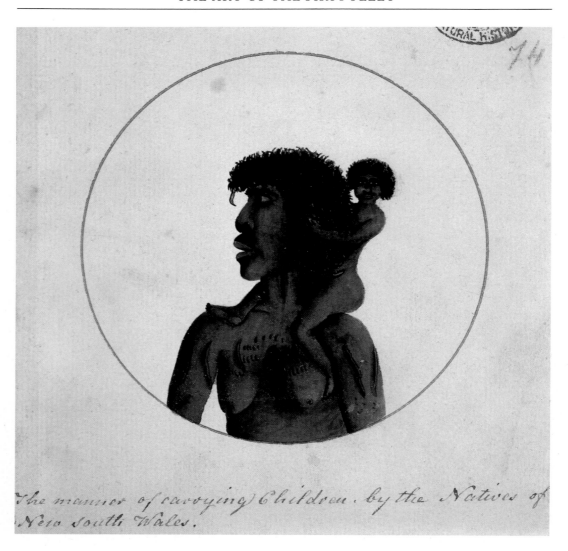

Plate 21 [Watling 65]
PORT JACKSON PAINTER
*The manner of carrying Children by
the Natives of New South Wales*
Ink and water-colour, tondo frame
91 diameter, sheet size 135 × 121

Courtship and marriage rites attracted unfavourable comment from writers, who saw the women as 'unfortunate victims of lust and cruelty'.[30] In a superficial view of such reports it would appear that women were abducted forcibly and haphazardly, being dragged away by men at whim. However closer inspection suggests that in most cases formal social relationships were being strictly observed: women were taken from a different band and brought to live in the man's band, thereby corresponding to the usual exogamous and patrilocal Aboriginal marriage pattern; members of a woman's band did not resist the abduction, nor did the woman later attempt to flee back to her original band; small girls and boys played abduction as a game, indicating it was a well-entrenched system. While 'marriage by capture' was rare in Aboriginal society generally,[31] it is known from other parts of the world. At Sydney it appears to have been a socially sanctioned ritual following acceptable marriage patterns despite the involvement of, apparently, quite brutal assault. However, not all abductions were sanctioned, as in the case of a man named Collindium who abducted the wife of Carruey and was nearly killed in the ensuing fight.[32]

Warfare appears to have been mainly formal combat between pairs of individual duellists. In preparation for a fight, men painted their bodies and equipped themselves with war spears, shield and spear thrower [plates 23, 30, 35]. In a fight at Manly,

two parties of natives met, and commenced hostilities . . . A champion from each party, armed with spear and shield, pressed forwards before the rest, and, as soon as a favourable opportunity offered (till which he advanced and retreated by turns), threw his spear, and then retired; when another immediately took his place, going through the same manoeuvres; and in this manner was the conflict carried on for more than two hours.[33]

In such combat 'honour was rigidly observed . . . never throwing at him until he covered himself with his shield'.[34] Dexterity in throwing the spear and parrying it with the shield were considered the most worthwhile of skills.[35] Children practised this from an early age, using rushes and twigs as spears and pieces of soft bark as shields [plate 24]. Some hostility was punitive, the offending party being compelled to stand while all who chose to threw spears at him.[36] Not all hostility was formal, revenge murders, even of little children, being recorded.[37] Sometimes revenge attacks were carried out at night on a sleeping person as plates 25 and 26 depict.[38]

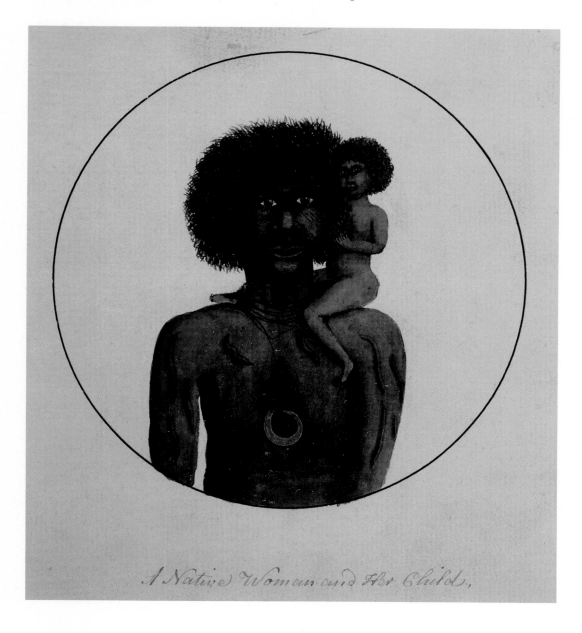

A Native Woman and Her Child,

Plate 22 [Watling 42]
PORT JACKSON PAINTER
A Native Woman and Her Child
Ink and water-colour, tondo frame
121 diameter, sheet size 180 × 166
Note the fish hook and line worn
around her neck and the manner in
which the child is carried.

Plate 23 [Watling 50]
PORT JACKSON PAINTER
A Native of New South Wales equipt for Fight
Ink and water-colour, 283 × 187

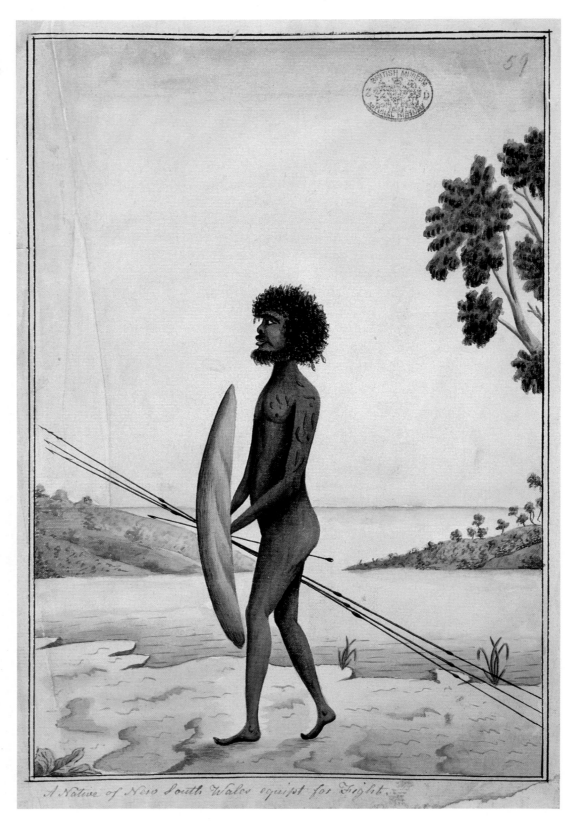

A Native of New South Wales equipt for Fight.

Plate 24 [Watling 46]
PORT JACKSON PAINTER
Two Native Boys – of New south Wales – practising throwing the Spear this they do with small twigs cut on purpose. A View in Port Jackson. 1792
Water-colour, 200 × 321

Plate 25 [Watling 47]
PORT JACKSON PAINTER
A Native of New South Wales surprising & wounding another whilst a sleep
Water-colour, 210 × 301

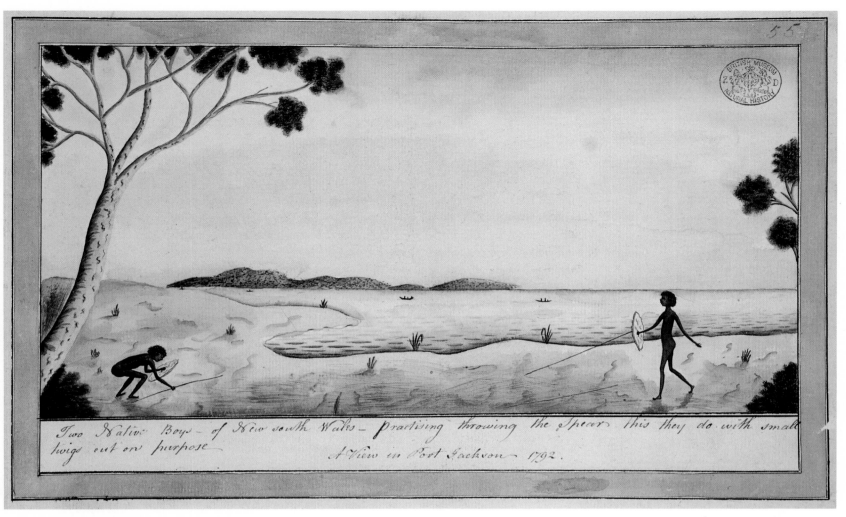

Two Native Boys — of New south Wales — practising throwing the Spear this they do with small
twigs cut on purpose
A View in Port Jackson 1792.

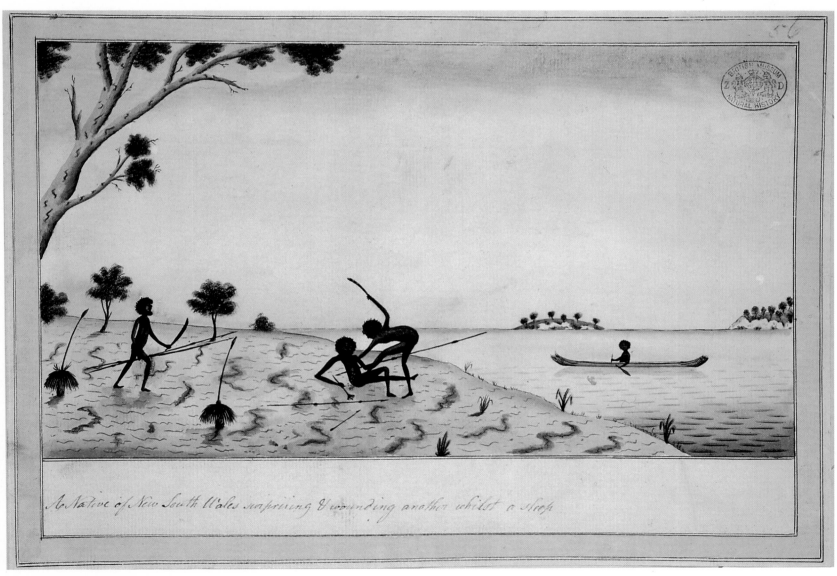

A Native of New South Wales surprising & wounding another whilst a sleep

Both Collins and Tench comment on the excellent health of people and on the rapidity with which their wounds healed. Pain was treated by applying a ligature to the affected part and temporarily stopping the circulation.[39] Burns were covered with a thin paste of clay to exclude the air.[40] The Port Jackson Painter shows a method for curing sickness [plates 27, 29] also described by Tench:

Abaroo was sick; to cure her, one of her own sex cut her slightly on the forehead . . . with an oyster shell, so as just to fetch blood; she then put one end of a string to the wound, and, beginning to sing, held the other end to her own gums, which she rubbed until they bled copiously. This blood, she contended, was the blood of the patient, flowing through the string, and that she would thereby soon recover.[41]

Although Tench considered Aboriginal doctors (carrahdis) to be concerned more with the occult than with science,[42] archaeologists have discovered many well-healed fractures of arm and leg bones while examining Aboriginal skeletal remains from the east

Plate 26 [Watling 52]
PORT JACKSON PAINTER
A Native Wounded while asleep
Ink and water-colour, 210 × 187

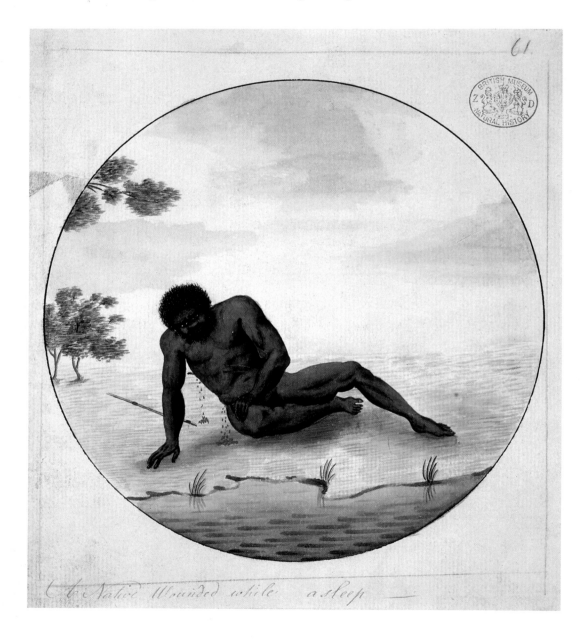

coast, showing that Aborigines were practised in techniques of setting and splinting limb fractures.[43] In the case of a leg fracture, the injured person must have been kept immobile for several months and looked after throughout this time by other members of the band.

The death of a person involved funerary and mourning rites, as it does in other societies. Collins notes that young people who died were buried, but those who had passed middle-age were cremated.[44] Ballooderry, whose funeral was attended by both Abarroo [plate 11] and Colebee [plate 13], was buried approximately a day and a half after death. His body, together with his personal possessions, (spears, spear thrower and belt), was placed in a coffin made from a canoe cut down to size. Two bearers carried his coffin attended by other mourners who waved bunches of grass during the funeral procession.[45] Bennelong cremated his wife, placing her body, together with her fishing lines and other personal property, on a pyre of dry wood. On the following day he raked the ashes and calcined bone together, and covered them with a carefully made mound of earth.[46] The chief mourners at funerals were called 'Mooby' and were painted red and white for the occasion [plates 10, 11, 13, 15]. It was forbidden to mention the name of a deceased person, a custom that persists among many Aboriginal communities today. At Port Jackson, persons bearing the same name as the deceased were renamed to ensure this rule was kept.[47]

Although Collins was of the firm opinion that the people were not religious in any way, he also describes many things that persuade modern scholars of the depth of Aboriginal religious belief.[48] These include a belief in the immortality of the human spirit, the idea of a mystical source and end of life, a well-developed moral code, and the importance of ritual in funerals and initiation.[49]

Plate 27 [Watling 62]
PORT JACKSON PAINTER
A Woman of New South Wales cureing the head ache, the blood which she takes from her own gums she supposes comes along the string from the part affected in the patient. This operation they call Bee-an-nee
Ink and water-colour, 217 × 346
The title (except the last word) appears to be in John White's hand.

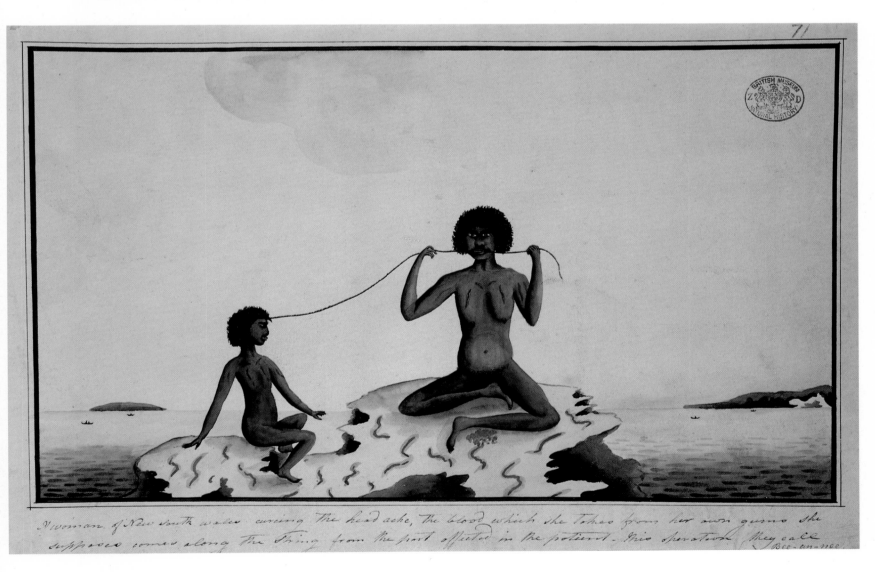

A woman of New South Wales cureing the head ache, the blood which she takes from her own gums she supposes comes along the string from the part affected in the patient. This operation they call Bee-an-nee

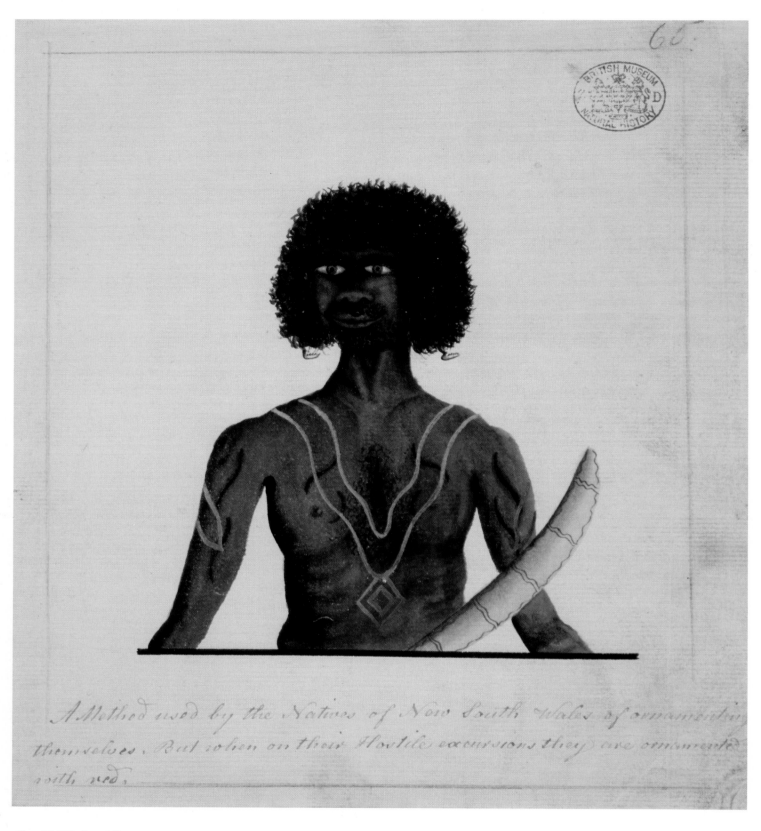

Plate 28 [Watling 56]
PORT JACKSON PAINTER
A Method used by the Natives of
New South Wales of ornamenting
themselves. But when on their
Hostile excursions they are
ornamented with red
Ink and water-colour, 213 × 192
The drawing is similar in style to
the men illustrated in the sheet of
drawings in the National Library of
Australia, Canberra, NK 144/C (see
plate 51).

Daily Life

People inhabiting the sea coast depended for their livelihood on fish and other sea foods. In the words of Collins: 'Fish is their chief support. Men, women, and children are employed in procuring them; but the means used are different according to the sex; the males always killing them with the fiz-gig, while the females use the hook and line.'[50]

Fishing was a prominent activity seen every day by members of the First Fleet, hence it was a frequent subject for artists as shown by the number of drawings depicting spear fishing by men [plates 36, 37, 40] and line fishing by women [plate 37]. Fishing occupied much of the day and during cold weather, when fish were scarce, it continued at night [plates 36, 38] to bolster the meagre catch.

Men fished with a fiz-gig (or fish-gig), a kind of harpoon. This was a three- or four-pronged spear, as depicted in a number of drawings, perhaps most clearly by Raper [plate 42:2]. The shaft was made from the light, but tough, flower stalk of the grass tree (*Xanthorrhoea resinosa*), the prongs from springy hardwood, each of which was tipped and barbed with a sliver of sharpened bone. The various components were held together with yellow gum from the grass tree, and a binding of strips of bark. Sometimes small wedges were driven into the binding to tighten it (for example, White, fig. *cc*). The barb at the tip of each prong was on the inside so that fish were held between the prongs. For fishing in deep waters, the spear could be extended in length, up to 20ft (6m), by joining several sections of shaft together. Fishing in waters deeper than this was the work of women who fished with hook and line from a canoe. The line was made of two narrow strips of inner bark stripped lengthwise from the trunk of a tree such as kurrajong (*Brachychiton populneum*) or sally wattle (*Acacia longifolia*), the

Plate 29 [Banks Ms34: 45]
PORT JACKSON PAINTER
Healing a child
Ink and water-colour, 205 × 318

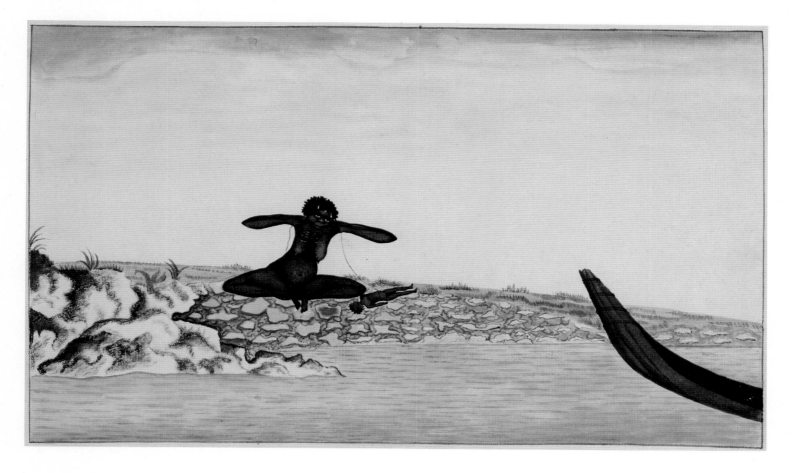

Plate 30 [Watling 53]
PORT JACKSON PAINTER
This Mans name is Cameragal the
chief of the most powerfull Tribe
that | we at present know of in New
south Wales. He holds two fighting
spears | and a Fizgig in one hand and
two throwing sticks in the other
Ink and water-colour, 296 × 188

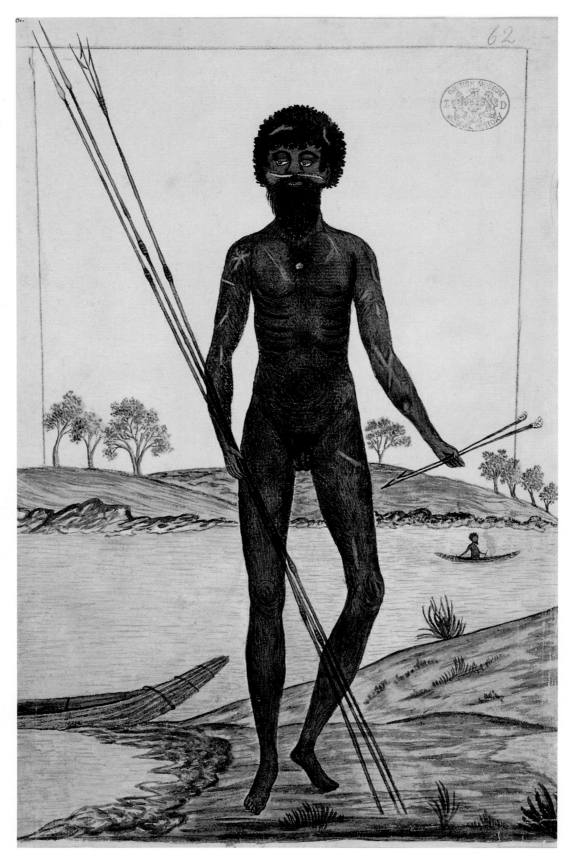

strips being twisted together by rolling along the inside of the thigh. The line was then rendered watertight by soaking it in the sap of the bloodwood tree (*Eucalyptus gummifera*).

The hook, attached to the line with yellow gum, was fashioned from the large turban shell (*Turbo torquata*) using a coarse stone file to produce the crescentic shape of the hook [plates 12, 22, 42, 43, 44]. Filing also removed the rough surface, exposing the nacrous inner shell which acted as a lure. The hook itself was not baited but a burly of chewed-up fish or shellfish was spat into the water to attract fish to the hook.

The accuracy of the drawings of artefacts, as well as the descriptions by First Fleet writers, is supported through examination of extant specimens. Very few fishing spears exist in museum collections even though these were collected in large numbers by early European observers, Cook alone collecting fifty such spears from Botany Bay. Today, only two complete fishing spears from the entire Sydney district are known to exist, both in the Miklukho-Maklay Institute, Leningrad.[51] However, the bone tips of such spears survive in archaeological deposits and have been recovered during the excavation of Aboriginal camp sites, both around Sydney and as far south as Durras North.[52] These sites also yielded fish hooks, the circular shell blanks from which hooks were fashioned, and the stone files used in their manufacture, showing that the type of subsistence seen by Watling and others at Port Jackson was more widespread on the east coast.

The same sites contain fish bones, used by archaeologists to identify the fish species eaten by Aborigines. At some sites two species predominate: snapper (*Chrysophrys auratus*), a deep water fish which is easily hooked, and bream (*Mylio* sp.), an inhabitant of shallower waters which is shy of the hook.[53] While camped at these sites it seems likely that women caught most snapper from canoes with their long lines, while men took mainly bream using their spears either from canoes or from the shore. In combination, the two methods of fishing allowed not only a wider species range of fish to be taken but it also exploited the waters more thoroughly.

Plate 31 [Banks Ms34: 43]
PORT JACKSON PAINTER
Bark canoes of Port Jackson
Water-colour, 286 × 168
Photographed for reproduction from the original bound volume before the drawings were mounted separately; the image of plate 34 (Banks Ms34:42) can be seen faintly, the pigment having bled through to plate 31 from the preceding leaf.

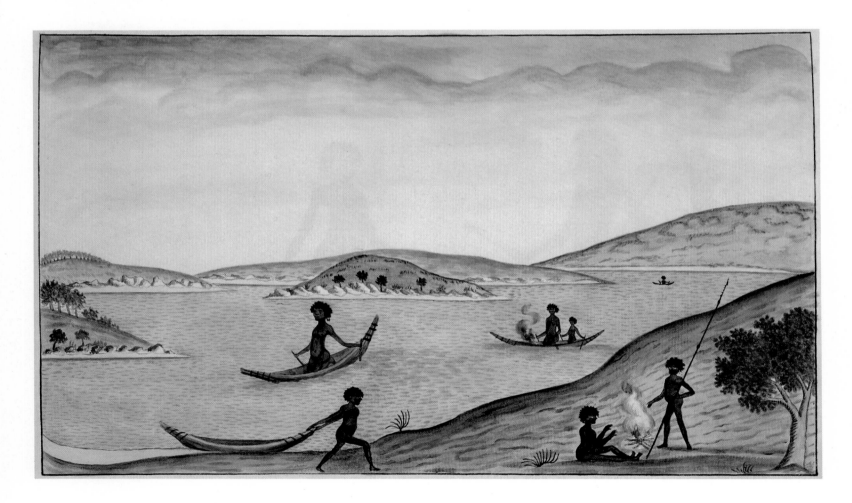

Plate 32 [Watling 51]
PORT JACKSON PAINTER
A woman and child by a fire
Ink and water-colour, 254 × 186
Inscribed (u.l.) 'The Hair appears as
if very woolley, but is only so with
grease and dirt'.

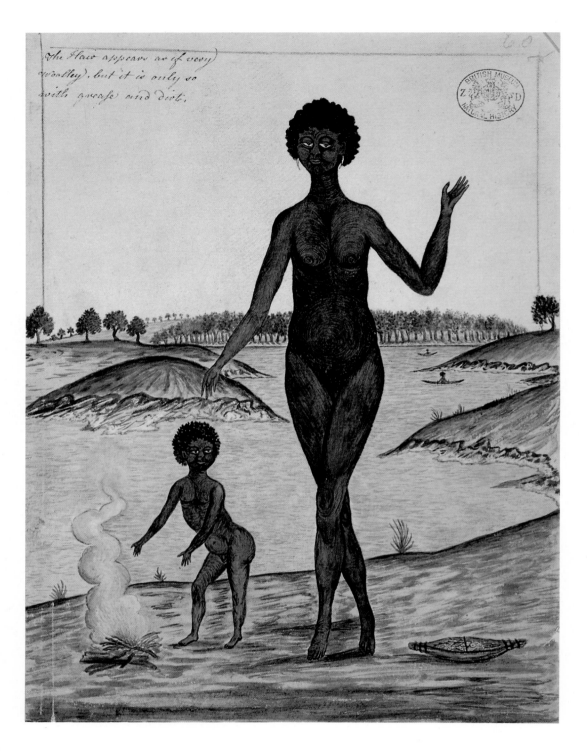

Plate 33 [Watling 59]
PORT JACKSON PAINTER
*A view in Port Jackson. A woman
meeting her Husband who had been
out on some exploit and offering
Him some Fish*
Ink and water-colour, 193 × 310

Plate 34 [Banks Ms34: 42]
PORT JACKSON PAINTER
A woman meeting her husband and
offering him some fish
Water-colour, 280 × 168
A more finished version of plate 33.

44

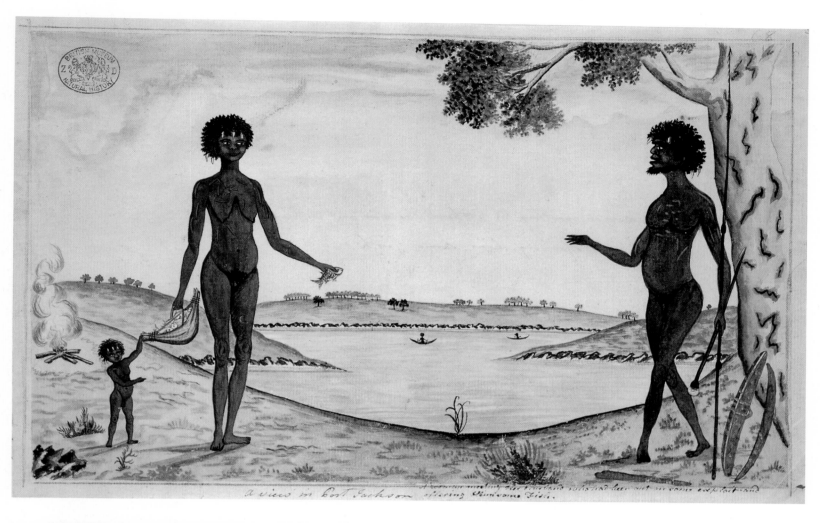

A view in Port Jackson ... offering ...

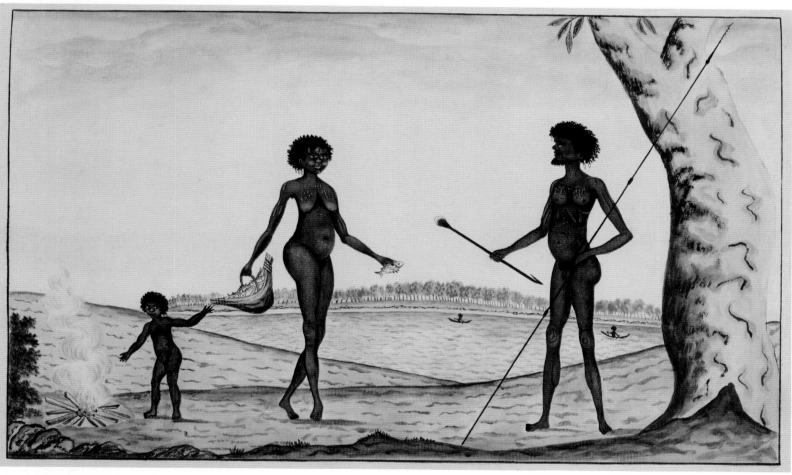

Plate 35 [Watling 54]
PORT JACKSON PAINTER
A Native of New South Wales with a Fizgig and a throwing stick in his Hand. the throwing sticks is always used | with the War Spear and not with the Fizgig
Ink and water-colour, 242 × 171
The inscribed title as above is on a label pasted beneath the drawing.

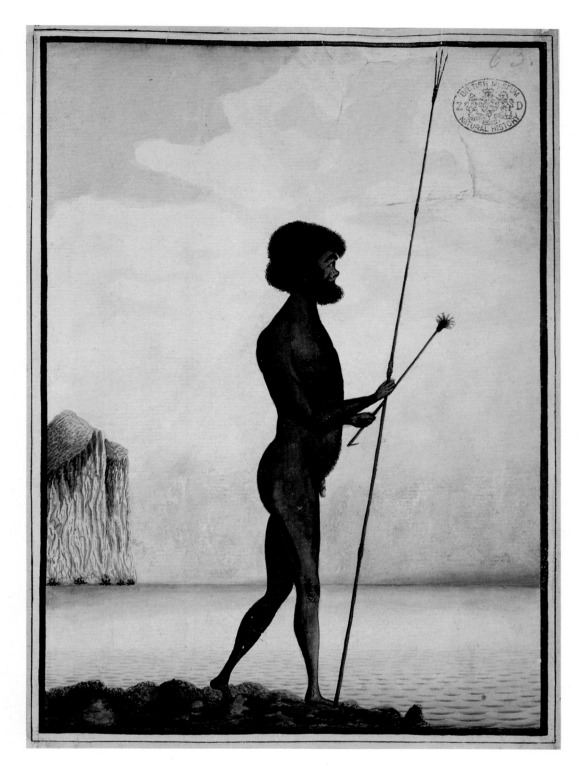

Plate 36 [Watling 49]
PORT JACKSON PAINTER
A N. South wales Native strick^g. fish by moon light while his wife paddles him along with a fire in the Canoe ready to broil the fish as caught
Ink and wash with some water-colour, 195 × 307
The title appears to be in John White's hand. Note the spelling of 'striking' here and in plate 37.

Plate 37 [Watling 29]
PORT JACKSON PAINTER
A New South Wales native Stricking fish while his wife is employed fishing with hooks & lines in her Canoe
Water-colour, 200 × 307
The title appears to be in John White's hand.

46

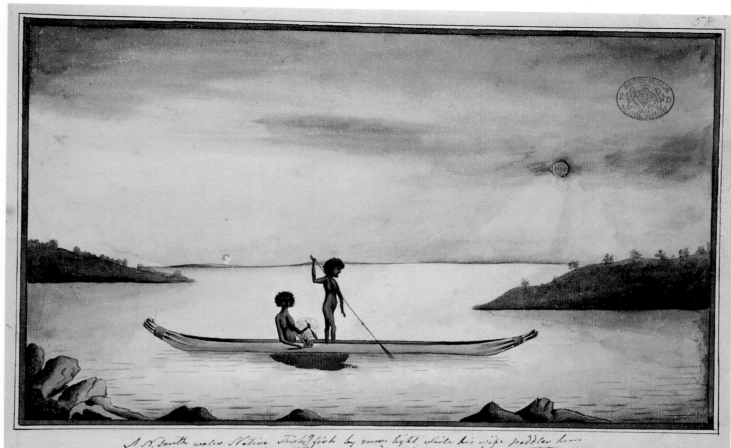

A N. South wales Native Strik'g fish by moon light while his wife poddles him
along with a fire in the Canoe ready to broil the fish as caught

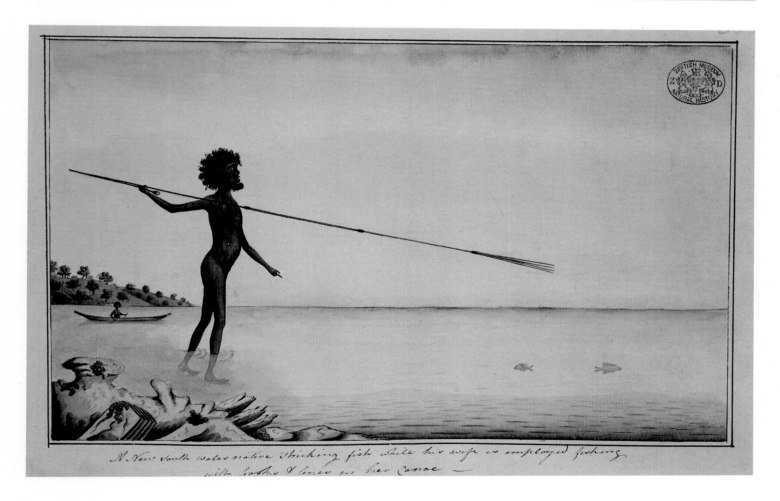

A New South wales native Stricking fish while his wife is employed fishing
with hooks & lines in her Canoe —

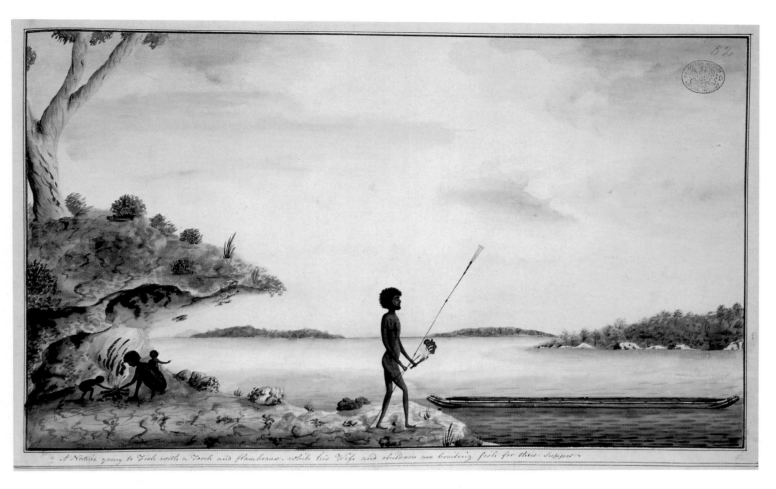

A Native going to Fish with a Torch and flambeaux, while his Wife and children are broiling fish for their Supper

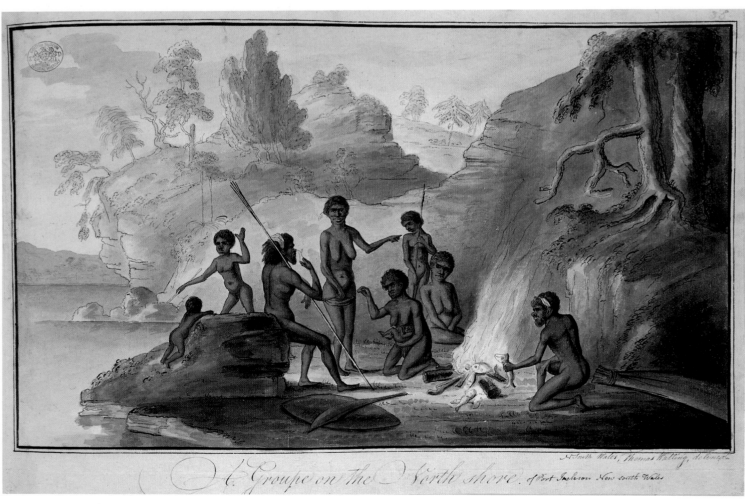

A Groupe on the North shore, of Port Jackson New south Wales

N.º South Wales, Thomas Walling, delint.

48

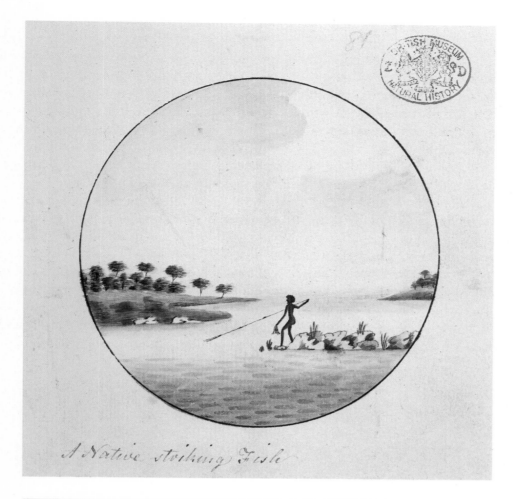

A Native striking Fish

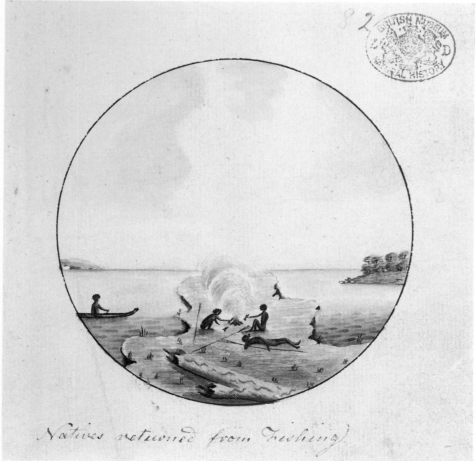

Natives returned from Fishing

facing page

Plate 38 [Watling 43]
PORT JACKSON PAINTER
*A Native going to Fish with a Torch
and flambeaux, while his Wife and
children are broiling fish for their
Supper*
Water-colour, 267 × 426

Plate 39 [Watling 26]
THOMAS WATLING
A Groupe on the North shore
Pencil, ink and wash, 302 × 449,
signed 'N South Wales, Thomas
Watling delineat'
The title as above in Watling's
'copperplate' hand, with 'of Port
Jackson, New south Wales' in
another hand, possibly John White's.
For comparison see 'A Night Scene
in the Neighbourhood of Port
Jackson' (frontispiece) and 'A Scene
by Moonlight' (p.*x*) in Collins
(1802).

Plate 40 [Watling 72]
PORT JACKSON PAINTER
A Native striking Fish
Ink and water-colour, tondo frame
93 diameter, sheet size 125 × 125

Plate 41 [Watling 73]
PORT JACKSON PAINTER
Natives returned from Fishing
Water-colour, tondo frame
95 diameter, sheet size 128 × 127

49

The canoes, used both for fishing and as transport, were simply a single sheet of bark taken with the aid of a stone hatchet from a stringybark tree (*Eucalyptus obliqua*) or she-oak (*Casuarina* sp.) [plates 31, 45]. The bark was bunched together and tied with a vine at each end. Any holes were sealed with yellow gum, short lengths of stick were fitted as thwarts, and to some canoes longer sticks appear to have been tied in place as gunwhales [plates 42, 43]. When fishing, a small fire was carried in the canoe, laid upon a bed of sand or damp seaweed. People broiled their catch on this and ate some of the fish as soon as they were caught [plate 36].

Among other seafoods, shellfish were widely eaten, the discarded shells being left as small mounds. Many of these shell middens are still visible at Aboriginal camp sites along the coast. A stranded whale provided an enormous amount of food, bringing people from far and wide, who very often took advantage of such a large gathering to hold a ceremony.[54] While seafoods predominated in the diet, birds, land mammals, fruits and roots were also eaten; fern root, notably, was consumed in quantity during times when fish were scarce.

Bands of people inhabiting such inland regions as the Cumberland Plain and the Blue Mountains subsisted almost entirely by hunting land mammals [plate 47] and

Plate 42 [Raper 18]
GEORGE RAPER
Natives Implements for War &cc, &cc, about Port Jackson
The central scene is inscribed 'Natives Fishing in their Canoe. Port Jackson'.
Ink and water-colour, 318 × 490, signed and dated twice at l.r. on the vignette and the l.r. of the larger frame
Probably drawn by Raper early in 1790 before he left for Norfolk Island on 6 March 1790.
For a copy by the Port Jackson Painter with some slight changes (note the two fish gigs depicted here) see plate 43.

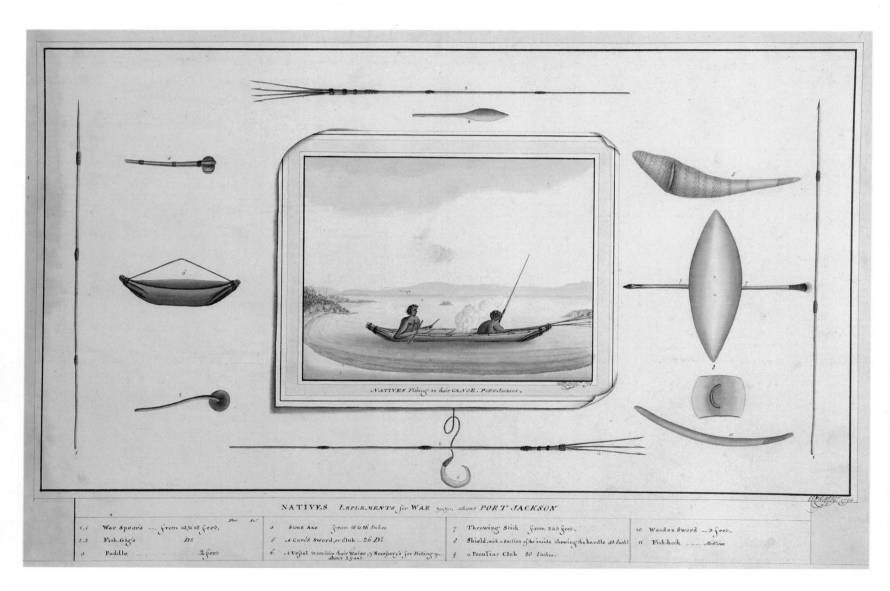

50

gathering vegetable foods. Elaborate traps were made for snaring birds. Holes were cut in trees into which such arboreal animals as possums and gliders retreated, and were then captured when hunters fired the surrounding undergrowth.[55] Men were expert in climbing trees [plates 48, 56] to reach prey. Aided by the use of a stone hatchet

he cut a small notch in the tree . . . in which he fixed the great toe of his left foot, and sprung upwards, at the same time embracing the tree with his left arm; in an instant he had cut a second notch for his right toe on the other side of the tree into which he sprung; and thus alternately cutting on each side, he mounted to the height of twenty feet, in nearly as short a space as if he had ascended by a ladder, although the bark of the tree, was quite smooth and slippery . . .[56]

The contribution to the diet by women was in gathering small animals and vegetable foods. Sometimes they turned over quite large areas of topsoil when digging for edible roots such as orchid bulbs and the daisy yam.

People fished inland rivers like the Nepean, using canoes identical to those seen on the coast, but fishing was a far less important sector of the inland economy. Besides canoes, a number of other tools and weapons appear to have been common to both

Plate 43 [Watling 77]
PORT JACKSON PAINTER
Weapons and implements of the Natives of New South Wales
Ink and water-colour, 313 × 396
A copy, with some slight variations, of plate 42. The lettering on the inscriptions is similar to that on Brewer's copies of Hunter's maps (see plates 233–235).

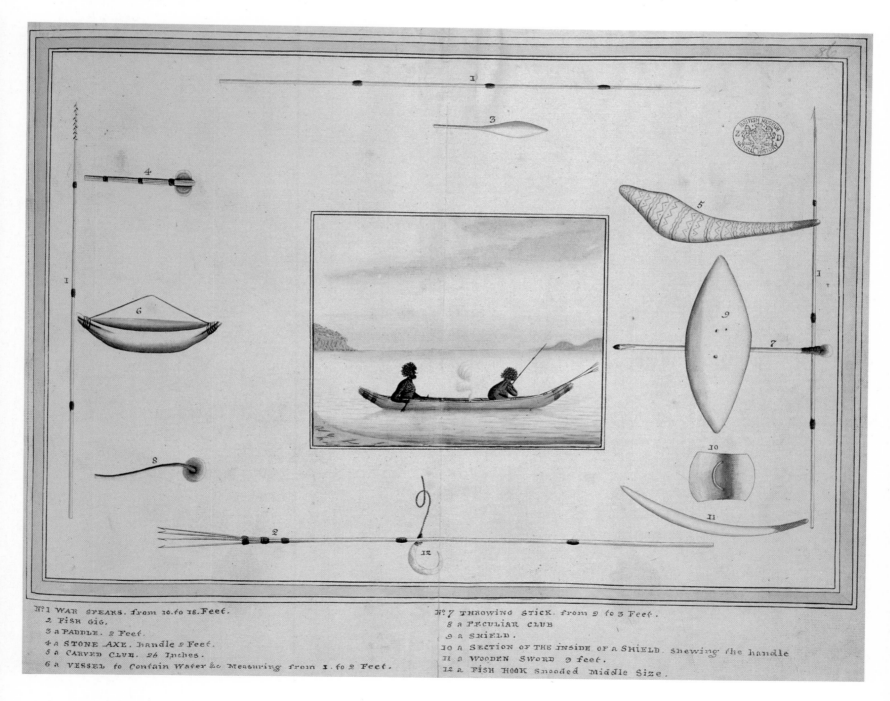

Nº 1 WAR SPEARS. from 10. to 18. Feet.
2 FISH GIG.
3 a PADDLE. 2 Feet.
4 a STONE AXE. handle 2 Feet.
5 a CARVED CLUB. 26 Inches.
6 a VESSEL to Contain Water &c Measuring from 1. to 2 Feet.
Nº 7 THROWING STICK. from 2 to 3 Feet.
8 a PECULIAR CLUB
9 a SHIELD.
10 a SECTION OF THE INSIDE OF A SHIELD. shewing the handle
11 a WOODEN SWORD 2 feet.
12 a FISH HOOK Snooded Middle Size.

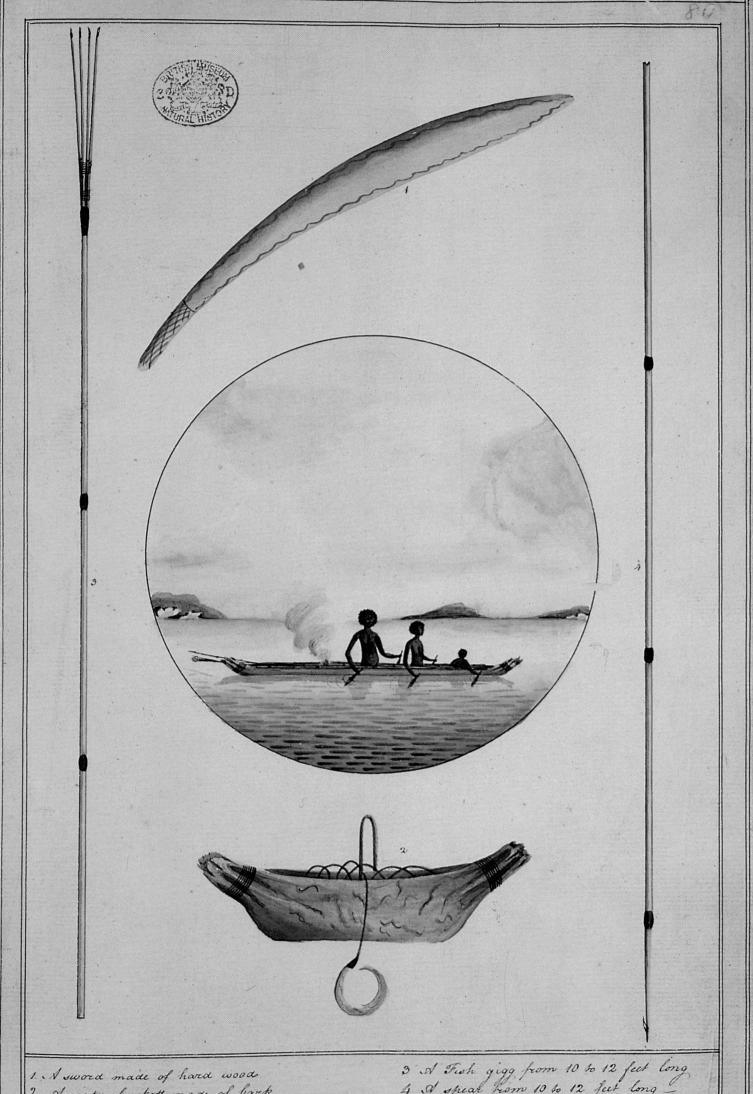

1. A sword made of hard wood

2. A water buckett made of bark

3 A Fish gigg from 10 to 12 feet long

4 A spear from 10 to 12 feet long

coastal and inland bands, some items no doubt, being spread by barter between bands, as McBryde describes for south-eastern Australia.[57] However, there were a number of notable differences, caused not only by varying modes of subsistence but also by the changing availability of raw materials. Stone which is hard enough to form the cutting edge of a tool is scarce on the coast around Port Jackson, although it is plentiful inland on the western reaches of the Cumberland Plain.[58] Consequently, shell was often substituted for stone on the coast. Inland, the barbs on a war spear [plate 56:4] were flakes of quartz cemented to the shaft with yellow gum, but on the coast fragments of shell were sometimes substituted for quartz.[59] Oyster-shell knives were used on the coast to sharpen spears,[60] and a shell (Sydney cockle, *Anadara trapezia*) was fixed with gum to the handle of the coastal spear thrower for use as a chisel [plates 33, 35, 42:7, 43:7], whereas more generally a specially shaped flake of hard stone was used in this manner.[61] Even in parts of the coast where hard stone was reasonably plentiful shell was often used as well, as is shown by excavated cutting tools of both shell and stone at the Durras North site.[62]

Though of particular importance inland, the stone hatchet was used also on the coast. Throughout Aboriginal Australia, axe stone was a prized commodity traded between groups of people, sometimes reaching a distance of several hundred kilometres from its source.[63] Tough stone was favoured, hard but resistant to chipping, such as basalt found as pebbles in the Nepean River some 60 kilometres inland. A suitable piece of stone weighing perhaps 1kg was ground to shape with a sharp cutting edge at one end by rubbing it on coarse sandstone, preferably in the stream bed where running water carried away the detritus.[64] This left characteristic grooves in the sandstone, many of which are still visible in the Sydney district. The stone was then fitted with a wooden handle by wrapping a split green sapling round it and holding it tight with gum and binding [plates 42:4, 43:4].

Plate 44 [Watling 71]
PORT JACKSON PAINTER
Weapons and implements of the
Natives of New South Wales
Ink and water-colour, 340 × 211

Plate 45 [Watling 27]
PORT JACKSON PAINTER
A Canoe of New South Wales
Water-colour, 197 × 337
The canoe was made from a single
sheet of bark banded and tied at
both ends. It carried a fire amidships
for cooking and was propelled by
bark paddles. Compare with tondo
on plate 44.

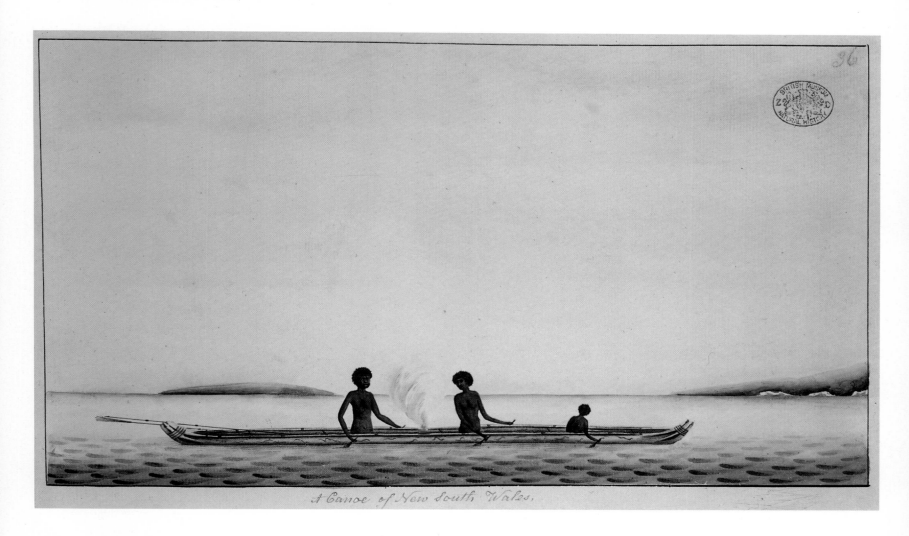

A Canoe of New South Wales.

Plate 46 [Watling 68]
PORT JACKSON PAINTER
A Native carrying a Water-basket of Bark
Ink and water-colour, tondo frame
91 diameter, sheet size 138 × 125

Plate 47 [Watling 74]
PORT JACKSON PAINTER
A Native spearing a Kangaroo
Water-colour, tondo frame
105 diameter, sheet size 127 × 125

Plate 48 [Watling 75]
PORT JACKSON PAINTER
Method of Climbing Trees
Water-colour, 316 × 190

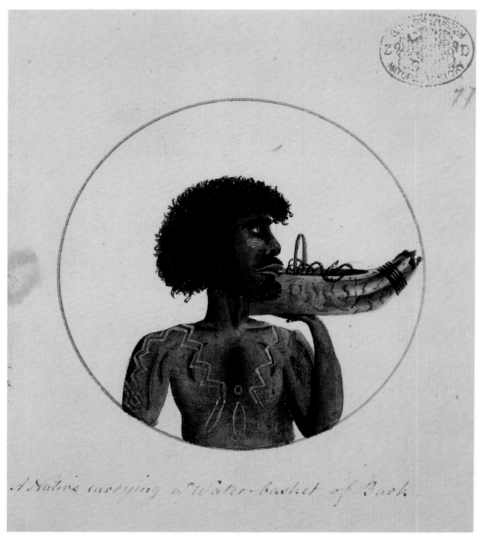

A Native carrying a Water-basket of Bark

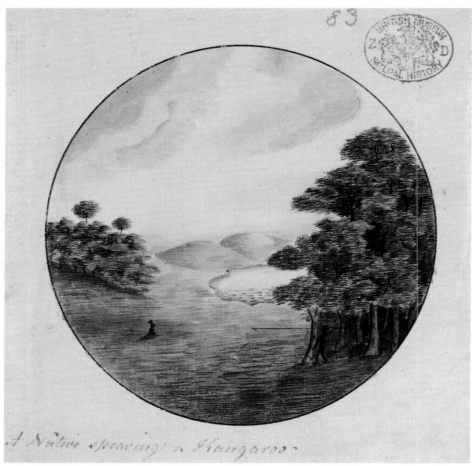

A Native spearing a Kangaroo

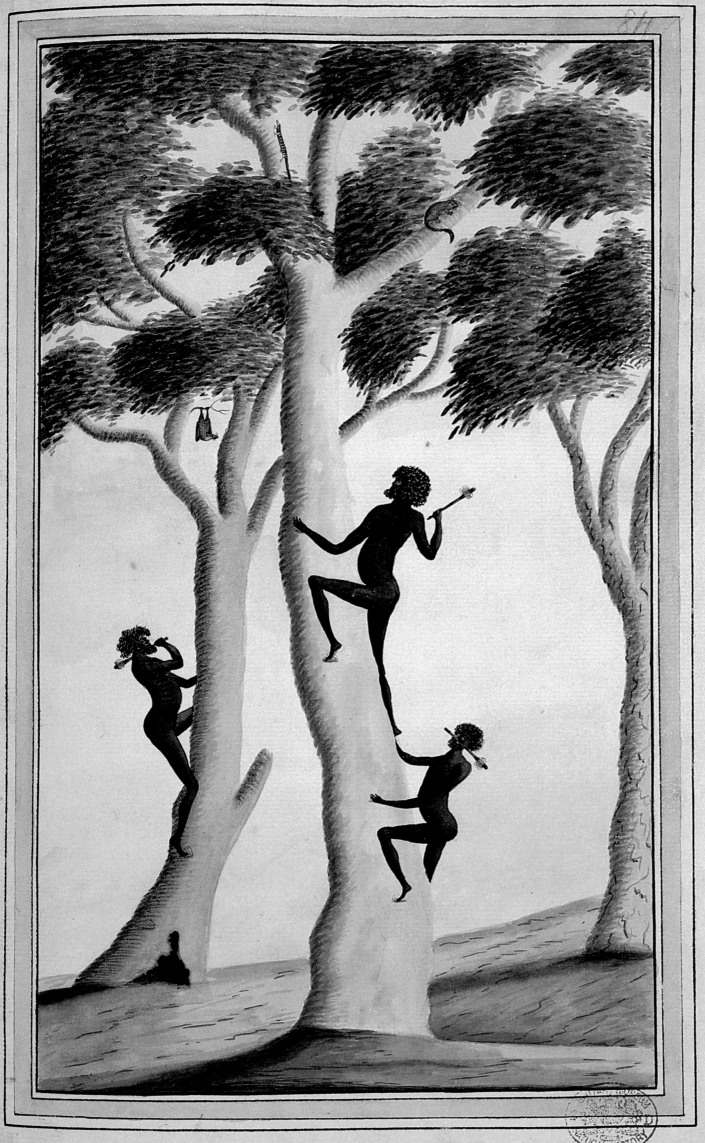

Method of climbing Trees

Plate 49 [Watling 57]
PORT JACKSON PAINTER
*The manner in which the Natives
of New South Wales ornament
themselves. Native name Goo-roo-
da. We suppose this Man is a chief
among the Thommarragals*
Ink and water-colour, 247 × 176
Compare with the figures in plate 51.

Plate 50 [Watling 64]
PORT JACKSON PAINTER
A Native with matted hair, a paddle
and a basket
Ink and water-colour, 328 × 199
Inscriptions in ink, 'A Paddle made
of Bark', 'A Native his hair matted
with gum, call'd in the native
Language Goonat', 'A Basket made
of the Knot of a Tree called Goo-
lime'.

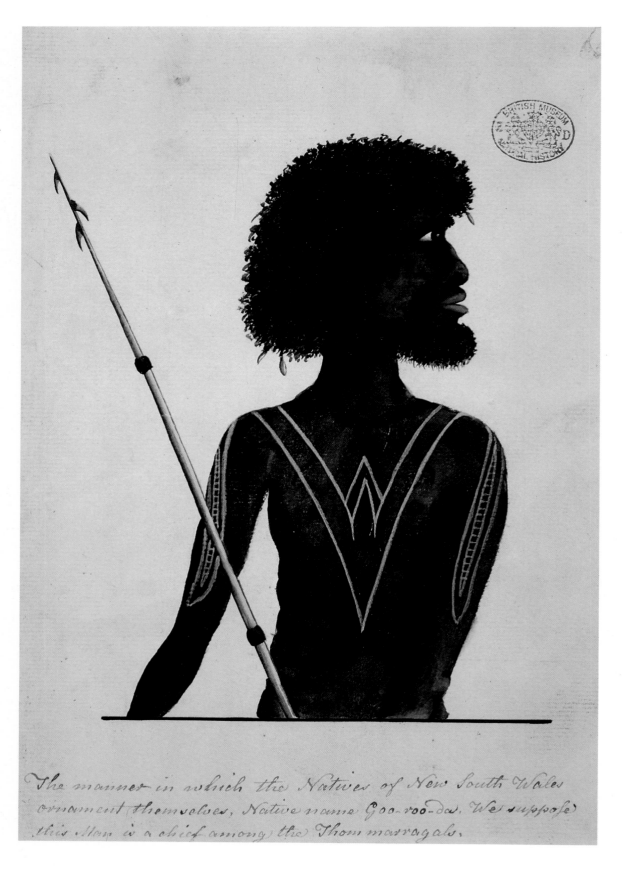

The manner in which the Natives of New South Wales ornament themselves, Native name Goo-roo-da. We suppose this Man is a chief among the Thom marragals.

A Native his hair matted with gum, call'd
in the native Language Goonat

A Basket made of the Knot of a Tree called
Goo-lime

As well as the spear thrower known as 'womera', with a hafted shell or stone in the handle, a second type called 'wiggoon' had a rounded wooden end [plate 52]. Made of heavier wood than the womera it was used to 'dig the fern root and yam out of the earth'.[65] Specimens of the wiggoon in the Australian Museum show striations at the rounded end consistent with this function.

The container most commonly used was a bark basket [plates 33, 42:6, 43:6, 44:2, 46]. These were made from 'a single piece of brown fibrous bark . . . gathered up at each end in folds, and bound in that form by withes, which also make the handle . . . patched in several places with yellow gum . . . used for carrying water'.[66] In the Richmond River district, some 350 kilometres north of Sydney, almost identical baskets were made of palm leaves.[67] As Raper [plate 43:6] notes, such containers were used for fresh water and other items and may have been essential when spending many hours fishing from a canoe. Another type of container was made from a hollowed-out tree gnarl [plate 50:3], examples from just north of Sydney are in the Australian Museum.

Spears for hunting and fighting were of several different kinds.[68] Collins lists seven, each type individually named. Of these we can identify in the drawings the 'nooro canny', a 'spear with one barb fastened on' [plates 33, 42:1, 43:1], the 'canny . . . with two barbs' [plate 33], possibly the 'bilarr . . . with one barb cut from the wood' [plate 43:1], either the 'wallangaleong . . . armed with pieces of shell' or the 'cannadiul . . . armed with stones' [plates 20, 56:4], and the 'gherubbine . . . without a barb' [plates 30, 42:1, 43:1, 56:4]. All of the spears depicted are made up from several sections joined together with gum and binding; most appear to have a hardwood head joined to a shaft of lighter wood, possibly grass tree flower stalk.

Plate 51
PORT JACKSON PAINTER
Five half-length portraits of men showing body paint designs and holding weapons and implements
Water-colour, 385 × 555
Previously ascribed to John Hunter.
The modelling and anatomy is markedly different, however, from the figures in Hunter's sketchbook [plates 221, 222]. See plates 5, 10, 12 and 15.
National Library of Australia, Canberra, NK 144/C.

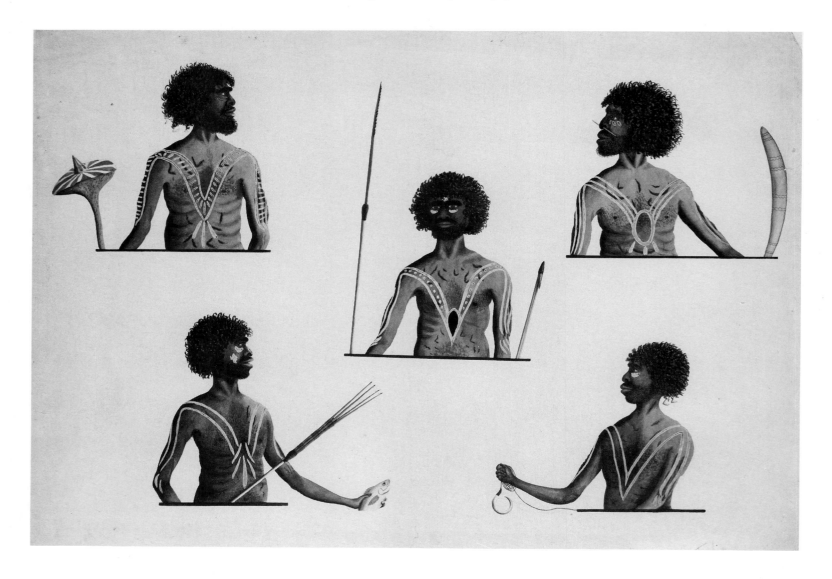

Shields were of two types, one being the 'eleemong . . . made of bark' with an applied handle fitted into two holes [plates 42:8, 43:9]. The way in which a shield of this type is removed from a tree, using stone wedges and hatchets, was demonstrated by Aboriginal men on the Hastings River between 1910 and 1927 and photographed by Thomas Dick (Australian Museum: V.7788). Other early drawings made in Sydney

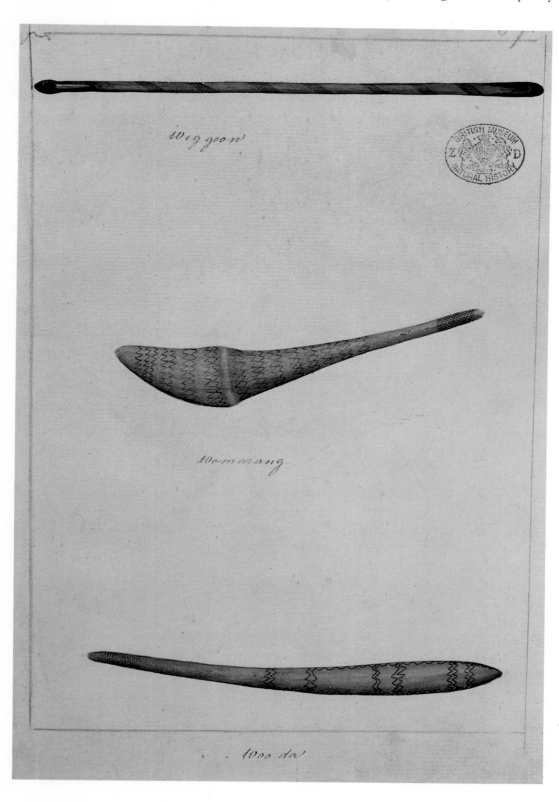

Plate 52 [Watling 78]
PORT JACKSON PAINTER
Weapons and implements of the
Natives of New South Wales
Wiggoon Womarang Wooda
Ink and water-colour, 240 × 164

(Peron 1808–11; National Library NK 144/F) [plate 51] show the red-on-white ochre style of decoration used, making it possible to identify three poorly documented bark shields in the Australian Museum as probably being from the Sydney district [plate 53].

The second type of shield, the 'arragong . . . cut from the solid wood'[69] was seen only rarely and, unfortunately, was not drawn by artists. However, an even rarer artefact, the 'tawarang' depicted by the Port Jackson Painter and labelled a 'musical instrument', was almost certainly another type of shield [plate 55:1]. Collins describes it thus:

It is about three feet long, is narrow, but has three sides, in one of which is the handle, hollowed by fire. The other sides are rudely carved with curved and wavy lines, and it is made use of in dancing, being struck upon for this purpose with a club.[70]

This describes exactly a type of parrying shield found in museum collections from inland south-eastern Australia, most commonly from western New South Wales [plate 54]. Its extreme rarity on the coast suggests it arrived as a trade item. Using a shield as a musical instrument was not unusual, since throughout Aboriginal Australia a variety of wooden weapons, such as shields, clubs and boomerangs, were beaten together in time with singing and dancing, in the same manner as clapsticks made for this specific purpose [plate 20].

Featured prominently among hardwood weapons are clubs which take a variety of forms, the one depicted most commonly being a 'wooden sword' [plates 19, 42:5, 43:5, 43:11, 44:1], described as 'a large heavy piece of wood, shaped like a sabre, and capable of inflicting a mortal wound . . .'[71] Also shown frequently is the 'gnallungula', a mushroom head club often with radial stripes of red and white on the head [plate 56:3]. The name of this club is the name also given to a mushroom.[72]

Only one of the drawings under consideration [plate 56] shows the bark hut 'formed of pieces of bark from several trees put together in the form of an oven with an entrance, and large enough to hold six or eight people'.[73] Other early artists (such as

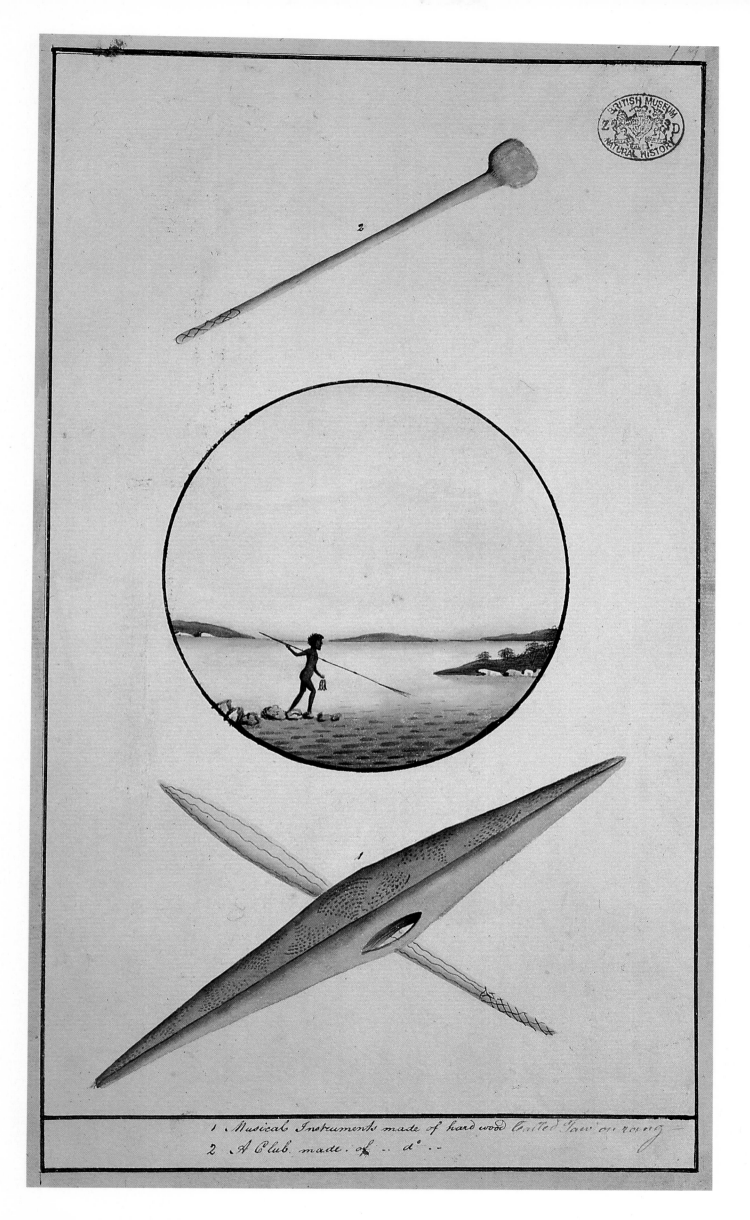

1. Musical Instruments made of hard wood Called Taw'arrang
2. A Club made of . do .

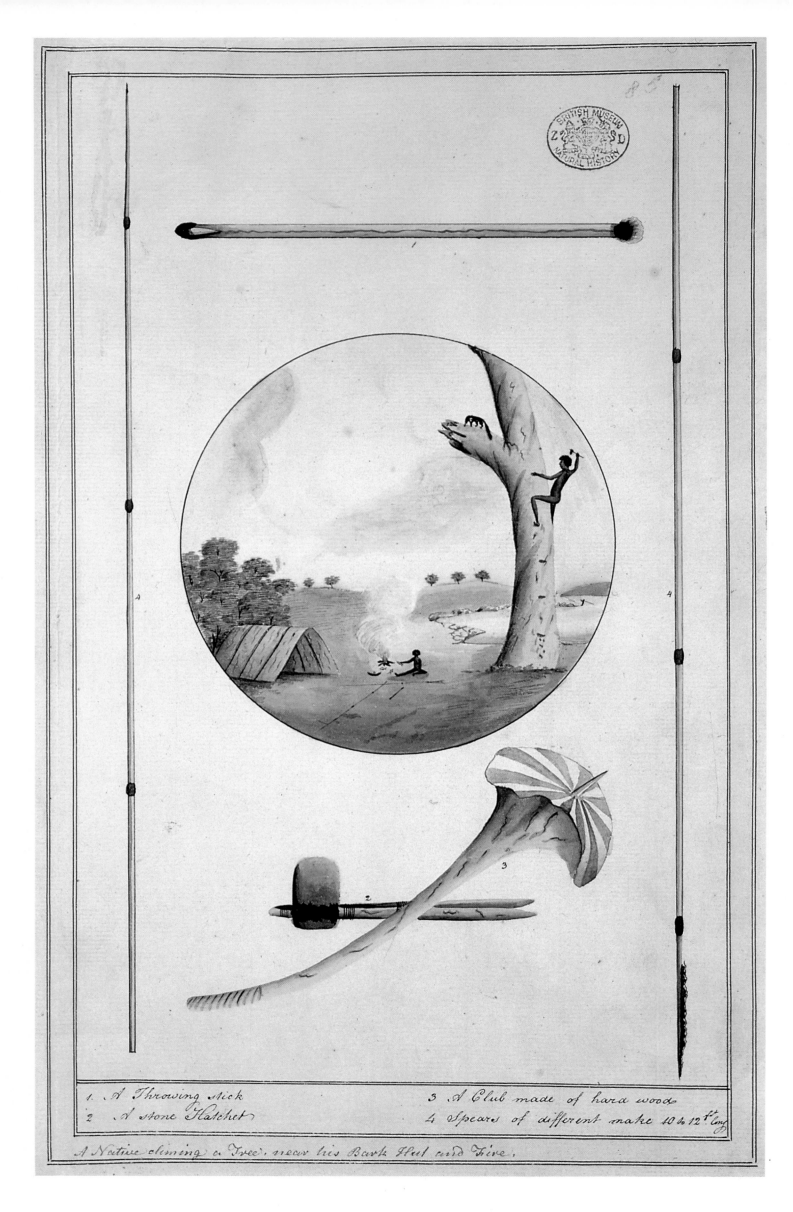

1. A Throwing Stick

2. A Stone Hatchet

3 A Club made of hard wood

4 Spears of different make 10 to 12 ft long

A Native climing a Tree, near his Bark Hut and Fire.

Augustus Earle, drawing about thirty years later), depict such huts and show them as sheets of bark over a framework of sticks [plate 57]. Another habitation commonly used was the rock shelter, shown by the Port Jackson Painter [plate 38].

The Effects of Contact

The arrival at Port Jackson of the technologically more powerful British, who took whatever territory and other resources they wanted, put immediate pressure on Aboriginal society. The majority of people simply tried to carry on with their traditional way of life, as indeed many of the drawings show. However there were more extreme reactions. As in most colonial situations, there were members of the indigenous population who resisted the expropriation of their resources; there were also those who, perhaps more from necessity than choice, joined forces with the colonists, taking on their mode of dress, speech and other customs. These reactions too can be seen in the drawings.

One of those who put up opposition was Ballooderry (Balloderree) [plate 1], a 'fine young man' provoked initially by the destruction of his canoe by a convict. In vengeance he speared another convict and for this he was forbidden from entering the European settlement.[74] Defiantly, Ballooderry ventured into town with a party of warriors, one of whom was wounded in the leg by musket fire during the ensuing skirmish.[75] Not

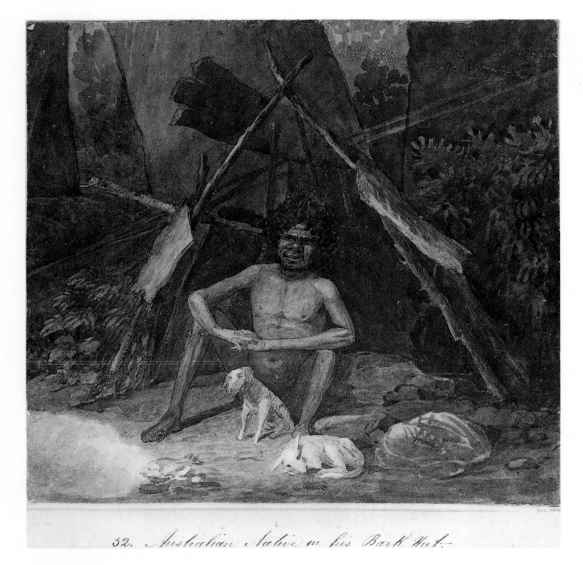

52. *Australian Native in his Bark Hut.—*

Plate 57
AUGUSTUS EARLE
Australian Native in his Bark Hut
(*c.* 1825–7).
Water-colour, 181 × 194
National Library of Australia,
Canberra, NK 12/52.

Plate 56 [Watling 76] *opposite*
PORT JACKSON PAINTER
Weapons and implements of the
Natives of New South Wales
[Inset] *A Native climing a Tree near his Bark Hut and Fire*
Ink and water-colour, 345 × 218
Compare with the Aboriginal hunting and fighting implements depicted in the drawing in the National Library of Australia, Canberra, NK 144/F.

63

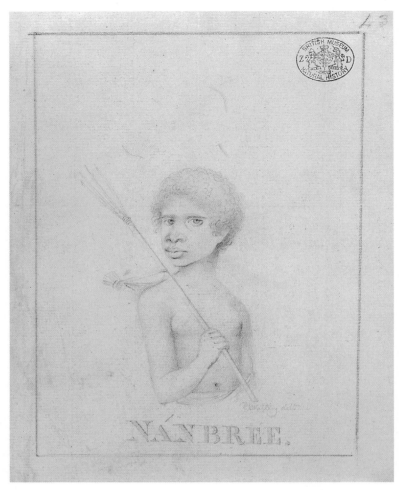

NÁNBREE.

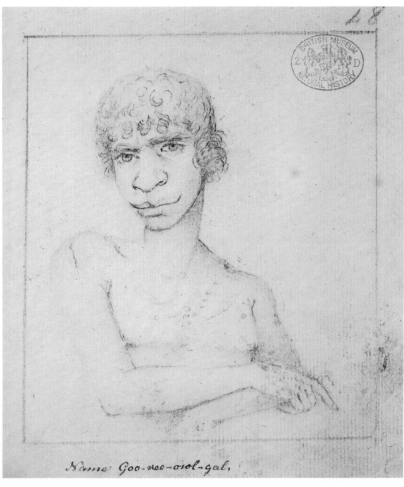

Name Goo-ree-oo-ol-gal.

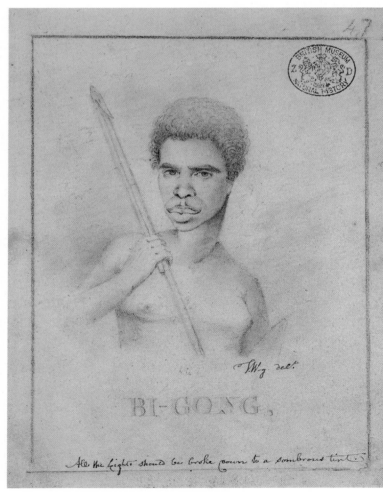

BI-GONG.

All the lights should be broke down to a sombrous tint.

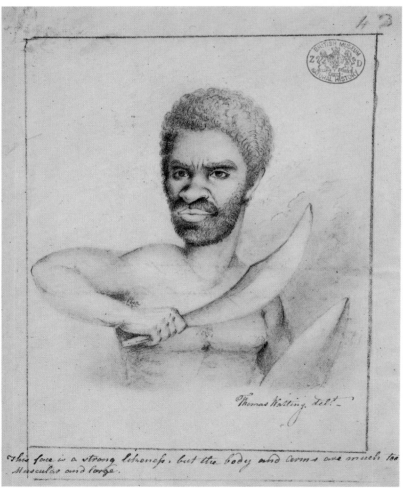

Thomas Watling. Delt.

This face is a strong likeness, but the body and arms are much too
Masculas and large.

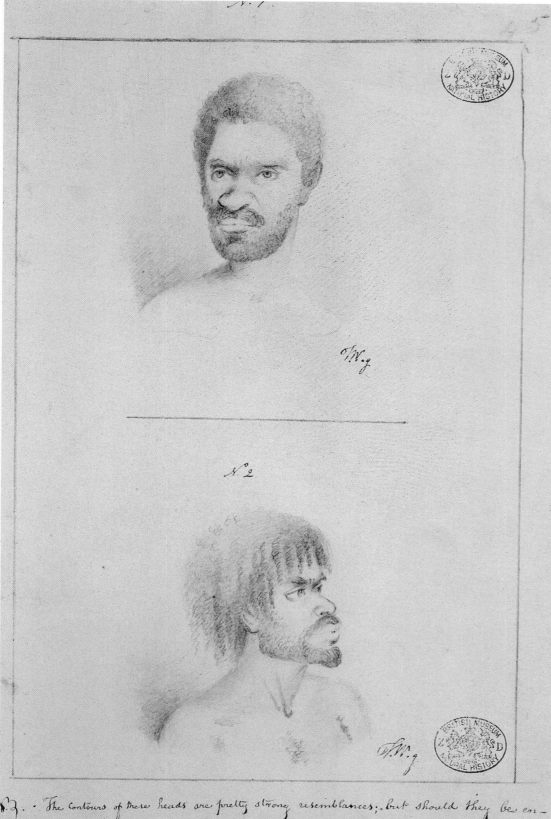

The contours of these heads are pretty strong resemblances; but should they be engraved, it will be necessary to observe that the high lights should be broke down to sable; as the pencil cannot give that strength without much labour and difficulty. – T.Watling.

Plate 62 [Watling 36]
THOMAS WATLING
Wearrung and Karrada
Two pencil portraits on one sheet, 310 × 192, both signed in ink 'T.W.g'
Inscribed in ink on two labels pasted on the mount beneath the sheet:
'No 1 Wearrung commonly known by the name of Mr Long, | having exchanged names at an early period with that | Gentleman.
'No 2 Karrada who exchanged names with Captᵗ. Ball of | His Majesty's Ship Supply. They both belong to the tribe | of *Boo.roo.bee.rung.al.* The likeness very strong indeed, insomuch | that every Native of their acquaintance at first sight exclaims | and calls them by name.'
Inscribed beneath the drawings in Watling's informal hand, 'NB. The contours of these heads are pretty good resemblances; but should they be engraved, it will be necessary to observe that the high lights should be broke down to sable, as the pencil cannot give that strength without much labour and difficulty. T.Watling'.

facing page

Plate 58 [Watling 34] *top left*
THOMAS WATLING
Nánbree
Pencil, 207 × 161, signed in pencil 'T. Watling del.'
In this portrait Nan.bar.ree is seen carrying a four-pronged fishing spear.

Plate 59 [Watling 39] *top right*
THOMAS WATLING
Goo-nee-owl-gal
Pencil, 163 × 138, unsigned
Inscribed 'Name Goo-nee-owl-gal,' beneath the drawing.

Plate 60 [Watling 38] *bottom left*
THOMAS WATLING
Bi-gong
Pencil, 175 × 140, signed in ink 'T.W.g del.'
Inscribed in Watling's hand, 'All the Lights should be broke down to a sombrous tint'.

Plate 61 [Watling 33] *bottom right*
THOMAS WATLING
Portrait of an Aboriginal man
Pencil, 206 × 165, signed in ink 'Thomas Watling del.'
Probably a portrait of Wearrung (see plate 62). Inscribed beneath the drawing 'This face is a strong likeness, but the body and Arms are much too Muscular and large'.

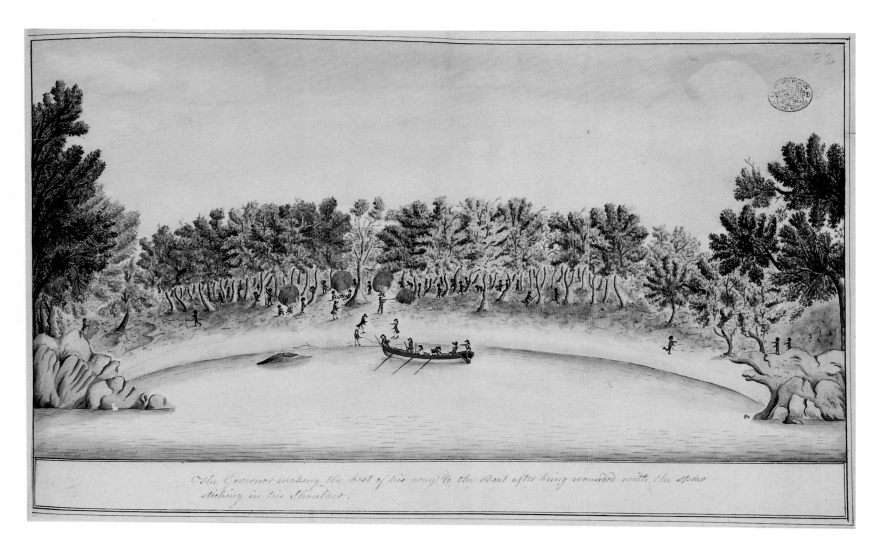

The Governor making the best of his way to the Boat after being wounded with the Spear sticking in his Shoulder.

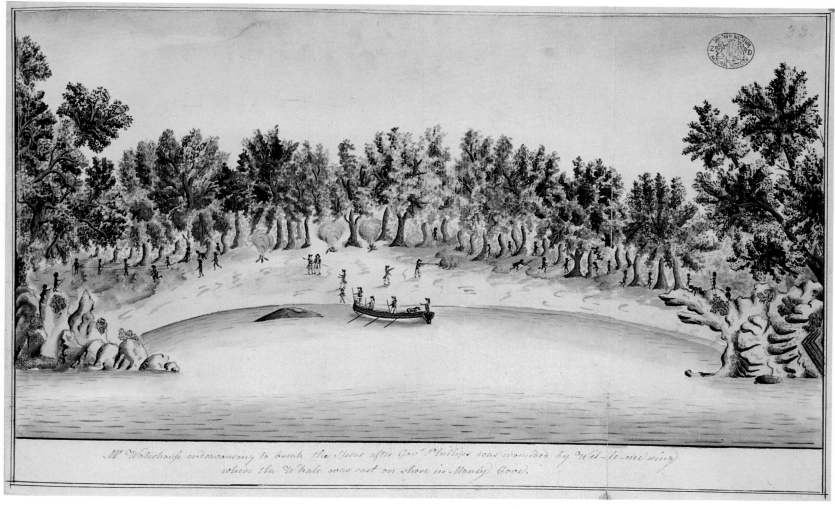

Mr Waterhouse endeavouring to break the Spear after Govr Phillips was wounded by Wil-le-me-ring where the Whale was cast on Shore in Manly Cove.

long afterwards Ballooderry was brought extremely ill to the settlement where he died. Mourners at his elaborate funeral included Colebee [plate 13], Darinha (Dorringa) [plate 14] and Abarroo (Abbarroo) [plate 11]. But for this premature death Ballooderry might have become as famous as Pemulwuy who, almost single-handedly carried on a guerilla war for twelve years against the British.[76]

The Port Jackson Painter also refers to Willemering, who speared Governor Phillip through the shoulder at Manly in 1790 [plates 63, 64] and shows the Governor meeting his main Aboriginal adviser, Bennelong, ten days after the incident [plate 66]. Bennelong expressed the view that Willemering had merely misunderstood the Governor's approach to him and had thrown his spear in self defence.[77] However, Tench saw the attack as an expression of more general dissatisfaction by the Aborigines at white occupation.[78] Certainly, writers describe a number of hostile incidents of this kind, usually attacks on small parties of convicts working some distance from the settlement, one being shown by the Port Jackson Painter [plate 65]. Although Smith gives this drawing the title 'The Hunted Rushcutter',[79] the foliage tucked under the fugitive's arm is clearly not rushes. The incident appears more like one described by White in which a convict gathering herbs as food was attacked.[80]

Prominent among Sydney Aborigines who established close contact with the British was Bennelong (Ben-nel-long) [plate 7]. This contact began forcibly when he and Colebee [plates 13, 16, 19] were captured and held prisoner to provide information about the country. As an informant Bennelong proved ideal. He quickly 'acquired knowledge, both of our manners and our language . . . he willingly communicated information; sang, danced and capered; told us all the customs of his country . . .'[81]

facing page

Plate 63 [Watling 23]
PORT JACKSON PAINTER
The Governor making the best of his way to the Boat after being wounded with the spear sticking in his Shoulder
Water-colour, 278 × 450
The incident depicted occurred on 7 September 1790.

Plate 64 [Watling 24]
PORT JACKSON PAINTER
Mr Waterhouse endeavouring to break the Spear after Gov' Phillips was wounded by Wil-le-me-ring where the Whale was cast on shore in Manly Cove
Water-colour, 260 × 425

Plate 65 [Banks Ms34: 44]
PORT JACKSON PAINTER
An attack by Natives
Water-colour, 205 × 318
The incident, if it records a specific one, has not been recorded in the First Fleet journals. Convicts gathering herbs and rushes were attacked (White, 1790, pp. 156, 160) but the man is dressed as a sailor.

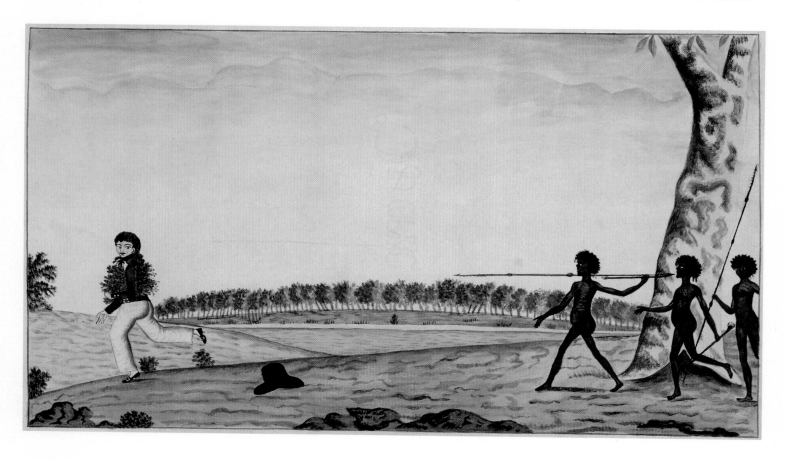

Although he escaped captivity Bennelong remained in contact, acting as a mediator between Phillip and the Aborigines, on one occasion successfully negotiating the return of stolen Aboriginal fishing gear. Eventually he chose to live in the settlement, and together with Yemmerrawannie, visited England when Phillip returned there.[82]

The smallpox epidemic which wiped out the majority of the Aboriginal population not long after European contact commenced forced survivors from various bands to regroup.[83] Homes were provided by the white community for some survivors, including Abarroo, a girl aged about thirteen at the time, whose portrait was drawn by the Port Jackson Painter [plate 11] some three years later. Another was Nan.bar.ree (Nanbree, Nanberry), a boy aged about eight, portrayed by the Port Jackson Painter [plate 9], Watling [plate 58] and Raper [plate 67]. Nan.bar.ree was given a home by John White and renamed 'Andrew Snape Hamilton Douglas White', but fortunately perhaps, this over-lengthy appellation does not appear to have stuck since he is referred to only by his Aboriginal name in later writings. Nor did Nan.bar.ree lose touch with Aboriginal culture, undergoing the rites of initiation some six years later.[84] When White returned to England Nan.bar.ree remained within white society, serving as a seaman on H.M.S. *Reliance* from 1795, and with Flinders on the *Investigator* from 1803.[85]

Plate 66 [Watling 40]
PORT JACKSON PAINTER
Ban nel lang meeting the Governor by appointment after he was wounded by Wil le ma ring in September 1790
Water-colour, 263 × 405

Plate 67 [Raper 3]
GEORGE RAPER
[Upper] *Nanberry, a Native Boy of Port Jackson, living with Mr White the Surgn. Genl.*
[Lower] *Implements of Port-Jackson*
Ink and water-colour, 315 × 195, signed 'Geo Raper 1792'

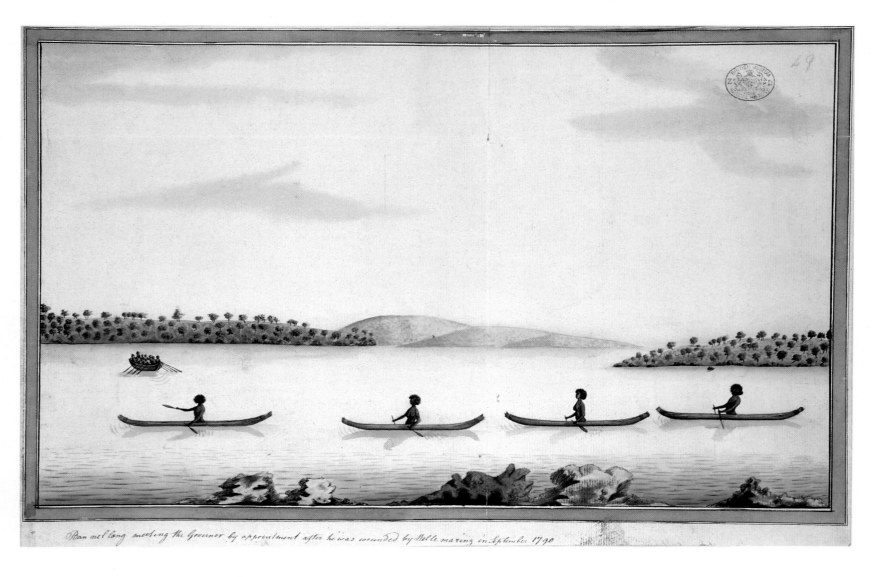

Ban nel lang meeting the Governor by appointment after he was wounded by Wil le ma ring in September 1790

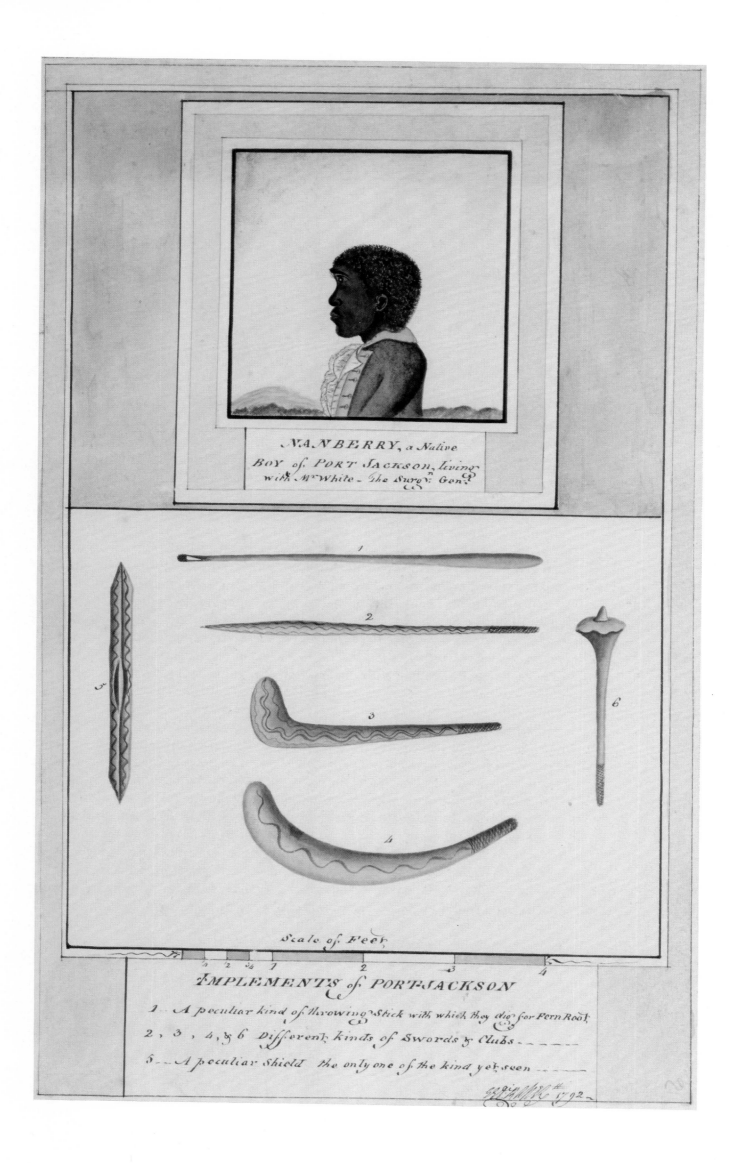

NANBERRY, a Native
Boy of PORT JACKSON, living
with Mr. White - the Surgn. Genl.

Scale of Feet

IMPLEMENTS of PORT JACKSON

1. A peculiar kind of throwing Stick with which they dig for Fern Root.

2, 3, 4, & 6 Different kinds of Swords & Clubs. _ _ _ _ _ _ _

5 _ A peculiar Shield the only one of the kind yet seen _ _ _ _ _

T. M. PERRY

2 / *Charts and Views*

From medieval times until electronic navigation systems came into use in the mid-twentieth century seamen relied on three aids to navigate the world's waters: charts showing coastlines and their offshore hazards (and usually showing little inland detail except for clearly outstanding features serving as readily identifiable 'landmarks'); written sailing directions advising of the safest routes to, and into, ports, and warning of rocks, shoals and currents affecting the approaches to ports; and views of the coasts to facilitate the identification of features marked on the charts and mentioned in the sailing directions.

Medieval pilots compiled handwritten 'rutters' that included sailing directions and views of coasts, and they copied and improved charts that they and their colleagues had made. For Mediterranean and western European waters many used the manuscript charts produced by the professional chart-makers in the Catalan and Dieppe schools of hydrographers. Following the introduction of printing both rutters and charts were published, but the rutters were soon replaced by 'sea atlases' and 'Pilots' containing charts with sailing directions and views of the coasts shown on the charts.[1]

By the late-eighteenth century those navigating the world's less-frequented waters had only the small-scale charts in the sea atlases and the charts in the published accounts of their predecessors' voyages to guide them.[2] So, as a matter of course, they regularly charted the ports they visited and the coasts they saw even though they may not have been engaged in voyages of exploration. Frequently the commanders and the senior officers of ships kept private journals into which they copied, for their own use, the charts whose originals would be sent to their superior authorities at the end of the voyage.[3] Skills in making surveys and in drawing coastal views were taught in the emerging naval colleges on land, and were encouraged in midshipmen at sea.

Ships' officers, both naval and mercantile, regularly produced three kinds of maps: charts, plans and sketches. 'Charts' were usually small-scale depictions of coastlines, while 'plans' were larger-scaled maps of bays, harbours and islands. Both charts and plans were usually produced using a systematic set of bearings constituting a triangulation: they are sometimes described as being 'laid down geometrically'. Sketches, eye-sketches and eye-draughts were less carefully compiled and were not based on a

systematic survey, though they might include a few bearings: they presented an approximation of the appearance of a bay or small extent of coast. Thus, in 1770 Captain Cook produced 'A Chart of the Sea Coast of New South Wales', 'A Plan of the entrance of Endeavour River', and 'A Sketch of Botany Bay'.[4]

Charts, plans and sketches were frequently accompanied by 'views' which were distinguished from picturesque landscapes by an exaggeration of the vertical scale to emphasize landmarks and make them more easily recognizable, by having the landmarks identified by letters or numbers, and by having the bearing of the central feature (and often those near the edges of the view) clearly stated with distances from the ship. Thus, for example, in the upper part of plate 68, *Views to the Northward of Port Jackson in 1789*, George Raper shows the coast with the north head of Port Jackson (marked with the letter 'a') bearing south-50°-west and 25 miles from his ship, the north head of Broken Bay ('b') bearing west-south-west, and a hill ('c') near the right-hand side of the view bearing north-48°15'-west and four or five leagues away. These bearings and distances made the view an aid to any ship approaching Port Jackson from the north-east. Because such views could help navigators they were, and still are, published with, or as adjuncts to, charts.[5]

The five maps in the Watling Collection and the views in the Watling and Raper Collections are a representative sample of the charts and views produced by officers of ships in the First Fleet and in some of the ships that followed it into Australian waters. These collections are only a part of a corpus of First Fleet work that is scattered through other collections in Britain and Australia.

As far as charts and views are concerned the more important, both in terms of numbers and through publication to later navigators, were made by officers of H.M.S.

Plate 68 [Raper 14]
GEORGE RAPER
Views to the Northward of Port Jackson in 1789
Ink and water-colour, 320 × 480, signed 'Geo. Raper'
Cape Three Points, to the north of Broken Bay, was like Port Jackson named by Captain Cook in 1770.

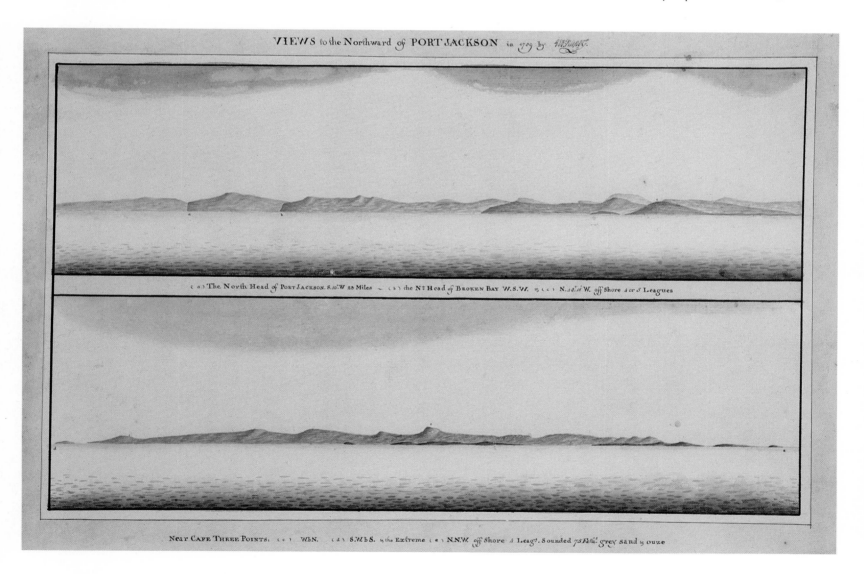

VIEWS to the Northward of PORT JACKSON in 1789 by G.R.Raper.

(a) The North Head of PORT JACKSON. S.50°.W 25 Miles (b) the N° Head of BROKEN BAY W.S.W. (c) N.48°15′ W. off Shore 4 or 5 Leagues

Near CAPE THREE POINTS. (c) W.b.N. (d) S.W.b.S. the Extreme (e) N.N.W. off Shore 4 Leag°. Sounded 75 fath° grey Sand & ouze

Sirius: Captain John Hunter, Lieutenant William Bradley, and midshipman George Raper. They made charts of the Atlantic Ocean and Southern Hemisphere showing the tracks of *Sirius* and *Waaksamheyd*; they copied published plans of some of their ports-of-call; they made plans of Sydney Cove, Port Jackson, Broken Bay, Botany Bay, Norfolk Island, and of shoals, islands and ports visited, or discovered, during *Waaksamheyd*'s voyage from Sydney to Batavia. The officers of other ships in the Fleet also produced some plans and views, mostly of Pacific islands discovered after the establishment of Sydney.

The publication of the First Fleet's charts and views began with the issuing of *The Voyage of Governor Phillip to Botany Bay* late in 1789. This first account of the settlement was compiled by the London publisher John Stockdale from Governor Phillip's first despatches to Lord Sydney, Secretary of State for the Home Department, and from several other sources including letters to officials in the Home Office and Admiralty and to private individuals, and from journals kept during the return voyage by officers on several of the transports in the First Fleet. *The Voyage* included among its illustrations seven fold-out charts two of which bore views, and three plates of views.[6]

A second group of charts was published with *An Historical Journal of the Transactions at Port Jackson and Norfolk Island* by Stockdale in 1793. Though Hunter is usually cited as the author of this volume (and the title page carries the words 'By Iohn Hunter, Esqr.') only the first ten chapters are based on a journal kept by Hunter between 1786 and 1792; six of the remaining fourteen were based on a journal written by Lieutenant P. G. King while commandant of Norfolk Island, seven are based on Governor Phillip's despatches describing events in the colony in 1790 and 1791, and the final chapter is Lieutenant Ball's account of *Supply*'s return voyage to England via Cape Horn. The *Historical Journal* is, in effect, Stockdale's sequel to the *Voyage*, continuing the story of New South Wales and Norfolk Island to the end of 1791 with a group of documents received in England before the end of November 1792. Five charts, two of which were fold-outs, were among the book's illustrations.[7]

The third group of charts was published in 1794, not as illustrations to books but as individual items: Alexander Dalrymple, hydrographer to the East India Company, issued four sheets of charts, plans and views made by Hunter and Bradley during *Waaksamheyd*'s voyage from Sydney to Batavia; and Bradley published his own chart of Norfolk Island. In 1795 John Shortland's chart of *Alexander*'s track off the southeastern coast of Borneo was included by Dalrymple on a chart of tracks taken by several vessels along the coasts of Borneo.

These three groups of published charts included not only the first detailed plans of the three harbours of central New South Wales, but charts of newly discovered islands, shoals and anchorages in the south-west Pacific.

The First Fleet's Chartmakers

1 / John Hunter

Captain John Hunter (1737–1821) was already known to be a skilled hydrographic surveyor and artist when he was appointed Second Captain and Commander of H.M.S. *Sirius*. During his service in the West Indies and then in Lord Howe's fleet during the American War of Independence he had made charts and plans of coasts and harbours, and so was the obvious man to take charge of the surveys in New South Wales. He was responsible for the charting of Port Jackson between 28 January and 6 February 1788, and of Broken Bay and Botany Bay in August and September 1789. In Port Jackson he was assisted by William Bradley and the Master, James Keltie, and a midshipman of H.M.S. *Sirius*. Bradley and Lieutenant

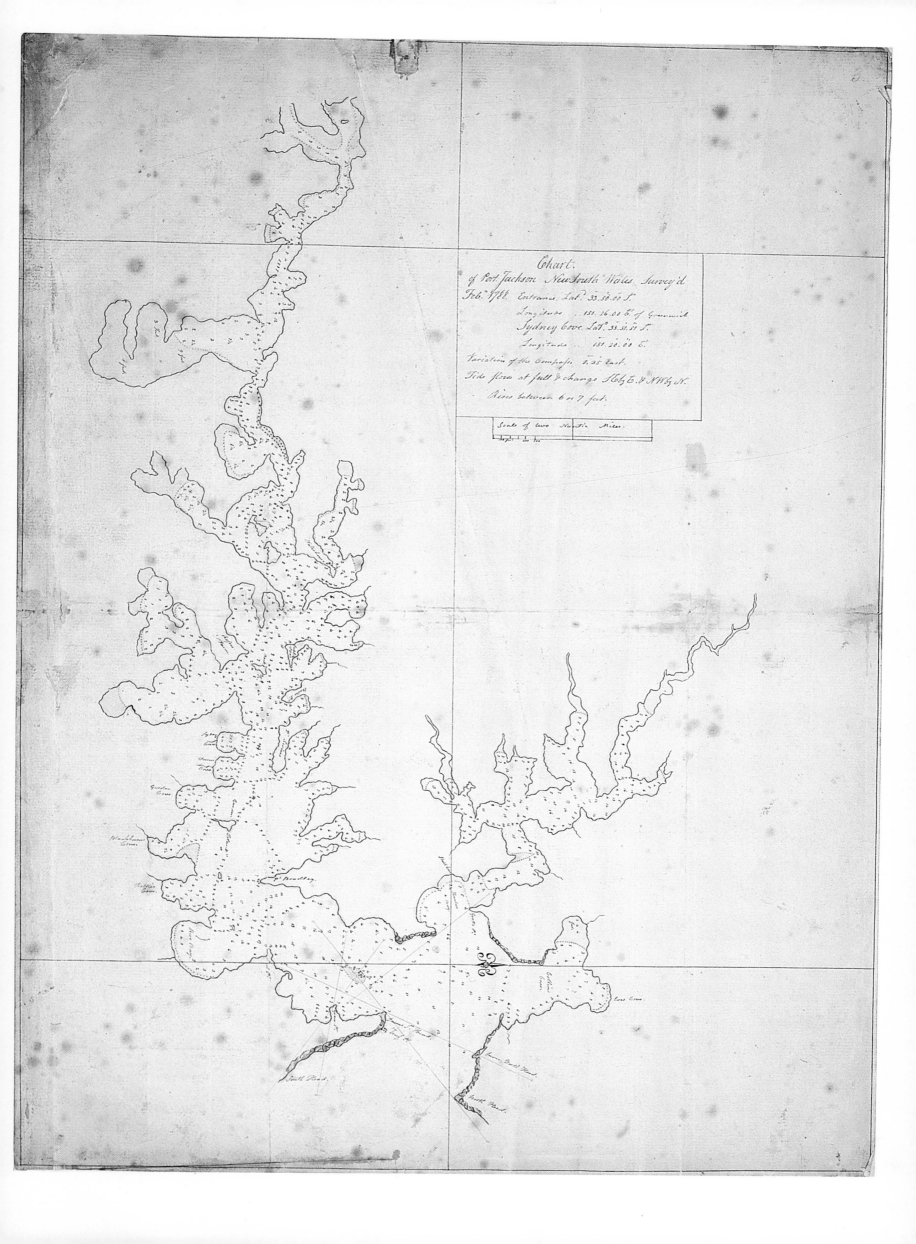

Chart.
of Port Jackson New South Wales Survey'd
Feb.ry 1788. Entrance Lat.e 33.50.00 S.
Longitude .. 151.16.00 E. of Greenwich
Sydney Cove Lat.e 33.51.51 S.
Longitude .. 151.20.00 E.
Variation of the Compass, E. 35 East.
Tide flows at full & change S by E. & N W by N.
Rises between 6 or 7 feet.

Scale of two Nautic Miles.

Henry Lidgbird Ball, commander of H.M.S. *Supply*, assisted in the survey of Broken Bay; and Keltie, and David Blackburn, Master of *Supply*, assisted in Botany Bay. All three charts were initially plotted at a scale of 3 inches to a nautical mile. Later copies were made at a reduced scale, usually 1½ inches to a nautical mile: the reducing and copying was one of the routine tasks performed by midshipmen. Because of its importance the chart of Port Jackson was frequently copied and later copies can be distinguished from earlier ones by the increasing numbers of place names that they bear.

A copy of the original plan of Port Jackson on a scale of 3 inches to the nautical mile was sent to England with Governor Phillip's first despatch in May 1788: it is now in the Public Record Office.[8] Though Phillip described it as 'a rough sketch' (which was hardly just), it was published at a reduced scale (about 1.15 inches to the nautical mile) in *The Voyage of Governor Phillip to Botany Bay* (fp. 142) with Stockdale's imprint dated 10 August 1789. The copy sent by Phillip carried Hunter's directions for entering the port and avoiding the shoal, now known as the Sow and Pigs, inside the entrance. These directions were not engraved on the plan but were published, slightly abridged, on pages 142 and 143 of *The Voyage*.

For many years John Hunter's plan of Port Jackson served ships entering Sydney harbour. Besides the manuscript copies made of it and the copies in the many English and foreign language editions of *The Voyage of Governor Phillip*, a slightly modified version found a place in the *Neptune des Côtes Orientales et du Grand Archipel d'Asie* (1803) and in the Atlas published with Louis Freycinet's *Voyage de Découvertes aux Terres Australes* (1812). Matthew Flinders included insets reproducing plans of the entrances of Botany Bay, Port Jackson, and Broken Bay from Hunter's originals on his 'Chart of Terra Australia' East Coast, Sheet I, in the atlas to his *Voyage to Terra Australis* (1814). The plan of Port Jackson was not superseded until 1822 when John Septimus Roe made a new survey that was published in Sydney in 1822 and by the Hydrographical Office, London, in 1826.

The unsigned and undated 'Chart of Port Jackson . . . Survey'd Feby 1788' in the Watling Collection [plate 69] is a copy on a scale of 1½ inches to the nautical mile of Hunter's plan. Like the copy of the plan by George Raper [plate 70] in the Mitchell Library, Sydney (M2 811.15/1788/1), this copy gives a number of names that have not survived for bays on the south side of the harbour: Keltie Cove for Double Bay, Blackburn Cove for Rushcutters Bay, Garden Cove for Woolloomooloo Bay. On the north side several points also have names that did not continue in use: Point Sirius for Kirribilli Point, Balls Point for Blues Point, Supply Head for Balls Point, and Waterhouse Point for Manns Point (Greenwich). None of these four names appear on Raper's copy. Like most copies of the plan it shows lines between landmarks to help ships locate the Sow and Pigs (North Head and Inner South Head in line and Green Point and South Head in line), and an anchor at the mouth of Sydney Cove marks *Sirius*'s position as guard ship.

The other unsigned plan of Port Jackson in the Watling Collection [plate 71] is clearly not a copy of Hunter's survey. Since it was 'taken in Oct^{br} 1788', by which time Hunter's plan would have been available to ships' officers, and since it is an eye-sketch rather than a plan, it seems likely that it was drawn by a person who would not have had access to Hunter's plan, but who, through fishing trips, had learned something of the configuration of the port – perhaps a seaman or convict. The *Golden Grove*, storeship, was only in Sydney Cove until 2 October when she sailed for Norfolk Island; the other ship may be H.M.S. *Supply* which was in port during October. *Sirius*

Plate 70
GEORGE RAPER
Chart of Port Jackson New South Wales as Survey'd by Captn Iohn Hunter . . . 1788
Ink and water-colour, 620 × 390, 'Drawn from the Original by George Raper Midn.'; original scale: 1 in. = 1.5 nautical miles (*c.* 1:108,000)
A reduced copy of Hunter's chart on a smaller scale than plate 69 and with some variations in place-names. The 1788 survey extended west only as far as Homebush Bay, 'the flats at the head of Port Jackson', and in January 1790 William Bradley extended it by surveying the Parramatta River westward to Rose Hill and Duck River, which joins the Parramatta River from the south-west. Since this chart of Port Jackson, like the one in Bradley's journal, includes the Parramatta and Duck Rivers it must have been drawn later than January 1790. Note Raper's style of lettering, particularly his capital I.
Mitchell Library, State Library of New South Wales, Sydney (M2 811.15/1788/1)

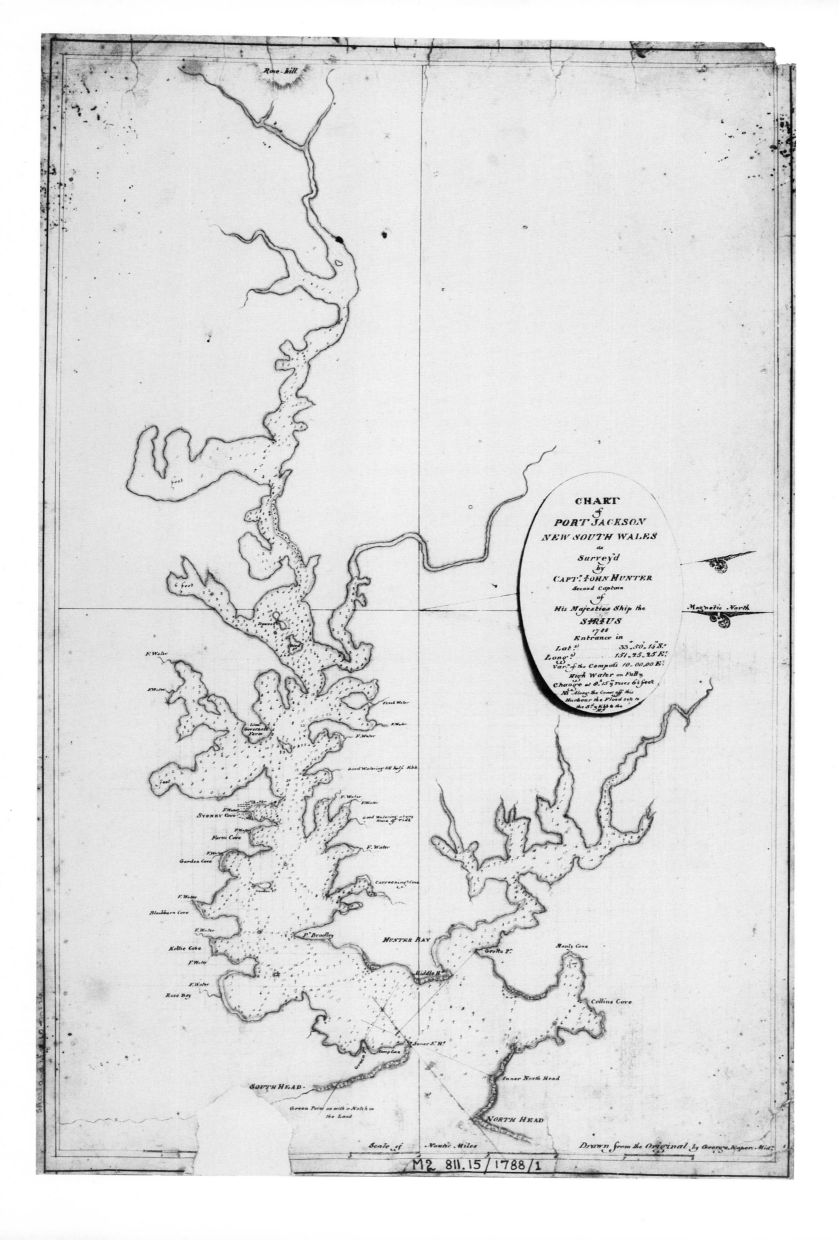

Rose-hill.

CHART
of
PORT JACKSON
NEW SOUTH WALES
as
Survey'd
by
CAPT. JOHN HUNTER
Second Captain
of
His Majesties Ship the
SIRIUS
1788
Entrance in
Lat.ᵈ 33.50.14 S.ᵗ
Long.ᵈ 151.25.25 E.ᵗ
Var.ⁿ of the Compass 10.00.00 E.ᵗ
High Water on Full &
Change at 9.15 ½ races 6 ½ feet
N.ᵇ Along the Coast off this
Harbour the Flood sets to
the S.ᵒ & Ebb to the
N.

Magnetic North

F. Water
F. Water
Fresh Water
F. Water
F. Water
Lieut Governor's Farm
Good Watering till half Ebb
F. Water F.Water
Good Watering at any
time of Tide
SYDNEY COVE
F. Water
Farm Cove
F. Water
F. Water
Garden Cove
Carreening Cove
F. Water
Blackburn Cove
P.ᵗ Bradley
HUNTER BAY
F. Water
Kellie Cove
Grotto P.ᵗ Manly Cove
F. Water
Riddle H.ᵈ
Rose Bay
Collins Cove
James S.ᵗ H.ᵈ
Jump Care
SOUTH HEAD
Inner North Head
Green Point on with a Notch in
the Land
NORTH HEAD

Scale of Nautic Miles Drawn from the Original by George Raper. Mid.

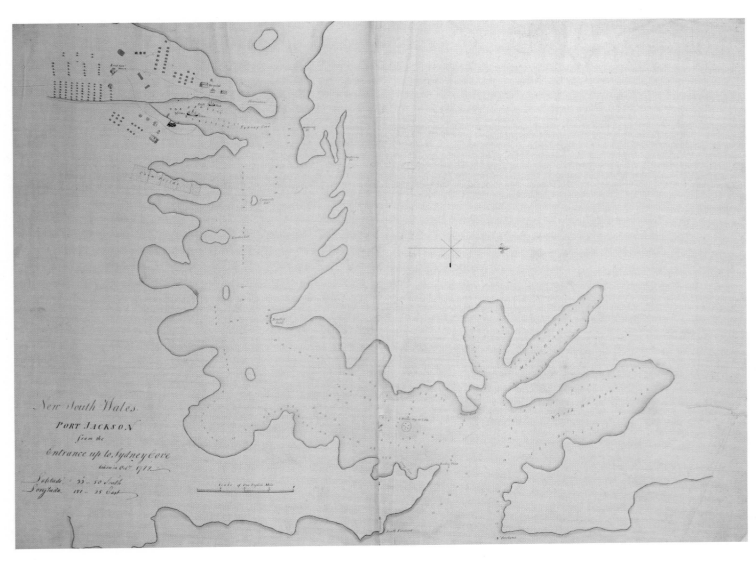

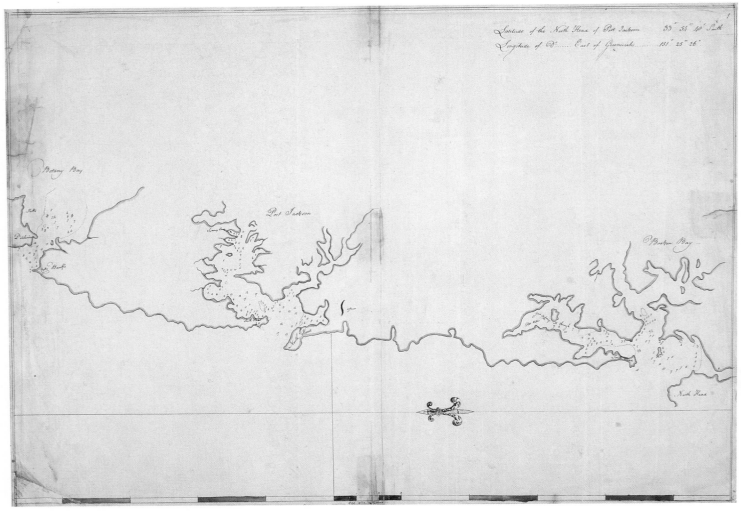

is not shown. She sailed at the same time as *Golden Grove* to obtain supplies at the Cape of Good Hope.

In February 1790 Phillip sent copies, on the original scale of 3 inches to the nautical mile, of Hunter's plans of Port Jackson, Broken Bay, and Botany Bay to England. These are now in the Hydrographic Department of the Ministry of Defence, Taunton, Somerset (Nos. 2, 4 and 15 in 548 Cz). Copies of the three charts by Henry Brewer [see plates 233–235] accompanied a duplicate copy of Phillip's despatch and are now in the Map Room of the British Library (Crown cxvi, 60-2). These, like the copies in the Hydrographic Department, are marked as being received with Phillip's letter dated 13 February 1790.

Hunter subsequently combined the three charts in a 'Chart of the Coast between Botany Bay and Broken Bay . . .' Plate 72 is probably an unfinished, reduced copy of this chart with only the entrances of the three harbours plotted. Manuscript copies, on various scales are held in the Hydrographic Department, Taunton (d89 Xc), and in the Dixson Library, Sydney (Cc 78/3 and Cc 78/4). It was published in Hunter's *Historical Journal* (fp. 1) and is the source of the coastline for a series of charts and maps usually called 'The Three Harbours of New South Wales'. The first of these, with inland detail added by William Dawes, Second Lieutenant of Marines on H.M.S. *Sirius*, was published as 'A Map of all those Parts of the Territory of New South Wales which have been seen by any Person belonging to the Settlement established at Port Jackson . . .' on a scale of about 4 miles to the inch, in the *Historical Journal* (fp. 1). During Hunter's governorship of New South Wales it was revised to show the areas of agricultural settlement, two versions being published in volumes I (1798) (facing title), and II (1802) (fp. 1) of David Collins's *An Account of the English Colony in New South Wales . . .* with the title 'Chart of the Three Harbours of Botany Bay, Port Jackson, and Broken Bay, showing the cultivated Grounds in and about the different Settlements . . .' (the title is given in the list of engravings in each volume, not on the charts). Manuscript copies of these two versions initialled by Hunter are in the Dixson Library, Sydney (Cb 79/7 and Cb 79/9). Another version with the coastline south of Botany Bay extended to Lake Illawarra by George Bass's and Matthew Flinders's *Tom Thumb* voyage in 1796, and showing the boundaries of lands granted to settlers plotted by Charles Grimes and titled 'A Topographical Plan of the Settlements of New South Wales . . . Surveyed by Messrs. Grimes & Flinders' was published in London by Aaron Arrowsmith in 1799.

The entrance to Port Jackson and the coast northward to Broken Bay and beyond, and southward to Botany Bay was depicted in views by George Raper [plates 68, 73 and 74], and by John Hunter (?) [plates 76 and 77] and by the Port Jackson Painter [plate 75].

In *Waaksamheyd* Hunter produced nine charts with views: of the Isle of Pines off the south end of New Caledonia (seen by Cook in 1774); of Stewart Island, Bradley's Shoals, and Lord Howe's Group (Ontong Java) in the Solomon Islands; of part of the Admiralty Islands and Bismarck Archipelago; of Phillip Island in the western Carolines; and of the islands of the southern end of Mindanao in the Philippines. Three sheets of these charts and views were published in 1794 by Alexander Dalrymple.[9]

Most of the views that Hunter painted in *Waaksamheyd* are taken at a greater distance from the land than those by Raper and Bradley. Sky often occupies two-thirds or more of the height of the view, and only the configuration of the land is shown by his delicately shaded painting. There is no close detail to obscure the lineaments of

Plate 71 [Watling LS2]
ANONYMOUS
Port Jackson from the Entrance up to Sydney Cove taken in Oct[r]*. 1788*
Ink and water-colour, 530 × 715; original scale: 3.5 in. = 1 English mile (c. 1:18,100)
This eye-sketch of Port Jackson by an unidentified draughtsman has similarities in the configuration of Sydney Cove and in the detail of the settlement to a 'Sketch and Description of the Settlement at Sydney Cove . . . taken by a transported Convict on 16th April 1788 . . .' published in London by R. Cribb in July 1789 (see plate 113). This is marked 'F. F. delineavit' and has been attributed to Francis Fowkes, the only convict with the First Fleet with those initials. Fowkes had served as a midshipman for five years and as a clerk in London before his conviction and transportation in *Alexander*. As a midshipman he may well have acquired the skills necessary to draw the two eye-sketches and to observe or collect the information presented on them. In both cases the lack of accuracy in the depiction of the shoreline bespeaks the want of instruments for taking bearings and measuring distances. Only the earliest of the place-names used in Port Jackson are shown on this chart, but the North and South Heads are named North and South Forelands. 'Convicts Isld' on which some convicts were placed with meagre rations as a punishment soon became known as Pinchgut. (For information on Fowkes, or Fokes, see Chapman, 1981, 96.)

Plate 72 [Watling LS1]
ANONYMOUS
Untitled chart showing the entrances to Botany Bay, Port Jackson and Broken Bay (c. 1789–93)
Pen and wash, 420 × 590; original scale: 0.7 in. = 1 sea league (c. 1:331,400)
This is an unfinished copy, at a reduced scale, of Captain John Hunter's 'Chart of the Coast between Botany Bay . . .' published in the *Historical Journal* (1793), fp. 160. It was plotted at about one-third of the scale of the copy in the Hydrographic Department, Taunton (d89 Xc).

the land on these coast profiles. Their composition emphasizes the smallness of the islands in the vastness of the sea: an impression destroyed by Dalrymple's engraver who, to save space, reduced the height of the views making them long and narrow [plates 80 and 81].

The major collection of Hunter's charts is a folio of sixteen manuscript charts held by the Hydrographic Department, Taunton (548 Cz). This contains charts sent to England by Governor Phillip in 1790, and a group of charts, including those made in New South Wales and in *Waaksamheyd*, marked 'Rec'd with Captain Hunter's Narrative 24th April, 1792' (*Waaksamheyd* anchored in Portsmouth Harbour on 22 April). The 'Narrative' is presumably the text of Hunter's part of the *Historical Journal*. The Hydrographic Department, Taunton, also holds a copy of the chart of Sydney Cove 'reduc'd from Capn. Hunter's Original by Geo. Raper 1791' [plate 82], and copies of the charts of Broken Bay, Botany Bay, and of the coast between Botany Bay and Broken Bay.[10] Manuscript copies of eleven charts by Hunter and Bradley are included in Hunter's own copy of the *Historical Journal* now in the Mitchell Library, Sydney (C689).[11]

2 / William Bradley

William Bradley (1757–1833), as First Lieutenant of H.M.S. *Sirius*, was Hunter's principal aide. Throughout their service together both made independent observations to determine the position of *Sirius* and *Waaksamheyd*, and of the fixed points of surveys (in Port Jackson, Point Maskelyne, now Dawes Point, and North and South Head). In the *Historical Journal* Hunter records their separate determinations of latitude and longitude, and presents the mean as the accepted position. Besides assisting in the surveys of Port Jackson and Broken Bay, Bradley himself surveyed the Parramatta River from 'the flats' (Homebush Bay) to Rose Hill, the 'north-west arm of Botany Bay' (Cooks River), Long Bay, and Great Sirius Cove (Mosman Bay) where *Sirius* was refitted. After *Sirius* was wrecked in March 1790, he surveyed Norfolk Island and the landing places in Sydney Bay, and in *Waaksamheyd* made a plan of Port Hunter on Duke of York's Island in St Georges Channel.

The major collection of his charts and views is in his private journal, 'A voyage to New South Wales' held by the Mitchell Library, Sydney, and published in facsimile by the Trustees of the Public Library of New South Wales and Ure Smith in 1969. The journal contains twenty-two charts and plans and twenty-nine views and landscapes, which cover the whole of his voyaging in *Sirius* and *Waaksamheyd*.

Most of the charts in Bradley's journal are copies of surveys he made with Hunter in New South Wales or in *Waaksamheyd* and are copies of charts in the Hunter portfolio in the Hydrographic Department, Taunton, or of the manuscripts inserted by Hunter in his copy of the *Historical Journal*. A few are copies of Bradley's own surveys listed above, and two are copies of published charts – those of Rio de Janeiro and Table Bay. Bradley's plan of Rio de Janeiro is almost identical with the one Hunter put into his copy of the *Historical Journal*, the differences between the two being in the omission from one of some names appearing on the other: both are probably copies of a plan in one of the sea atlases. Bradley's plan of Robben Island and Table Bay is a copy of one published by Dalrymple in 1780 which was a copy of Johannes van Keulen's 'Kaart van de Tafel-Baay . . .' published in Part VI of his *Zee-Fakkel* in 1753.

Bradley's journal contains copies of charts of the North Atlantic Ocean and the Southern Hemisphere showing the tracks of *Sirius* and *Waaksamheyd*, and a more

Plate 73 [Raper 17]
GEORGE RAPER
Views of land in the Neighbourhood of Port Jackson
Ink and water-colour, 315 × 479, signed 'Geo. Raper 1790'
These three views showing the entrance to Port Jackson from different distances as seen from the south-east, complement plate 68 which shows the entrance from the north-east, and shows how such views could help sailors locate the Port.

Plate 74 [Raper 15]
GEORGE RAPER
Entrance of Port Jackson from a Boat close under the South Head
Ink and water-colour, 324 × 489, signed 'Geo. Raper 1789'
This view clearly shows the horizontal bedding of the sandstone of the Head and the force of the surf breaking upon it.

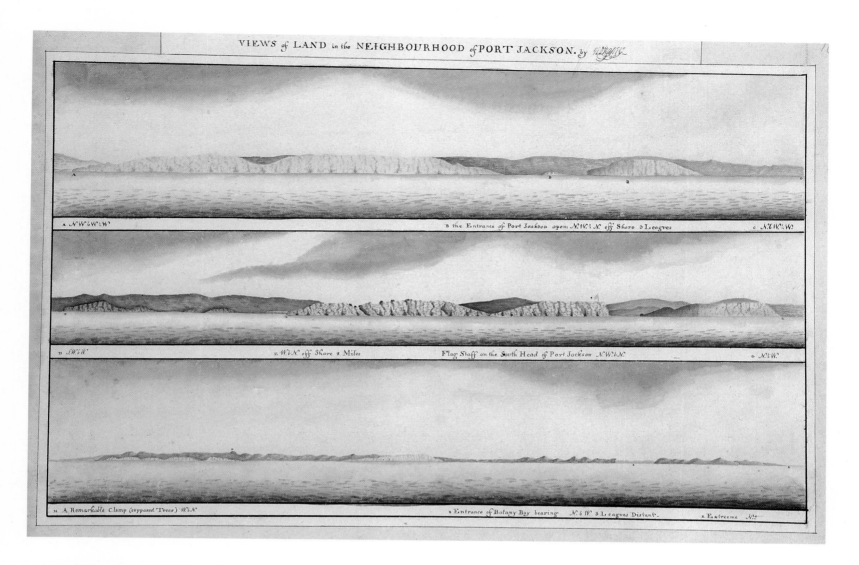

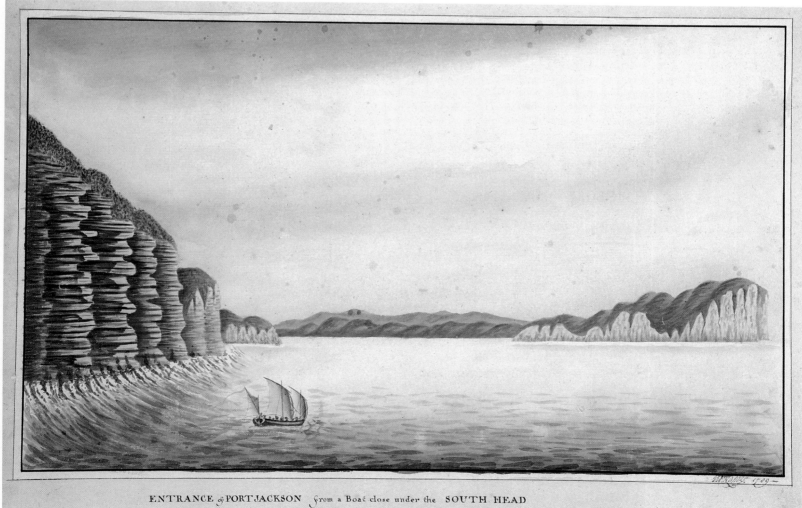

ENTRANCE of PORT JACKSON from a Boat close under the SOUTH HEAD

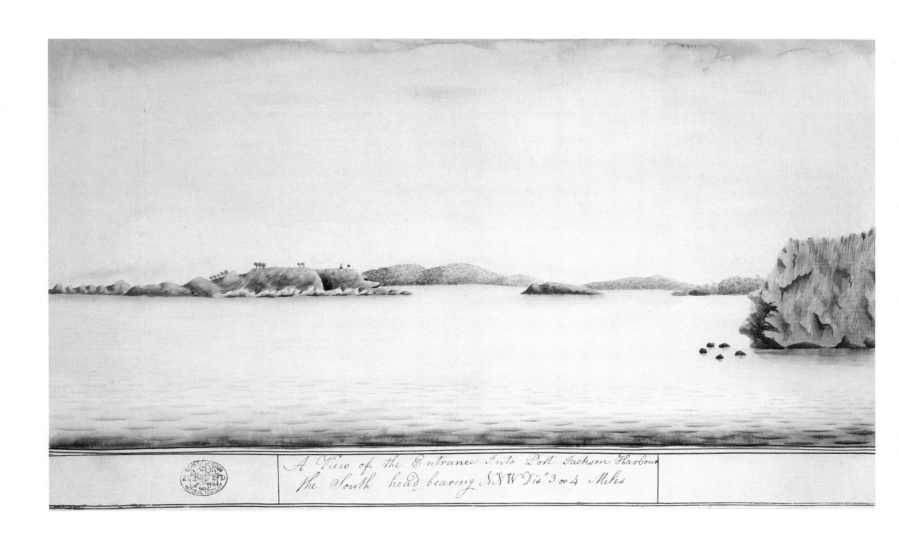

A View of the Entrance Into Port Jackson Harbour the South head bearing N&W Dist 3 or 4 Miles

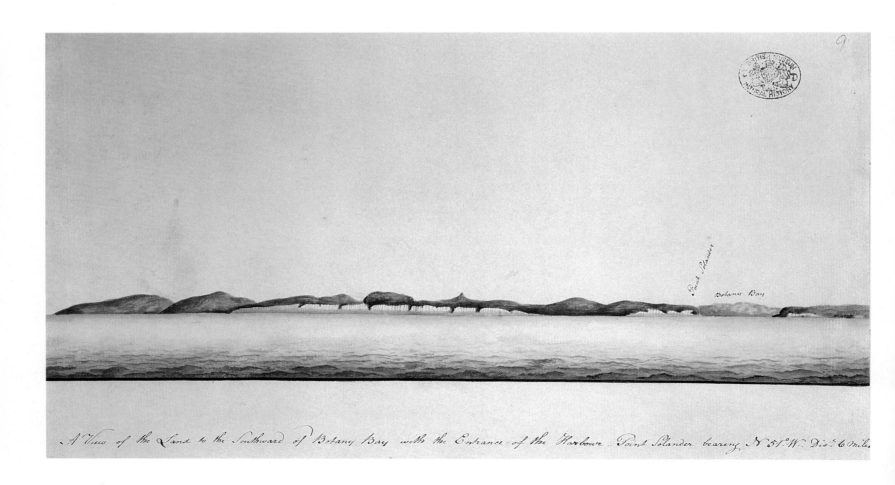

Point Solander

Botany Bay

A View of the Land to the Southward of Botany Bay with the Entrance of the Harbour Point Solander bearing N 51° W Dist 6 Miles

detailed chart of *Waaksamheyd*'s track from Port Jackson to Batavia. His chart of the Southern Hemisphere seems to be the original of the one published in the *Historical Journal*, 'Southern Hemisphere Shewing the Track of His Majesties Ship Sirius from the Equator to the Compleating the Circle' (fp. 126) which omits *Sirius*'s second passage from the Cape of Good Hope to Sydney and the track of *Waaksamheyd*, as does a manuscript copy of the chart in the Dixson Library, Sydney (Cb 78/5). Bradley is also probably the author of the 'Chart Shewing the Track of the Waaksamhey'd Transport from Port Jackson in New South Wales, to Batavia, in 1792' in the *Historical Journal* (fp. 264). Manuscript copies of this chart are in his journal and in the Dixson Library, Sydney (Cc 79/4).

After *Sirius* was wrecked on Norfolk Island in 1790, Bradley charted it and nearby Phillip Island [plate 84], and made a larger scale plan of the south side of the island including Sydney Bay where the settlement had been established. Plates 85 and 86 are copies of these charts. He also made a detailed plan of the two channels through the reefs in Sydney Bay that led to landing places. Copies of this are in his journal (fp. 225) and among the manuscripts Hunter pasted into his copy of the *Historical Journal* which contained, as Pl. 13, the chart of Norfolk Island without Phillip Island. In 1794 Bradley published on his own account 'A Chart of Norfolk Island from an Actual Survey by Captain Willm. Bradley, R.N.'. This presented the charts of Norfolk and Phillip Islands, and of the south side of Norfolk Island on the one sheet. It was reissued by the Hydrographical Office in 1823. (Bradley had been promoted on the recommendations of both Governor Phillip and Captain Hunter in 1792.)

When *Waaksamheyd* reached England Bradley, at Phillip's request, sent a copy of his 'more accurate survey of Norfolk Island' to Evan Nepean, Under-Secretary for the Home Department.[12] The delivery of this 'more accurate survey' and the inclusion of 'from an Actual Survey' in the title of his published chart were, no doubt, to make clear that the chart of Norfolk Island published in *The Voyage of Governor Phillip* had been superseded and probably that Bradley was disowning it. It bore an inscription 'W. Bradley delin. 1788', and consequently Bradley has often been cited as its author, which

Plate 75 [Watling 4]
PORT JACKSON PAINTER
A View of the Entrance Into Port Jackson Harbour (c. 1788–9)
Water-colour, 260 × 448
This is probably a view of the entrance to Broken Bay. The rounded 'South Head' looks more like Barranjoey than Port Jackson's South Head whose cliffs rise to its summit and which is not backed by lower land to the south as in this view. Bradley's view of the 'S.W. Arm of Broken Bay', shows Barranjoey as a similar double-humped headland. The mid-stream island is Lion Island (Eliot Island on the early charts) which is shown on plate 72.

Plate 76 [Watling 5]
JOHN HUNTER (?)
A View of the Land to the Southward of Botany Bay with the Entrance of the Harbour . . . (c. 1788)
Water-colour, 171 × 318
The title on this view, which joins plate 77, may be in Hunter's hand.

Plate 77 [Watling 6] *below*
JOHN HUNTER (?)
A View of the Land from Botany Bay to Port Jackson (c. 1788)
Water-colour, 168 × 325
Plates 76 and 77 are overlapping views of the coast south of Botany Bay and between Botany Bay and Port Jackson. The title seems to be in Hunter's hand.

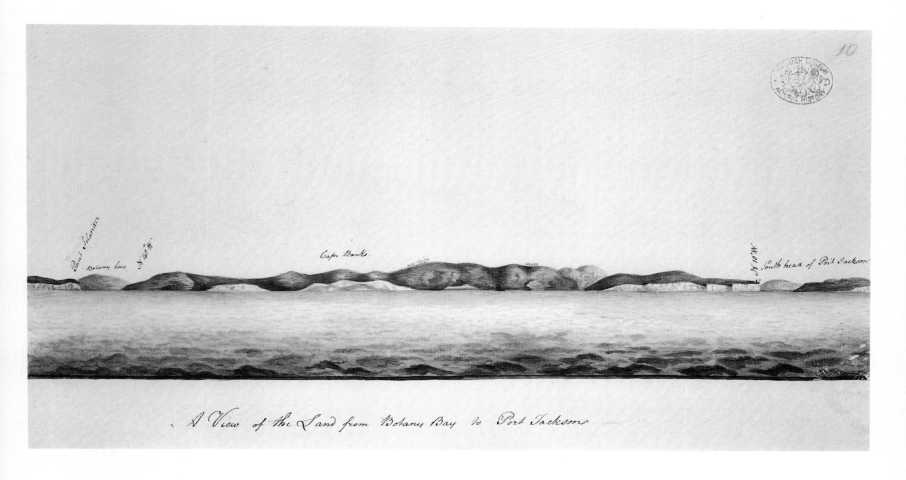

A View of the Land from Botany Bay to Port Jacksons

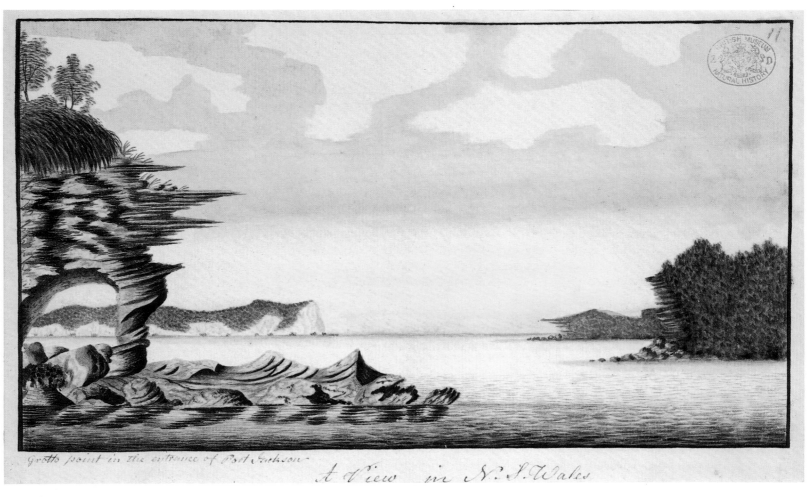

Grotto point in the entrance of Port Jackson

A View in N.ᵗ S. Wales

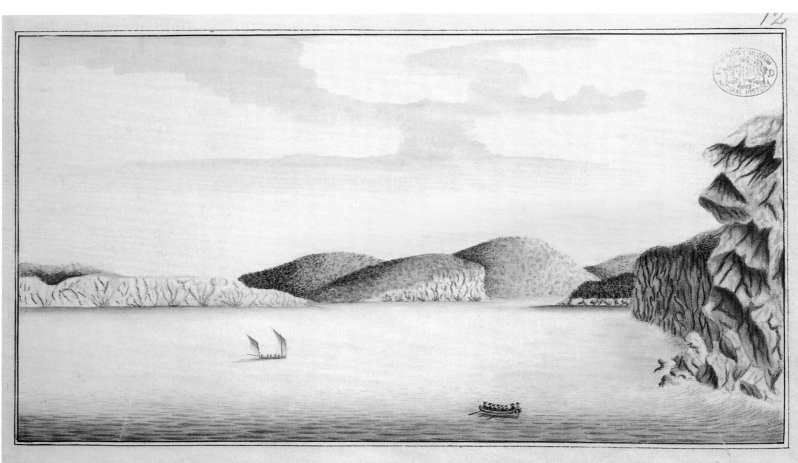

View of the Entrance into the Harbour of port Jackson – taken in a boat under the North Head

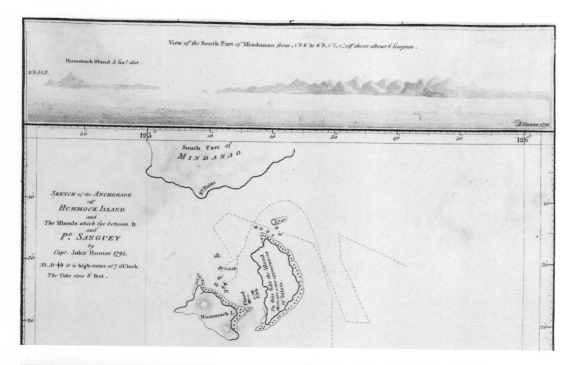

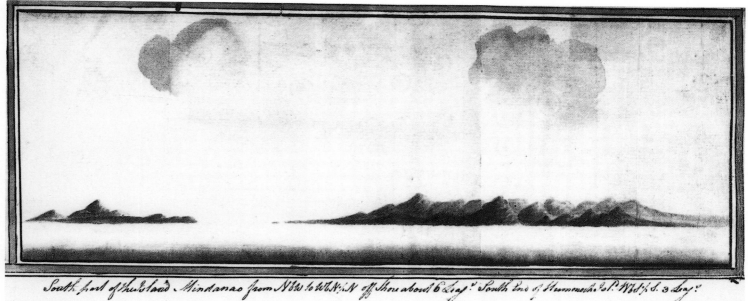

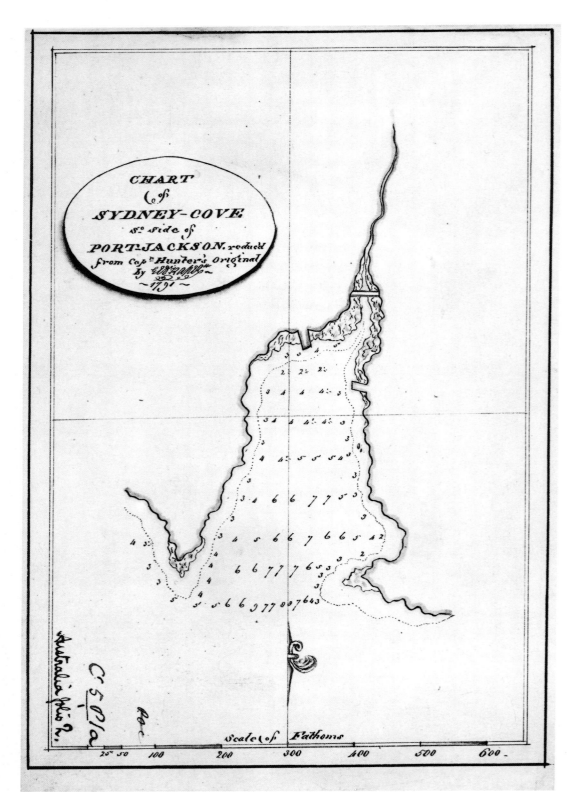

Plate 82
GEORGE RAPER
Chart of Sydney-Cove So. Side of Port-Jackson reduc'd from Capn. Hunter's Original by Geo. Raper 1791
Ink and water-colour, 270 × 184; original scale: 0.95 in. = 100 fathoms (*c.* 1:7,500)
Only the coastline on this chart has been copied from Hunter's survey of 1788. The soundings are not Hunter's and their regular east-west alignment suggests that this chart, like the one of Careening Cove in the Raper Papers, is in part the product of a training exercise. It includes three features not included in the published version of Hunter's plan in *The Voyage of Governor Phillip . . .*: the Governor's Wharf on the east side of Sydney Cove; the Hospital Wharf on the west side (this became the principal landing place for ships' passengers and cargo); and the log bridge built over the Tank Stream in 1788. Note Raper's capital H and A in the title.
Australia Folio 2, C581a/1, Hydrographic Department, Taunton; reproduced by permission of the Hydrographer of the Navy.

84

he was not. He did not visit Norfolk Island until *Sirius* was wrecked there, and *delineavit* means 'drew this' indicating that Bradley had drawn the fair copy sent to the engraver, not that he was the surveyor. The author of the chart in *The Voyage* has not been identified: he must have been either one of the party settled on the island or in *Supply* when she made her February-March or July-August 1788 visit to the island. Had the chart come to Sydney later, Bradley would not have been able to copy it in time for its inclusion in *The Voyage* (the *Golden Grove*, that made the third voyage from Sydney to Norfolk Island, sailed on the same day that *Sirius* left to obtain supplies from Cape Town). Bradley's use of the phrase 'from an Actual Survey' on his chart implies that the one in *The Voyage* (fp. 87) was an eye-sketch: an impression that can be sustained by comparing the two.

When *Waaksamheyd* was in Port Hunter on the north-west of Duke of York's Island Bradley made a plan of the port and adjoining Waterhouse Cove, a small-scale sketch of their environs, and painted a view of the port: these are in his 'Voyage' manuscript. The plan and sketch, with a view that is more like Raper's [plate 88] than Bradley's view [plate 89], were published by Dalrymple in 1794 [plate 87]. It was subsequently twice reissued by the Hydrographical Office. The first reissue had the Hydrographical Office seal in the top-left corner and rhumb lines and a north point added to the plan; for the second reissue 'Duke of York I.' was added above the title, the longitude was altered, and a chart number '1104' placed beneath the engraver's name at the bottom-right corner.

The pictures in Bradley's journal are a personal record of his voyage: he used his water-colour brush as a modern sailor might use a camera. Some depict incidents and landscapes that are illustrations rather than 'views' in the nautical sense. Those that are nautical views frequently include foreground detail of a kind not usually presented:

Plate 83 [Raper 28]
GEORGE RAPER
Hummock Island . . . Where we Watered and Refreshed in the Waaksaamheydt . . .
Ink and water-colour, 319 × 497, inscribed 'Taken on board the Waaksaamheyd Geo. Raper 1791'
Both Raper and Bradley painted views of Hummock Island from the anchorage about a mile offshore. Hunter's view (plates 80 and 81) is a more distant one taken from 3 leagues (about 9 nautical miles) offshore. Bradley's view is reproduced fp. 276 in his *Voyage to New South Wales* (1969).

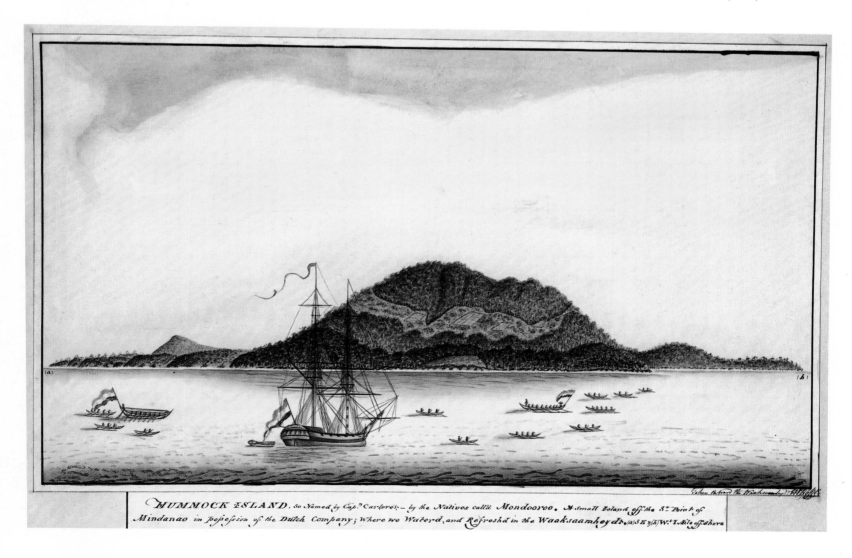

HUMMOCK ISLAND, So Named by Cap.t Carteret; — by the Natives call'd Mondooroo. A Small Island off the S.t Point of Mindanao in possession of the Dutch Company; Where we Water'd, and Refresh'd in the Waaksaamheyd.

Plate 84
WILLIAM BRADLEY
Norfolk Island . . . [and Phillip Island]
Ink and water-colour, 358 × 232, inscribed 'by William Bradley'; original scale: 1.25 in. = 1 nautical mile (*c.* 1:5,800) Chart 12 in Bradley's manuscript 'A Voyage to New South Wales', Mitchell Library, State Library of New South Wales, Sydney (Safe p.h.8).
Bradley's plan of Norfolk Island was published, without Phillip Island, in the *Historical Journal* (1793) fp. 393, and with Phillip Island and a plan of the southern part of the island on a larger scale by Bradley himself in 1794.

facing page

Plate 85 [Watling 1]
PORT JACKSON PAINTER
Norfolk Island . . . [and Phillip Island]
Ink and water-colour, 310 × 386; original scale: 1.3 in. = 1 nautical mile (*c.* 1:57,000)
A manuscript copy of Bradley's plan of Norfolk Island (plate 84).

Plate 86 [Watling 2]
PORT JACKSON PAINTER
South Coast of Norfolk Island (c. 1791)
Ink and water-colour, 307 × 400; original scale: 3.75 in. = 1,000 fathoms (*c.* 1:19,200)
A copy of Bradley's plan of Sydney Bay and adjoining coast of Norfolk Island. This plan was published on the same sheet as his chart of Norfolk Island (plate 84) by Bradley in 1794. Bradley made a more detailed plan, 'Landing places through the reef, Sydney Bay, Norfolk Island': the section of Sydney Bay near the flagstaff. Copies of this are in his manuscript journal and among the charts inserted by Hunter in his copy of the *Historical Journal* (Mitchell Library, Safe p.h.8, and C689).

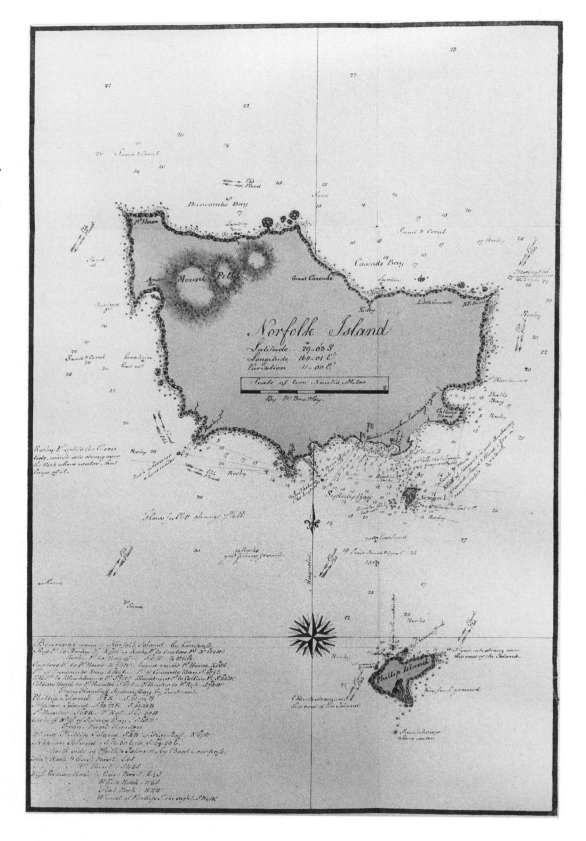

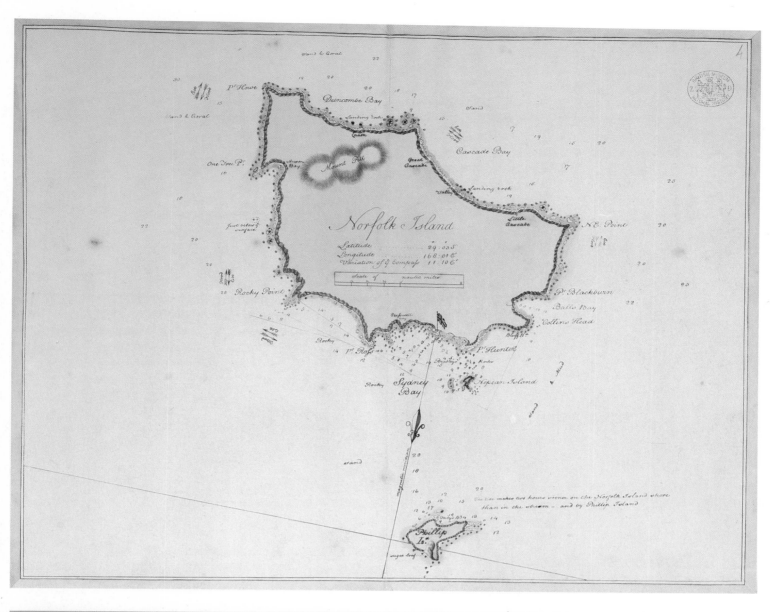

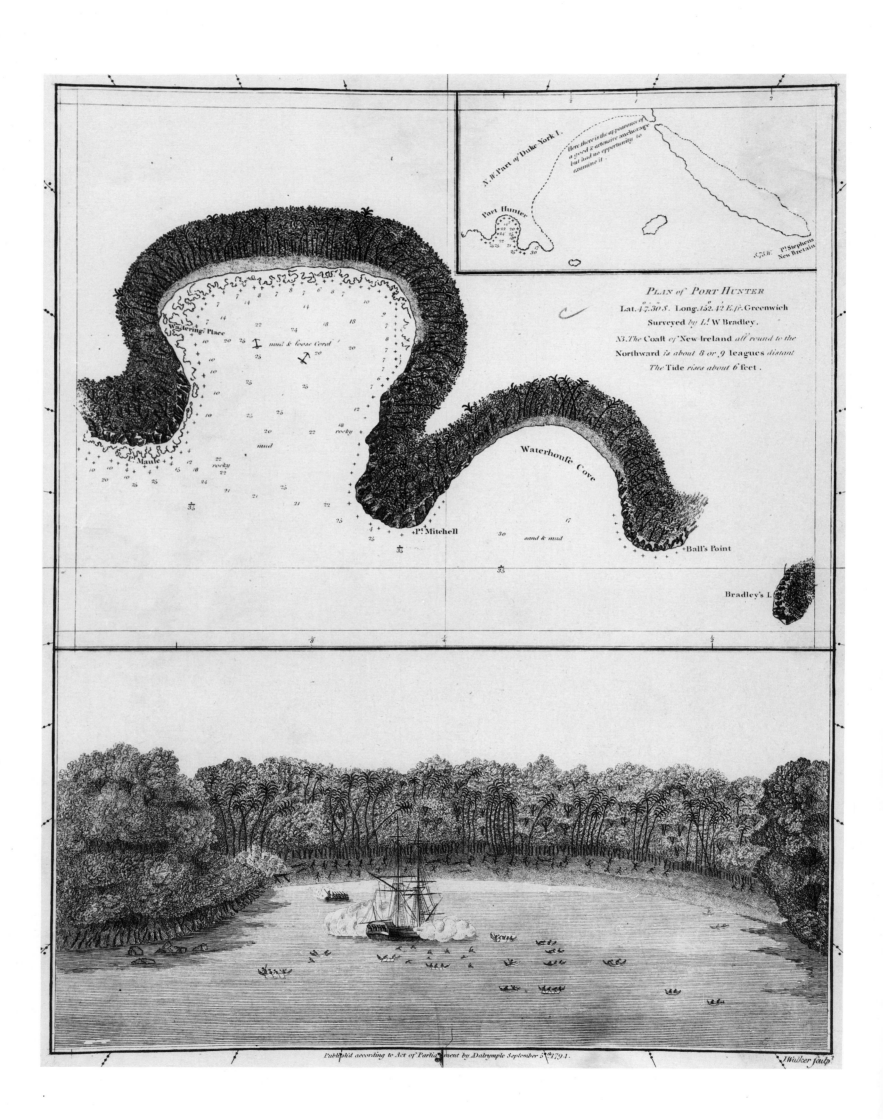

Here there is the appearance of
a good & extensive anchorage
but had no opportunity to
examine it.

N.W. Part of Duke York I.

Port Hunter

P.t Stephens
New Bretain

PLAN of PORT HUNTER
Lat. 47.30 S. Long. 152.42 E. fr. Greenwich
Surveyed by L.t W Bradley.
N3. The Coast of New Ireland all round to the
Northward is about 8 or 9 leagues distant
The Tide rises about 6 feet.

Watering Place

P.t Maule

mud & loose Coral

mud

rocky

rocky

Waterhouse Cove

P.t Mitchell

sand & mud

Ball's Point

Bradley's I.

Publish'd according to Act of Parliament by Dalrymple September 3.d 1794.

J.Walker sculp.t

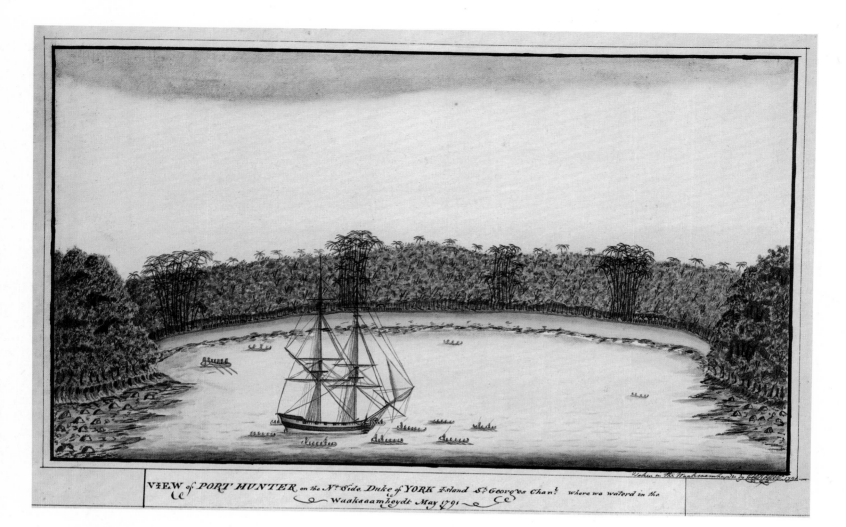

VIEW of PORT HUNTER on the N.ᵒ Side Duke of YORK Island S.ᵗ George's Chan.ˡ where we water'd in the Waaksaamheydt May 1791

Plate 87 *left*
WILLIAM BRADLEY
Plan of Port Hunter [Duke of York's I.] . . . Surveyed by Lt. W. Bradley [with view] (1791)
Engraving, first state, by J. Walker, 301 × 232, published by A. Dalrymple, September 1794; scale not stated
Waaksamheyd spent four days in Port Hunter during which Bradley surveyed the Port. The copy of his plan in his journal does not name the Port; the copy by Hunter in his copy of the *Historical Journal* does. The view appears to have been based on Raper's (plate 88) rather than Bradley's (plate 89).
National Library of Australia, Canberra, *East India Pilot*, II, (Ra 42, No. 491).

Plate 88 [Raper 27] *above*
GEORGE RAPER
View of Port Hunter . . . May 1791
Ink and water-colour, 316 × 497, inscribed 'Taken in the Waaksaamheydt by Geo. Raper 1791'
This view of Port Hunter is more carefully drawn than the view in Bradley's journal (plate 89) and is probably the original of the view engraved with Bradley's plan and published by Dalrymple (plate 87).

Plate 89 *below*
WILLIAM BRADLEY
Port Hunter, Duke of York's Island, May 1791
Water-colour, 146 × 200, signed 'W.B.', in Bradley's 'A Voyage to New South Wales', fp. 260, Mitchell Library, State Library of New South Wales, Sydney (Safe p.h.8).

Port Hunter, Duke of York's Island, May. 1791. N.ᵒ3.

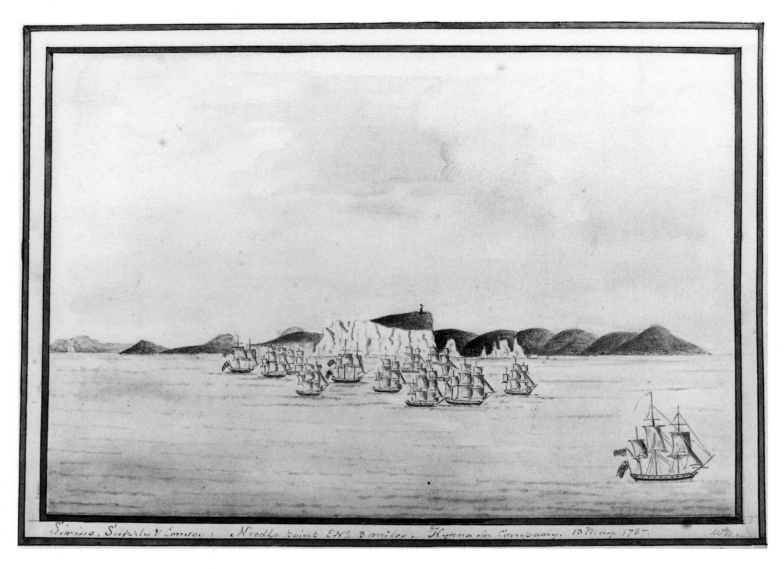

Sirius, Supply & Convoy : Needle Point ENE 3 miles. Hyæna in Company. 13 May 1787.

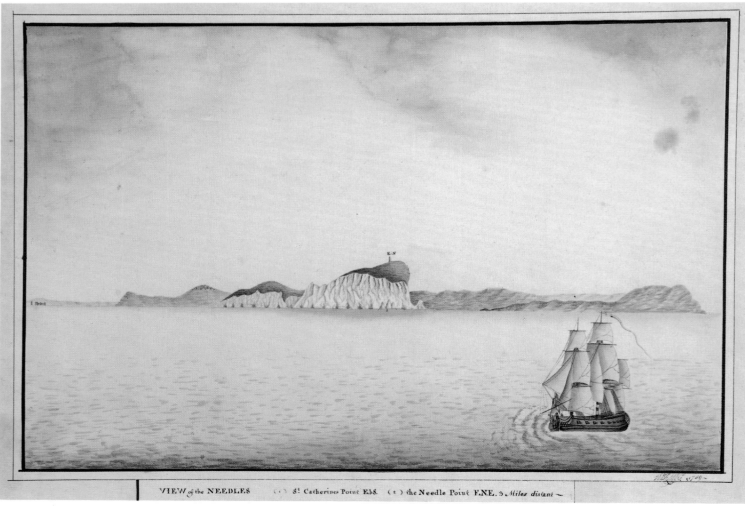

VIEW of the NEEDLES (a) St Catherines Point E.b.S. (b) the Needle Point E.NE. 3 Miles distant

his view of the Needles [plate 90], which is his version of Raper's [plate 91], shows the whole First Fleet sailing past St Catherine's Point; his view of Table Bay shows 'Sirius and Convoy in the Bay, November 1787' (fp. 46). In almost all there is in the foreground, a ship, a boat, canoes, or people (officers' red jackets contrasting with the blackness of Aborigines): detail that sets them apart as a personal not an official record.

The Australian National Library, Canberra, holds three pictures attributed to Bradley. One, *View of the Governor's house at Sydney . . . 1791* is by Bradley [plate 117]: it is signed and is almost the same as the view of the Governor's House in his journal (fp. 225). The view of the *Principal Settlement on Norfolk Island* is by George Raper [plate 130]: a copy of plate 129. The third, 'View of the Entrance into Port Jackson taken from a boat under North Head' (NK 205) is more like the work of the Port Jackson Painter than that of Bradley.

3 / George Raper

George Raper (1768?–97) entered the navy in 1783 and after serving on two ships as a captain's servant, and lieutenant's servant (usual first appointments for boys aspiring to commissions) joined H.M.S. *Sirius* as an able seaman in December 1786. He became a midshipman on 30 September 1787, in mid-Atlantic a fortnight out of Cape Town. As a midshipman he became Hunter's and Bradley's pupil in nautical matters, which included making determinations of the ship's position, surveying, reducing and copying charts, and making views.

The Raper Collection in the British Museum (Natural History) contains the greatest number of his 'views', most of which are reproduced in this volume. They are fine examples of this style of painting, with landmarks clearly identified, bearings and distances clearly stated, and, when the visibility was not good, a note on the weather. From those that are dated it seems that most were painted from preliminary sketches long after *Sirius* had been in the place depicted: they are fair copies. The *View of the Needles* [plate 91], passed in 1787, is dated 1789; the *Views in the neighbourhood of the Cape of Good Hope* [plate 98] are dated 1790, after both of *Sirius*'s visits to Cape Town; the *Ice Islands as seen . . . in 1788* [plate 102], is dated 1789.

Raper's pictures include portraits of *Supply* and *Sirius* [plate 92], views of some of the islands sighted in the Atlantic Ocean between the Isle of Wight [plate 93] and Brazil, off Rio de Janeiro and the Cape Peninsula [plates 95–98], of *Sirius*'s landfalls in Van Diemen's Land [plate 104] and on the New South Wales coast [plates 68, 73 and 74], of the 'ice islands' seen near Cape Horn in 1788 [plate 102], of Lord Howe Island [plate 217] and Norfolk Island [plates 124 and 125]. On Norfolk Island he painted pictures of the wrecking of *Sirius* and the salvaging of her cargo [plates 126 and 127], of the settlement there [plate 129] and made a plan of the farms in Arthur's Vale [plate 131]. In *Waaksamheyd* he painted views of the ports visited [plates 83, 99 and 216]. Most are rather austere and correct naval 'views', but in a few he has, like Bradley, depicted the First Fleet [plate 95] or ships in port [plates 99, 216].

George Raper's Papers, in the hands of the Raper family, contain five sheets of views which are copies, painted in 1790 and 1791, of some of the views in the British Museum collection.[13] Sheet I reproduces plates 91 and 93; Sheet II, plate 94; Sheet III, plate 95, and a view of Table Bay (a version of plate 99); Sheet IV, the upper view of plate 104, the lowest of plate 73, and plate 74; while Sheet V is a copy of plate 126, but with the flagstaff and a large flag at the right-hand side of the picture.

There is only one plan by Raper in the British Museum (Natural History) Raper Collection [plate 131], but his Papers contain nine charts or plans: charts of the North

Plate 90
WILLIAM BRADLEY
Sirius, Supply & Convoy: Needle Point ENE 3 miles. Hyena in Company. 13 May 1787
Water-colour, 150 × 206, signed 'WB', in Bradley's 'A Voyage to New South Wales', fp. 12, Mitchell Library, State Library of New South Wales, Sydney (Safe p.h.8)
This view of the First Fleet leaving England shows it sailing out of the Solent into the English Channel past Needle Point at the west end of the Isle of Wight. H.M.S. *Hyena* escorted the Fleet 300 miles into the Atlantic.

Plate 91 [Raper 5]
GEORGE RAPER
View of the Needles . . .
Ink and water-colour, 326 × 469, signed 'Geo. Raper 1789'
This is Raper's version of the view shown in plate 90: Needle Point, with the Solent to the left, and the coast of the Isle of Wight to St Catherine's Point on the right.

and South Atlantic Ocean showing the track of *Sirius*; plans of Port Praya (Cape Verde Islands, made in expectation of a visit that did not take place), Rio de Janeiro, and Table Bay (the last, like Bradley's, obviously derived from Dalrymple's published plan, and the other two probably copied from yet unidentified published originals); copies of Hunter's charts of Port Jackson and Botany Bay; and of Bradley's chart of Norfolk Island and Sydney Bay. There is also an original plan of 'Careening Cove' (Mosman Bay) which is signed, 'Taken by Geo Raper 1789'. This last is interesting because it is not a copy of Bradley's plan of the same cove. It includes Little Sirius Cove, which Bradley's does not, gives a slightly different configuration to the cove and particularly to the point at its western entrance (now Robertsons Point), and shows soundings in regular east-west lines (Bradley's soundings are not so regularly patterned). This plan may have been made as a training exercise in surveying while *Sirius* was being refitted: perhaps an application of skills taught whilst assisting in the survey of Port Jackson. These charts and plans, like Bradley's, were drawn for personal, not official use, and on some of them he has allowed himself a little artistic freedom. On the plans of Botany Bay and Careening Cove the titles are given in scroll cartouches, and on the Careening Cove one the curled up end of the scroll partly obscures the statement of Latitude and Longitude usually placed on plans (perhaps he was unsure of the correctness of his position). On the plan of Port Jackson the title appears to have been carved into a rocky sandstone headland. Local features, a pine tree and flax plants, are similarly used to decorate the cartouche on plate 131.

George Raper's work is distinguished from that of Hunter and Bradley by his development of a clearly recognizable style of lettering. On most of the charts produced by Hunter and Bradley they wrote titles and place-names in a cursive hand: Raper

Plate 92 [Raper 4]
GEORGE RAPER
His Majesty's Brig Supply 1790 off Lord Howe Island. Disc. Feb. 1788
His Majesty's Ship Sirius in Sidney Cove 1789
Ink and water-colour, 332 × 489, unsigned
Supply and *Sirius* provided the naval escort for the First Fleet. *Sirius*, the larger of the two, was rated at 540 tons, the gundeck was 110 feet long and 32 feet broad and carried 20 guns (six-pounders) and 160 men. *Supply*, an armed tender, was rated at 170 tons, carried 8 guns and 50 men.

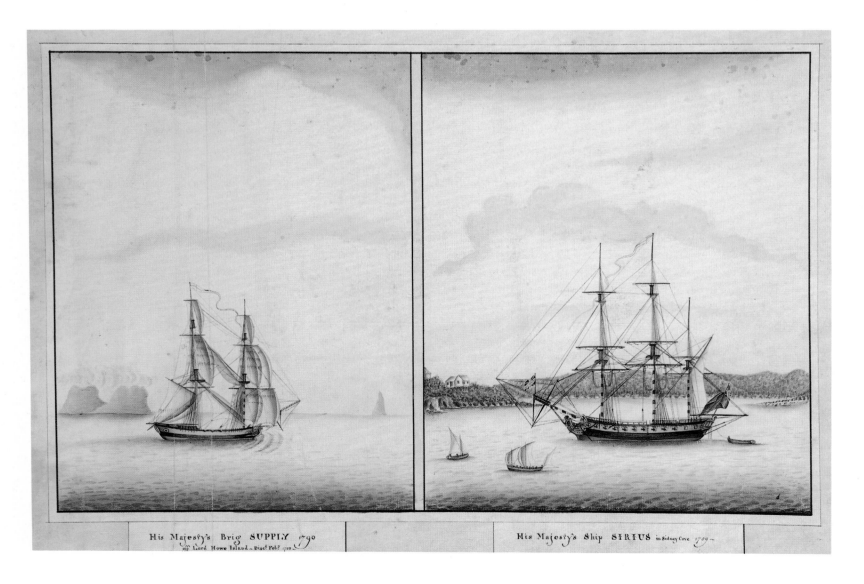

His Majesty's Brig SUPPLY 1790 off Lord Howe Island – Disc Feb. 1788

His Majesty's Ship SIRIUS in Sidney Cove 1789

used Roman and italic letters. As his confidence and skill with the pen increased his style became increasingly elaborate. On the earlier of his views his lettering is usually simple and occasionally awkward (he often emphasized the right-hand rather than the left-hand arms of capital V and W) but three characteristics of his style are present: the use of chevrons for the crossbars of capital A and H, the swashing of the tails of lower case f and g, and the decoration of capital I with tiny dashes on either side of the middle of the vertical [plates 91, 93 and 96]. As his style developed he exaggerated the serifs on the capital letters C, G and S, and swashed some initial letters. On the later of his drawings his swashing of letters is more elaborate and the dashes on capital I have become a knobbed bar across the letter [plates 83, 88, 99, 129 and 130]. Other eighteenth-century cartographers used chevrons for the crossbars of A and H, exaggerated serifs, and used elaborate swashes, but the decoration of capital I seems to be unique to Raper.[14] The style of lettering suggests that five charts, attributed to Bradley in the Dixson Library, Sydney, are in fact by Raper.[15]

With the possible exception of Hunter's, Raper's views are probably the finest produced by those who sailed in the First Fleet. Only one, the view of Port Hunter, which was improved by the engraver, and printed with Bradley's plan, appears to have been published. It was inevitable that for the places visited in *Waaksamheyd*, Hunter's views would be preferred to Raper's by Dalrymple. But it is surprising that no views of the New South Wales coast, except a rather poor one on Marshall's chart, found a place in *The Voyage of Governor Phillip*. Perhaps Raper's first sketches were not good enough, and the ones now reproduced had not been finished when *Alexander* sailed from Port Jackson in July 1788: the earliest of Raper's dated views was painted in 1789.

Plate 93 [Raper 6]
GEORGE RAPER
Two views of the Salvages and Island of Teneriffe (1789–91)
Ink and water-colour, 321 × 537, unsigned
The Salvages, or Selvagens, are two small groups of islands between Madeira and the Canary Islands. Tenerife, the largest of the Canary Islands, is dominated by the Pico de Teide, a volcanic cone which rises to 3,707 metres. These views were probably developed from Raper's own sketches made in 1787.

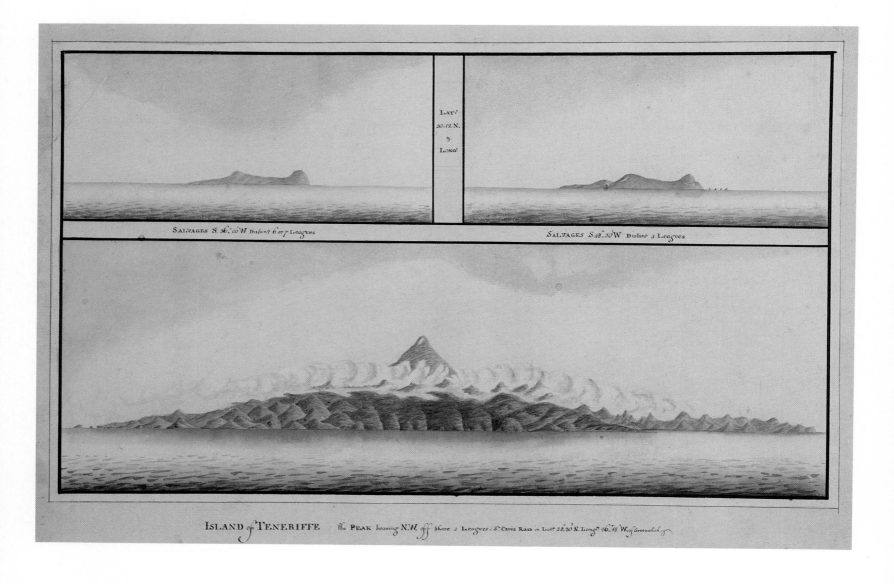

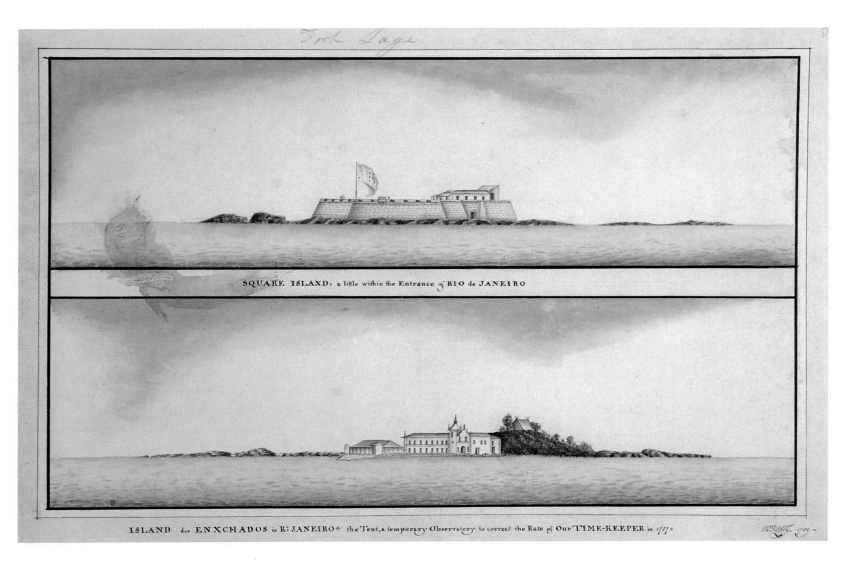

ISLAND des ENXCHADOS in R⁰ JANEIRO ↟ the Tent, a temporary Observatory to correct the Rate of Our TIME-KEEPER in 1787 ↟

Plate 94 [Raper 9]
GEORGE RAPER
Square Island and *Island dos
Enxchados in R⁰. Janeiro* . . .
Ink and water-colour, 312 × 476,
signed Geo. Raper 1789'
'Square Island', a fortified island
midstream in the narrowest part of
the entrance to Guanabara Bay can
be seen on plate 95. The Island dos
Enxchados (Enxadas) lies to the
north of the city and was the site for
a tent observatory erected to enable
Lieutenant William Dawes to make
astronomical observations to check
the Fleet's chronometers.

Plate 95 [Raper 8] *top right*
GEORGE RAPER
*Entrance of Rio de Janeiro (Brasil)
from the Anchorage* . . .
Ink and water-colour, 326 × 482,
signed 'Geo. Raper 1790'
This view shows all eleven ships of
the First Fleet anchored outside the
entrance to Guanabara Bay, the
harbour of Rio de Janeiro, on 6
August 1787. On the following day
they sailed into the bay and anchored
about 1½ miles off the city.

Plate 96 [Raper 7] *right*
GEORGE RAPER
*Views of the Cape de Verd Islands –
Sirius. June 1787 (c. 1789–91)*
Ink and water-colour, 321 × 492,
unsigned
Sal, Boa Vista and Maio, three of the
eastern group of Cape Verde Islands
were passed as the Fleet sailed
toward Port Praia (Praya) on S.
Tiago (Saint Jago), the largest of the
eastern islands, where it was hoped
to obtain fresh vegetables for crews
and convicts. Strong north-westerly
winds made entering the Port
hazardous and the attempt was
abandoned. These views were
probably developed from sketches
made by Raper in 1787.

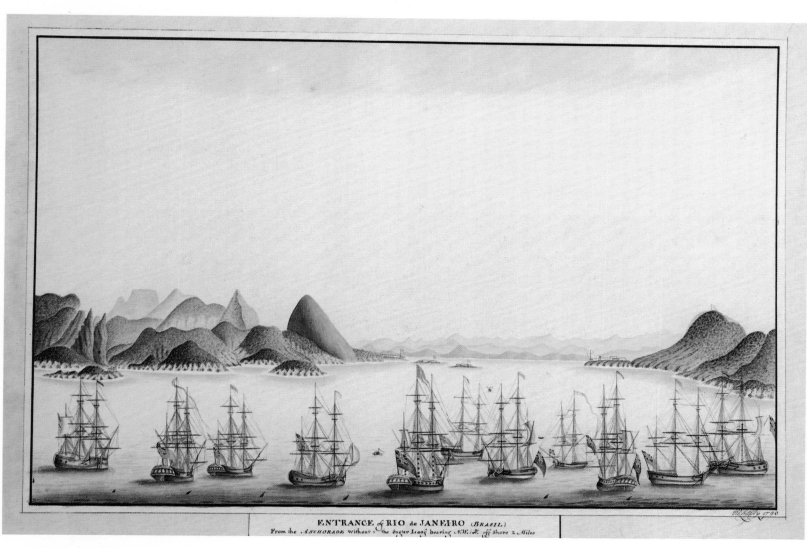

ENTRANCE of RIO de JANEIRO (BRASIL)
From the ANCHORAGE without the Sugar Loaf bearing N.W.¼N. off Shore 2 Miles

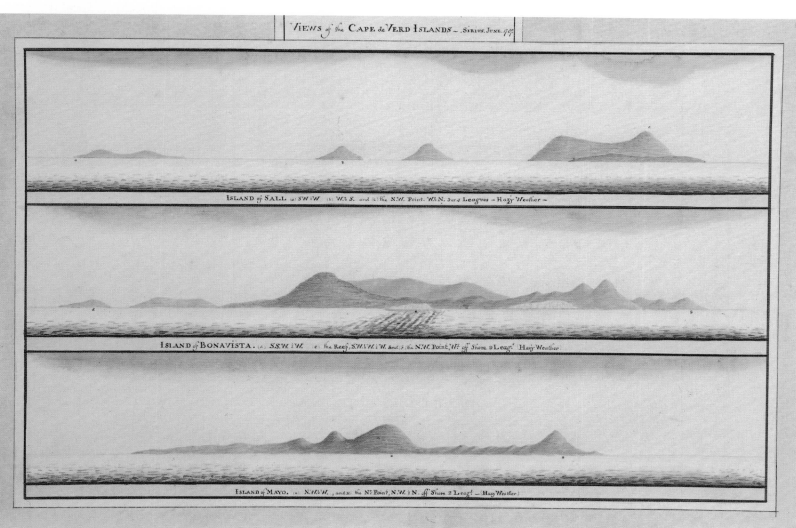

VIEWS of the CAPE de VERD ISLANDS — Sirius June 1787

ISLAND of SALL (a) S.W.¼W. (b) W.¼S. and (c) the N.W. Point W.¼N. 3or4 Leagves — Hazy Weather —

ISLAND of BONAVISTA. (a) S.S.W.¼W. (c) the Reef, S.W.¼W.¼W. and (f) the N.W. Point W.ᵗ off Shore 2 Leag.ᵉ Hazy Weather

ISLAND of MAYO. (a) N.W.¼W. and b) the N.ᵗ Point, N.W.½N. off Shore 2 Leag.ᵗ — Hazy Weather)

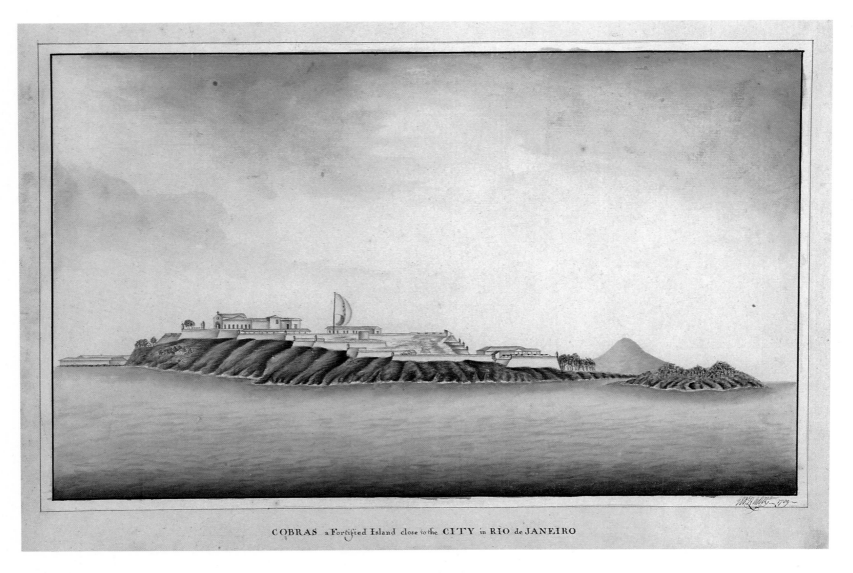

COBRAS a Fortified Island close to the CITY in RIO de JANEIRO

Plate 97 [Raper 10]
GEORGE RAPER
Cobras a Fortified Island close to the
City in Rio de Janeiro
Ink and water-colour, 327 × 472,
signed 'Geo. Raper 1789'

Plate 98 [Raper 11] *top right*
GEORGE RAPER
Views in the Neighbourhood of the
Cape of Good-Hope
Ink and water-colour, 327 × 490,
signed 'Geo. Raper 1790'
These two views of the north-
western face of the Cape Peninsula
show the Twelve Apostles rising
abruptly from the sea to the south of
the Sugarloaf, now Lions Head. The
ridge between Lions Head and Lions
Rump shelters Table Bay from south-
westerly winds. The sharp point to
the left of Table Mountain in the
lower view is Devil's Peak on the
eastern arm of the amphitheatre in
which Cape Town nestles.

Plate 99 [Raper 12] *right*
GEORGE RAPER
View of the Table-land from the
Anchorage in the Bay Cape Good-
hope . . .
Ink and water-colour, 321 × 486,
inscribed 'Geo. Raper 1792 taken on
board the Waaksaamheydt'
During the eighteenth century Cape
Town was known as the Tavern of
the Seas: it was a port of call for
every ship passing from the Atlantic
to the Indian Ocean, or making the
return voyage. Raper's view shows
Cape Town at the foot of the 'Table-
land', Table Mountain, and Table
Bay thronged with ships. The two
flying the blue ensign may be
Providence and *Assistant* bound for
Tahiti under William Bligh's
command. Boats from these and
other ships assisted *Waaksamheyd*
into the Bay after she lost two
anchors off Robben Island.

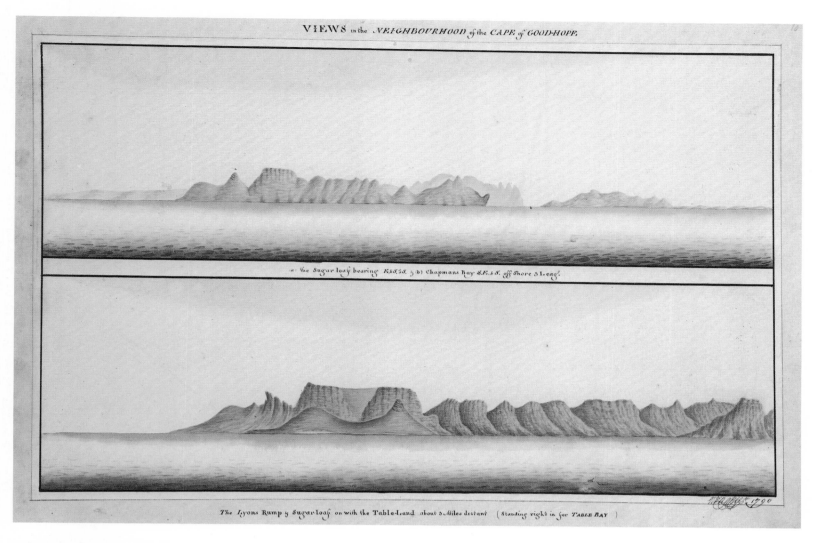

a. the Sugar loaf bearing E.b.S.½S. ; (b) Chapmans Bay S.E.½S. off shore 3 Leag.ᵗ

The Lyons Rump & Sugar loaf on with the Table-Land about 5 Miles distant (Standing right in for TABLE BAY)

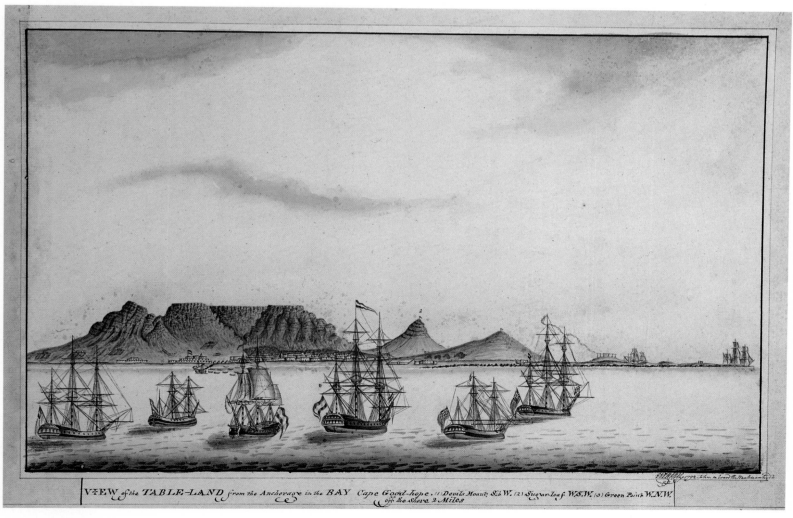

VIEW of the TABLE-LAND from the Anchorage in the BAY Cape Good-hope. (1) Devils Mount. S.b.W. (2) Sugar-loaf. W.S.W. (3) Green Point W.N.W.
off the Shore 2 Miles

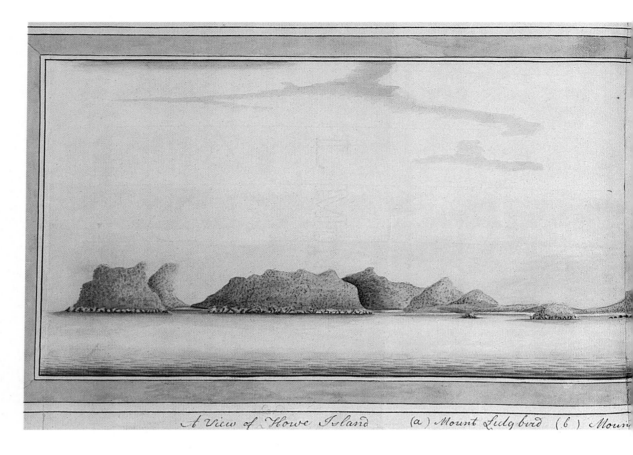

A View of Howe Island (a) Mount Lidgbird (b) Moun...

Plate 101 *below*
HENRY LIDGBIRD BALL
A View of Lord Howe Island and *A Chart of Lord Howe Island Discovered by Lieut. Henry Lidgbird Ball in his Majesty's Arm'd Tender Supply On the 17th of Feby. 1788 . . .*
Engraving by T. M. [Thomas Medland], *c.* 240 × 330, 'Publish'd July 31 1789 by J. Stockdale'; original scale: 1.65 in. = 1 mile (*c.* 1:38,400); in *The Voyage of Governor Phillip to Botany Bay* (1789), fp. 180
Lord Howe Island was discovered by Ball *en route* to Norfolk Island to land the first settlers there. On the return journey to Port Jackson he called to chart it. A manuscript copy of the chart and view from which this engraving was made is in the Hydrographic Department, Taunton (451 Pe).

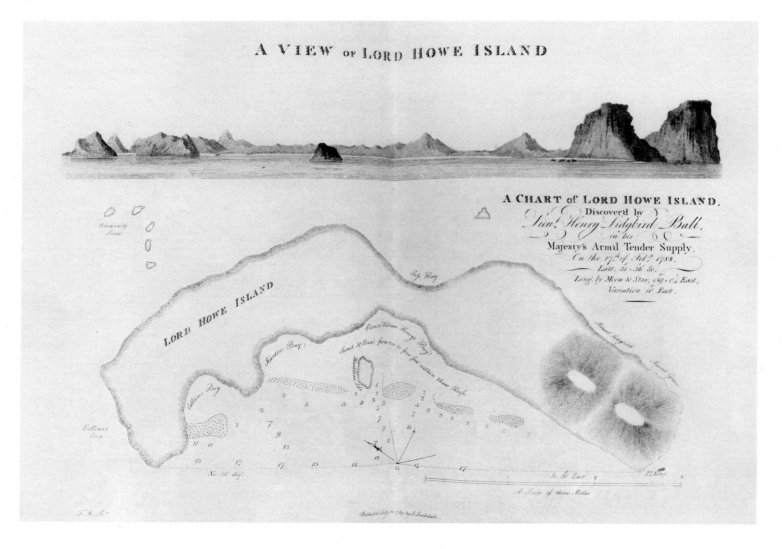

A VIEW OF LORD HOWE ISLAND

A CHART OF LORD HOWE ISLAND.
Discover'd by
Lieut. Henry Lidgbird Ball.
in his
Majesty's Arm'd Tender Supply.
On the 17th of Feby. 1788.
Latt. 31 . 36. So.
Long. by Moon & Star, 159 . 04 East.
Variation 10 East.

LORD HOWE ISLAND

A Scale of three Miles

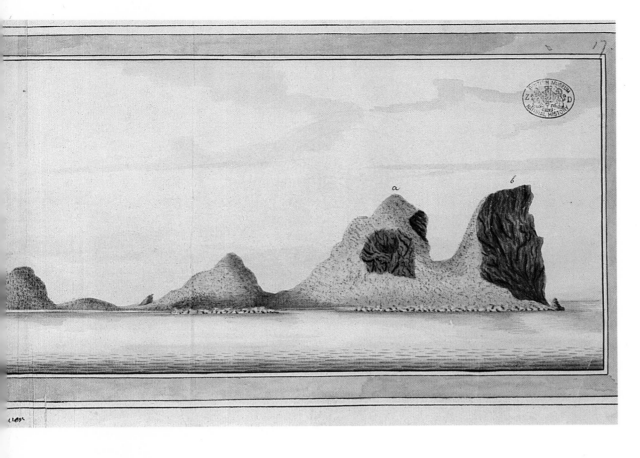

Plate 100 [Watling LS5] *left*
PORT JACKSON PAINTER
A View of Lord Howe Island (a)
Mount Lidgbird (b) Mount Gower
Water-colour, 201 × 602
This view looking into the wide bay
on the western side of Lord Howe
Island does not seem to be a copy of
the engraving (plate 101). The
treatment of the south face of Mt
Lidgbird is markedly different, as is
that of the rocky shelving below both
Lidgbird and Gower. A similar view,
attributed to Ball but not signed, and
with an inset view of Ball's Pyramid
(plate 103), is in the Dixson Library,
Sydney (Cb 78/6). Plate 100 was
probably copied from the view now
in the Hydrographic Department,
Taunton (451 Pe).

Plate 102 [Raper 19] *below*
GEORGE RAPER
Ice Islands as seen on our Passage
round Cape Horn in 1788
Ink and water-colour, 312 × 483,
signed 'Geo. Raper 1789'
During the voyage to Cape Town via
Cape Horn 'ice islands' were sighted
by *Sirius* from 22 November to 21
December 1788. At this time
'iceberg' (literally 'ice mountain') was
the term used for the seaward face of
glaciers, the parts that had broken
free and were floating were called
'ice islands'.

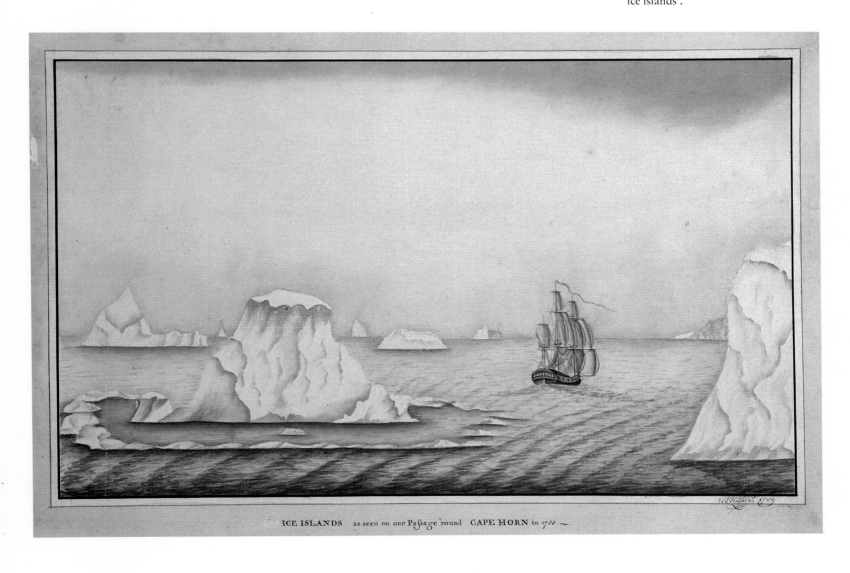

ICE ISLANDS as seen on our Passage round CAPE HORN in 1788

4 / Philip Gidley King and Henry Lidgbird Ball

Philip Gidley King (1758–1808), a protégé of Governor Phillip, sailed from England as Second Lieutenant of H.M.S. *Sirius* and went with Phillip when he transferred to H.M.S. *Supply* in the hope of making a faster passage to Botany Bay. Soon after the First Fleet's arrival King was appointed commandant of the settlement to be formed on Norfolk Island. He and the founding party were carried there by *Supply*, commanded by Lieutenant Henry Lidgbird Ball (?–1818). On the way Ball discovered Lord Howe Island and Ball's Pyramid, and on the return journey called to make a survey of the island. 'A Chart of Lord Howe Island . . .', with a view, was published in *The Voyage of Governor Phillip* (fp. 180). The original chart with a 'good painted view' is in the Hydrographic Department, Taunton (451 Pe). Plate 100 is a copy of this view. *The Voyage of Governor Phillip* also contains a view of 'Ball Pyramid' [plate 103]. The Dixson Library, Sydney, holds a copy of both views (Cb 78/6). It is not clear whether Ball himself, or one of his ship's company, painted the views. His sailing directions for Norfolk Island, Ball's Pyramid and Lord Howe Island are printed in chapter XVII of *The Voyage*.

After *Sirius* was wrecked on Norfolk Island Ball took *Supply* to Batavia for stores and to hire a ship to carry *Sirius*'s people to England. On the way he discovered and named Booby Shoal in the Coral Sea, 'Sirius Isl'd, in memory of the old ship' in the south-east Solomons (this has not been positively identified), and Tench (or Enus) Island and 'Prince Wm. Henry's Isld' (possibly the St Matthias group) in the northern Bismarck Archipelago.[16] King, who travelled in *Supply* to Batavia *en route* to England, drew a chart showing 'The Track of His Majesty's Armed Tender Supply, Lieut^t H. L. Ball, Commander. From Port Jackson to Batavia . . .' (Hydrographic Department, Taunton, 552 He).

On his arrival in England late in 1790 King presented a copy of his journal to Philip Stephens, Secretary to the Admiralty, who made it available to John Stockdale for inclusion in the *Historical Journal*. It was probably accompanied by a 'Chart of Norfolk Isle', signed and dated '1790' by King, and now in the Hydrographic Department, Taunton (y73 Pc). Compared with Bradley's this chart seems to be more an eye-sketch

Plate 103 *below*
ANONYMOUS
Ball Pyramid
Engraving by Prattent, c. 185 × 255, 'Publish'd Aug. 4 1789 by J. Stockdale' in *The Voyage of Governor Phillip to Botany Bay* (1789) fp. 181.
Ball's Pyramid rises abruptly to 552 metres above sea-level about 20 kilometres south-east of Lord Howe Island. It was sighted by Lieutenant Ball when he discovered Lord Howe Island. A view of Lord Howe Island in the Dixson Library, Sydney (Cb 78/6) has a view of Ball's Pyramid, similar to this one (including the improbably-topped island on the right). *The Voyage of Governor Phillip* assures us that the engraving is taken from 'a correct drawing of this rock and others near it' (p. 181).

Plate 104 [Raper 13]
GEORGE RAPER
(upper) *Van Diemen's Land, New-Holland . . . (in the Sirius Jan^y.) 1788*
(lower) *Distant View off Port Jackson . . . (Sirius 1790 May–)*
Ink and water-colour, 323 × 484, signed 'Geo. Raper 1789'
The upper view depicts part of the south coast of Van Diemen's Land, the First Fleet's landfall on the Australian coast. The Mewstone was named by Tobias Furneaux in 1773 because of its resemblance to the Mew Stone off Dartmouth, Devon. The lower view of the coast between Port Jackson and Broken Bay is probably misdated. In early May 1789 *Sirius* returned to New South Wales from the Cape of Good Hope making her landfall off Cape Three Points and approaching Port Jackson from the north-east: this view seems to be the third of a series made on that occasion, the other two being on plate 68 and dated 'in 1789'. By May 1790 *Sirius* had been wrecked on Norfolk Island, and the drawing is dated 1789.

Plate 105 [Watling 3]
PORT JACKSON PAINTER
A View of Vandiemans Land the S.W. Cape bearing ESE distance 5 or 6 Miles (c. 1788)
Water-colour, 263 × 427
This is another view of the south coast of Van Dieman's Land, possibly a copy of a lost original.

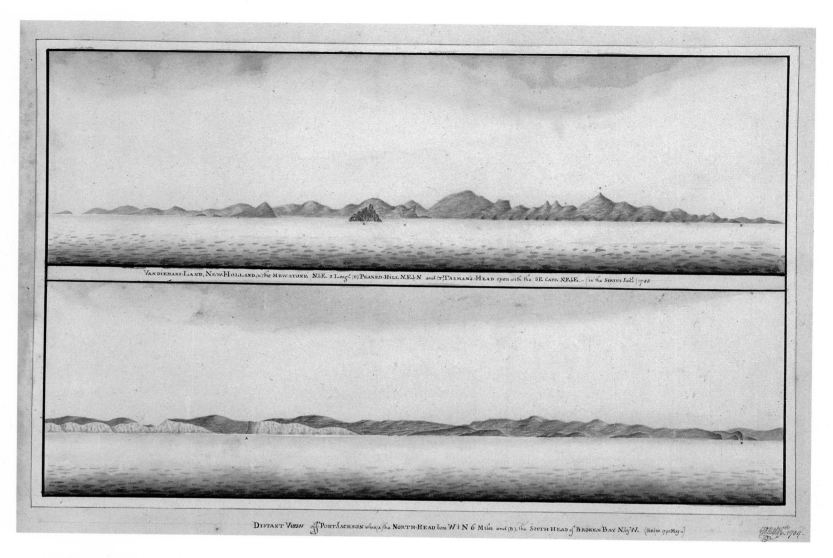

VANDIEMANS-LAND, NEW-HOLLAND, (A) the MEW-STONE N.b.E. 2 Leag.ˢ (F) PEAKED-HILL N.E.b.N and (T) TASMAN'S-HEAD open with the S.E. Cape N.E.½E. ~ (in the SIRIUS Jan.ʸ 1788

DISTANT VIEW off PORT JACKSON when (A) the NORTH-HEAD bore W.½N. 6 Miles and (B), the SOUTH HEAD of BROKEN BAY N.b.W. (SIRIUS 1790 May ~)

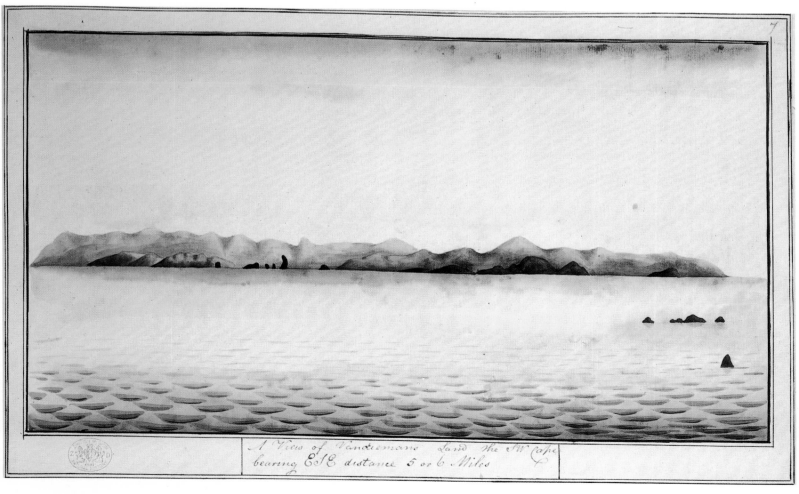

A View of Vandiemans Land the S.W. Cape bearing E.S.E distance 5 or 6 Miles

than the result of a careful survey, but it is an improvement on the chart in *The Voyage of Governor Phillip*. It seems unlikely that the chart in *The Voyage* is by King. He does not mention enclosing a chart in his letters to Governor Phillip describing Norfolk Island, and Phillip makes no mention of one when transmitting King's comments to England; King would not have needed Bradley to make a fair copy of a chart – he was quite capable, given time, of doing that himself.

5 / The Officers of the Transports

Five of the six transports that carried convicts to New South Wales made discoveries in the western Pacific after leaving New South Wales. The sixth, *Prince of Wales*, went home round Cape Horn. Three transports were under charter to the East India Company and sailed from Sydney to China for cargoes of tea, then for England. All three sailed in early May 1788 and parted company off Lord Howe Island. *Charlotte* (Thomas Gilbert, Master) and *Scarborough* (John Marshall, Master) discovered Matthew Island in the southern New Hebrides, and some of the islands in the Gilbert and Marshall groups. Gilbert's account of their passage, *Voyage from New South Wales to Canton in the year 1788*, was published in London in 1789, with a title page vignette of Matthew's Rock and four plates of views. Marshall's account was published as chapter XXI of *The Voyage of Governor Phillip* with a chart of *Scarborough*'s track from Port Jackson to the Ladrone Islands with seventeen small views. Discrepancies between the two accounts, particularly in the names of islands in the Gilbert and Marshall groups cloud their achievement.[17]

Lady Penrhyn (William Crompton Sever, Master), the third of the ships chartered by the East India Company, went from Lord Howe Island to Tahiti, discovering Curtis and Macaulay Islands in the Kermadec Group on the way, and Penrhyn Island in the northern Cooks after leaving Tahiti. This voyage is described in chapter XX, and tables VII and VIII, in *The Voyage of Governor Phillip*, which also contains four views by Lieutenant Watts, two each of Curtis and Macaulay Islands.

The second group of transports left Sydney in mid-July 1788, accompanied by the *Borrowdale* storeship. *Prince of Wales* and *Borrowdale* parted company from *Alexander* and *Friendship* soon after sailing. *Alexander* was commanded by Lieutenant John

Plate 106 [Watling 9]
JOHN HUNTER (attributed)
The S.W. Cape bearing NNW½W about 3 Leagues (c. 1788)
Water-colour, 173 × 326
Inscribed with 'A.' before title as above.

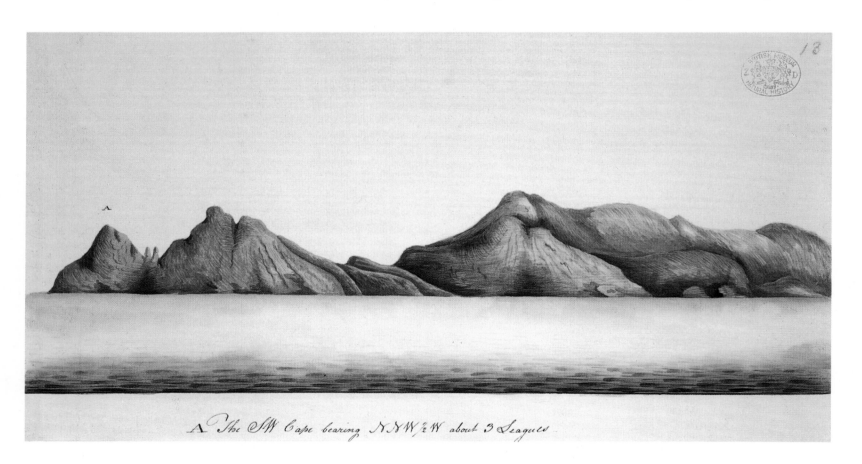

A The SW Cape bearing NNW½W about 3 Leagues

Shortland, Naval Agent to the First Fleet, who carried the first despatches from the settlement, and *Friendship*, by Francis Walton. They took 'the northern route' to Batavia, discovering Middleton Reef to the north of Lord Howe Island and the south-west coast of New Georgia. Shortland's account of the voyage was published, as chapters XVIII and XIX and table VI in *The Voyage of Governor Phillip*, with two charts by Thomas George Shortland, second mate of *Alexander* and her commander's son. The original of the chart showing the track from Port Jackson to Batavia is in the Hydrographic Department, Taunton (D999 Hg). *Alexander*'s route along the south-east coast of Borneo is shown on one of a set of charts showing tracks along the coast of Borneo, published by Alexander Dalrymple in 1795. The second chart in *The Voyage* by T. G. Shortland is a more detailed one of New Georgia.

T he southern part of Van Diemen's Land, discovered and named by Abel Tasman in 1642, visited by Captain Furneaux in *Adventure* in 1773 and by Captain Cook in 1777, became a first destination after Cape Town for ships sailing into the Pacific from the south-west. For English voyagers, Adventure Bay was a recognized source of wood and water: Captain William Bligh called there in both *Bounty* and *Providence*, having already been there in *Resolution* in 1777 when he made the 'Plan of Adventure Bay' published in Cook's *Voyage to the Pacific Ocean* (London, 1784). Ships sailing eastward made their landfall at South West Cape or South Cape and the coast between the two with its offshore islands, the Maatsuyker Group and the Mewstone which rises abruptly to almost 300 metres, were frequently depicted in views. Plates 104–107 show this part of the coast.

Strong seas prevented John Henry Cox in the brig, *Mercury*, remaining in what is now Cox's Bight to the east of South West Cape in July 1789. The cable was cut and Cox tried to get into Adventure Bay, but he was carried too far north and finally came to anchor in Oyster Bay on the west side of Maria's Island where he was able to obtain the wood and water he sought.[18] Cox made a 'Plan of Oyster Bay and Part of Maria's Islands . . .' that was published by Alexander Dalrymple in 1791 with two views: *View of Cape Pillar on the Largest of Maria's Islands . . .* and *View of the South Entrance*

Some Successors of the First Fleet

1 / In Van Diemen's Land

Plate 107 [Watling 10]
JOHN HUNTER (attributed)
A View of the Islands that lay between the S.W. Cape and the Mew Stone (c. 1788)
Water-colour, 172 × 320

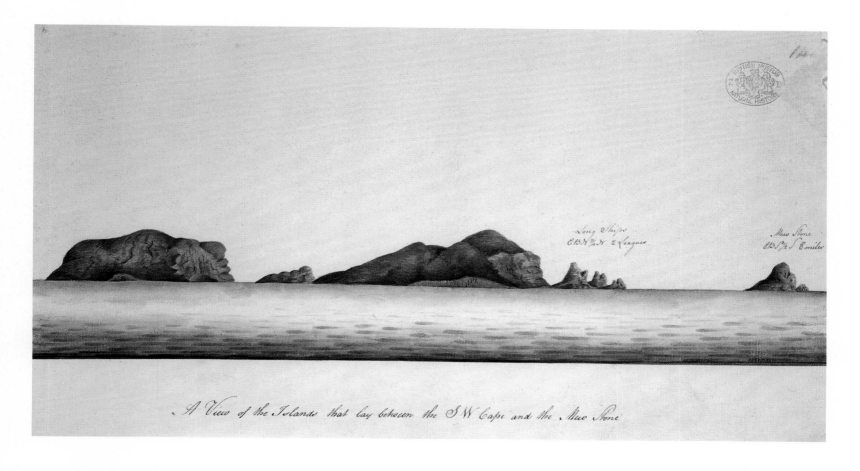

A View of the Islands that lay between the SW Cape and the Mew Stone

Plate 108 *right*
JOHN HENRY COX
View of Cape Pillar on the Largest of the Maria's Islands . . . and *View of the South Entrance into Oyster-Bay*
Detail from *Plan of Oyster Bay and Part of Maria's Islands by Capt. J. H. Cox 1789*
Engraving by W. Harrison and J. Walker, 285 × 214 (the two views 76 × 115), published by A. Dalrymple 27 February 1791. Besides being issued as a single-sheet chart by Dalrymple, Cox's 'Plan of Oyster Bay . . .' with Dalrymple's imprint was included as one of the plates in George Mortimer, *Observations and Remarks made during a Voyage . . . in the Brig Mercury, commanded by John Henry Cox Esq.* (London and Dublin, 1791). In August 1791 Dalrymple issued a 'Sketch of Oyster Bay . . .' by Cox with a view of the Bay (NLA Ra 42, No. 504). The strait between Maria's Island and Tasmania is named Mercury Passage after Cox's ship.
National Library of Australia, Canberra, *East India Pilot*, II (Ra 42, No. 505).

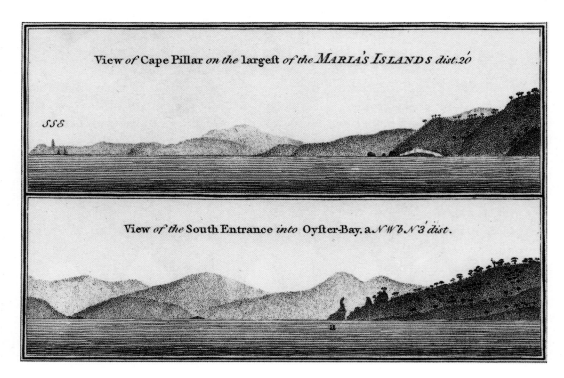

Plate 109 [Watling 12] *below*
ANONYMOUS
View of [Cape Pillar on] the largest of Maria's Islands
Water-colour, 190 × 310
This view is taken from Mercury Passage looking southward along the coast of the Forestier and Tasman Peninsulas to Cape Pillar, the extreme south-east point of the Tasman Peninsula. It is the same view as the upper one on plate 108, but missing three words of its title.

Plate 110 [Watling 11] *right*
ANONYMOUS
View of the South Entrance into Oyster Bay
Water-colour, 183 × 310
This view of Mercury Passage shows Cape Peron (a), the southern point of Maria's Island, and is the lower of the two views engraved on Cox's 'Plan of Oyster Bay . . .' (plate 108).

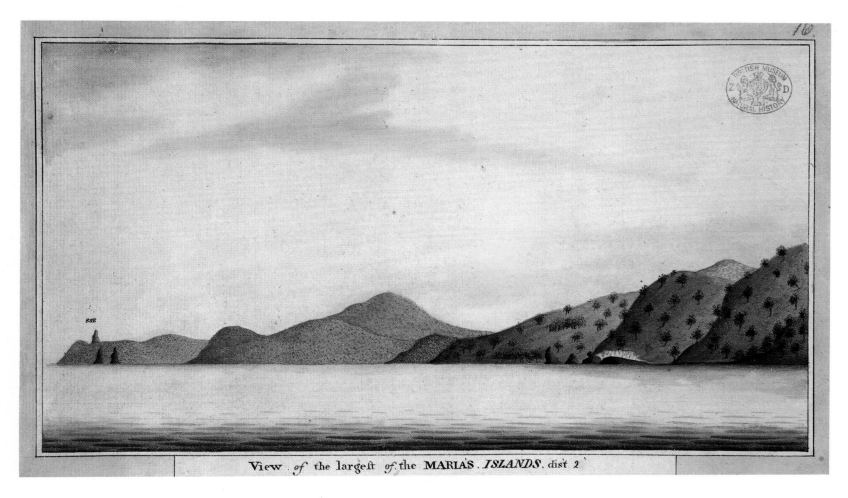

into Oyster Bay . . . [plate 108]. These are the views on plates 109 and 110. At that time, what are now the Tasman and Forestier Peninsulas were thought to be one of Maria's Islands, named by Tasman: that it was not became clear from the examination of Frederick Henry Bay by George Bass and Matthew Flinders in the *Norfolk* sloop in January 1799. Flinders used Cox's plan of Oyster Bay in compiling his chart of Van Diemen's Land.

2 / In Port Stephens

As Captain Cook passed northward along the New South Wales coast in 1770, Port Stephens, which he named after Philip Stephens, Secretary to the Admiralty, was the next obvious opening in the coast beyond Broken Bay. After leaving Port Jackson in 1788 Lieutenant John Shortland, in the transport *Alexander*, experienced difficulty keeping off shore with a strong south-easterly wind pushing him towards rocks near the entrance to Port Stephens. In the account of *Alexander*'s voyage, published in *The Voyage of Governor Phillip*, he is reported as regretting that Port Stephens had not been examined for it might have offered a haven to ships in his predicament. Late in 1791 the convict transport, *Salamander*, one of the ships in the Third Fleet, put into Port Stephens and an eye-sketch was made of it. Plate 111 is probably a copy of this sketch. A more thorough examination was made by Charles Grimes, Deputy Surveyor, in the *Francis* in February 1795.[19]

The Achievement

The people who disembarked from the First Fleet and remained in New South Wales have been dubbed 'The Founders of the Nation', even though most of them had, as their song put it, left their country for their country's good. Their trials and subsequent achievements are chronicled in the histories of Australia, but these histories say little of the work of the naval officers that brought the fleet safely into Port Jackson, or the work they did on the way home.

When the First Fleet reached New South Wales little was known of the south-west Pacific. The Spaniards had established a diagonal route across the Pacific from Cape

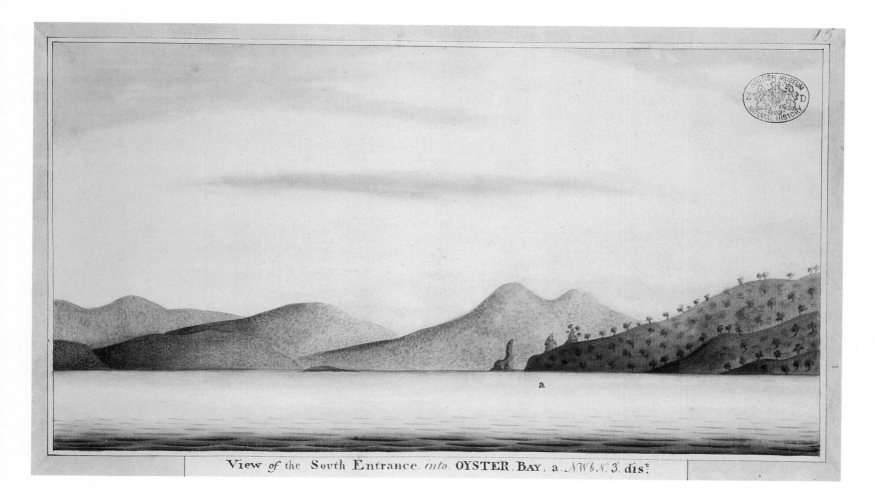

View of the South Entrance *into* OYSTER BAY. a NW b N 3. dis.ᵗ

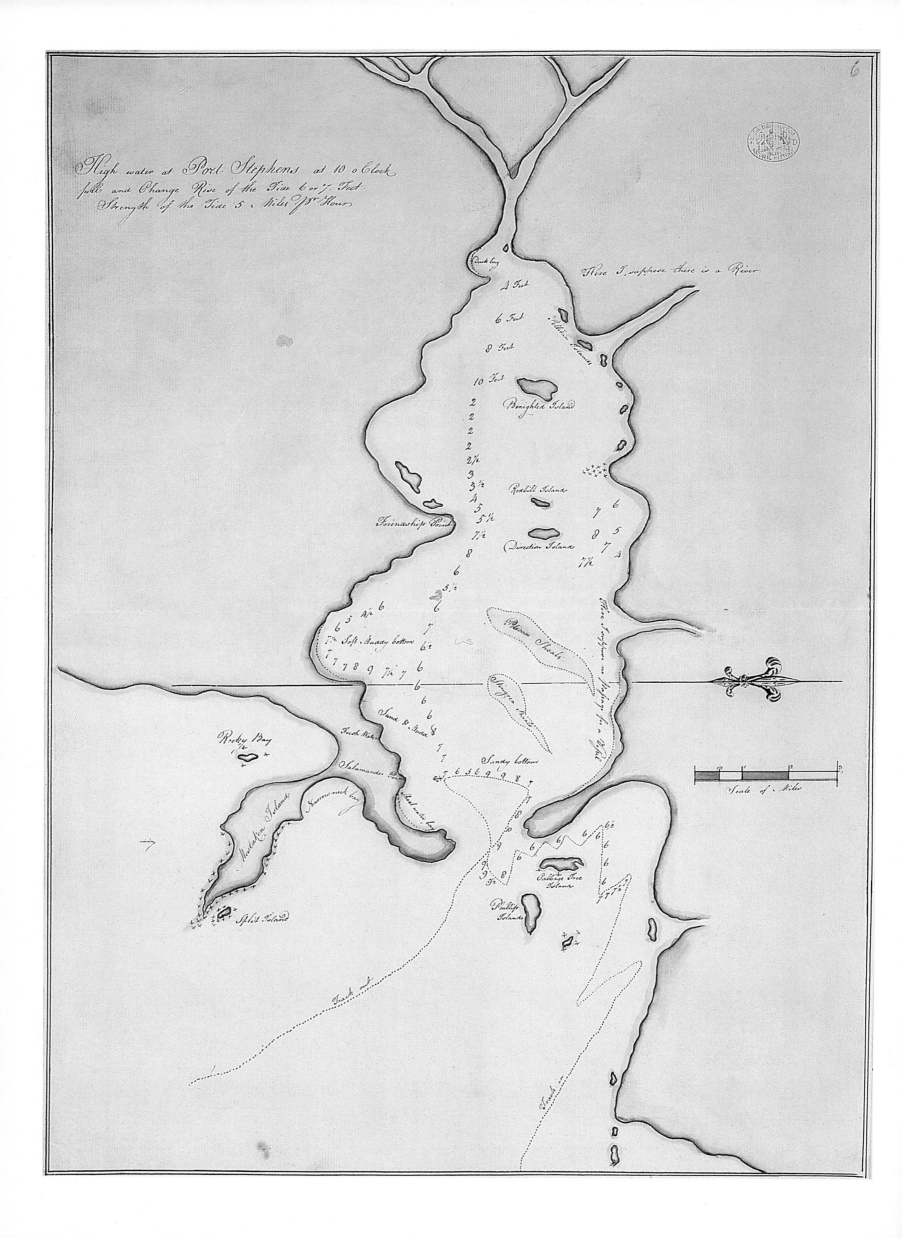

High water at Port Stephens at 10 oClock
full and Change Rise of the Tide 6 or 7 Feet.
Strength of the Tide 5 Miles $\frac{1}{8}$ the Hour

Here I suppose there is a River

Duck bay

4 Feet
6 Feet
8 Feet
10 Feet
2
2
2
2
2½
3½
4
5 5½ 7 6
7½ 8 5
8 7 3
6 7½
5½
5 2½ 6
7½ Soft Muddy bottom 6½
7 7 7 8 9 7½ 7 6
6
6
Sand & Mud 8
7
Sandy bottom
7 6 5 6 9 9 8 7
8

Benighted Island
Redbill Island
Direction Island

Pelican Shoals

Fresh Water
Salamander Point
Rocky Bay

Middleton Island

Narrow neck bay

Split Island

Cabbage Tree Island

Phillip Island

6½
6 6
6 6
6 6
9 6
9½ 8
9½

Scale of Miles

Horn to the Philippines and in the East Indies, connected with the Portuguese and Dutch routes from the Cape of Good Hope. The Dutch had discovered most of the north, west, and south coasts of New Holland and Cook's New South Wales was often described as the east coast of New Holland. Some of the islands to the east and south-east of New Guinea were known but the Coral Sea and the waters around New Guinea had been traversed by few ships. For the commanders of the First Fleet's ships the way home was less obvious, and likely to be more hazardous, than the way to Botany Bay.

Governor Phillip advised those transports going directly home against a passage by Cape Horn, as much, perhaps, because of the want of places where fresh food could be obtained as for the dangers of rounding the Horn. One ship, the *Prince of Wales*, disregarded his advice, and reached Rio de Janeiro with so many of her crew disabled by scurvy that men had to be put aboard to bring her safely into port. Later in 1788, when the settlement's stores needed replenishing, Phillip, while preferring that *Sirius* should go to the Cape of Good Hope round Van Diemen's Land and westward, allowed Hunter discretion to choose his own route. Hunter opted for the easterly passage and made a very fast voyage via Cape Horn, 'compleating the circle', as the charts put it, when he reached Cape Town (having had two Christmas Days when crossing the Meridian of Greenwich in the South Atlantic).

For the ships sailing directly home, and for those going first to China, 'the northern route' had to be taken. Cook's experiences in the Barrier Reef led them all to choose a track to the east and north of New Guinea. Their discoveries have been outlined in this essay and were recorded first in *The Voyage of Governor Phillip*. It aroused a great deal of interest, partly because of the story it told of the establishment of Britain's newest colony, and partly because of the charts it contained of New South Wales itself, and of the waters that had to be navigated by ships that might, if mercantilist hopes were to be achieved, bring ships' timber from Norfolk Island, open up trade with China, and establish whaling in the south-west Pacific. Hence, the first edition of 1789 was issued in a German edition in the same year; a second and third English edition were published in London in 1790 (the third edition in two printings) and a Dublin edition was also issued in 1790; 1791 saw editions printed in Paris, Hamburg and Nurnburg; and in 1792 there was a Vienna edition.

The charts in *The Voyage* were subject to private copyright and so could only be obtained by buying the book. Information from them was slowly incorporated into Pacific Ocean maps in the various *Pilots*. Some of the other charts, most importantly some of those produced by Hunter (but not the plan of Port Jackson) and Bradley, became available through publication by Alexander Dalrymple.

Some of the discoveries of the returning First Fleet cannot be positively identified (mostly because of errors in determining their positions), some have acquired other names, but many have survived on the modern charts: Marshall and Gilbert gave each other's names to large groups of islands, Hunter and Bradley still have their names on reefs. A chart of the south-west Pacific is in part an unrecognized memorial to the First Fleet.

Plate 111 [Watling LS4]
ANONYMOUS
Untitled sketch of Port Stephens, NSW (*c*. 1791–2)
Ink and water-colour, 524 × 375; original scale: 0.85 in. = 1 mile (*c*. 1:74,500)
This eye-sketch is probably a copy of the one made in the convict transport *Salamander* when she put into Port Stephens, to the north of Broken Bay, late in 1791.

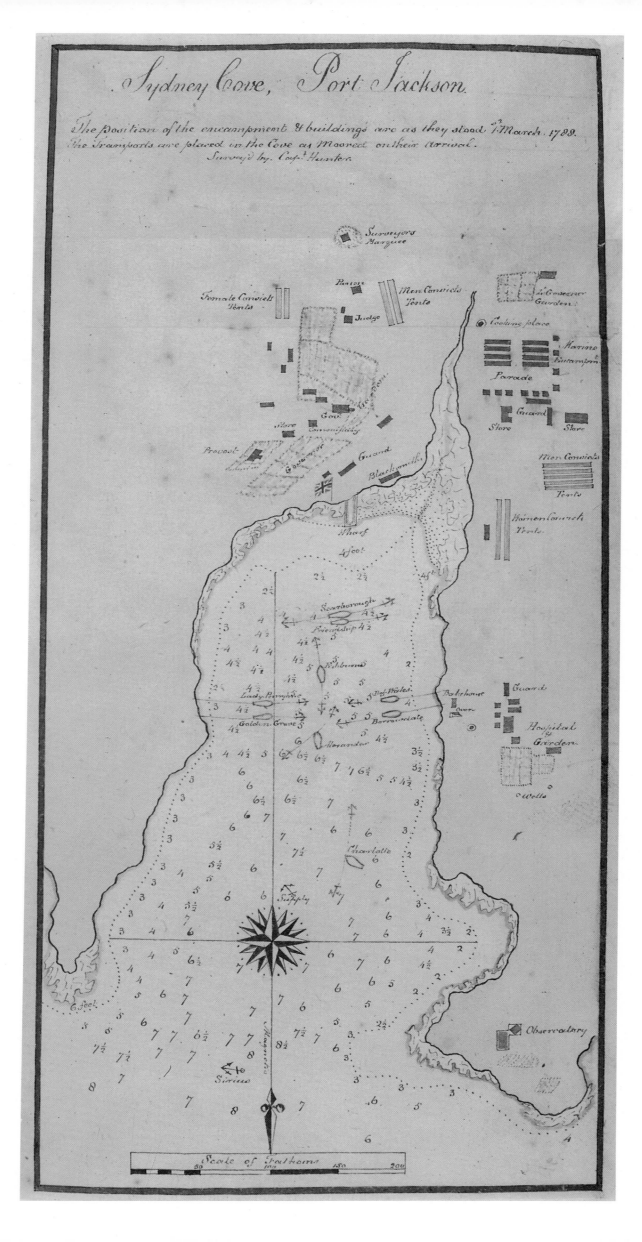

ALAN FROST

3 / The Growth of Settlement

Though the Aborigines had shaped the Botany Bay/Port Jackson environment by 'fire-stick farming' to some extent, the first European visitors saw nothing of this shaping. To Captain Cook, New South Wales in general and the Botany Bay area in particular was a 'Country in a pure state of Nature, the Industry of Man has had nothing to do with any part of it'.[1] It was a consequence of such descriptions (by Joseph Banks and James Matra also) that the British officials who decided on colonization and those whom they sent to effect it saw the region as a 'Virgin Mould, undisturbed since the Creation'.[2]

The First Fleet colonists who landed at Sydney Cove as January turned to February in 1788 were, as first colonists, with 'the World . . . all before them'. Before they might properly enter on the details of their business though, they had to delineate their space. This Governor Arthur Phillip did progressively through the first five months: at the ceremony of 7 February when his governorship was activated;[3] when, one week later, he sent a small party to occupy Norfolk Island;[4] and in June, when he declared the County of Cumberland, fixing its limits as 'to the northward . . . the northernmost point of Broken Bay, to the southward . . . the southernmost point of Botany Bay, and to the westward . . . [the] Lansdown and Carmarthen Hills'.[5]

Phillip began landing people and stores immediately he decided on Sydney Cove as the site for the settlement, and this business proceeded through the next weeks. Inevitably, it was rather chaotic at first, with the civil officers, the marine guard, the men and women convicts, stores, and animals scattered in confusion over the surrounds of the cove. But, as one who saw it observed, this confusion should not

be wondered at, when it is considered that every man stepped from the boat literally into a wood. Parties of people were every where heard and seen variously employed; some in clearing ground for the different encampments; others in pitching tents, or bringing up such stores as were more immediately wanted; and the spot which had so lately been the abode of silence and tranquillity was now changed to that of noise, clamour, and confusion.[6]

Still, 'after a time order gradually prevailed every where [as] the woods were opened and the ground cleared'.[7] Taking advantage of the site's features, Phillip designated

Plate 112
WILLIAM BRADLEY
Sydney Cove, Port Jackson
Ink and water-colour, 270 × 130
Inscribed 'The position of the encampment & buildings are as they stood 1.st March 1788. The Transports are placed in the Cove as Moored on their arrival. Survey'd by Cap.t Hunter.'
From Bradley's manuscript
'A Voyage to New South Wales',
Mitchell Library, State Library of New South Wales, Sydney, fp. 77.

an area on the western side of the cove as the site of the hospital, to the south of which he placed some of the men and women convicts and the marines. On the east side of the cove, he located the other convicts and himself and his assistants [plates 112, 113]. The most pressing work was to erect shelters for the people, storehouses, yards for the stock, and to plant vegetables and crops. Immediately, Phillip put up tents for the people, his prefabricated house of timber and canvas, and storehouses of timber; but as he and the civil and military officers desired more permanent and comfortable accommodation, and as it became clear that the timber buildings could not adequately protect the stores, the colonists began to raise more substantial structures as soon as they had a supply of bricks from James Bloodworth and his convict gang. In May Phillip laid the foundation of the first substantial European building in Australia. Who the designer of Government House was is uncertain – most likely it was Bloodworth, but it might have been Phillip's clerk Henry Brewer, or even Phillip himself.

As the buildings became more substantial, Phillip had to arrange them so as to shape the general lines of the future township. By July, he had sketched a plan that, with its provision for and placement of public buildings (including a grander Government House), its 200-foot-wide avenue, its open space at the head of the cove and its vista to the harbour heads, would offer an imperial aspect [plate 114].[8] By this time, it was possible to say that 'the Town now begins to cut a figure'.[9] In July 1788,

Plate 113
Sketch & Description of the Settlement at Sydney Cove Port Jackson in the County of Cumberland taken by a transported Convict on the 16th of April, 1788 which was not quite 3 Months after Commodore Phillips's Landing there Beneath the title above 'Sydney Cove lies 3 Leagues to the Northwards of Botany Bay which is situated in Lat. 34S: Long. 151'E'.
Engraved by Neele after 'F.F. delineavit' (Francis Fowkes?) and published on 24 July 1789 by R. Cribb, no. 288 High Holburn.

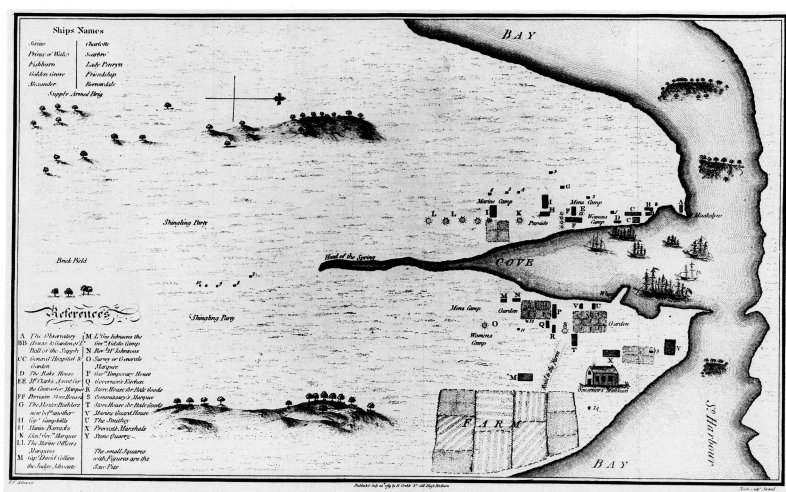

the camp took up 'exactly one acre eight perches'.[10] There were now rows of officers' huts and convict tents, brick storehouses to be roofed with she-oak shingles were rising, as was, on the slight slope on the eastern side of the cove, Phillip's brick house. In August 1788, John Hunter apparently drew the first known view of the new settlement, later engraved for his *Historical Journal* [plate 115] and copied by Bradley [plate 116].

As clearing and building had proceeded, so too had planting. Without indigenous antecedents, the finding of areas in which crops and vegetables might grow was very much a matter of trial and error. Phillip began substantial gardens about the hospital and his residence; he allotted two acres to each officer and he designated ground in common for the convicts, the marines, and the ships' crews. The European and tropical fruit trees which he put into the ground generally prospered. However, many of the first seeds planted in the autumn – by necessity, not by error – either failed to germinate, or withered soon after doing so. Simultaneously, it became clear that the soil skirting

Plate 114
Sketch of Sydney Cove, Port Jackson in the County of Cumberland. New South Wales. July 1788
Engraved by Thomas Medland after Dawes and Hunter; the coastline by Dawes, the soundings by Hunter. Published in *The Voyage of Governor Phillip to Botany Bay*, (1789) fp. 123.

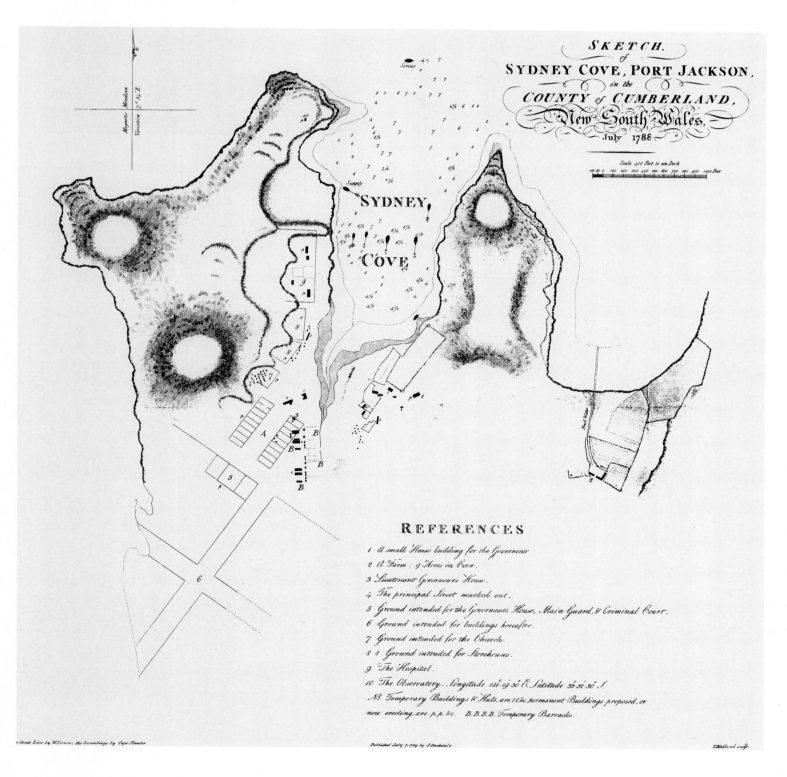

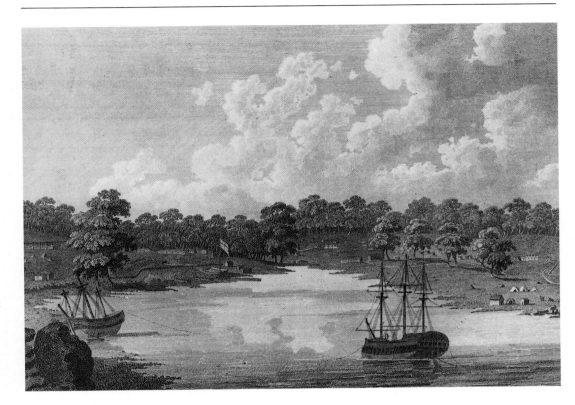

Plate 115
View of the Settlement on Sydney Cove. Port Jackson 20th August 1788
Engraved after a drawing by Edward Dayes taken from a sketch of John Hunter. Published 18 October 1792 by John Stockdale, Piccadilly and in Hunter's *Historical Journal* (1793), fp. 77.
The earliest engraved view of the settlement. Compare with plate 116.

the next cove to the east was somewhat better, so Phillip established a government farm there ('Farm Cove') under the superintendence of his old servant Henry Dodd, 'For the cultivation of seed & Cattle for the Public'.[11]

By the first spring the colony had made some distinct progress. In September, Phillip reported home that 'those who have gardens have Vegitables in plenty & exceeding good in kind', that the 'oranges, Figs, Vines, Pomore Roses Apples, pears, Sugar cane & Straw berry' he had brought from Rio de Janeiro and the Cape of Good Hope were in 'fine order'; and that they had 'near twenty Acres in Tillage & the Corn in particular places when the ground was well Clear'd is as fine as ever I saw'.[12] This 'corn' included about nine acres of wheat and barley at Farm Cove;[13] and while the promised harvests were not such as to make any significant contribution to the colony's food supplies, they would provide seed for the following year. These plantings were accompanied by some consolidation of the settlement. Phillip had had the convict men use some of the felled timber to raise picket fences, against which the women had piled the stones cleared from the enclosed areas. A timber bridge had been built over the Tank Stream at the head of the cove. There was now a permanent hospital 84 by 20 feet; Government House, now to be of two storeys, was rising steadily; some of the officers' huts were up; and on the ridge behind the cove to the west a 'small redoubt' was finished near the Observatory.[14]

These small but necessary gains had been slowly and laboriously won, for a number of circumstances had conspired to impede the colonists' progress. There was the hardness of the trees' timber, against which axes blunted and broke, and the very size of the fallen trees – it was 'hardly possible' to give 'a just idea' of the labour involved in clearing ground, the governor reported. And then, many of the convicts proved very reluctant labourers. Phillip estimated that in the first two weeks, for example, up to four hundred had skulked in the woods rather than worked.[15] Phillip was not helped

in his attempts to get his charges to work for the common good by the refusal of the marine officers to supervise them. In the face of this churlishness, he was forced to appoint overseers from amongst the convicts themselves, and these persons, led by the examples of Dodd and Bloodworth, did have some effect, but it was not a striking one, for many of the convicts only 'barely exert[ed] themselves beyond what was necessary to avoid immediate punishment for idleness'.[16] In their recalcitrance, many convicts also preferred to steal from the rations and gardens of others rather than to husband and create their own food supplies; and this problem was compounded by erring seamen and marines, some of whom stole from the Government Store itself. Also, it quickly appeared that amongst the party there was less agricultural knowledge than was required for success, a lack stemming partly from the disinclination of the botanist Francis Masson to join them at the Cape of Good Hope.

Yet, however significant in themselves, these problems were rather incidental to the major one of the comparative poverty of the soil about Sydney Cove. Geologically, the Cumberland Plain, that area of the colony's first domain, shows a preponderance of Triassic shales and sandstones, with some Tertiary pockets of sand, silt, clay and basalt, and some more recent deposits of alluvium, gravel, sand and clay.[17] The environs of Sydney Cove consisted predominantly of Hawkesbury sandstone, and the soil cover was frequently so thin as to leave the stone exposed. There were some small pockets of somewhat better soils, such as that about Farm Cove, but lacking in nutrients these could not be really productive without manuring – which the colonists could not do, for they had few animals.[18] It was hardly surprising then, that the returns from the

Plate 116
WILLIAM BRADLEY
Sydney Cove, Port Jackson 1788
Water-colour, 135 × 190, signed
'W: Bradley'
In Bradley's manuscript 'A Voyage to New South Wales' in the Mitchell Library, State Library of New South Wales, Sydney, fp. 84.
Probably copied by Bradley from Hunter's original sketch for plate 115 or from the engraving.

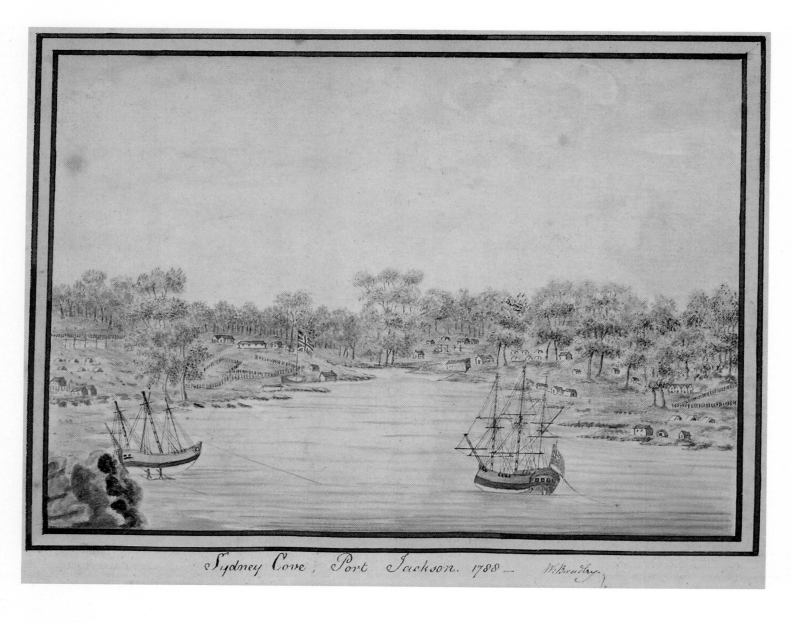

Sydney Cove, Port Jackson. 1788 — W. Bradley

Plate 117
WILLIAM BRADLEY
View of the Governor's house at Sydney in Port Jackson, New South Wales, January 1791
Pen and water-colour, 216 × 360
The title appears to be in Bradley's hand but has been overwritten later. This appears to be the original drawing from which Bradley made a copy for his manuscript 'A Voyage to New South Wales' in the Mitchell Library (fp. 225). But if so the date January 1791 must be incorrect because Bradley did not return from Norfolk Island until 26 February and left for England in the *Waaksamheyd* on 28 March 1791. It may be noted that Bradley inserted his 'Voyage' version of the drawing at p. 225 that refers to events of February 1791. The drawing was probably made from the *Sirius* at anchor in the Cove.
National Library of Australia, Canberra, R. 9867.

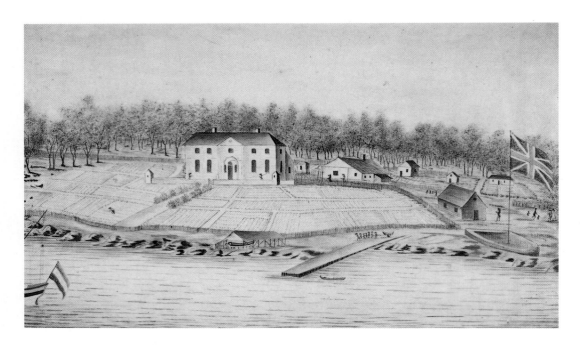

Plate 118 [Watling 19]
PORT JACKSON PAINTER
A View of Governor Philips House Sydney Cove Port Jackson taken from the NNW
Ink and water-colour, 223 × 307

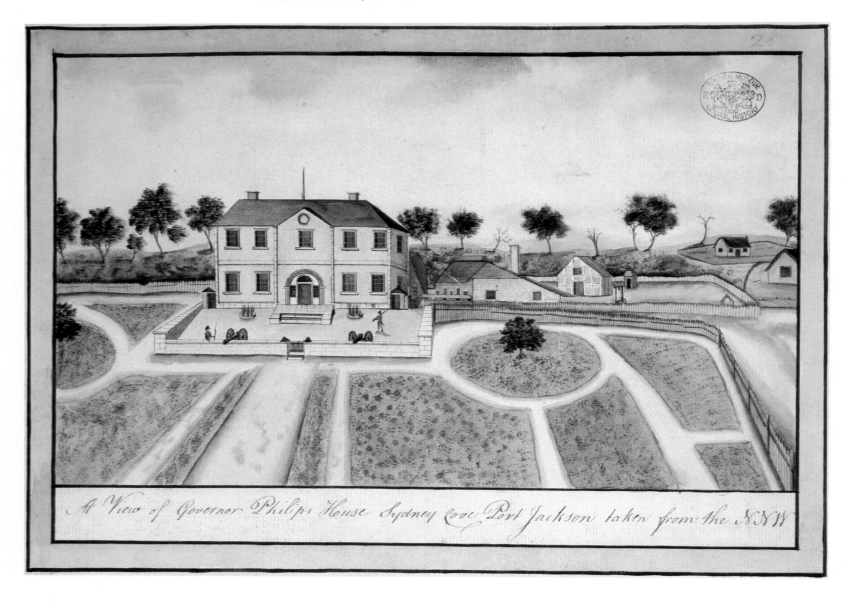

first year's plantings should have been meagre, as Watkin Tench recorded, 'experience proved to us, that the soil would produce neither [grain nor vegetables] without manure; and as this was not to be procured, our vigour soon slackened; and most of the farms . . . were successively abandoned'.[19]

Well before this first harvest though, it had become clear that to succeed at agriculture, and therefore to succeed with the venture, the colonists needed to work better soil. In March and April 1788 Phillip looked for it: northwards to Broken Bay, across the harbour to the north-west, and then directly west. It was this last probe, into the area now known as Parramatta, that brought results. The governor reported that his party had proceeded westward for three days, 'finding the country in general as fine as any I ever saw, the trees growing from twenty to forty feet from each other, and . . . no underwood'.[20] He was correct to think the area promising, for it consists mostly of deposits of clay, which also required manuring to produce abundantly, but which were nonetheless intrinsically more fertile than the Sydney sands; and about Prospect Hill there was an irregular vein of rich volcanic soil.

Seeing that it 'might be cultivated with ease', Phillip decided to settle the area the following spring, which he did when he sent a party of marines and convicts under Dodd to Parramatta at the beginning of November.[21] Through the next year Dodd, who seems to have had a commanding presence, worked the party to clear, plant, and build, and as the marines followed suit, a centre of production began to develop. By the beginning of 1791, there were 'a barn, granary, and other necessary buildings' at Parramatta, and 'seventy-seven acres in corn' which promised 'a good crop'.[22] The

Plate 119 [Raper 16]
GEORGE RAPER
View of the East Side of Sidney Cove, Port Jackson; from the Anchorage. The Governours House bearing S.b E. ½ E. & the Flag Staff S.E b E. ¼ E
Ink and water-colour, 317 × 474, unsigned
Drawn from the *Sirius* at anchor and probably completed before Raper left in the *Sirius* for Norfolk Island on 5 February 1790. Note that it does not depict the outbuildings on the right of Government House as shown in plates 117 and 118.

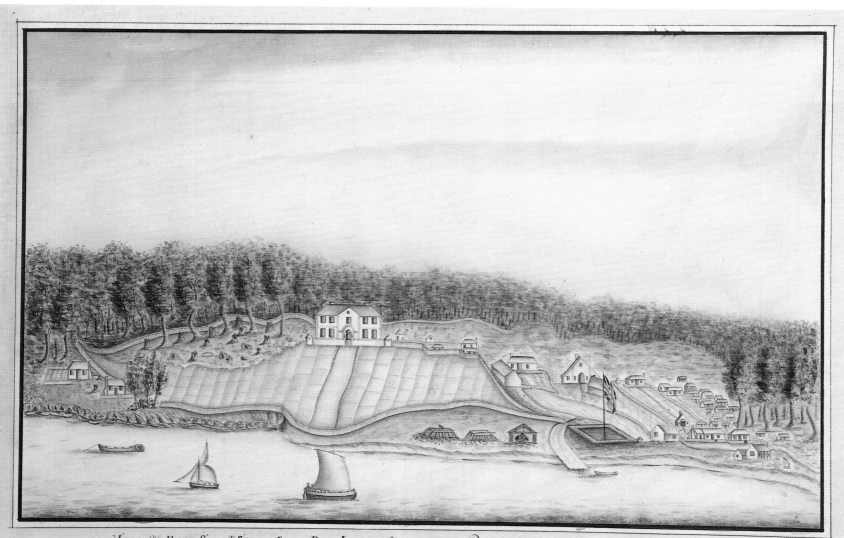

VIEW of the EAST SIDE of SIDNEY COVE, PORT JACKSON; from the ANCHORAGE the GOVERNOURS HOUSE bearing S.b E.½E. & the FLAG STAFF S.E.b.E.

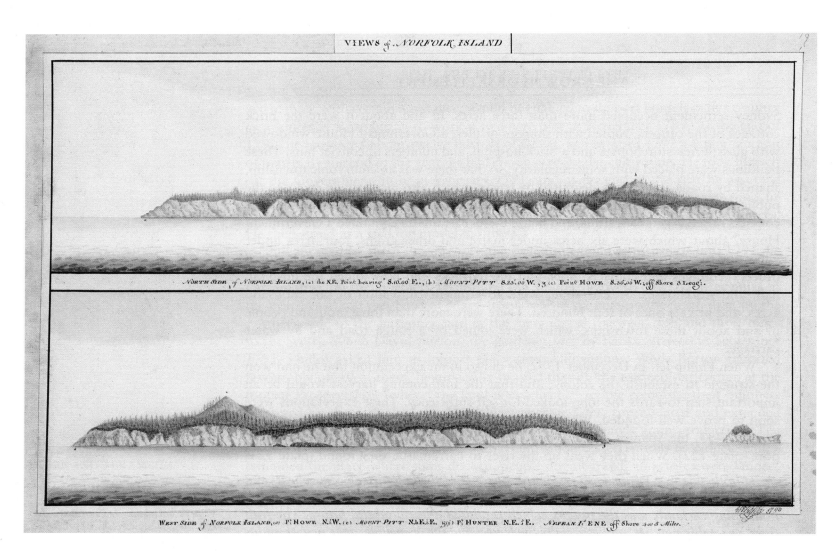

VIEWS of NORFOLK ISLAND

NORTH SIDE of NORFOLK ISLAND, (a) the N.E. Point bearing S.10°.00 E., (b) MOUNT PITT S.25°.00 W., (c) Point HOWE S.36°.00 W. off Shore 3 Leag.

WEST SIDE of NORFOLK ISLAND, (a) P.ᵗ HOWE N.½.W. (c) MOUNT PITT N.b.E.½.E. (f) P.ᵗ HUNTER N.E.½.E. NEPEAN I.ᵗ ENE off Shore 4 or 5 Miles.

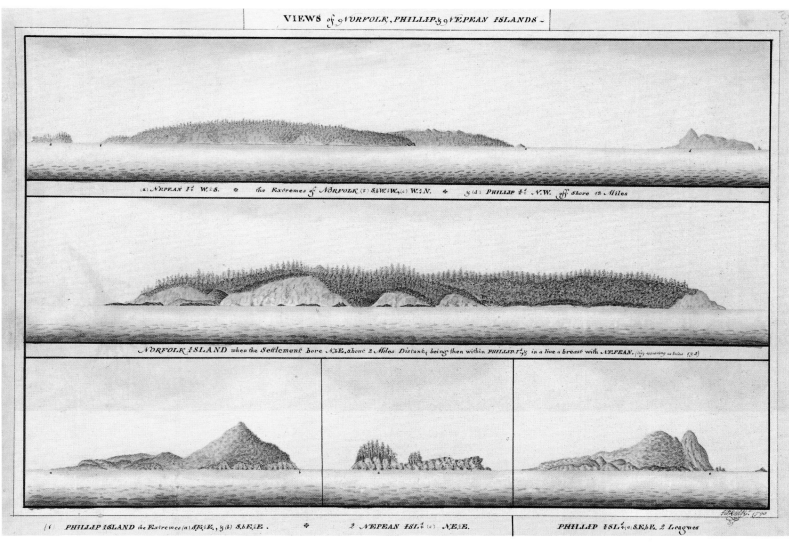

VIEWS of NORFOLK, PHILLIP, & NEPEAN ISLANDS

(a) NEPEAN I.ᵗ W.½.S. & the Extremes of NORFOLK (f) S.½.W.½.W., (c) W.½.N. & (d) PHILLIP I.½ N.W. off Shore 12 Miles

NORFOLK ISLAND when the Settlement bore N.bE. about 2 Miles Distant, being then within PHILLIP I.ᵗ & in a line a breast with NEPEAN. (they appearing as below (##)

(f) PHILLIP ISLAND the Extremes (a) S.E.½.E., & (b) S.b.E.½.E. — 2 NEPEAN ISL.ᵗ (c) N.E.½.E. PHILLIP ISL.ᵗ (c) S.E.b.E. 2 Leagues

120

few in number, of cattle, sheep, and horses, gave good hopes for combining, in this new centre of national wealth, English energy and policy with a climate and soil not unlike that of our own Andalucia.[30]

'It delights the spirit', these visitors concluded,

to see the happy change in conduct of some men who, if they had been enemies of society, were today useful to their country by their application to work and because of the constant efforts by which they transformed a rough and uncultivated country into a pleasant garden. It had been in existence for hardly five years and yet had the appearance of an old establishment.[31]

As the settlement on the mainland took root, so too did a smaller one on Norfolk Island, 1600 kilometres to the north-east. On the face of things, this was hardly a promising place for a colony. The remnant of a volcano, the island is tiny, being only 26 square kilometres in area, with two peaks of about 300 metres. Its coastline is abrupt and jagged, and shoals and reefs cluster in and about it, so that it offers no safe anchorage [plate 85]. After finding it impossible to land there in January 1788, Lapérouse described it as 'only a place fit for angels and eagles to reside in' [plates 124, 125][32]. Nonetheless, it then had two distinct attractions which made it an object of European attention: the *Phormium tenax* or 'New Zealand' flax, which so covered it as to be 'scarce possible to get through'; and the *Araucaria heterophylla* or Norfolk Island pine, which grew 'in vast abundance and to a vast size, from two to three feet diametre and upwards'.[33] Norfolk Island therefore offered the prospect of becoming a valuable source of the materials essential for the operation of European navies. The purposes of the small party under the command of Lieutenant Philip Gidley King which Phillip despatched there in February 1788 were, first, to obtain possession of the island, and second, to begin developing its resources.

Norfolk Island, 1788-92

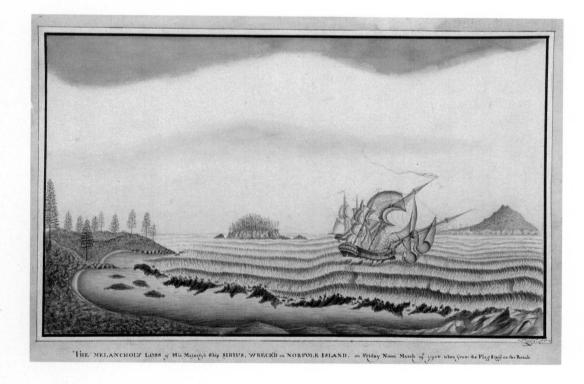

THE MELANCHOLY LOSS of His Majesty's Ship SIRIUS, WRECK'D on NORFOLK ISLAND, on Friday Noon March 19 1790 taken from the Flag Staff on the Beach

Plate 126 [Raper 22]
GEORGE RAPER
The Melancholy Loss of His Majesty's Ship Sirius Wreck'd on Norfolk Island on Friday Noon March 19th 1790 taken from the Flag Staff on the Beach
Water-colour, 475 × 317, signed 'Geo Raper 1790'
Another version of this drawing is in the Raper papers (AJCP, Reel M 1183). It includes the flagstaff at the right of the drawing.

facing page

Plate 124 [Raper 20]
GEORGE RAPER
Views of Norfolk Island
Ink and water-colour, 322 × 495, signed 'Geo Raper 1790'

Plate 125 [Raper 21]
GEORGE RAPER
Views of Norfolk, Phillip & Nepean Islands
Ink and water-colour, 321 × 470, signed 'Geo Raper 1790'
Raper's views of Norfolk and nearby islands show clearly their cliffy coasts and endangering reefs.

Like Lapérouse, King found landing very difficult 'on account of ye Surf & Rocks', but after several days of trial and error and exploration, he decided to establish his party about Sydney Bay [plate 86] on the south side, where there was a small passage through the reefs to a sandy beach, a 'very fine spring of fresh water', and a gentle hill of 'rich & deep' soil which seemed well-suited to gardening.[34] By mid-May, they had built a timber house for King and a storehouse, and had begun a house for the surgeon, and cleared and planted some ground.[35] These moves achieved the first purpose straight-forwardly, but the effecting of the second one proved increasingly elusive. The pine trees which promised so well were too often rotten in their cores, and the 'flax' was not amenable to European methods of treatment. In the first two years, King did attend diligently to the twin businesses of cutting masts and spars and manufacturing flax, but the results were disappointing.[36]

However, the settlement quickly developed another rationale, one deriving this time from the inherent fertility of the island's soil. The weathered basalt of the volcanic core, enriched by aeons of vegetative decomposition, constituted 'from the coast to the sum-mit of Mount Pitt . . . a continuation of the richest and deepest soil in the world, which varys from a rich black mould to a fat red earth', and was 'well supplied with many streams of very fine water'.[37] The first plantings promised well, and progressively King turned the energies of his little group to clearing and cultivation. When experience showed that the hillside was dangerously exposed to salt-laden south-west winds, he made the area he called Arthur's Vale (inland to the north-west) the centre of farming operations, in the expectation that it might produce 'an immense quantity of Grain'.[38]

Plate 127 [Raper 23]
GEORGE RAPER
View of the West Side of Sidney Bay Norfolk Island Shewing the Method by which the Crew & Provisions &cc &cc Were saved from the Wreck of Hs. Ms. Sp. Sirius; as also a Boat Landing. Taken from the West side of Turtle Bay
Water-colour, 344 × 488, signed 'Geo Raper 1790'

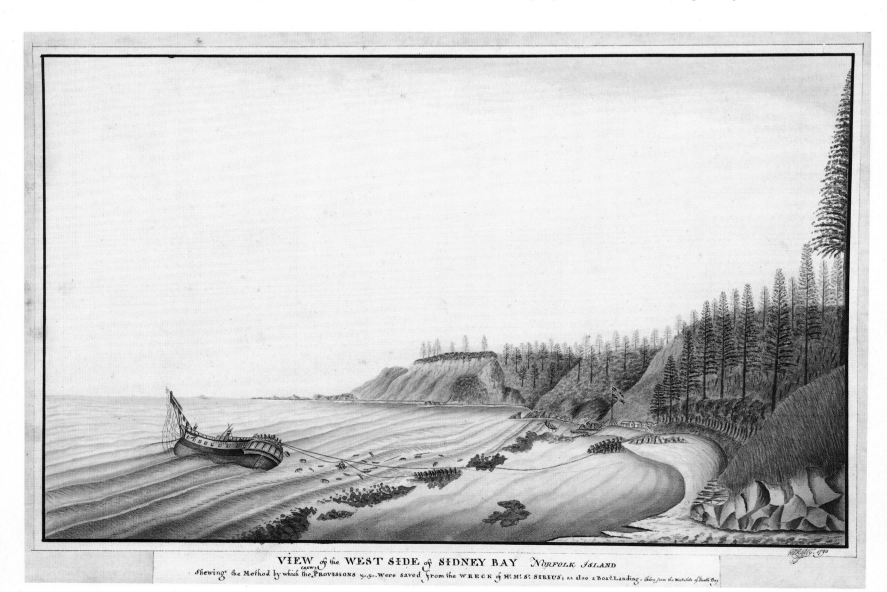

VIEW of the WEST SIDE of SIDNEY BAY *Norfolk Island*
Shewing the Method by which the CREW PROVISIONS &c. &c. were saved from the WRECK of H: M: S: SIRIUS; as also a Boat Landing. *Taken from the Westside of Turtle Bay*

There, they found plaintains growing spontaneously, which they transplanted to form the borders of the fields, to which they added sugar cane brought from Rio de Janeiro. As they cleared, they planted limes and other fruit trees and European vegetables and grains. By the first spring, they had 'vegetables in great abundance', and in expectation of a substantial harvest King erected a granary.[39]

Heartened by this progress, and painfully aware of how slowly things were going in Sydney, Phillip sent another forty convicts to Norfolk Island in October 1788. King was therefore able to expand his clearing and planting at Arthur's Vale ('the plantation'), and his building. So as to augment the little settlement's storage capacity he increased the size of his house at Sydney Bay, and erected more storehouses and huts for the marines and convicts; he put up a supervisor's hut and dwellings for the convicts at Arthur's Vale, to where he began cutting a road. He also established an outpost at Ball's Bay, on the east, and began making a road to there.[40] The Norfolk Island colonists encountered a number of difficulties. Rats, caterpillars and parroquets proved constant menaces, some recalcitrant convicts robbed the gardens and killed precious animals, and a cyclone devastated the island.[41] But by March 1789, they had seven acres under wheat at the 'plantation', and at the end of the year they harvested sufficient grain 'for six months' bread for everyone on the island'; and they had grown 'vast quantities' of vegetables. In March 1790, they had cleared and planted about fifty acres, they harvested twenty-four bushels of barley, maize promised well, vines and oranges were 'very thriving', potatoes were growing 'remarkably well, and yield[ing] a very great increase', the sugar cane was growing 'very well', and also the bananas.[42]

Plate 128 [Watling 22]
PORT JACKSON PAINTER
A View of the West side of Norfolk Island and the Manner in which the Crew and Provisions were saved out of His Maiesty's Ship the Sirius taken from the West Side of Turtle Bay after She was Wreck'd
Water-colour, 310 × 389
The lettering bears some similarity to Henry Brewer's lettering on his embellishment of the title of a copy of Hunter's map of Botany Bay (see plate 233).

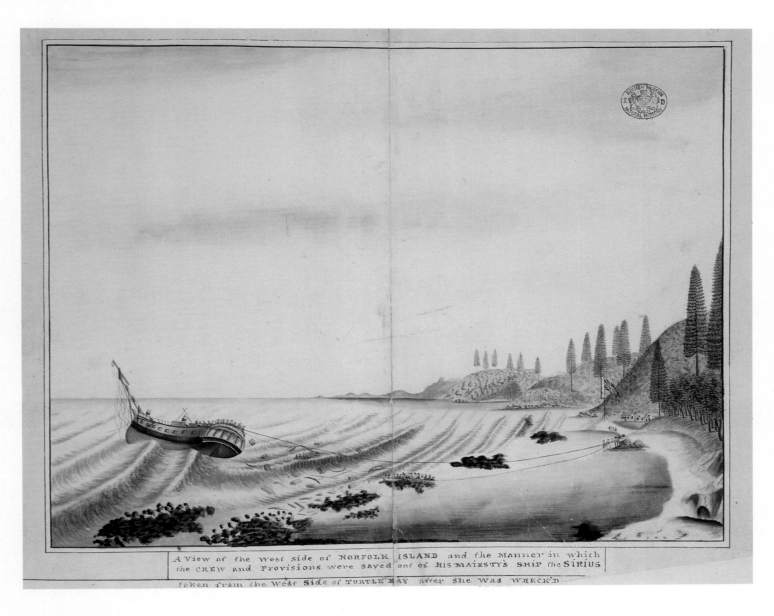

As he had wrought these gains, King had also attended to the problem of the lack of a safe landing place. He had parties broaden the narrow entrances through the reefs at Sydney Bay and Ball's Bay but close examination showed that the only place which offered any real prospect of improvement was Cascade Bay, on the island's northern side. Here, the beach was strewn dangerously with large rocks, but there was also deep water close inshore, which on fine days could be as still as a mill pond, and to which ran a shelf of solid rock where goods might be safely landed. King saw that the 'practicability of making a good landing place here is, running a pier out, which is a work that will demand a number of hands & some person conversant in an undertaking of that kind, Stones are ready & of an excellent kind, I should suppose forty Men might make a very lasting pier in six Months'.[43] As a preliminary, he began cutting a road to join the site with the south, and when his labour force was augmented by the October 1788 arrivals, he began shifting the loose boulders. By the middle of 1789, the road was finished and Cascade Bay became the preferred place for landing stores.

At the beginning of 1790, when the colony had still not been resupplied from England, Phillip decided to transfer a substantial part of the mainland population to Norfolk Island, in the expectation that they would be able to maintain themselves more

Plate 129 [Raper 24]
GEORGE RAPER
*Chief Settlement on Norfolk-Island
April 1790*
Water-colour, 326 × 485, signed
'Geo Raper 1790'

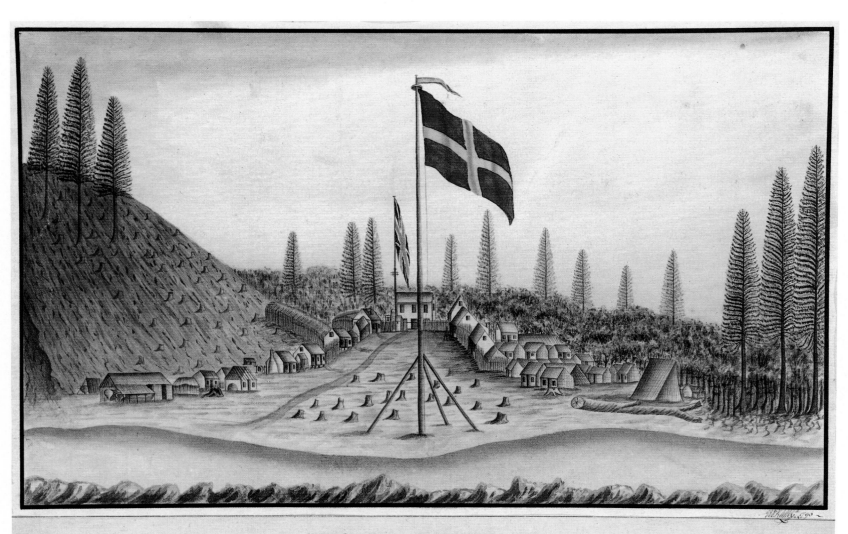

CHIEF SETTLEMENT on NORFOLK-ISLAND April 1790

easily there. Early in March, Major Ross sailed with two hundred and eighty men, women, and children in the *Sirius* and the *Supply*. The ships disembarked the people and unloaded some of the stores at Cascade Bay on 14 and 15 March, but when the *Sirius* attempted to land more stores directly at Sydney Bay on 19 March she was swept against the reef. With great difficulty, and heroic endeavour from one convict, most of the stores and some of the ship's equipment were saved, but she was wrecked [plates 126, 127, 128]. This meant that her crew was marooned on the island for the next eleven months, where the difficult Major Ross took charge while King went to England to report on Phillip's behalf on the colony's progress. Despite the dramatic increase in the claims on the settlement's flimsy resources, continued trouble with rats, birds, and insects, and the Major's impossible personality, the Norfolk Island colony continued to make progress. Ross reported at the end of 1790 that he had flour, corn, and potatoes for the next twelve months, and six hundred flourishing grape vines; and that 'the land . . . will, without the smallest hazard of loseing a seed season, produce two crops in the year'.[44] He also instituted a plan designed to bring a large proportion of the colonists to self-sufficiency by the autumn of 1792 [plates 129, 130, 131].[45]

With some exceptions, the crew of the *Sirius* left Norfolk Island in February 1791.

Plate 130
GEORGE RAPER
Principal Settlement on Norfolk Island
Pencil, pen and water-colour, 238 × 338
Formerly attributed to William Bradley. A somewhat less-finished version of plate 129.
National Library of Australia, Canberra, Petherick Collection.

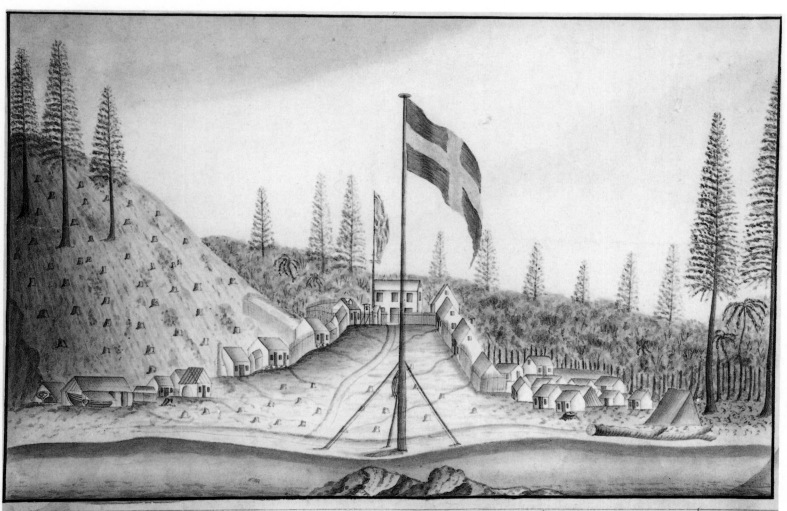

PRINCIPAL SETTLEMENT on NORFOLK ISLAND
NB The Blue Flag with a Yellow Cross is the Signal hoisted when the Landing is very good

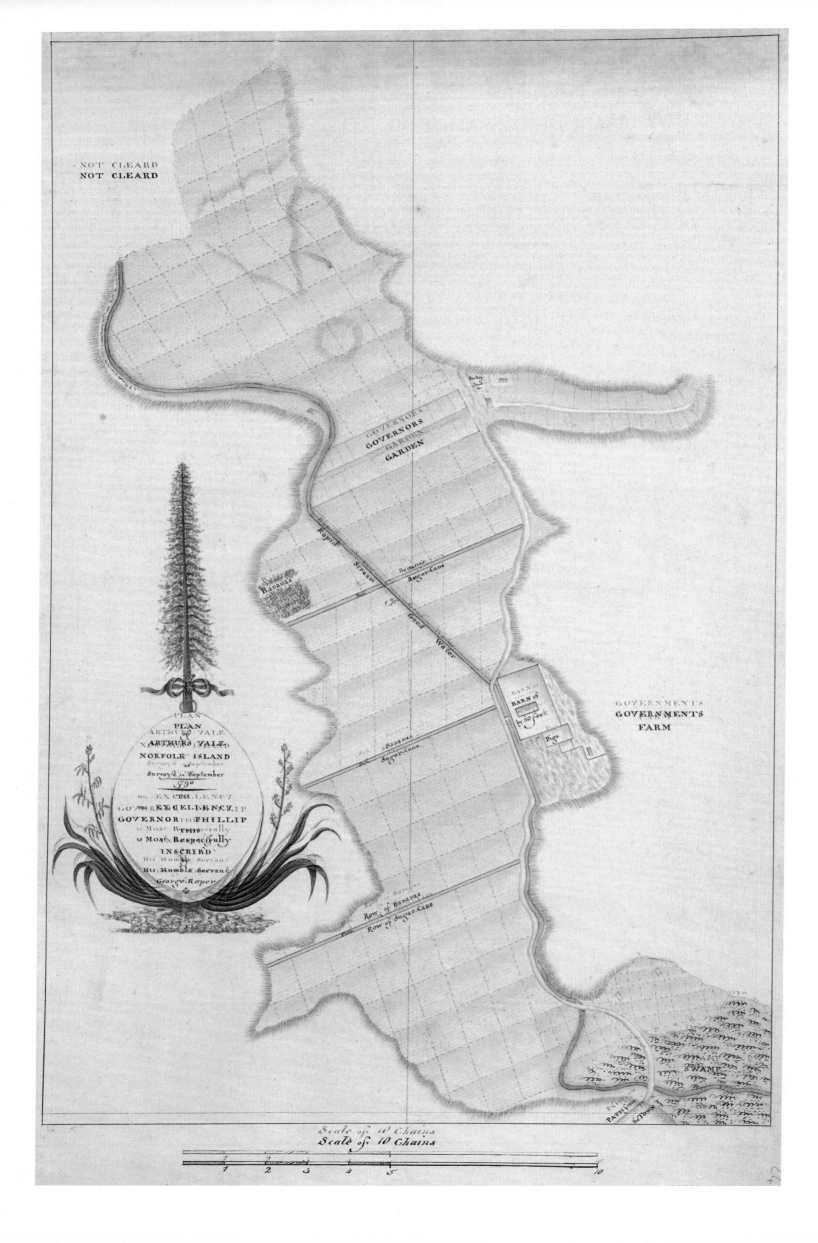

NOT CLEARD
NOT CLEARD

GOVERNORS
GOVERNORS GARDEN
GARDEN

Bananas

Rapid

Stream

Fall

Bananas Cane

Sugar-Cane

of

Good

Water

Bananas

Path

Sugar-Cane

BARN 10
BARN 10

by 30 feet

Pigs

GOVERNMENT'S
GOVERNMENTS
FARM

Row of Bananas
Row of Bananas

Path

Row of Sugar-Cane

PLAN
PLAN
of
ARTHUR'S VALE
ARTHUR'S VALE
NORFOLK ISLAND
NORFOLK ISLAND
Surveyd in September
Surveyd in September
1790
His EXCELLENCY
EXCELLENCY
GOVERNOR the PHILLIP
GOVERNOR the PHILLIP
is Most Respectfully
THIS is Most Respectfully
INSCRIBD
INSCRIBD
His Humble Servant
His Humble Servant
George Raper

SWAMP

Path from
the Town

Scale of 10 Chains
Scale of 10 Chains

1 2 3 4 5 10
1 2 3 4 5

Ross and the marines departed it at the beginning of December 1791 on the reappearance of Philip Gidley King, now appointed the settlement's Lieutenant-Governor. King found a population of about one thousand, including sixty-four settlers from among the sailors, marines and convicts whose sentences had expired. He found that the sailors and convict settlers were making good progress, but that the marines generally lacked the ability or interest to do so. There were 100 acres of government cultivation under wheat, which soon produced 1000 bushels, and 60 acres under maize, which also promised a good harvest, so King built a new granary. Other centres of settlement had emerged – Queensborough (Longridge) and Phillipsburgh (Cascade Bay) – and the road joining Phillipsburgh to the south was now much improved. All was not well on the island though, for King found much discontent at Ross's rule, and rebellious behaviour amongst the convicts.[46]

One of King's principal tasks, then, was to reduce the incidence of 'bushranging' and robberies, and raise community spirit. This he achieved by a judicious mixture of punishment and encouragement; at the same time, he consolidated settlement. He set a gang of eighteen convicts to making bricks, and another to burning coral for lime. The new buildings that these innovations permitted, including a large house for himself as Lieutenant-Governor, not only increased the European aspect of the island, but gave that aspect a solidity it had previously lacked. King also extended plantings. By the spring of 1792, there were 253 acres in government cultivation, 116 under wheat at Arthur's Vale and 17 under maize, and 14 under maize at Phillipsburgh.[47] And at last, too, King succeeded in making the landing at Cascade Bay safe in good weather. After storms and tides had undone his work of moving the boulders, he 'erected a crane on the landing-rock, at the east end of Cascade Bay, which is connected

Plate 131 [Raper 25]
GEORGE RAPER
Plan of Arthur's Vale Norfolk Island as survey'd in September 1790. To His Excellency Governor Phillip This is Most Respectfully Inscrib'd by His Humble Servant George Raper
Water-colour, 305 × 482
The enforced stay on Norfolk Island gave Raper the opportunity to record the settlement's progress to date. His drawing of the settlement at Sydney Bay in April 1790 shows a small but ordered centre, while this of Arthur's Vale in the following September gives splendid details of the plantation.

Plate 132
WILLIAM NEATE CHAPMAN
Cascade Bay, Norfolk Island
Ink and grey wash, 165 × 291
Mitchell Library, State Library of New South Wales, Sydney.

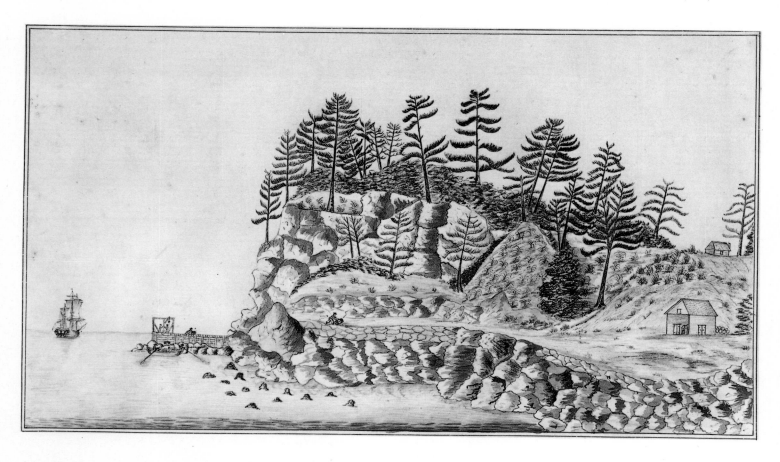

with the road by a strong and well-framed bridge, and some rocks that were under water, and have been blown to pieces, [which has] rendered the north side of the island very accessible' [plate 132].[48]

Expansion and Consolidation, 1793-98

The mainland colony prospered under the administrations of Major Francis Grose (December 1792–December 1794) and Captain William Paterson (December 1794–August 1795). It did so from a combination of circumstances. First, perceiving that the smallholders (mostly ex-convicts and marines) were rarely in a position to develop their plots effectively, and also wishing to favour their colleagues, these administrators made large grants of land to the officers of the New South Wales Corps and to some civil officials, allowing each the use of ten convicts victualled by the Government Store. As their increasingly lucrative trading activities gave these officers access to capital, they were well-placed to improve their grants. Grose reported in April 1794 that 2,962 acres had been cleared in the previous seventeen months, and that 'three large mills' were processing the autumn harvest; and he made the point that the 'promising appearance' of the colony was to be 'entirely attributed' to the 'great exertions' of the officers.[49] He exaggerated somewhat so as to justify actions that he knew the Home administration would frown on, but his general point seems to have been true. It is well-exemplified by John Macarthur's progress on his Parramatta farm. Macarthur wrote in August 1794:

The changes that we have undergone since the departure of Governor Phillip are so great and extraordinary that to recite them all might create some suspicion of their truth. From a state of desponding poverty and threatened famine that this settlement should be raised to its present aspect in so short a time is scarcely credible. As to myself,

Plate 133
THOMAS WATLING (?)
View of Sydney (c. 1795)
Watercolour, 395 × 600
Government House is shown here
with a verandah.
Mitchell Library, State Library of
New South Wales, Sydney

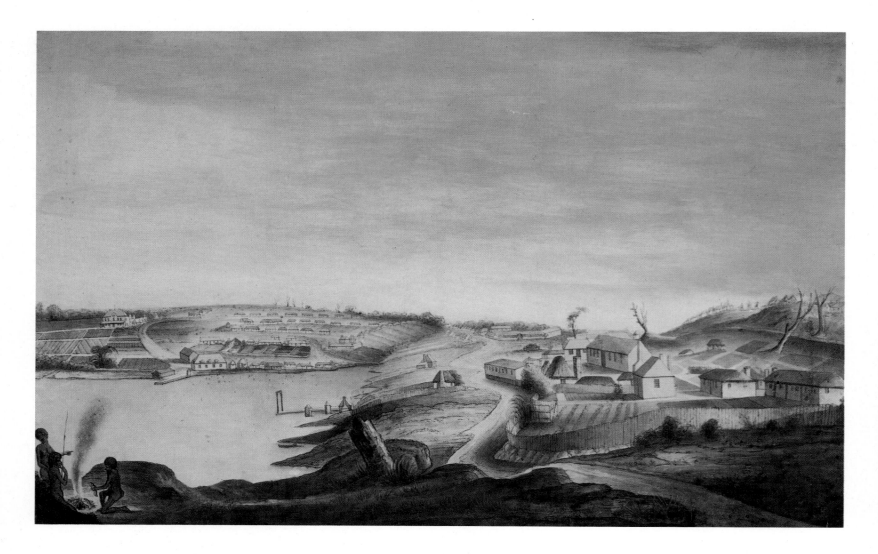

*I have a farm containing nearly 250 acres, of which upwards of 100 are under culti-
vation, and the greater part of the remainder is cleared of the timber which grows upon
it. Of this year's produce I have sold £400 worth, and I have now remaining in my
Granaries upwards of 1,800 bushels of corn. I have at this moment 20 acres of fine
wheat growing, and 80 acres prepared for Indian corn and potatoes, with which it will
be planted in less than a month.*

*My stock consists of a horse, 2 mares, 2 cows, 130 goats, upwards of 100 hogs.
Poultry of all kinds I have in the greatest abundance. I have received no stock from
Government, but one cow, the rest I have either purchased or bred. With the assistance
of one man and half a dozen greyhounds, which I keep, my table is constantly supplied
with wild ducks or kangaroos. Averaging one week with another these dogs do not kill
less than 300 lb. weight. In the centre of my farm I have built a most excellent brick
house, 68 feet in front and 18 feet in breadth. It has no upper story, but consists of four
rooms on the ground floor, a large hall, closets, cellar, etc.; adjoining is a kitchen, with
servants' apartments, and other necessary offices. The house is surrounded by a vine-
yard and garden of about 3 acres, the former full of vines and fruit trees, and the latter
abounding with most excellent vegetables.*[50]

Second, Grose granted land on the Hawkesbury floodplains. By August 1794 there
were seventy settlers there, who quickly found that the rich alluvial deposits nurtured
crops of the 'greatest luxuriance'.[51] Ten months later, the same region held almost 550
settlers, and a road linked it with Parramatta and Sydney. While severe flooding
periodically devastated their farms, these settlers did generally prosper, and their pro-
ductions soon swelled the colony's. In June 1795, for example, there was a total of
2721 acres under wheat in the mainland districts.[52] In this period, there was similar

Plate 134 [Watling 14]
THOMAS WATLING
*A partial view of Sydney Cove taken
from the Sea side before the Surgeon
Generals House*
Pencil, ink and wash, 320 × 451,
unsigned

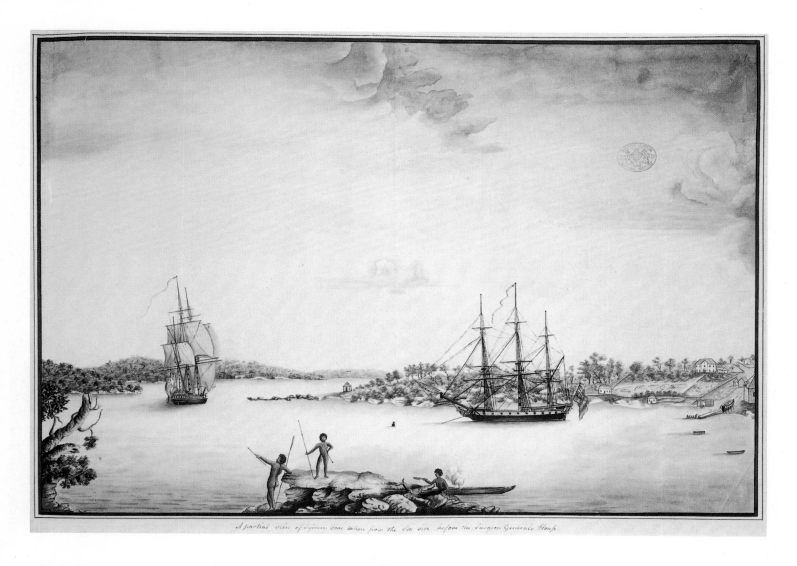

A partial view of Sydney Cove taken from the Sea side before the Surgeon Generals House

progress on Norfolk Island. King reported in July 1794 that 'the produce of this year very far exceeds any idea which could have been formed of it three months ago; and from the very abundant increase of the second crops, the settlers, &c., have been enabled to give the whole of their first crops into store (which amounts to 11,476 bushels), excepting about 4,000 bushels reserved for the use of their families and stock'.[53]

This general improvement in agriculture was aided by a steady if slow increase in the numbers of livestock in the colony. Phillip had reported insistently on the need for much greater numbers of animals, not only for the fresh meat they could provide but for their manure. With this need in view, and also so that provisions might be landed there more regularly, in September 1790 the Pitt Administration had decided that the colony should henceforth be supplied as much as possible from India. The first attempts to ship animals from the sub-continent were only partly successful, but by 1795 horses, cattle, and sheep were arriving in significantly greater numbers, and the colonists were caring for them better and beginning to breed them more carefully.[54] Paterson reported in March that 'stock of every kind' was thriving 'remarkably well' in the Hawkesbury region. At mid-year, there were 49 horses, 176 cattle, 832 sheep and 985 goats in the mainland colony.[55] Goats, poultry, and especially swine were also thriving on Norfolk Island and its outliers; by June 1795, for example, in excess of 3,500 pigs roamed the woods there together with hundreds of fowls and turkeys, and the colonists had consumed more than 250,000 lbs of pork in twenty-four months.[56]

There was more to the colony's growth in these years though, than expansion of

Plate 135 [Watling LS6]
THOMAS WATLING
Taken from the West side of Sydney Cove behind the Hospital
Pencil, ink and wash, 395 × 525, signed 'Thomas Watling del.'
The drawing appears to have been used as a preparatory study for the painting *A Direct North General View of Sydney Cove 1794* in the Dixson Gallery, State Library of New South Wales, Sydney (see plate 242).

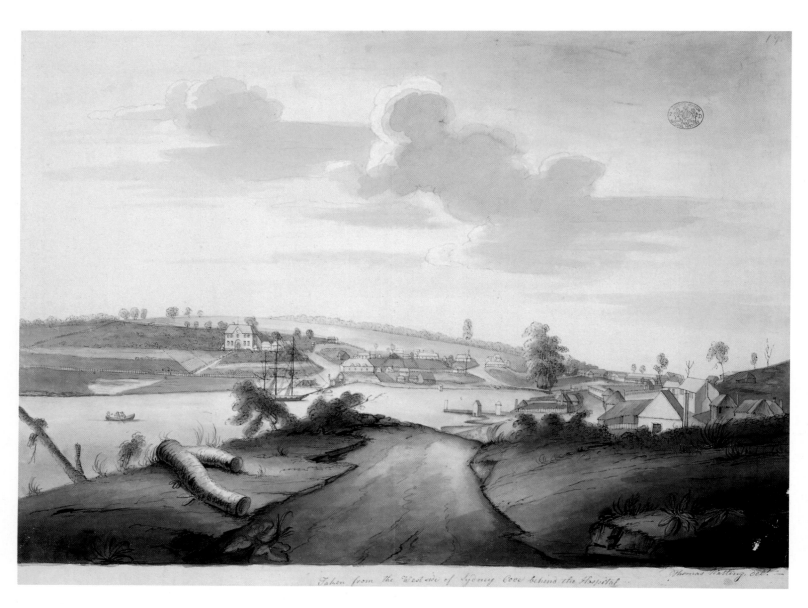

130

agriculture and raising of animals. The move to supply it from India had led merchants there to sense opportunity. They began to send down speculative cargoes, in which endeavour they were soon followed by others – by Captain Raven of the Third Fleet transport *Britannia*, for example, and by the owner of the American ship *Philadelphia* in 1792. With their appetites whetted, between the time of Phillip's departure and Hunter's arrival those in the colony with the means to trade did so increasingly. Having access to sterling bills, the officers of the New South Wales Corps dominated the infant commerce, but they were not the only colonists to benefit. Watermen, ex-convict and free, built small boats to facilitate the movement of goods between ship and shore, and also up the harbour to Parramatta and between Sydney and the Hawkesbury settlements via Broken Bay. Others, such as the resourceful Simeon Lord, emerged to fill the necessary roles of agents and middlemen. All these developments were underwritten by a steady increase in population,[57] and together they caused Sydney to develop as a port and as a town [plates 133–142].

The process of expansion and consolidation continued under Hunter (1795–1800) [plate 143]. He granted more land about the Hawkesbury River and in the Toongabbie area, and he 'widen'd and repair'd the public roads for the more easy and expeditious traveling between the different districts in the colony'.[58] Production increased again. After the 1796 autumn harvest, the new governor reported with satisfaction that 'the quantity of wheat, public and private, ... may amount to from 35,000 to 40,000 bushels, which will more than ensure us bread for twelve months to come, exclusive of maize, which we continue to issue as part of the weekly ration'.[59] With this increased

Plate 136 [Watling 16]
THOMAS WATLING
An East View of Port-Jackson, and Sydney-Cove, taken from behind the New Barracks
Pencil, ink and wash, 212 × 230, signed 'Thomas Watling del.'
The title in Watling's copperplate hand.

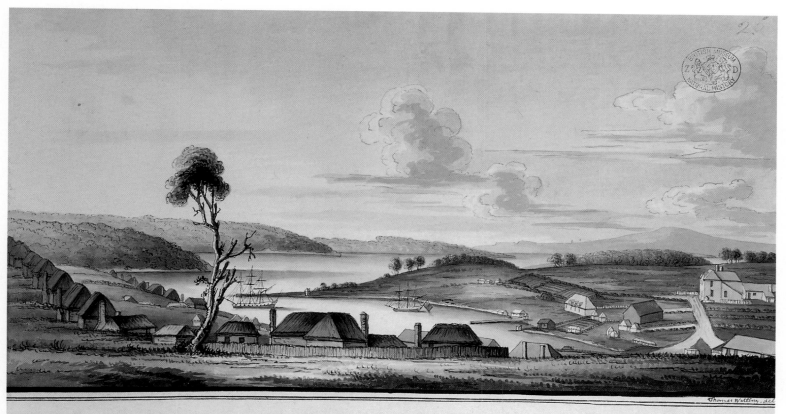

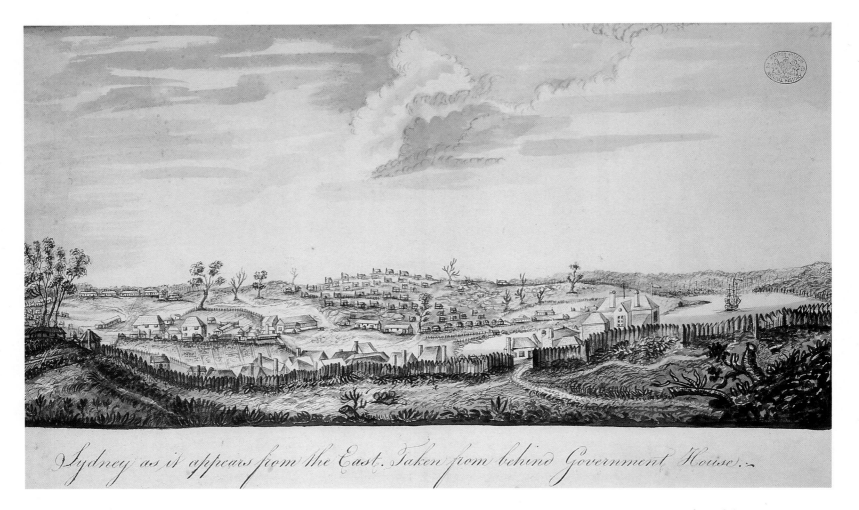

Sydney as it appears from the East. Taken from behind Government House.

Plate 137 [Watling 15]
THOMAS WATLING
Sydney as it appears from the East. Taken from behind Government House
Pen, pencil and wash, 280 × 475
The title appears to be in Watling's copperplate hand.

Plate 138 [Watling LS9]
THOMAS WATLING
South View of Sydney-Cove taken from the General Spring nigh the Eastern entrance to Pitt's Row
Pencil, ink and wash, 277 × 486
The title appears to be in Watling's copperplate hand.

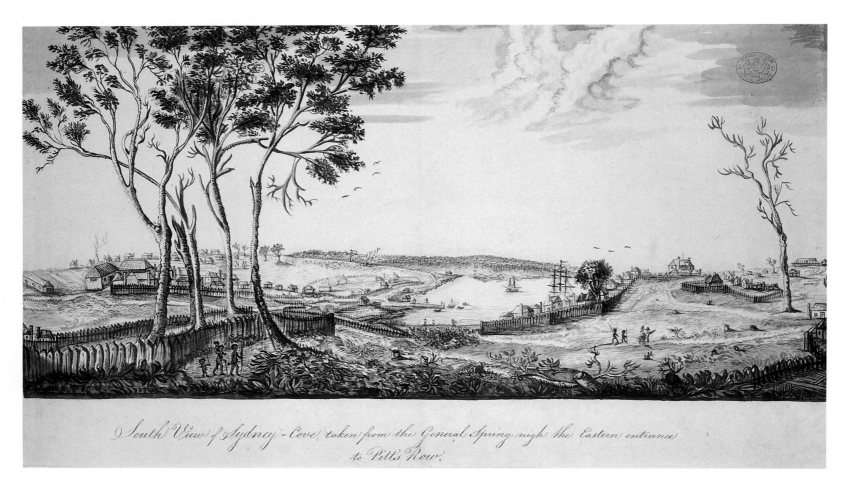

South View of Sydney-Cove, taken from the General Spring nigh the Eastern entrance to Pitt's Row.

production, Parramatta became an even more important market for the surrounding districts [plate 146]. As more people built there, Hunter added to the government buildings: a school in 1796, a windmill and a 'strong log-prison' in 1797, a church from late 1798 onwards, and he enlarged the Government House [plate 146].[60] By the end of the decade, the mainland settlement's success was evident – as one colonist recorded,

The inconveniences and embarrassments which fettered the growth of this infant Colony, are now daily disappearing. Population rapidly increases, agriculture begins to flourish, and industry is actively employed in many of those subdivisions which seldom prevail but in a long settled country. In short, the present state of the Colony affords every reason to expect that it will soon be able amply to compensate the Mother Country for the expence and trouble of establishing and protecting it.[61]

The situation on Norfolk Island was similar. Though the population remained more or less static,[62] public buildings became more numerous and substantial, the European presence more striking [plate 147]. King erected brick and stone barracks, houses, storehouses and a school at Sydney Bay, and additional timber buildings. He built timber houses and a barn and granary at Queensborough, a dam and watermill in Arthur's Vale [plate 145], and barracks, houses and a flax house, storehouse, and

Plate 139 [Watling 17]
THOMAS WATLING
North view of Sydney Cove; taken from the Flag-staff, opposite the Observatory
Pencil, ink and wash, 270 × 415
The title appears to be in Watling's copperplate hand.

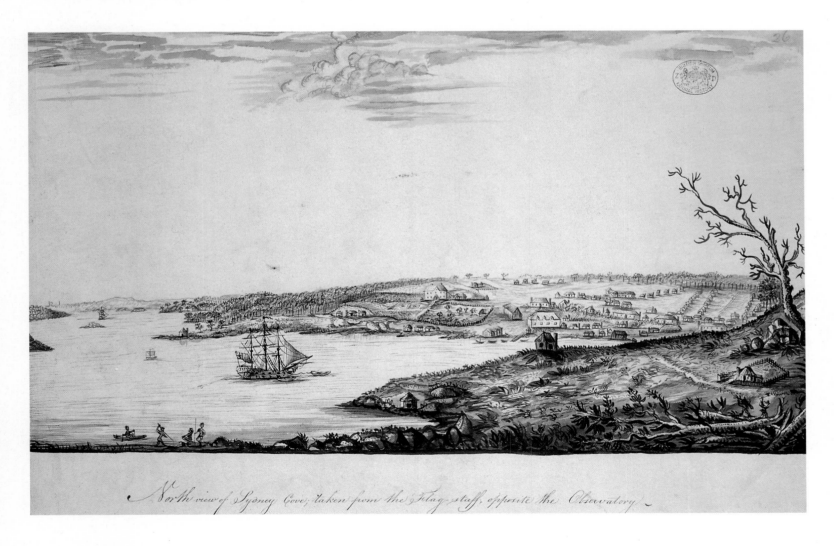

North view of Sydney Cove; taken from the Flag-staff, opposite the Observatory

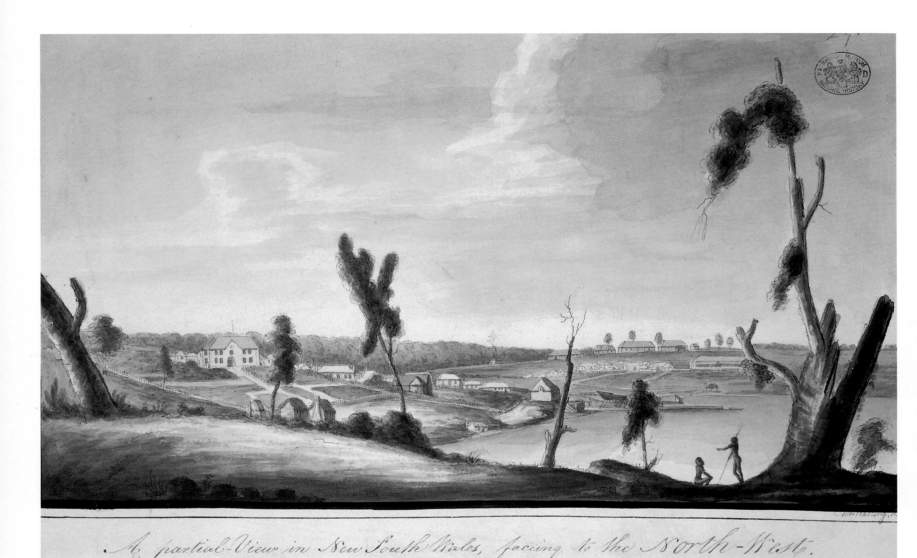

A partial-View in New South Wales, faceing to the North-West.

Plate 140 [Watling 20]
THOMAS WATLING
*A partial-View in New South Wales,
faceing to the North-West*
Pencil, ink, wash and water-colour,
250 × 380, signed 'Thos Watling
del'.'
The title appears to be in Watling's
copperplate hand.

Plate 141 [Watling LS7] *above right*
THOMAS WATLING
*A Direct North View of Sydney Cove
and Port Jackson, the Chief British
Settlement in New South Wales,
Taken from the North Shore, about
one Mile distant, for John White
Esq'.*
Pencil, ink and wash, 415 × 530,
signed 'T. Watling del'.'
The title apparently in Watling's
copperplate hand, followed by 'It
must be observed that the Masts of
the Ships are out of all proportion',
probably in John White's hand.

Plate 142 [Watling LS8] *right*
THOMAS WATLING
*A View of the west Side of Sydney
Cove taken from Too-bay-ulee, or
Bannellongs Point*
Pencil, ink and wash, 340 × 460
(sky trimmed in reproduction)

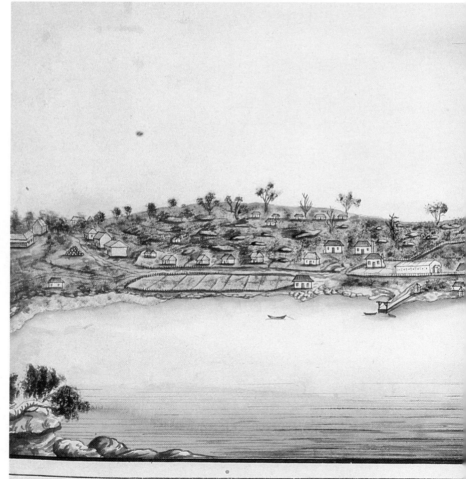

A View of the west side of Sydney Cove taken fr...

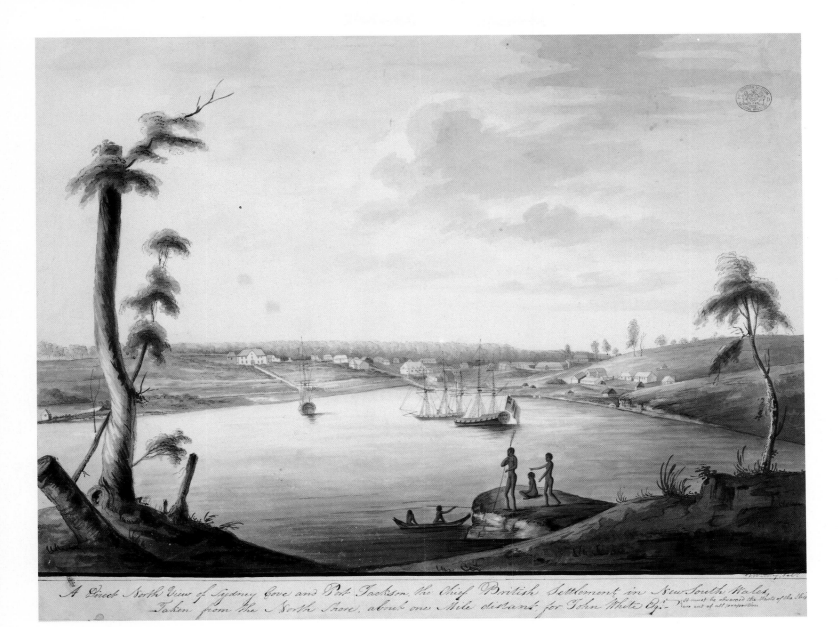

A Direct North View of Sydney Cove and Port Jackson, the Chief British Settlement in New South Wales, Taken from the North Shore, about one Mile distant, for John White Esqr.

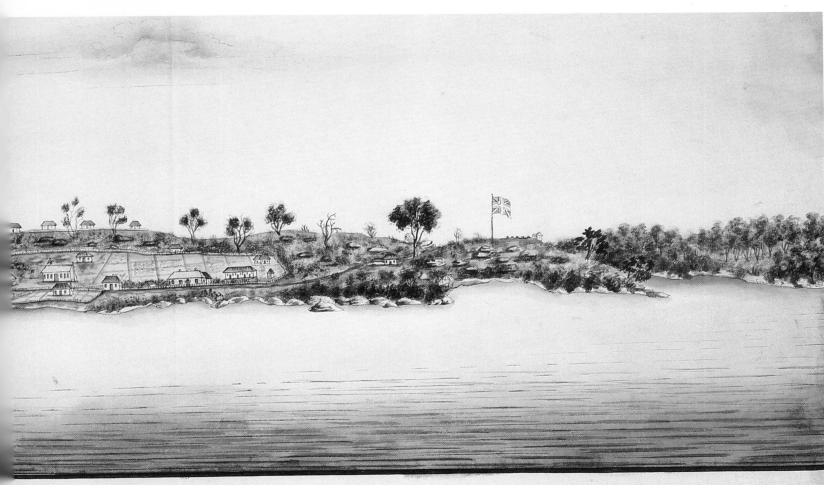

Too-bay-wee, or Bannelong's Point.

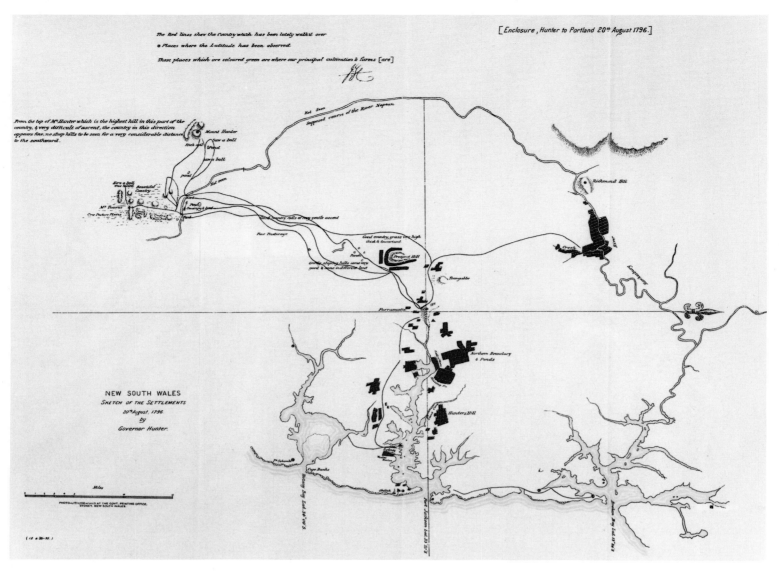

The red lines shew the Country which has been lately walked over

● Places where the Latitude has been observed.

Those places which are coloured green are where our principal cultivation & farms [are]

From the top of Mt Hunter which is the highest hill in this part of the country, & very difficult of ascent, the country in this direction appears fine, no steep hills to be seen, for a very considerable distance to the southward.

NEW SOUTH WALES

Sketch of the Settlements

20th August, 1796.

By

Governor Hunter.

PHOTO-LITHOGRAPHED AT THE GOVT. PRINTING OFFICE,
SYDNEY, NEW SOUTH WALES.

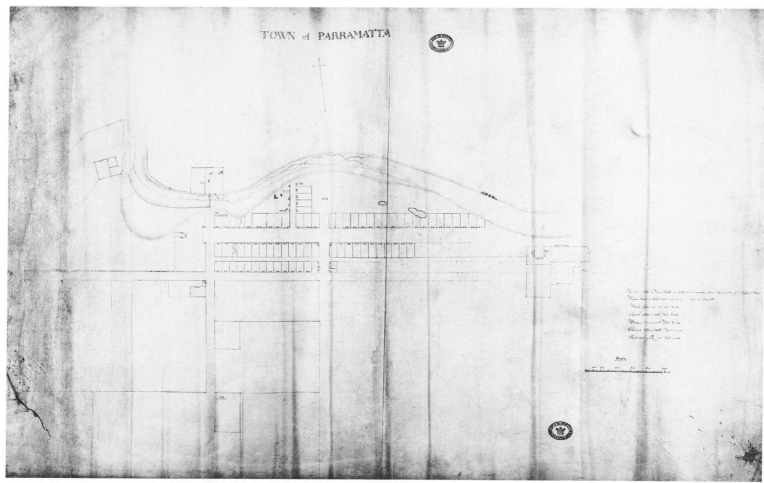

TOWN of PARRAMATTA

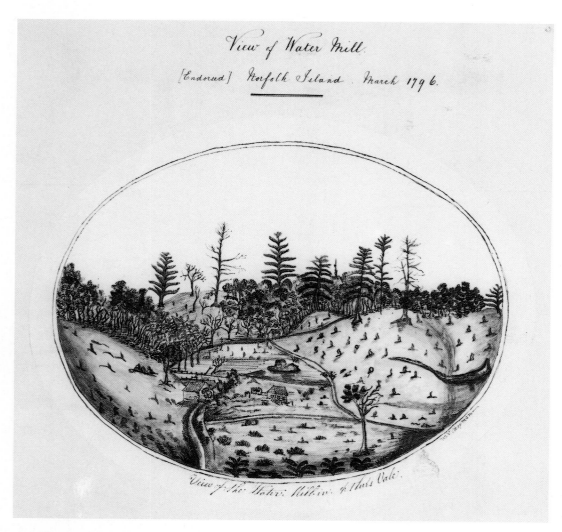

View of Water Mill.

[Endorsed] *Norfolk Island. March 1796.*

View of the Water Mill in Arthur's Vale.

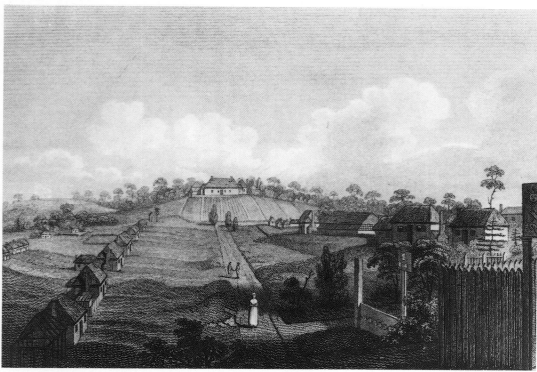

Plate 145
(After) WILLIAM NEATE CHAPMAN
View of the Water Mill in Arthur's Vale, Norfolk Island, 1796
Pencil, pen and wash, oval frame 188 × 242; inscribed 'W. N. Chapman'
Copy made by F. M. Bladen after the original in the Public Record Office, London.
Mitchell Library, State Library of New South Wales, Sydney.

Plate 146
A View of the Governor's House at Rose-hill in the Township of Parramatta
Engraving by J. Heath after a sketch probably by Watling. Published in Collins's *Account* (1798), I, fp. 125.

facing page

Plate 143
JOHN HUNTER
New South Wales Sketch of the Settlements 20th August, 1796
From the engraving reproduced in *Historical Records of New South Wales*, III, fp. 72.

Plate 144
Town of Parramatta
Black and red pen and ink and grey wash, 663 x 1022
Public Record Office, London, C0700/N.S.W. 4.

137

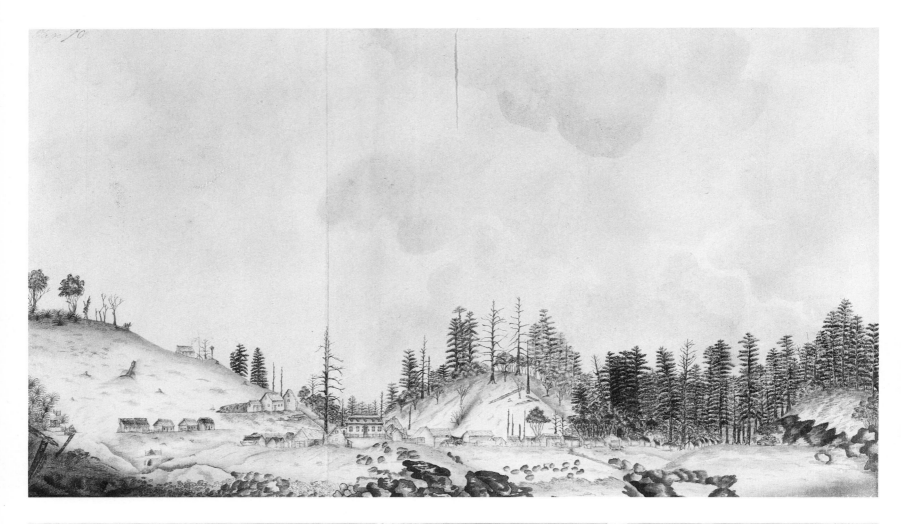

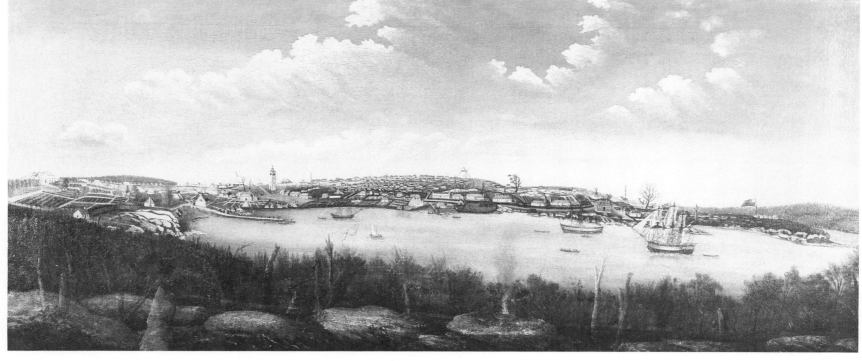

barn at Phillipsburgh where he also constructed a 'very strong wharf, 126 feet long' with a 'swinging crane and capstern' at its end.[63] One observer considered that in 1798 the island offered a 'perfect image of Paradise':

the air is more soft and the soil inexpressibly productive. . . . Our officers and their ladies, while they never regret their absence from Old England, were sensibly affected at their departure from this insular garden, and at their banishment to Sydney. There the annual harvest of wheat is double. There the limes are so exuberant that the Governor from the same tree plucked sixteen pecks of ripe, and left upon it a greater proportion of green fruit. Pomegranates, melons, figs, and the sugar-cane are there equally prolific. Though its circumference be merely seven leagues, or twenty-eight miles, it contains 1200 settlers, or reformed farmers, and enjoys a state of cultivation equal to the West India Islands.[64]

But it was at Sydney especially that the Old World displayed its gathering hold on the New. There, Hunter refurbished the public buildings, delineated new streets and numbered the houses, including those of the convicts which spread increasingly over the Rocks area [plate 148]. The ex-convict boatbuilders, Henry Kable and James Underwood, constructed more and larger vessels, some of which their colleague Simeon Lord used to expand his trading activities. Other merchants, among them the immigrant Robert Campbell, established themselves. Wharves, warehouses and taverns sprang up between the Rocks and the western side of Sydney Cove. And about were potent signs of the new dispensation. From 1795 Government House displayed a verandah; Hunter installed a town clock in the tower of St Philip's church; on the ridge behind the Cove to the west he built a 'strong [and] substantial' windmill that he hoped would last 'for two hundred years'.[65]

With ever-gathering pace in the 1790s, the town of Sydney developed a rhythm of life, and the whole colony (including Norfolk Island) a rationale, little related to the motives that had first started the venture. As observers noted, population was increasing, and also agricultural production. As well, the convicts 'feel the value of regaining some footing in society . . . and endeavour, by a course of diligent exertion, to earn the esteem of the other settlers, and to atone for the errors of the former part of their lives'.[66] No matter what exceptions there might have been to this glowing picture, the percipient observer could not but be impressed by the colony's progress. Entering Port Jackson in mid-1802 and expecting to find a primitive outpost, Baudin and his officers were filled with admiration for the 'immense' achievement, and found it difficult to conceive how the colonists had 'so speedily attained to the state of splendour and comfort in which they now find themselves'.[67] Again, the privations of a long voyage might explain some of this praise, but they cannot explain all of it. The colonization of New South Wales was a striking achievement, and has scarcely any parallel in European expansion. We are fortunate to have such a splendid visual record to help us make sense of the written one.

Plate 147
WILLIAM NEATE CHAPMAN
View of the Town of Sydney, Norfolk Island
Pencil, pen and wash, 266 × 443, signed W. N. Chapman, 1796
Inserted in John Hunter's autographed copy of *The Voyage of Governor Phillip to Botany Bay.*
Mitchell Library, State Library of New South Wales, Sydney, C 688⁻².

Plate 148
ANONYMOUS
View of Sydney from the West side of the Cove (c. 1800)
Oil on canvas, 600 × 1370
It has been attributed to Watling. As seen from Bennelong Point, showing Government House at left and the east side of the Cove with the build-up of the Rocks area in the distance.
Mitchell Library, State Library of New South Wales, Sydney.

J. H. CALABY

4 / *The Natural History Drawings*

Scientific knowledge of the remarkable Australian flora and fauna accumulated slowly following the European discovery of Australia early in the seventeenth century. In the accounts of their voyages a few of the Dutch explorers briefly described birds or other strange animals. The first known drawings were the rather crude woodcuts illustrating a few fishes, birds and plants in William Dampier's narrative of his voyage to New Holland in 1699, published in 1703. During most of the eighteenth century European interest in the southern continent all but languished. The explorers had found no valuable minerals, or plants or animals of commercial importance, and they saw nothing attractive in the arid western coast, or the south-west or tropical north, during hot, dry seasons.

The real interest in the Australian flora and fauna began with the discoveries on the eastern coast by James Cook and Sir Joseph Banks and his company in 1770. By that time however, interest in natural history had increased enormously, and methods of study and classification of natural history specimens had been revolutionized.

One outcome of this activity was the formation of natural history societies, the membership consisting of the wealthy, or at least the comfortable well-off, with the necessary leisure to pursue their interests.[1] The great majority of these societies were short-lived; however it is an interesting coincidence that the oldest society devoted solely to natural history that is still in existence, the Linnean Society of London, was founded in 1788 within weeks of the beginning of British settlement in Australia.

The formation of private museums that included natural history specimens and drawings, and the publication of increasing numbers of books on natural history subjects, were also characteristics of this century. The British Museum, founded in 1753 with the purchase of Sir Hans Sloane's collection, opened to the public six years later. Exotic animals and plants were especially sought by the collectors. The two books that had greatest effect on the systematic study of plants and animals were the *Species Plantarum* and the tenth edition of the *Systema Naturae*, published by the great Swedish naturalist Linnaeus, in 1753 and 1758 respectively. These works were the first to consistently use Latinized binomial names for plants and animals, and they are the official starting points for botanical and zoological nomenclature.

Plate 149 [Raper 36]
GEORGE RAPER
New Guinean cassowary, *Casuarius casuarius* (Linnaeus, 1758)
Ink and water-colour, 238 × 192, signed 'Geo Raper 1792'
Inscribed in Raper's hand beneath the drawing 'Cassowary from an Original Drawing in possession of M[r]. Mason. Cape Good Hope'.

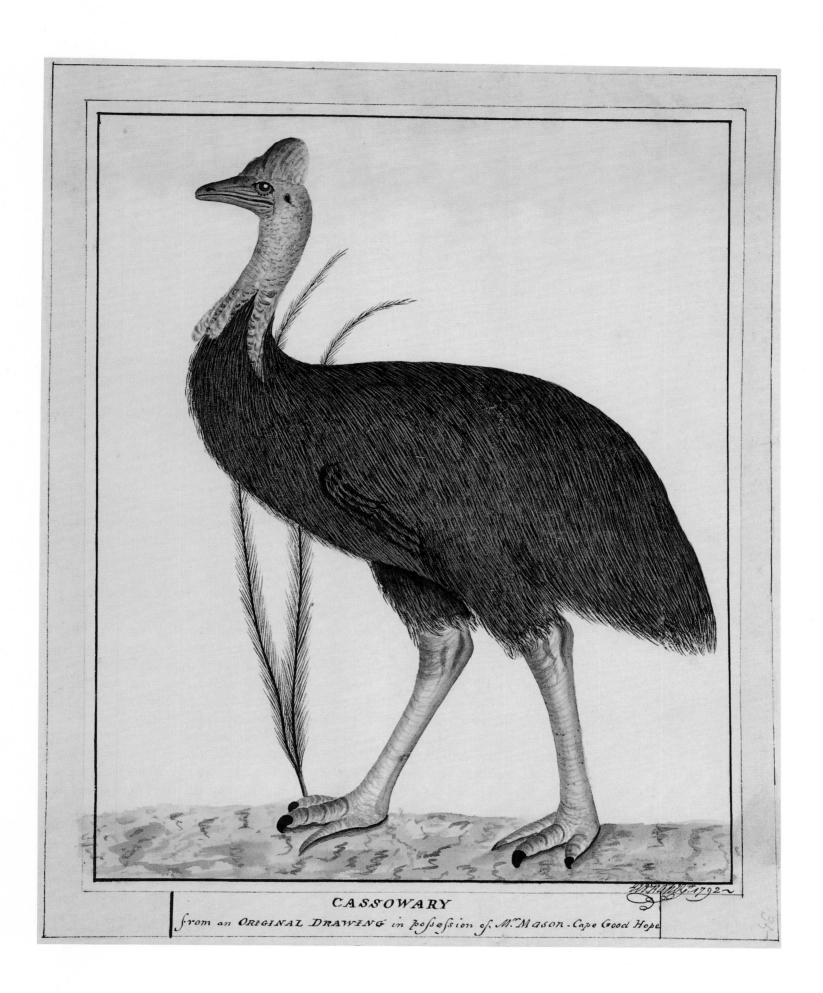

CASSOWARY
from an ORIGINAL DRAWING in possession of Mr. Mason. Cape Good Hope

141

Plate 150 [Raper 56]
GEORGE RAPER
Eastern grey kangaroo, *Macropus
giganteus* Shaw, 1790
Ink and water-colour, 325 × 460,
signed 'Geo Raper 1789'
Inscribed in Raper's hand 'Gum-Plant,
& Kangooroo of New-Holland.
Reduced Size'. The 'Gum-plant' is
the Grasstree, *Xanthorrhoea* sp.

Cook's expedition in the *Endeavour* was the first official British voyage of discovery to include professional naturalists and artists in the ship's company. The great wealth of specimens, drawings and descriptions in manuscript that was brought back is well known. Unfortunately, most of this remarkable and well-documented collection was never described and published. Because of Banks's special interest in botany, the plant specimens remained in his possession and were eventually bequeathed to his librarian, the great botanist Robert Brown. Brown presented the collection to the British Museum in 1827 and it is now housed in the British Museum (Natural History). The eastern Australian flora was scientifically described and documented in publication from new collections and by later authorities. On the other hand, a great many of the specimens of animals were widely dispersed, given away to private collectors or otherwise disposed of, and much of this material is not now traceable. Dr Whitehead has given an excellent account of the fate of the zoological specimens from Cook's voyages.[2] In spite of the scientific neglect of the Banks and Solander collections however, the first Australian animals to be scientifically classified and named in accordance with the Linnaean system were collected on the *Endeavour* voyage. These included a few mammals and birds, brief descriptions of which were based on observations included in Hawkesworth's official account of the voyage (1773) or Parkinson's *Journal* (1773). The insect and crustacean collections fared rather better than those of other kinds of animals. A considerable number of species were described by the Danish entomologist J. C. Fabricius, in his *Systema Entomologiae* (1775).

The British settlement at Port Jackson in 1788 was made at a time when European interest in newly discovered remote lands and their fauna and flora and native peoples was at a high point. It is all the more strange, therefore, that no official naturalists or artists were included in the company of the First Fleet, especially so as Sir Joseph Banks was a promoter of settlement in New South Wales and maintained close contact with its progress. Moreover, he had personal knowledge of the region and its strange plants and animals.

There were, however, several individuals in the First Fleet with an interest in natural history who recorded their observations in diaries, letters or books that are still available to modern students.[3] Some of them had artistic ability and made drawings of natural history subjects and there are several surviving collections. Notable among these were John Hunter, second captain on H.M.S. *Sirius* and later Governor, George Raper, midshipman on the *Sirius*, and another artist whose identity is not known but who painted in a distinctive style and is referred to as the Port Jackson Painter. A later arrival, Thomas Watling, was an experienced artist. Arriving in Sydney in October 1792 he was assigned to Surgeon-General John White to draw the 'non-descript productions of the country'.[4] The Watling Collection in the British Museum (Natural History) is the largest surviving collection of early natural history drawings associated with the new settlement at Sydney Cove and contains many drawings both signed and unsigned by Watling, together with an even greater number by unidentified artists.

The importance of these collections is in their great value as scientific records. With their annotations they have a scientific importance beyond their merits as art. They eclipsed the *Endeavour* material in providing the first detailed European knowledge of the unique Australian fauna, and they were the first illustrations to be made of a large number of species. The drawings and notes give the first pictures of the status of animals and plants in their pristine state in the Sydney region, and enable later comparisons of the effects of European settlement on the fauna. Many of the drawings, particularly in

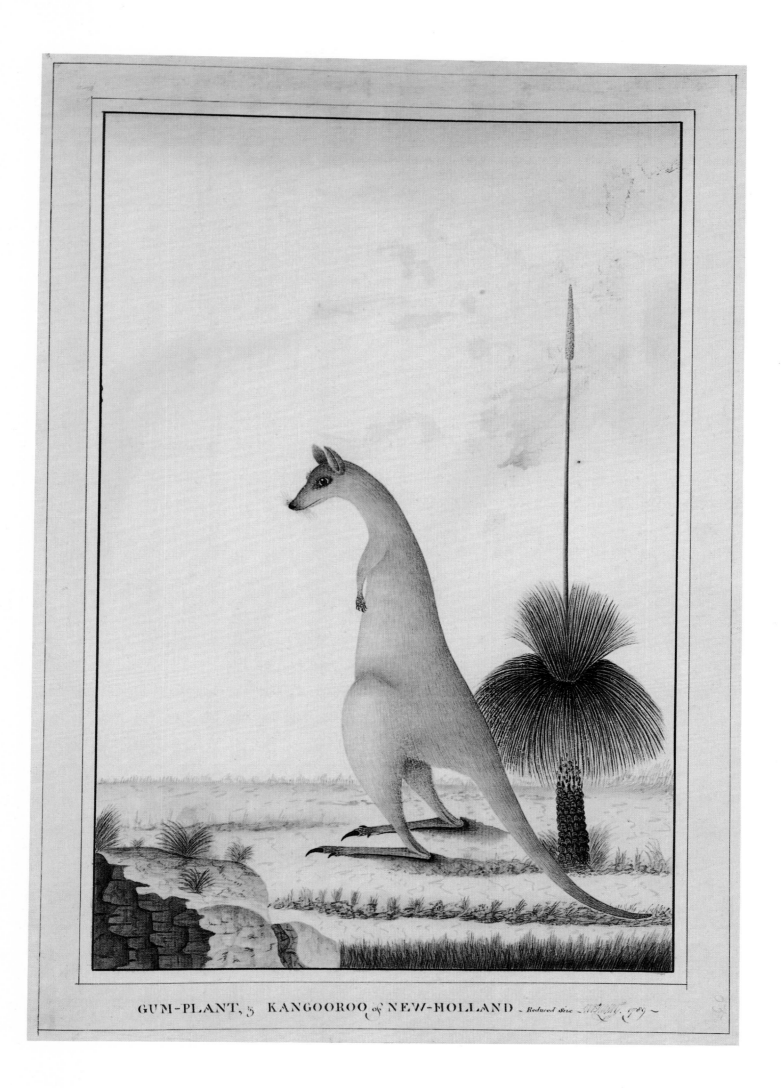

GUM-PLANT, & KANGOOROO of NEW-HOLLAND — Reduced Size

the Watling Collection, were later used as the sources of information for the formal description of species of animals. They therefore have some status as type material of these scientific names and are particularly important to taxonomists. One good example of the scientific value of these early drawings is given by one of Hunter's water-colours of a dove of Norfolk Island tentatively named *Gallicolumba norfolciensis*, a unique species confined to that island.[5] This appears to be the only extant representation of the bird which apparently became extinct by 1800. Otherwise it is known only from a few fossil bones.[6] Other animals that are now extinct are depicted in these early drawings.

It must be stated that as representations of botanical and zoological specimens many of the drawings can only be described as mediocre. They cannot be compared in quality

Plate 151 [Banks Ms34: 49]
ANONYMOUS
Owlet-nightjar *Aegotheles cristatus*
(Shaw, 1790)
Ink and water-colour, 205 × 318,
unsigned
The drawing corresponds closely to plate 19 in White's *Journal of a Voyage to New South Wales* (1790), which is signed by Sarah Stone. The drawing is possibly Stone's original drawing for the engraving or an excellent copy after the engraving, probably by Watling. It represents the type of the species.

Plate 152 [Banks Ms34: 51]
ANONYMOUS
Copper-tailed skink, *Ctenoltus taeniolatus* (Shaw, 1790)
Leaf-tailed gecko, *Phyllurus platurus* (Shaw, 1790)
Blue-tongue lizard, *Tiliqua scincoides* (Shaw, 1790)
Ink and water-colour, 205 × 318
The drawings represent the type specimens of the species. The original specimens from which the drawings were made were formerly in the collections of the British Museum (Natural History). Only a specimen of the common blue-tongue lizard is now certainly identifiable in the collections.
Since Sarah Stone signed the engraving of the 'Leaf-tailed gecko', White (1790) plate 20, she probably drew the other two specimens also. If these are not Stone's original drawings then they are outstanding copies after the engravings, probably by Watling.

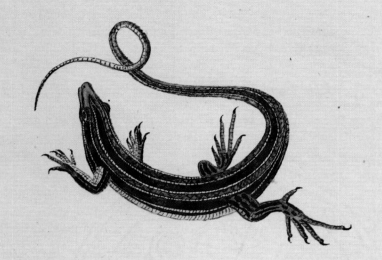

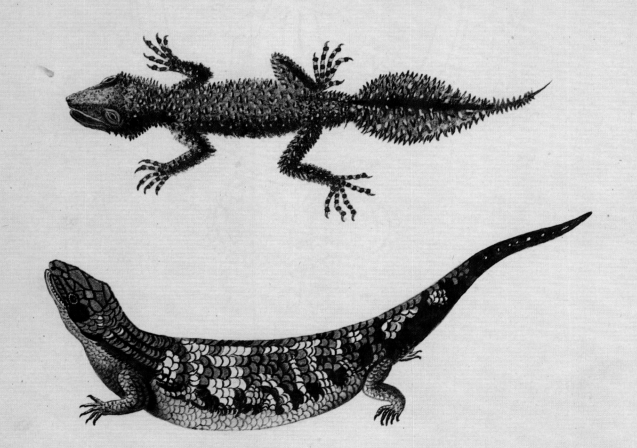

with those of Sydney Parkinson, natural history artist on the *Endeavour*, or with the superb plant and animal drawings of Ferdinand Bauer, the Austrian natural history artist with Matthew Flinders on the *Investigator* who accompanied Robert Brown the naturalist on the voyage, during his time on the ship or in Australia from 1801 to 1805.

The drawings considered in this chapter are in the Watling and Raper Collections and those in the Banks Ms34. They are housed in the Zoology and Botany Libraries of the Department of Library Services, British Museum (Natural History). Although the majority of subjects in all three series of drawings is birds, a variety of animals and plants is illustrated.

In the Raper drawings there are forty-two sheets of natural history subjects and most of them are signed and dated. Twenty-nine of the sheets are of birds of which twenty-seven depict a total of thirty-one species from the Sydney district, and Norfolk and Lord Howe Islands. The remaining two are an unsigned incomplete water-colour labelled 'Teneriffe Partridge' [plate 218], and a New Guinean cassowary (*Casuarius casuarius*) [plate 149]. The partridge is the red-legged species (*Alectoris rufa*) of south-western Europe which is also found in the Canary Islands. The drawing of the cassowary

Plate 153 [Watling 89]
THOMAS WATLING
Potoroo, *Potorous tridactylus* (Kerr, 1792)
Ink and water-colour, 220 × 206, signed 'Tho? Watling del.'
This is probably the potoroo. There is a sketch of the animal on verso.

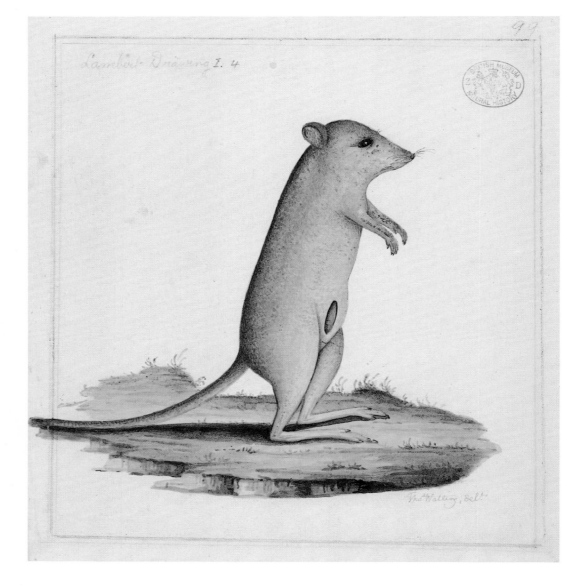

was copied 'from an original drawing in possession of Mr Mason [sic] – Cape of Good Hope' dated 1792, when Raper was on his way back to England. Masson was employed in the English East India Company's garden at Cape Town, which also contained a menagerie. Although the same species of cassowary is found on Cape York Peninsula it was not discovered in Australia until half a century later.

Three of the Raper drawings are of mammals: an eastern grey kangaroo (*Macropus giganteus*) [plate 150], a dolphin, and a southern African antelope, the female of the gemsbok (*Oryx gazella*), dated 1792 and copied from another drawing in Masson's possession. There are eight sheets of marine fishes illustrating eleven species, one labelled as from Rio de Janeiro and the remainder from Port Jackson or Norfolk Island. One drawing is of the common blue-tongue lizard (*Tiliqua scincoides*), and the remaining one shows the beautiful epiphytic orchid of the Sydney area, the rock lily (*Dendrobium speciosum*). In addition ten paintings of birds also depict flowers, and the kangaroo is balanced by a grass tree (*Xanthorrhoea* sp.).

The Raper drawings have been discussed in detail by Hindwood who identified the bird subjects.[7] Hindwood described two other collections of 'Raper drawings' in the

Plate 154 [Banks Ms34: 59]
ANONYMOUS
Potoroo, *Potorous tridactylus* (Kerr, 1792)
Pencil and water-colour, 205 × 318, unsigned
The original scientific description was based on this drawing as engraved in White (1790) plate 35, 'A Poto Roo' signed 'S. Stone'. The skull of the specimen on which the drawing was based was formerly in the Museum of the Royal College of Surgeons.
This is either Stone's original drawing or an excellent copy after the engraving, probably by Watling.

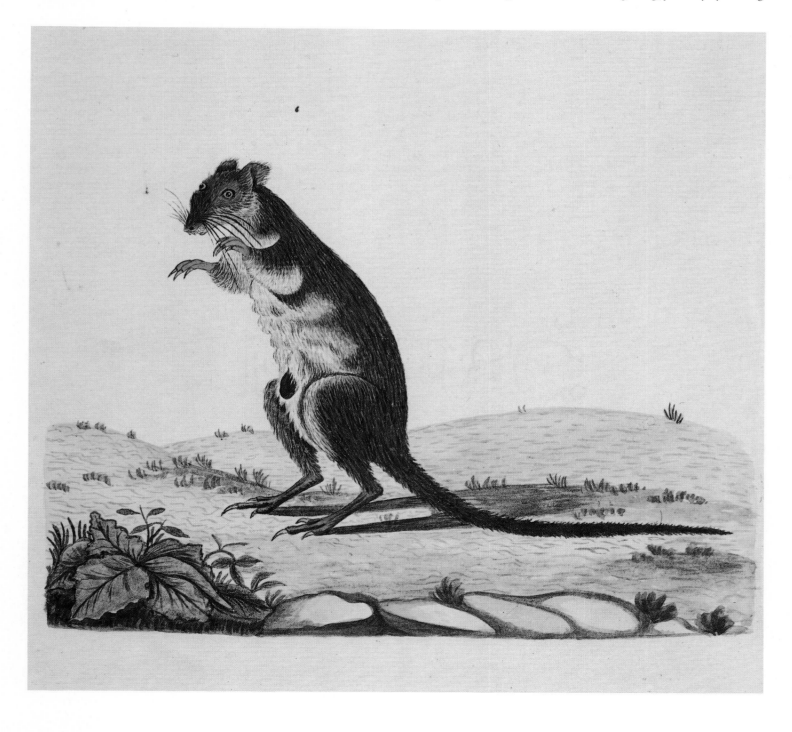

147

Mitchell Library, Sydney, and the Alexander Turnbull Library, Wellington. In both of these collections all but a few are unsigned and artists other than Raper also appear to be represented.

The natural history drawings in the Banks Ms34 total 65: 32 sheets illustrating 38 species of birds, 9 of reptiles depicting a total of 7 species of snakes and 5 of lizards, 5 of fishes showing 10 species, one insect, 15 of plants and 3 illustrating mammals.

Scientifically the drawings in the Banks Ms34 are an important series because some of them closely resemble engravings which illustrate Surgeon-General John White's *Journal of a Voyage to New South Wales*, published in 1790. In an appendix to that work, some of the species figured are scientifically described and named for the first time. White's editor, his friend Thomas Wilson, acknowledged the assistance of well-known naturalists, George Shaw, zoologist at the British Museum, and the botanist James Edward Smith, and the distinguished anatomist-surgeon John Hunter, in describing the plants and animals. The scientific names of birds, reptiles and fishes that appear for the first time in White's *Journal* are usually attributed to Shaw or sometimes to 'White, ex Shaw ms'.

Rienits and Rienits noted that the illustrations in White's *Journal* were prepared in England from specimens sent home by White, and concluded that the drawings in the Banks Ms34 that are identical with engravings in the book were copies made in the colony after publication of the book.[8] In 1960 Smith adopted the view that most of the engravings were based on drawings sent with the manuscript.[9] Some at least of the engravings in the *Journal* were based on specimens that White sent to England and the whereabouts of some of them have been traced. For example, the specimen of the white gallinule (*Porphyrio albus*) went to the Leverian Museum, a well-known private collection open to the public, and was bought for the Imperial collection at Vienna when the Leverian specimens were sold by auction in 1806. The specimen, one of only two known surviving examples of the species, is now in the Naturhisto-

Plate 155 [Banks Ms34: 52]
ANONYMOUS
Dingo, *Canis familiaris dingo*
Meyer, 1793
Water-colour, 205 × 318
The original scientific description of the dingo is based on this drawing as reproduced in White (1790) plate 33, signed 'Mortimer', and the engraving in *The Voyage of Governor Phillip to Botany Bay* (1789) plate 45, fp. 274. This drawing is probably the earliest illustration known to exist of the dingo (see also plate 241).
The drawing is either the original by Mortimer or an excellent copy from the engraving, probably by Watling.

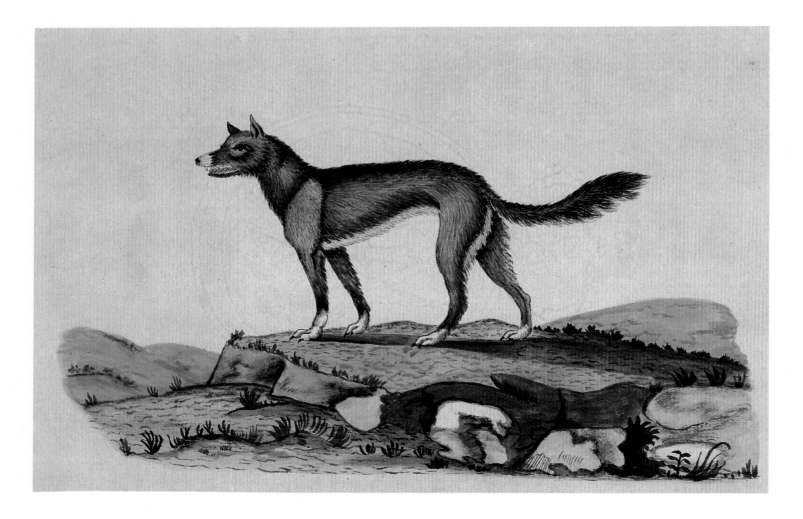

risches Museum, Vienna. Some of White's specimens of reptiles reached the British Museum. Type specimens of the jacky lizard, *Amphibolurus muricatus*, and the common blue-tongue lizard, *Tiliqua scincoides*, and probably that of the leaf-tailed gecko, *Phyllurus platurus*, all described in White's *Journal*, are still in the collections of the British Museum (Natural History). It is of course possible that White sent to Wilson both drawings and specimens with his manuscript.

Of the birds figured in White's engravings only two, the emu (*Dromaius novae-hollandiae*), and the 'crested goatsucker' now known as the owlet-nightjar (*Aegotheles cristatus*) [plate 151] are represented in the Banks Ms34. The original scientific description of the latter species is included in White's book. Drawings of three of the five species of lizards figured and scientifically described in White's *Journal*, are present in the Banks Ms34 [plate 152].

Figures of seven species of mammals with descriptions provided by Dr John Hunter, are given in White's *Journal* but no scientific names are attached to them.[10] Within a few years however, Shaw or other authorities published scientific descriptions and names, basing most of these on the text and engravings in White's book. The three drawings of mammals in the Banks Ms34 are represented among the engravings in White's *Journal* and are the basis of scientific descriptions published in subsequent years. They are the Hepoona Roo (yellow-bellied glider, *Petaurus australis*), Poto Roo (Potoroo, *Potorous tridactylus*) [plate 154] and the 'Dingo, or Dog of New South Wales', (*Canis familiaris dingo*) [plate 155]. Chisholm (1962) edited a reprint of White's *Journal* and in footnotes incorrectly identified the Hepoona Roo and Poto Roo from the engravings as the greater glider-possum, (*Schoinobates volans*) and rufous rat-kangaroo (*Aepyprymnus rufescens*), respectively.[11] However, the problems of identity of these two animals were solved long ago by Waterhouse (1841) who found White's original specimens in the Museum of the Royal College of Surgeons.[12] This museum was founded in 1800 to house John Hunter's private collection.

If the drawing of the dingo [plate 155] is the original for the engraving in White's book it is probably the earliest known drawing made of that creature, though the drawing for the engraving in *The Voyage of Governor Phillip to Botany Bay* (1789) fp. 274 must have predated it. The accepted scientific name of the animal is based on the engravings in both *The Voyage of Governor Phillip to Botany Bay* and White's *Journal*. The illustration in Phillip's *Voyage* was drawn from a live specimen sent to England. Another early drawing, the fine woodcut of the 'New South Wales Dog' in Thomas Bewick's *General History of Quadrupeds* published in 1790, the same year

Plate 156
THOMAS BEWICK
The New South Wales Dog
Wood engraving, 55 × 80
From Bewick's *General History of Quadrupeds* (1790) p. 315. Probably copied from the engraving in *The Voyage of Governor Phillip to Botany Bay* (1789) plate 45, fp. 274, but it is a much better illustration and may have been drawn independently.

as White's book, has some resemblance to a reversed image of Phillip's engraving and is probably a copy from it. It is certainly a much better figure. Bewick's text, however, contains similar information to Phillip's. Poignant thought that the oil painting entitled 'A large dog' by the celebrated animal painter George Stubbs was the earliest representation of a dingo.[13] This was commissioned by Banks and exhibited alongside Stubbs's portrait of a kangaroo in 1773. Stubbs's 'large dog' has some of the features of a primitive dog such as the dingo but it is not a good representation of that animal. If Stubbs's painting represents a dingo it could only have been based on information supplied by Banks. There is no evidence that the *Endeavour* naturalists or artists obtained or saw a dingo. The name 'dingo' was first recorded as the Aboriginal name of the animal by Watkin Tench, Captain of the Marines, in his *Narrative of the Expedition to Botany Bay* published in 1789.[14]

The largest series of drawings is that known as the Watling collection of drawings. Its coverage of subjects is described by Smith and Rienits and Rienits who give the total number as 512.[15] The natural history drawings number 400, of which 271 represent birds, 16 are of mammals, 9 of reptiles, 15 of fishes, 13 of arthropods, 17 of mollusca and 59 of plants. Two of the drawings of molluscs present different views of an octopus and there are one to several species of shells on the others. In addition, one drawing shows a variety of small invertebrates, all arthropods except for a small snail. Twenty-five of the drawings of birds are now missing but the identities of these are known from a manuscript list prepared by the ornithologist John Latham when he examined the drawings about the year 1800, and which is still filed with them.[16] The collection received its present name because 123 of the drawings bear Watling's signature and are the only signed ones. However, it is clear that a number of artists of varying degrees of ability are represented, including the Port Jackson Painter.

Scientifically the Watling series is the most important of the early collections of natural history drawings and as a consequence they have been generally well studied by biologists. There is good evidence that the collection was put together by John White. In 1797, about two years after he returned to England, he delivered to Aylmer Bourke Lambert, distinguished botanist and founding member and vice-president of the Linnean Society, the manuscript of the journal he kept of his seven years in New South Wales, together with at least the majority of the drawings, in the hope that publication could be arranged. Lambert had copies made of many of the drawings minus the annotations, and subsequently lent these copies to John Latham, a medical practitioner and the leading ornithologist of his time. The copies, now known as the 'Lambert Drawings', were bought by the 13th Earl of Derby on Lambert's death in 1842, and are now located in the Library of Knowsley Hall, near Liverpool.

Latham was an assiduous collector of bird drawings, and published copies of them with descriptive text in his works. From 1781 to 1785 he published his *General Synopsis of Birds*, with Supplements in 1787 and 1801. Between 1821 and 1824 when he was over eighty years of age, Latham produced *A General History of Birds* in ten volumes. It is clear from this latter work that at some time Latham had also studied the Watling drawings as he used the annotations on the drawings in his text. The annotations, some at least of which are in the handwriting of John White, could be described as the first field observations on the birds and other animals of New South Wales, and greatly increase the scientific value of the drawings. With regard to the scientific use made of the drawings, the most important of Latham's works are the Second Supplement of 1801 to the *General Synopsis*, and a Latin work published in

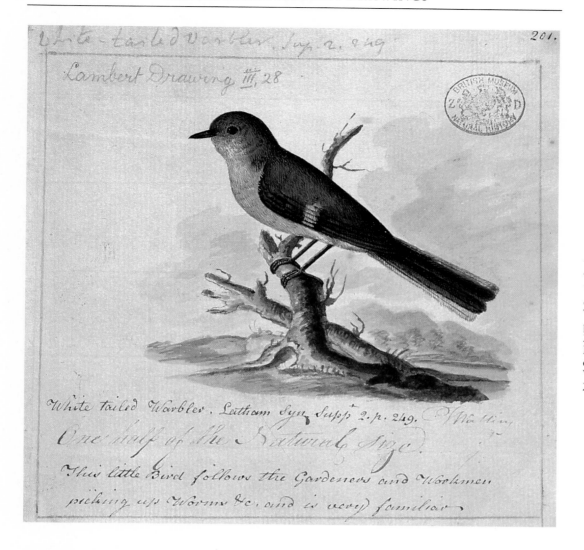

Plate 157 [Watling 276]
THOMAS WATLING
Unidentified bird
Water-colour, 153 × 161, signed
'T. Watling'
Inscribed 'One half the Natural Size'
in Watling's copperplate hand.
The drawing may be a composite
representation, for the bird depicted
has the characteristics of both the
Jacky Winter, *Microeca leucophaea*
(Latham, 1801) and the rather
similar-looking females of the Flame
Robin, *Petroica phoenicea*, Gould,
1837, or Rose Robin, *Petroica rosea*,
Gould, 1839, although it is more like
a female robin. The drawing is
annotated 'This little Bird follows the
Gardeners and Workmen, picking up
Worms, &c., and is very familiar'.
The note well describes the
behaviour of the Jacky Winter and
could not be applied to the robins.
The drawing is also annotated in
pencil 'White-tailed Warbler, Sup 2,
249' and in another hand 'Lambert
Drawing III, 28', and beneath the
drawing in ink 'White tailed
Warbler. Latham Syn Supp[t] 2. p.
249'.

the same year with the title *Supplementum Indicis Ornithologici, sive Systematis Or-
nithologiae*. In these works a considerable number of the birds depicted in Lambert's
copies of the Watling drawings are dealt with and in the latter they are given scientific
diagnoses and names. The drawings are therefore the original source for the description
of the species and have great scientific value in the absence of specimens.

The taxonomy and classification of birds were still at a relatively elementary stage
in Latham's time. Collections of specimens continued to reach Britain and Europe in
increasingly greater numbers, and it was often difficult ·to determine whether these
had already been described, and if so, to which of the described species they belonged.
Latham's published drawings and descriptions were found to be inadequate in many
cases. As soon as the Lambert drawings became available in Lord Derby's library they
were examined by G. R. Gray who was in charge of the collections of birds in the
British Museum,[17] and by the ornithologist H. E. Strickland.[18] Strickland observed that
'many of the drawings are but rude and unscientific copies of nature', and of subjects
he failed to identify, 'these may either represent true species unknown to modern
science, or they may possibly be, as Mr Gould conjectures, mere inventions of the
artist'.

The most detailed examination of the birds in the Watling drawings was carried

out by Richard Bowdler Sharpe soon after they unexpectedly came into the possession of the British Museum (Natural History).[19] Sharpe was the curator of the bird collections in the museum, and among the most distinguished ornithologists of his time. He compared the drawings with specimens, correctly identified the great majority and determined which of the drawings were the 'type specimens' of Latham's species. He also published the annotations accompanying the drawings, and showed that the birds in some of the drawings could not be assigned to any known species. The drawings were subsequently studied by other ornithologists notably G. M. Mathews and Sir Hugh Gladstone. Gladstone wrote a biography of Watling and brought to light much that was previously unknown of his life.[20]

The latest review was that of Hindwood who checked the drawings against Sharpe's determinations and corrected some errors that he made.[21] Hindwood lists thirty-seven indeterminate drawings. Some of them do not closely resemble any known species from Australia or elsewhere, others may be composite and based on more than one closely related species, which was not appreciated by the original artists [plate 157]. The poor quality of some of the drawings militates against their identification.

The drawings of animals other than birds have received varying degrees of attention as mentioned by Hindwood. He included in his work a list of determinations of the fishes, provided by G. P. Whitley. Iredale identified the mollusc shells and published the annotations on the drawings.[22] The reptiles and mammals have not been studied although Whitley gave some broad identifications of the latter, most of which are incorrect. The drawings of reptiles and mammals were neglected by contemporary naturalists as a basis for scientific descriptions, which probably explains a lack of interest in them in more recent times.

Plate 158 [Watling 362]
THOMAS WATLING
Bearded dragon, *Pogona barbata*
(Cuvier, 1829)
Water-colour, 177 × 296, unsigned
Inscribed on a label beneath the drawing 'This curious Lizard (the 2nd yet seen in N.S. Wales) is about one | third the size of Nature with a large bag or pouch under | the lower Jaw which it delates & contracts at will – when | puffed out its appearance is truly Singular something re- | sembling the full Beard of a Jew from which it has here | obtain'd the appelation of the Jew Lizard | The Natives call it Bid de wang'.

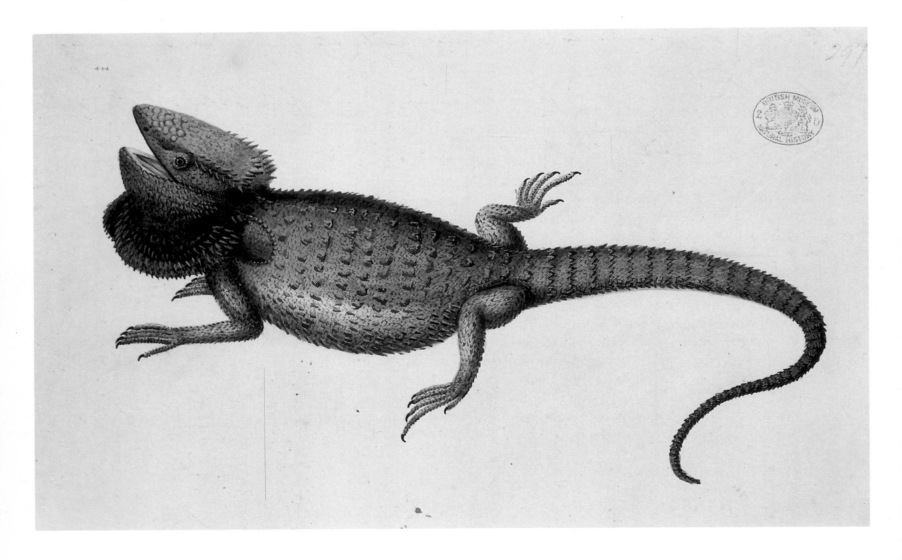

The drawings of reptiles and mammals and the accompanying annotations are of considerable scientific interest. They give information on the state of knowledge of the species in the earliest period of settlement and they are the first illustrations of most species. Some of them are now very rare or have disappeared.

Reptiles

The identities of the reptiles are as follows: Bearded dragon, *Pogona barbata* (Family Agamidae) [plates 158 and 159]. Plate 158 is annotated: 'This curious Lizard (the 2nd yet seen in N.S. Wales) is about one third the size of Nature with a large bag or pouch under the lower Jaw which it delates and contracts at will – when puffed out its appearance is truly Singular something resembling the full Beard of a Jew from which it has here obtain'd the appelation of the Jew Lizard – The Natives call it Bid de wang.' The bearded dragon is common in eastern Australia. It is still called the Jew Lizard on occasions but the origin of the name is no longer generally known. The annotation is probably the earliest record known of the usage of the name in Australia. The inflation of the beard accompanied by opening of the mouth is a threat display.

There is a third drawing of the bearded dragon (Watling 364) not illustrated in this book. Plate 159 is the only one of these three drawings signed by Watling, but the remaining six are all signed by him.

Leaf-tailed gecko, *Phyllurus platurus* (Gekkonidae) [plate 160]. 'This broad tail'd Lizard is not very common in N.S. Wales and never seen or at least very rarely except in the Summer – The Natives will not touch it, because they say it emits a fluid that stings like a common Nettle – The Beauty of its colors are but very humbly imitated in this delineation – The skin is full of small tubercules of various shades terminating

Plate 159 [Watling 361]
THOMAS WATLING
Bearded dragon, *Pogona barbata* (Cuvier, 1829)
Water-colour, 187 × 307, signed 'Thomas Watling del.'
Inscribed 'One half the natural size' and 'Native name Ngarrang', both probably in Watling's hand.

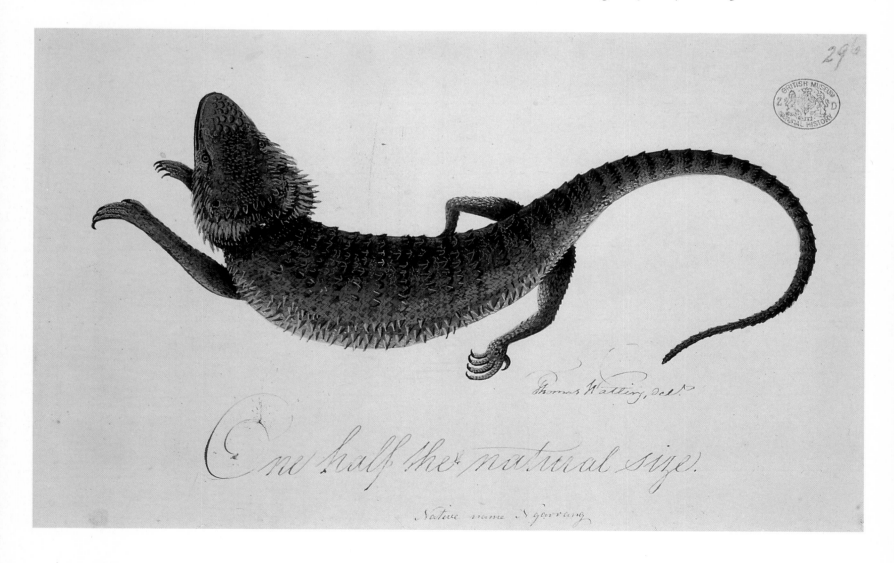

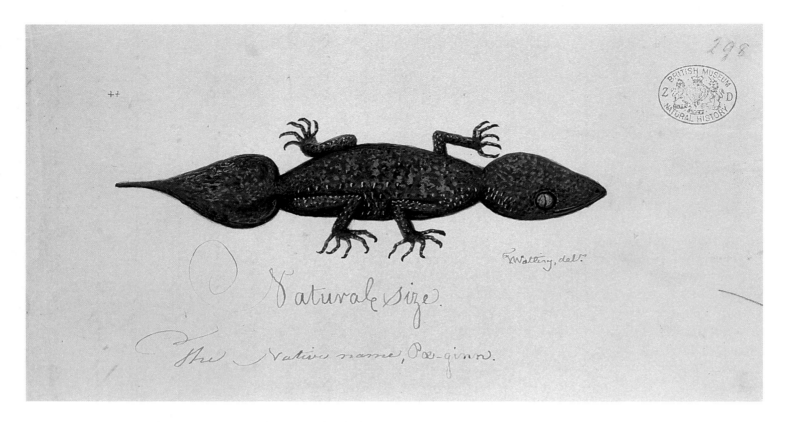

Plate 160 [Watling 363] *above*
THOMAS WATLING
Leaf-tailed gecko, *Phyllurus platurus*
(Shaw, 1790)
Water-colour, 120 × 230, signed
'Watling del.'
Inscribed 'Natural Size' and
'The Native name Pae-ginn', both
probably in Watling's hand.
Also inscribed on a label beneath
the drawing pasted on the mount:
'This broad tail'd Lizard is not very
common in N.S. Wales and | never
seen or at least very rarely except in
the Summer. | – The Natives will not
touch it, because they say it emits a |
fluid that stings like a common

Nettle. The Beauty of its | colors are
but very humbly imitated in this
delineation. – | The skin is full of
small tubercles of various shades
terminating | in points, which to
touch are quite rough. – Its Eyes are
prom | inent, the Iris beautifully
transparent with lengthen'd pupils |
standing perpendicular to the Earth
instead of round or Horizontal. |
Native Name Pae-ginn.'

Plate 161 [Watling 365] *below*
THOMAS WATLING
Lace monitor or goanna, *Varanus
varius* (Shaw, 1790)
Water-colour, 122 × 349, signed
'Tho: Watling del.'
Inscribed on a label pasted on the
mount, beneath the drawing: 'This
drawing is about one half the size of
Nature. However in that point they
vary exceedingly | for they are to be
found much larger, and also much
smaller, this Genus is not very |
numerous in New South Wales, like
all the Lizards and Guana tribe they
live in holes | of Rocks, the Earth,
&c, &c and Insects are their Food.'

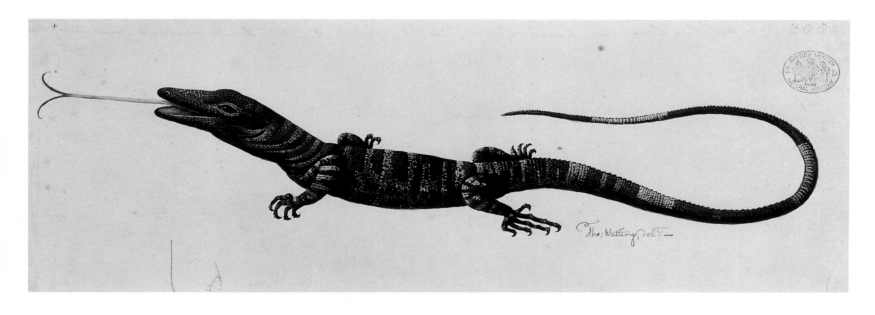

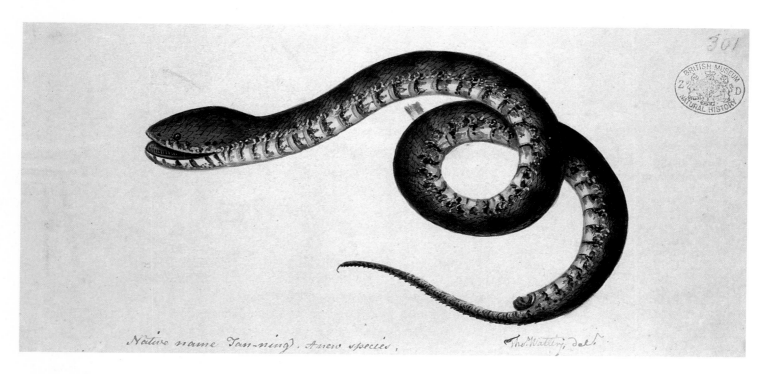

Plate 162 [Watling 366] *above*
THOMAS WATLING
Death adder, *Acanthophis
antarcticus* (Shaw, 1802)
Water-colour, 118 × 252, signed
'Tho? Watling del?'
Inscribed 'Native name Tan-ning.
A new species'.

Plate 163 [Watling 367] *below*
THOMAS WATLING
Diamond python, *Morelia spilota*
(Lacépède, 1804)
Water-colour, 93 × 277, signed
'T. Watling del?'
Inscribed 'About three feet long.
Native name Mal-lea'. See also plate
229.

Plate 164 [Watling 369] *bottom*
THOMAS WATLING
Bandy Bandy, *Vermicella annulata*
(Gray, 1841)
Water-colour, 88 × 287, signed
'T. Watling del?'
Inscribed 'Native name Wirra-ga- dera
about two feet in length, and it is eaten
by the Natives of New South Wales'.

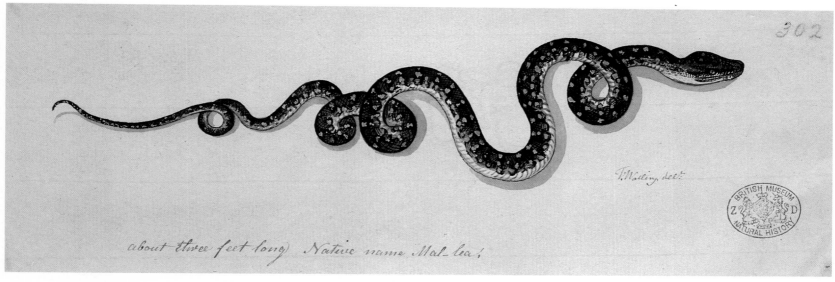

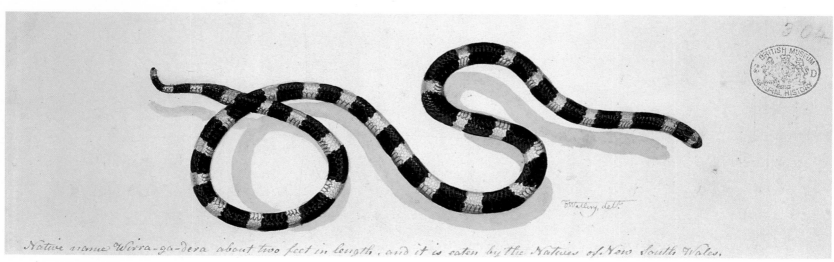

in points, which to the touch are quite rough. – Its Eyes are prominent, the Iris beautifully transparent with lengthened pupils standing perpendicular to the Earth instead of round or Horizontal – Native name Pae-ginn.' There is no basis for the reported belief of the Aborigines that this or any other species of lizard in the region produces a harmful fluid.

Lace monitor or goanna, *Varanus varius* (Varanidae) [plate 161]. The note pasted beneath the drawing reads 'This drawing is about one half the size of Nature. However in that point they vary exceedingly for they are to be found much larger and also much smaller. This Genus is not very numerous in New South Wales. Like all the lizards or Guana Tribe they live in holes of Rocks, the Earth, &c, &c and Insects are their food.' The example drawn by Watling must have been a juvenile as this species is a very large lizard, averaging 1.5m in total length and reaching up to 2m. It is carnivorous and eats insects, reptiles, small mammals, birds, especially nestlings, and carrion.

Death adder, *Acanthophis antarcticus* (Elapidae) [plate 162]. 'Native name Tanning. A new species.' The death adder is a very venomous snake and is regarded as dangerous. It has become very rare in the Sydney region.

Diamond python, *Morelia spilota* (Boidae) [plate 163]. 'About three feet long. Native name Mal-lea'. Watling's specimen was a small one as the average length of the diamond python is about 2m and it may reach 4m. The species is non-venomous.

Bandy Bandy, *Vermicella annulata* (Elapidae) [plate 164]. 'Native name Wirra-gadera about two feet in length, and it is eaten by the Natives of New South Wales.' The Bandy Bandy is venomous but not regarded as dangerous. It grows to about 40cm in total length.

Red-bellied black snake, *Pseudechis porphyriacus* (Elapidae) [plate 165]. 'The original about four feet long. A species of snake that the natives are much afraid of (though it is Harmless).' This snake is venomous and although not harmless it is not regarded as dangerous. It averages 1.5m in total length.

Plate 165 [Watling 368]
THOMAS WATLING
Red-bellied black snake, *Pseudechis porphyriacus* (Shaw, 1794)
Water-colour, 121 × 290, signed 'T Watling'
Inscribed in Watling's hand 'The Original about four feet long. A species of Snake that the natives are much afraid of', and in what may be another hand 'though it is Harmless'.

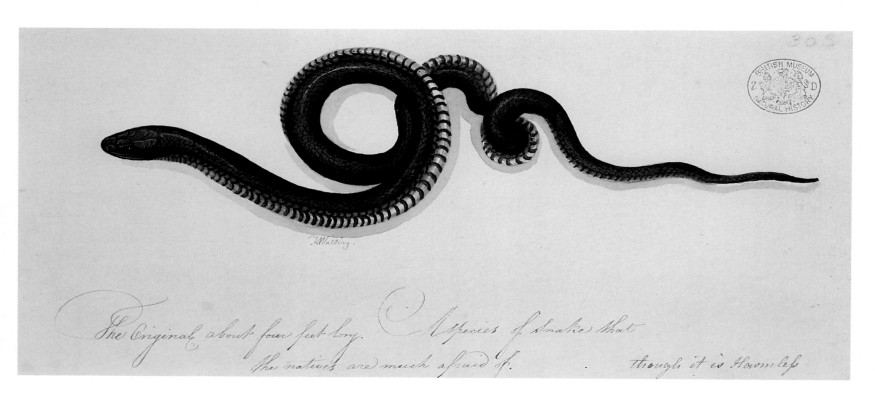

Mammals

Three of the drawings of mammals are signed by Watling [plates 153, 174, 179]; the others are unsigned but the style of all of them has at least some of the characteristics of the Port Jackson Painter. Watling 92 [plate 166] was misplaced among the mammals in its original portfolio. It is annotated 'N°. 1. the upper and 2. the under inside of the Mandibles of a very curious Animal drawn the Natural size'. Previously it had been thought that the drawing showed the mandibles of the monotreme echidna (*Tachyglossus aculeatus*). In fact it is a very good drawing of the mandibles of a pink-eared duck (*Malacorhynchus membranaceus*), the 'membranaceous duck' of Latham. According to Latham's manuscript list, Watling bird drawing no. 289 (old series) is an illustration of this duck but it is now missing from the series.

Plate 166 [Watling 92]
THOMAS WATLING
Mandibles of a Pink-eared duck,
Malacorhynchus membranaceus
(Latham, 1801)
Ink and water-colour, 166 × 137
Inscribed 'N°. 1. the upper, and 2 the under inside of the Mandibles of a very curious Animal, drawn the Natural size'.

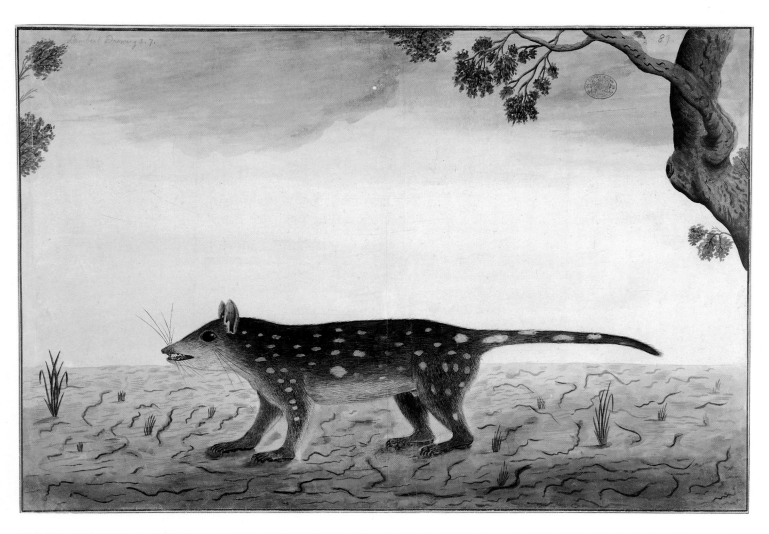

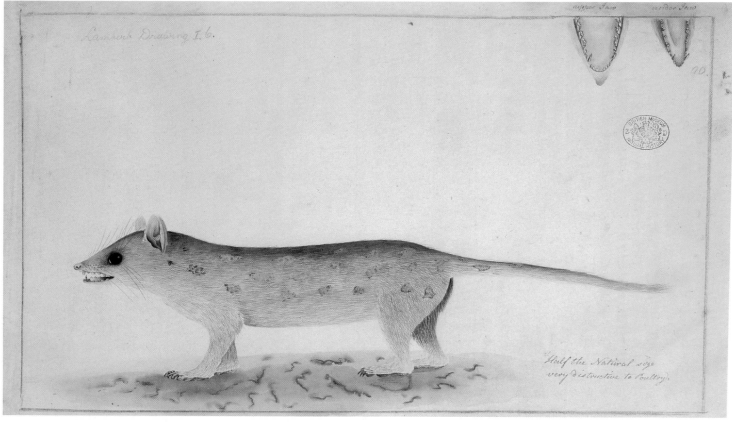

One of the drawings of mammals represents a rodent, two are of a monotreme, the echidna, and the remainder are of marsupials. The identities of the mammals, and the annotations to the drawings are as follows;

Tiger cat, *Dasyurus maculatus* (Dasyuridae) [plates 167, 168]. The latter appears to be a pale copy of the preceding one, but occlusal views of the upper and lower jaws are added to the upper margin of the latter. The first drawing is annotated 'The Natural size. Native name Mer-ri-e-gang. This animal is very distructive to Poultry etc. It was killed in a Fowl house, among Hens and Chickens'. Some of this information is repeated on the latter drawing. The tiger cat of eastern and south-eastern Australia including Tasmania, has become much less abundant because of the clearing of its forest habitat. It is rarely seen and even where it is relatively common it comes to notice usually only when raiding fowl-houses, as in the earliest days of the colony.

White-footed tree-rat, *Conilurus albipes* (Muridae) [plate 169]. Inscribed on a label beneath the drawing 'Natural size. Native name Gnar-ruck. This animal is not very common, tho more so in the interior parts than near the Shores. It sometimes gets into the Houses and live on Corn of every kind, it proves very distructive to Indian Corn. It sometimes burrows in the ground but it is oftener found to retreat into the holes of Rocks, or into hollow Trees. It has a false Belly or Pouch for its young like the Opossum tribe. It generally has two young ones.'

facing page

Plate 167 [Watling LS10]
PORT JACKSON PAINTER
Tiger cat, *Dasyurus maculatus* (Kerr, 1792)
Ink and water-colour, 372 × 545
Inscribed 'Lambert Drawing' 1.7.

Plate 168 [Watling 80]
PORT JACKSON PAINTER
Tiger cat, *Dasyurus maculatus* (Kerr, 1792)
Ink and water-colour, 225 × 384
Inscribed 'Half the Natural size very distructive to Poultry' (l.r.) and 'upper Jaw', 'under Jaw' (u.r.) in ink, and 'Lambert Drawing I.6.' in pencil.

Plate 169 [Watling 81]
PORT JACKSON PAINTER
White-footed tree-rat, *Conilurus albipes* (Lichtenstein, 1829)
Ink and water-colour, 241 × 266
Inscribed 'Native name Gnar-ruck' and 'Lambert Drawing I.3'.

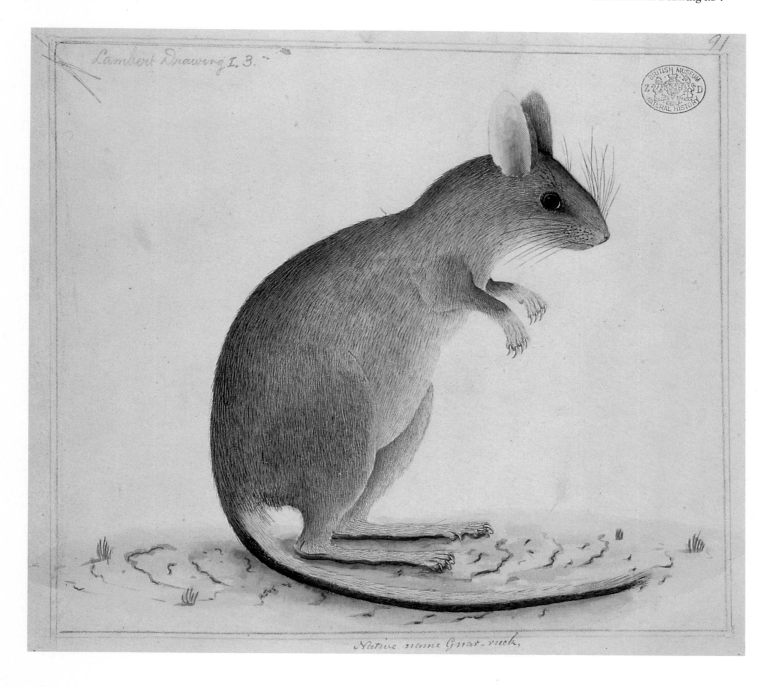

Plate 170 [Watling 82]
PORT JACKSON PAINTER
Long-nosed bandicoot, *Perameles nasuta* Geoffroy, 1804
Ink and water-colour, 188 × 320
Inscribed in pencil, 'Lambert Drawing I.9' and in ink, 'Nat. size: tail cut off' and 'Kangaroo Rat'.

Plate 171 [Watling 83]
PORT JACKSON PAINTER
Brown marsupial-mouse, *Antechinus stuartii* (Macleay, 1841)
Water-colour, 320 × 225
Inscribed in pencil 'Lambert Drawing III. 8', and beneath drawing in ink 'The Natural Size' and 'Native Name Mirrin. The Penes and Testacles made visible. The former placed between the latter and the Anus. This Animal I cut out of a fallen Rotten Tree, into which my Dog drove it'.

No living examples of this attractive indigenous rodent have been seen for over a century and it is certainly extinct. It seems to have been in decline even when the first settlers arrived, and although its bones are common in cave deposits in coastal south-eastern Australia, most of the few known specimens were collected much further inland. There seems to be no previous record of its presence in the Sydney area in historical times. The 'interior parts' of the above notes means no more than 20 or 30 kilometres from Sydney. Very few observations on the natural history of the living animal were made. The statement that the animal has a 'pouch for its young' is explained by the fact that females of this group of Australian rodents have four teats grouped together on the lower abdomen, and they produce small litters of precocious young that attach firmly to the teats and are dragged around by the mother for some considerable time after birth. In this characteristic they resemble superficially those species of marsupials that do not have pouches.

Long-nosed bandicoot, *Perameles nasuta* (Peramelidae) [plate 170]. 'Nat. size: tail cut off. Kangaroo rat.' This species remains common in eastern Australia, including some suburban areas of Sydney. It has no resemblance to a 'kangaroo rat'.

Brown antechinus or marsupial-mouse, *Antechinus stuartii* (Dasyuridae) [plate 171]. 'Native Name Mirrin. The Penes and Testacles made visible. The former placed between the latter and the Anus. The animal I cut out of a fallen Rotten Tree, into which my Dog drove it.' The brown marsupial mouse is common in eastern and south-eastern Australia including the Sydney area. Strangely enough, it was not described

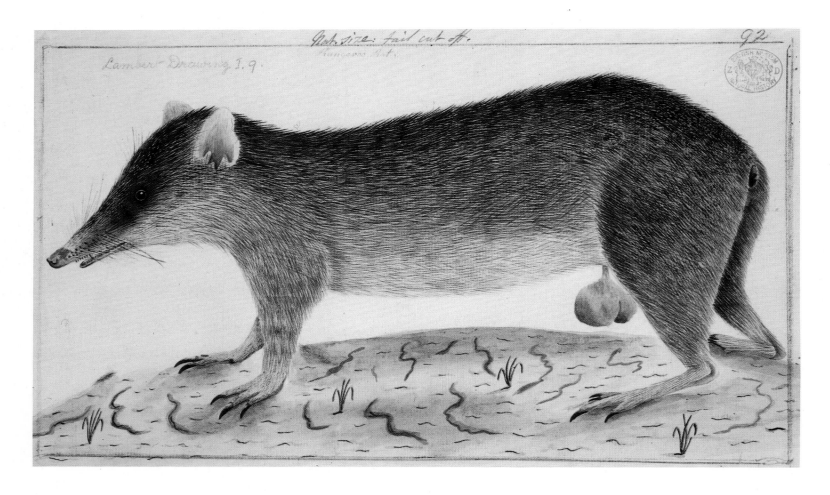

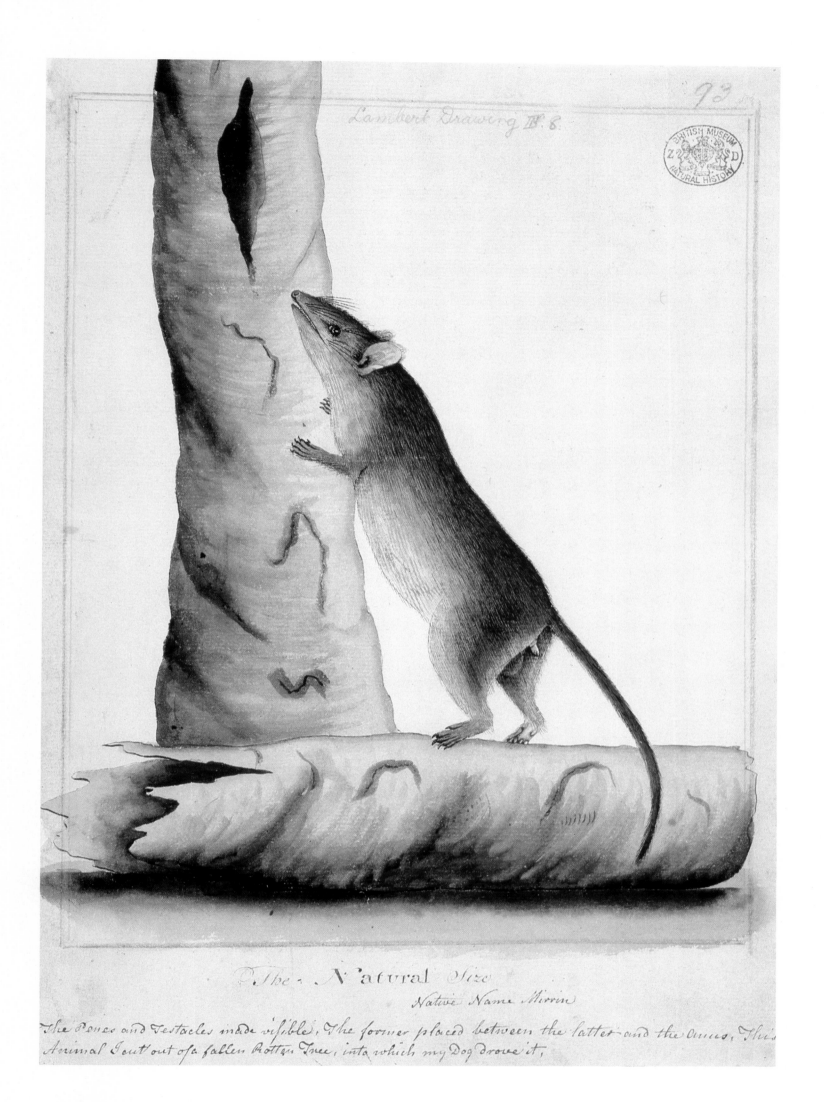

Lambert Drawing IV. 8.

The · Natural Size

Native Name Mirrin

The Penes and Testacles made visible. The former placed between the latter and the anus. This
Animal I cut out of a fallen Rotten Tree, into which my dog drove it,

scientifically until 1841. The arrangement of the male genitalia is a distinguishing feature of marsupials. Only in rabbits and hares among other mammals are the testes placed anterior to the penis, however in these animals they are relatively small and usually withdrawn, and go unnoticed even when descended. In general, marsupials have relatively very large testes. In his *Narrative* Tench had noticed this feature in male kangaroos and rather delicately observed that 'the testicles of the male are placed contrary to the usual order of nature'.[23]

Eastern native cat, *Dasyurus viverrinus* (Dasyuridae) [plate 172]. 'The native name of the brown Animal is Mer-re-a-gan, the black Din-e-gow-a.' The eastern native cat has two colour phases, black and fawn, as in this drawing, and there are no intermediate-coloured animals. Young of both colours may be found in the same litter irrespective of the colour of the parents. The native name given for the brown animal is similar to that recorded for the tiger cat (see above) and it is probable that the first settlers did not realize that they were dealing with two distinct species. This animal was once common in south-eastern Australia but none have been seen for at least two decades and it may have disappeared from the mainland. However, it remains common in Tasmania. Like the tiger cat it is an inveterate raider of unprotected fowl-houses.

Sugar glider, *Petaurus breviceps* (Petauridae) [plate 175]. 'Native name Dab-bee.' This is still a common species, including in the Sydney district.

Feathertail or pigmy glider, *Acrobates pygmaeus* (Burramyidae) [plates 173, 174, 176]. In the margin of plate 173 are diagrams of jaws labelled 'upper jaw' and 'under

Plate 172 [Watling 84]
PORT JACKSON PAINTER
Eastern native cat, *Dasyurus viverrinus* (Shaw, 1800)
Ink and water-colour, 173 × 286
Inscribed beneath the drawing, 'The native name of the brown Animal is Mer-re-a-gan, the black Din-e-gow-a', and in pencil 'Lambert Drawing. I.5'.

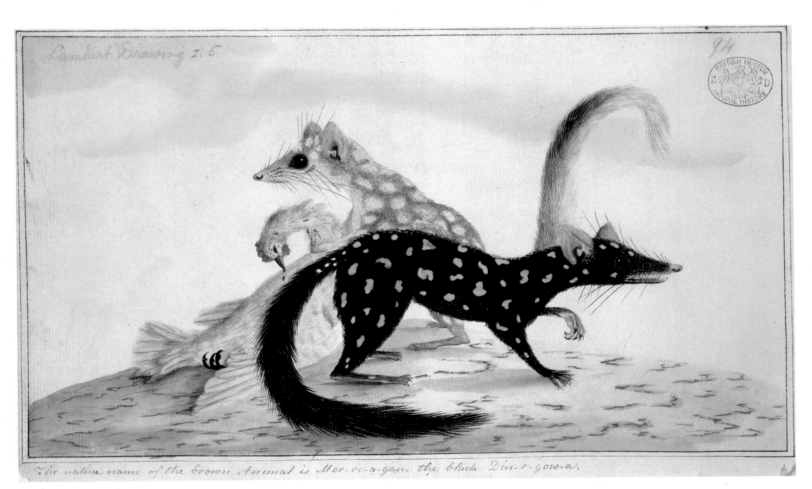

jaws'. These jaws and teeth are not those of the feathertail glider and probably not those of any other mammalian species. The feathertail glider remains a common species, including in the Sydney district.

Eastern grey kangaroo, *Macropus giganteus* (Macropodidae) [plate 177] (see also plate 150). Inscribed 'Kangoroo or The Pattagorang in the act of setting off on hearing a noise'. This is the common kangaroo of the forests and woodlands of eastern Australia.

Swamp wallaby, *Wallabia bicolor* (Macropodidae) [plate 178]. 'The Native Name Bag-ga-ree, or a species of Kangoroo. This Animal was run down by Grey Hounds and the only one of the color seen, it differs from the Pattegorang or Kangaroo a little in the shape of the Head and in the form of the Ears, but nothing so much as in the

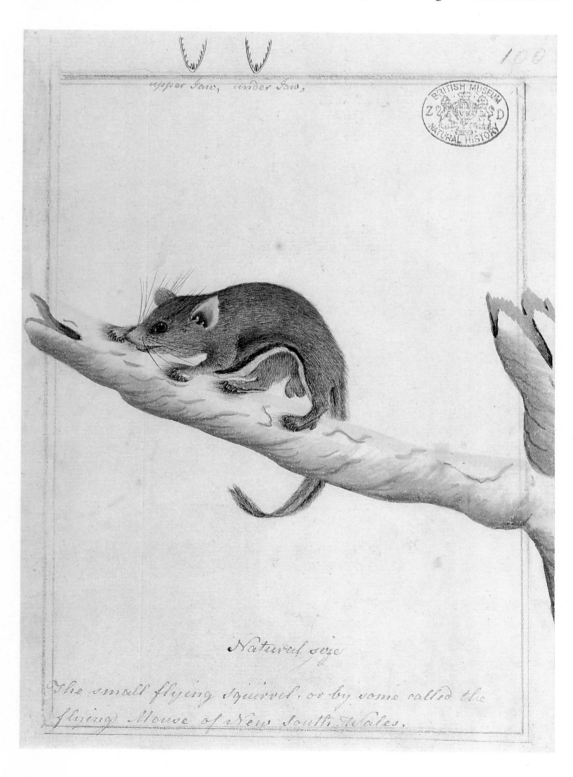

Plate 173 [Watling 90]
PORT JACKSON PAINTER
Feathertail or pigmy glider,
Acrobates pygmaeus (Shaw, 1793)
Water-colour, 205 × 146
Inscribed 'Natural size. The small
flying squirrel, or by some called the
flying Mouse of New South Wales.'
and 'upper Jaw', 'under Jaw'.

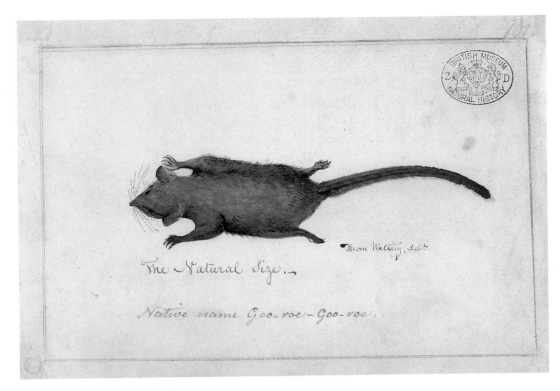

Plate 174 [Watling 97]
THOMAS WATLING
Feathertail or pigmy glider,
Acrobates pygmaeus (Shaw, 1793)
Water-colour, 123 × 176, signed
'Thom. Watling del.'
Inscribed 'The Natural Size' and
'Native name Goo-roe-Goo-roe'.

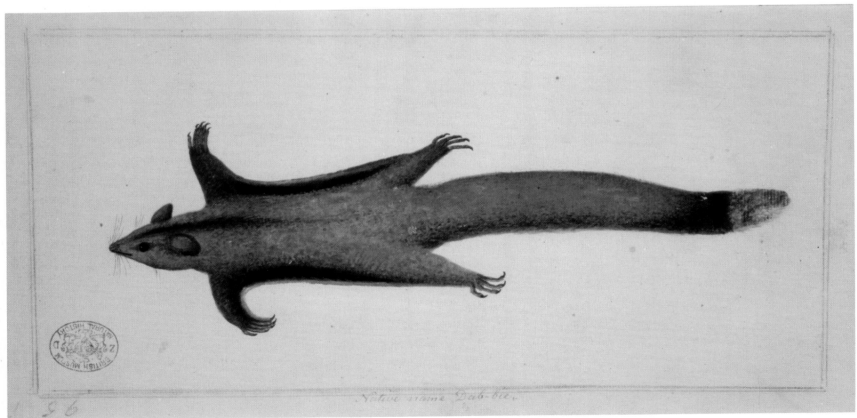

Plate 175 [Watling 85]
THOMAS WATLING
Sugar glider, *Petaurus breviceps*
(Waterhouse, 1839)
Ink and water-colour, 149 × 300
Inscribed beneath drawing 'Native
name Dab-bie'.

164

Tail, which has the Hair longer near the tip than in any other part. The hinder parts are not so much out of all proportion to the fore parts as in the Kangaroo. I take it to be a kind of mixed Genus between that Animal and some other perhaps the Kangaroo Rat. I was led to this conclusion because it was found near a Brush or low woody Swampy place where the Kangaroo Rats mostly frequent. Governor Phillips has taken home the Skin, and Bones of the Head'. This is a common large wallaby in eastern Australia. It shelters in dense vegetation as described in these early observations.

Probably the Potoroo, *Potorous tridactylus* (Potoroidae) [plate 153]. The drawing is signed by Watling, and there are no accompanying notes. This is a very poor drawing but it probably represents a potoroo. It is possibly based on an over-stuffed skin, or it may be a copy by Watling of a drawing by an artist with considerably less talent than Watling that Watling has himself signed.

Echidna, *Tachyglossus aculeatus* (Tachyglossidae) [plates 179, 180]. Plate 179 is signed by Watling, the other is unsigned. Watling's drawing is a good representation of the animal and is much superior to the other. The annotations to Watling's drawing are: 'Native name Burroo-gin. The Natives informed me this Animal (which is very shy and can conceal itself in the Earth by scratching a Hole with the greatest readiness & rapidity) tho' rarely seen by us is pretty numerous in the interior parts of the

Plate 176 [Watling 86]
PORT JACKSON PAINTER
Feathertail or pigmy glider,
Acrobates pygmaeus (Shaw, 1793)
Ink and water-colour, 153 × 246
Inscribed 'Natural size. This is a species of the flying squirrel or Mouse in the act of flying'.

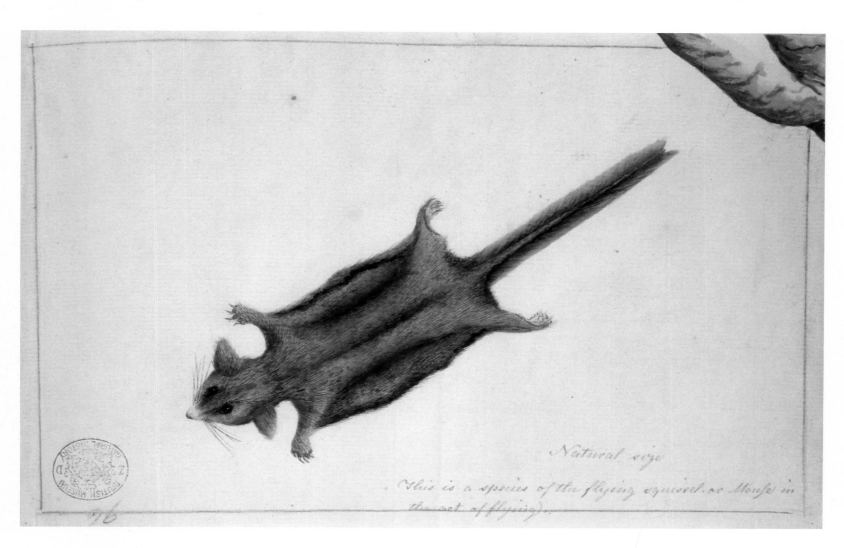

Country. They added that the flesh they consider a great delicacy. That the Animal lives a good deal on Ants being mostly found in the neighbourhood of their Hills, as will be seen by this Drawing which is about 1/5 part of the size of the Animal from which it was taken, but that they principally live on the Dew which they lick in with a red flesh Tongue well-fitted to their Extraordinary small Bill or Mouth – In the daytime we seldom or ever have seen any of them; the Natives say in the nights, or very late in the Evening or early in the Morning they may be discover'd (at least their Haunts) by a constant single Whistle which the natives well imitate, and by that means surprise them, before they discover their danger, or they can get off (for their gait or movements are slow and heavy) or burrow themselves in the Earth – The Tongue of this Animal is in Spirits with that of various Lizards & Guona's etc. Colebee has by comparing them to the size of another Animal which weigh'd from ten to twenty

Plate 177 [Watling 87]
PORT JACKSON PAINTER
Eastern grey kangaroo, *Macropus giganteus* (Shaw, 1790)
Ink and water-colour, 248 × 209
Inscribed beneath 'The Pattagorang in the act of setting off on hearing a noise', to which 'Kangoroo or' has been added in another hand.

Plate 178 [Watling 88]
PORT JACKSON PAINTER
Swamp wallaby, *Wallabia bicolor* (Desmarest, 1804)
Ink and water-colour, 118 × 221
Inscribed beneath drawing: 'The Native Name Bag-ga-ree, or a species of Kangoroo' and 'Scale of Four feet'. On label pasted on mount below drawing: 'This Animal was run down by Grey Hounds and the only one | of the color seen, it differs from the Pattegorang or Kangaroo | a little in the shape of the Head and in the form of the | Ears, but in nothing so much as in the Tail, which has | the Hair longer near the tip than in any other part. | The hinder parts are not so much out of all proportion to | the fore parts as in the Kangaroo. I take it to be a kind | of mixed Genus between that Animal and some other, per | haps the Kangaroo Rat. I was led to this conclusion because | it was found near a Brush or low woody Swampy place where | the Kangaroo Rats mostly frequent. Governor Phillips has | taken home the Skin, and Bones of the Head'. In browned ink in another hand, 'Native name Bag-ga-ree'.

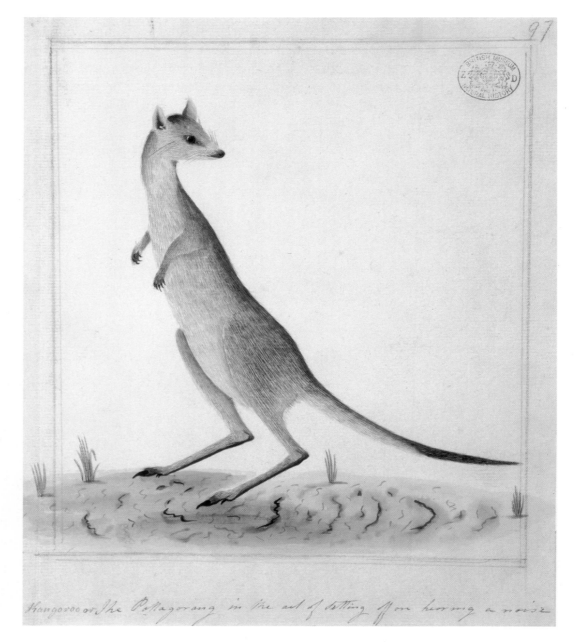

Kangoroo or The Pattagorang in the act of setting off on hearing a noise

pounds, satisfied me that they grow to that size.' The note to plate 180 states: 'This Animal was taken on a large red Ant-hill, it seems to live on them, therefore we gave it the name of the Ant eating Porcupine of N.S. Wales'. Some of the information provided by the Aborigines is fanciful. Dew could not be a food item but may be utilized as drinking water. There is no scientific basis for the supposed belief that the echidna produces a 'constant single whistle' as it is incapable of making sounds. Colebee's estimate of the weight is close to the mark; the largest echidnas weigh about 7 kg although the average weight is about 3 or 4 kg.

The second drawing [plate 180] is a very important one as it is the basis for the original scientific description. John White provided a copy to George Shaw who published it in his *Naturalists' Miscellany* (vol. 3, no. 36) in 1792, together with a Latin diagnosis and scientific name, and descriptive text, including a paraphrased

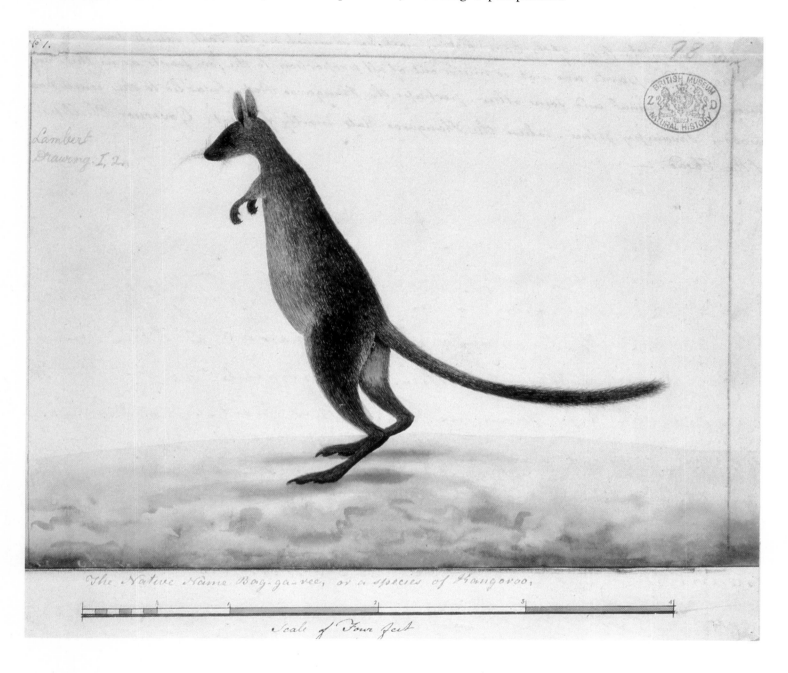

version of the annotations of the drawing in the Watling collection. Shaw's copy of the drawing with marginal notes in his handwriting acknowledging information from 'White', is in the Zoology Library, British Museum (Natural History).

The natural history drawings produced in the first few years of settlement made an enormous contribution to the scientific study of the Australian fauna even though, as knowledge advanced and considerable numbers of specimens became available in later years, many of the drawings were found to be inadequate as representations of their subjects. One interesting aspect arising from studies of the early drawings is the general inability of artists to come to grips with subjects that were quite outside their

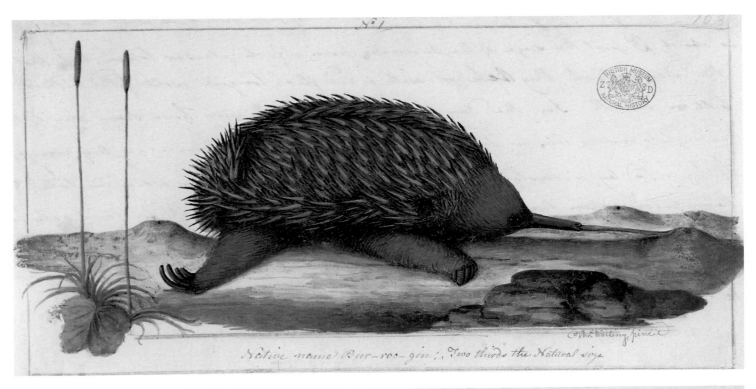

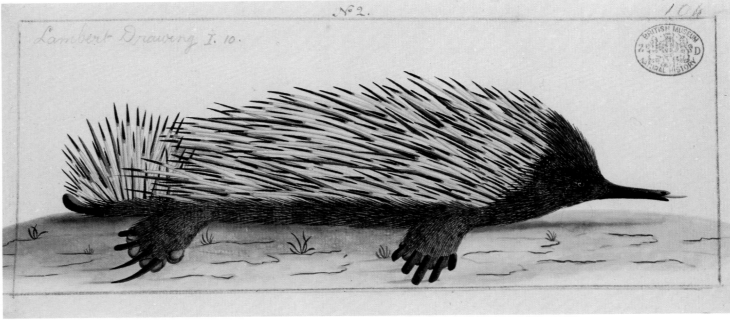

previous experience, such as the very large ground birds and the kangaroos. All of the early drawings of the emu [plate 181] are poor representations of the bird, although the cassowary in the drawing copied by Raper in Cape Town is a good illustration of this creature [plate 149]. The early drawings of members of the kangaroo family are very poor indeed, and the artists were seemingly unable to capture the bizarre body shape and means of locomotion of such large mammals. Parkinson's pencil sketches of a freshly dead kangaroo at the Endeavour River in 1770 are much better drawings,[24] and had Parkinson survived the voyage and produced a finished painting the early history of kangaroo illustration may well have taken a different course.

Plate 179 [Watling 93]
THOMAS WATLING
Echidna, *Tachyglossus aculeatus* (Shaw, 1792)
Ink and water-colour, 150 × 301, signed 'Thos Watling pinxit' Inscribed 'Native name Burroo-gin. Two thirds the Natural size', and on a sheet pasted below the drawing 'Nº 1 Native Name Burroo-gin | The Natives informed me this Animal (which is very shy and can conceal itself in the Earth by scratching a Hole with the greatest | readiness & rapidity) | tho' rarely seen by us is pretty numerous | in the interior parts of the Country; they added that the flesh | they consider a great delicacy; that the Animal lives a good | deal on Ants, being mostly found in the neighbourhood of | their Hills, as will be seen by this Drawing which is about | 1/5 part of the size of the Animal from which it was taken | but that they principally live on the Dew which they lick in | with a red flesh Tongue well fitted to their Extraordinary | small Bill or Mouth. In the Day time we seldom or ever | have seen any of them; the Natives say in the Nights, or | very late in the Evening, or early in the Morning they may | be discover'd (at least their Haunts) by a constant single Whistle | which the Natives well imitate, and by that means surprise | them, before they discover their danger, or they can get off (for | their gait or movements are slow and heavy) or burrow themselves | in the Earth. The Tongue of this Animal is in Spirits with | that of various Lizards and Guona's &c. Colebee has by com- | paring them to the size of another Animal which weigh'd | from ten to twenty pounds satisfied me that they grow | to that size'.

Plate 180 [Watling 94]
PORT JACKSON PAINTER
Echidna, *Tachyglossus aculeatus* (Shaw, 1792)
Ink and water-colour, 114 × 257
Inscribed on a label pasted on the mount below drawing: 'This Animal was taken on a large | red Ant-hill, it seems to live on | them, therefore we gave it the name | of the Ant eating Porcupine of N.S. | Wales'.

Plate 181 [Raper 67]
GEORGE RAPER
Emu, *Dromaius novaehollandiae* (Latham, 1790)
Ink and water-colour, 476 × 315, signed 'Geo Raper 1791'
Inscribed in Raper's hand: 'Emu of Port Jackson. References – 1. A Body Feather of the Natural size – 2 Its Egg 5 inches by 3¾ – from the only one yet seen'.

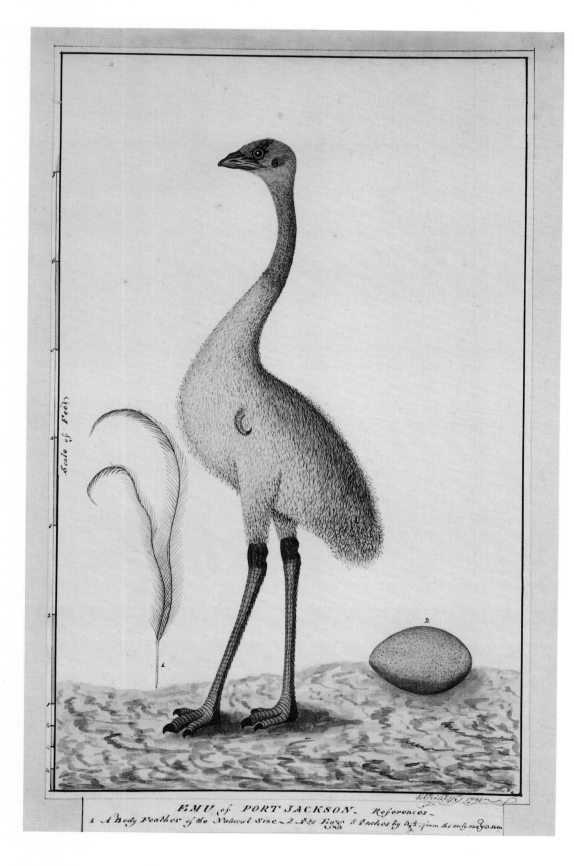

EMU of PORT JACKSON. References –
1 A Body Feather of the Natural Size – 2 Its Egg 5 Inches by 3¾ from the only one yet seen

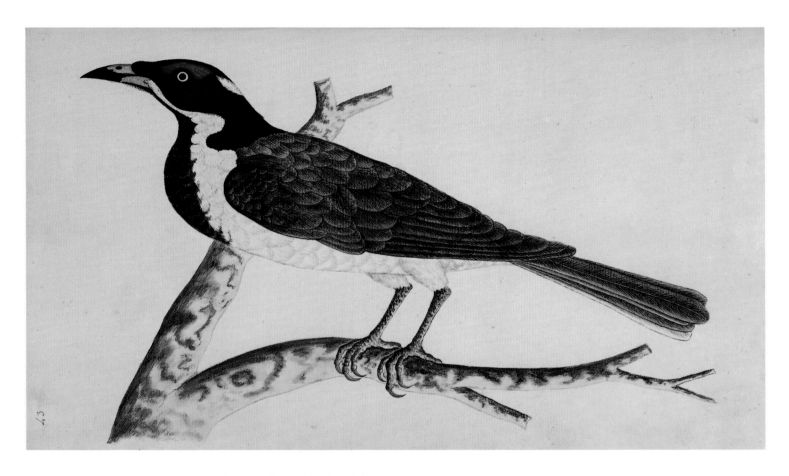

Plate 182 [Banks Ms34: 60]
PORT JACKSON PAINTER
Blue-faced honeyeater, *Entomyzon cyanotis* (Latham, 1801)
Water-colour, 205 × 318
This bird is now very rarely seen in the Sydney district. The species was probably common in the first years of the colony as it is represented in all of the early collections of drawings.

Plate 183 [Raper 49]
GEORGE RAPER
Blue-faced honeyeater, *Entomyzon cyanotis* (Latham, 1801) with a native iris, *Patersonia* sp., and a sundew, *Drosera* sp.
Water-colour, 332 × 498, signed 'Geo Raper 1789'
Inscribed 'Bird & Flower of Port Jackson – Natural Size'.

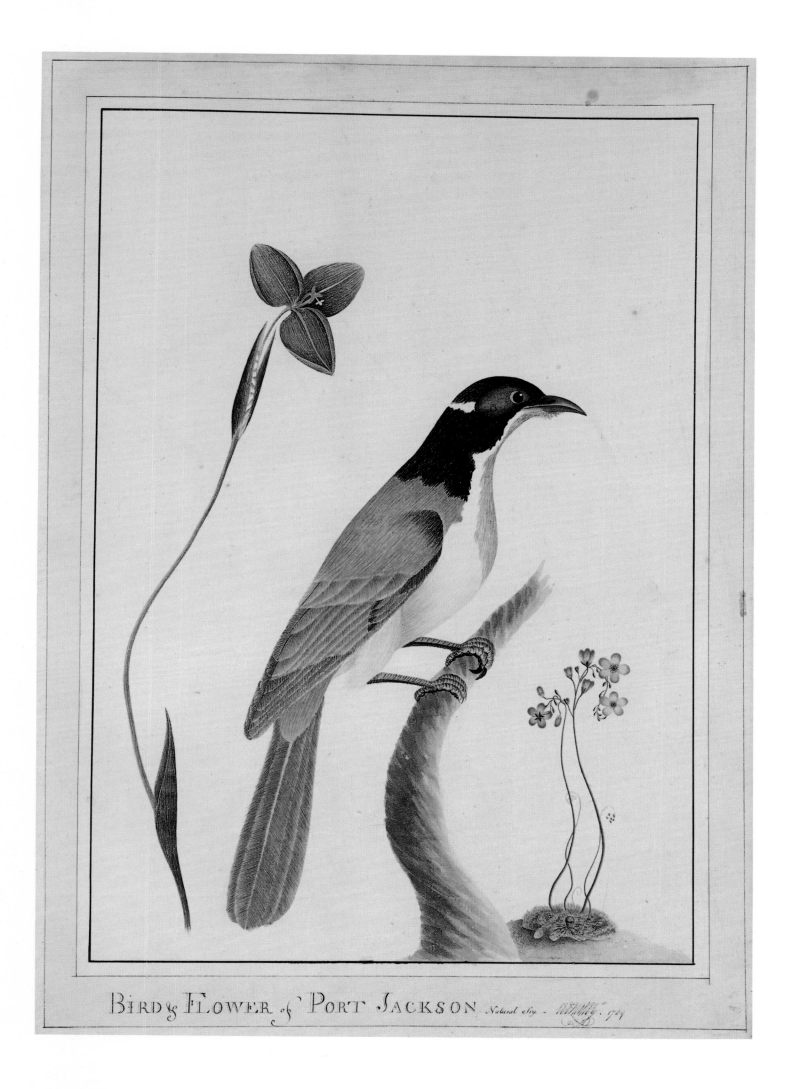

BIRD & FLOWER of PORT JACKSON *Natural Size* - W. White 1789

Plate 184 [Banks Ms34: 23]
PORT JACKSON PAINTER
Scarlet robin, *Petroica multicolor
boodang* (Lesson, 1837), male of
eastern Australian subspecies (above)
and Flame robin, *Petroica phoenicea*
Gould 1837, male.
Water-colour, 318 × 205
The scarlet robin of eastern Australia
differs from the subspecies of
Norfolk Island (plate 185) in having
more white in the wings, and in the
outer tail feathers.

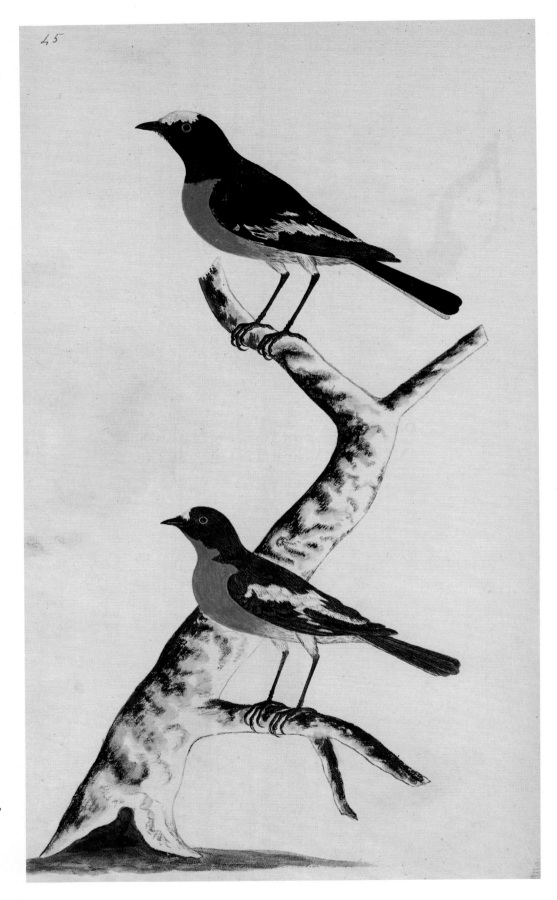

Plate 185 [Raper 69] *opposite*
GEORGE RAPER
Scarlet robin, *Petroica multicolor,*
(Gmelin, 1789) male, Norfolk Island,
and Grey-headed thrush, *Turdus
poliocephalus* Latham, 1801,
Norfolk Island
Water-colour, 479 x 322, signed
'Geo Raper 1790'
Inscribed in Raper's hand 'Birds of
Norfolk Island'.
Both the Scarlet robin and Grey-
headed Thrush were once very
common on Norfolk Island. The
robin still persists in reasonable
numbers but is restricted to the
remaining stands of tall native
vegetation. The thrush has declined
drastically and appears to be close to
extinction.

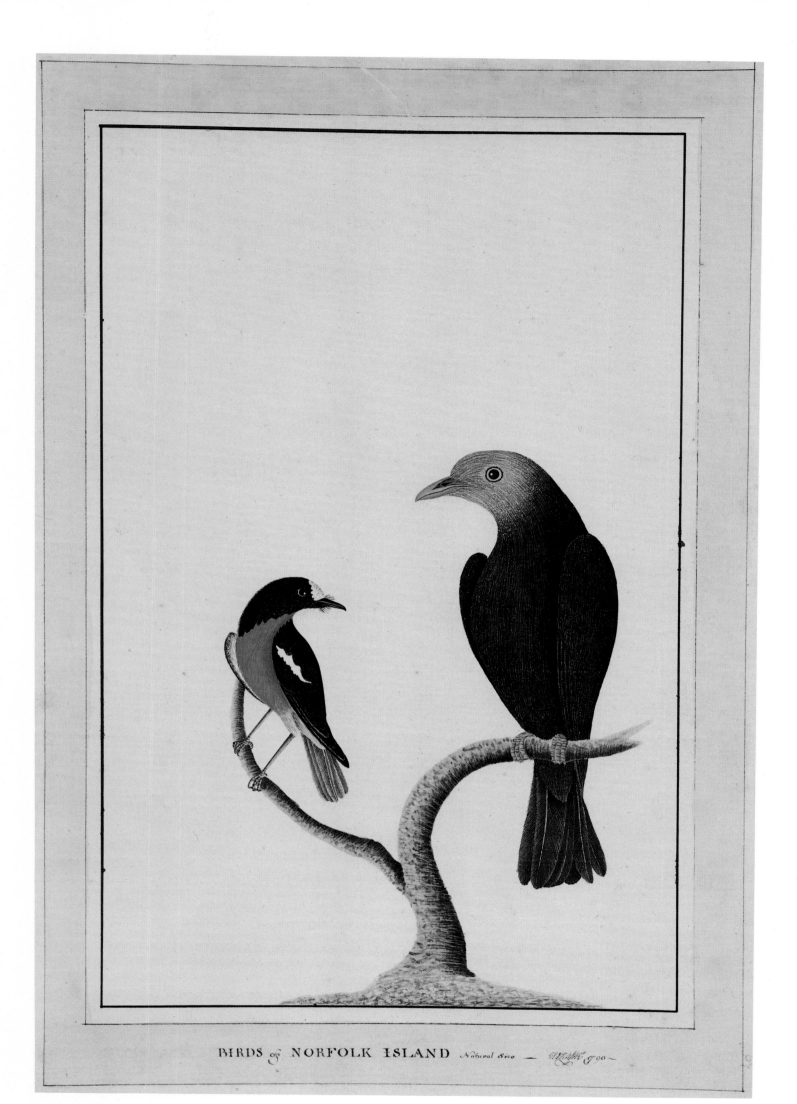

BIRDS of NORFOLK ISLAND *Natural Size* — *P. Raper. 1790*

173

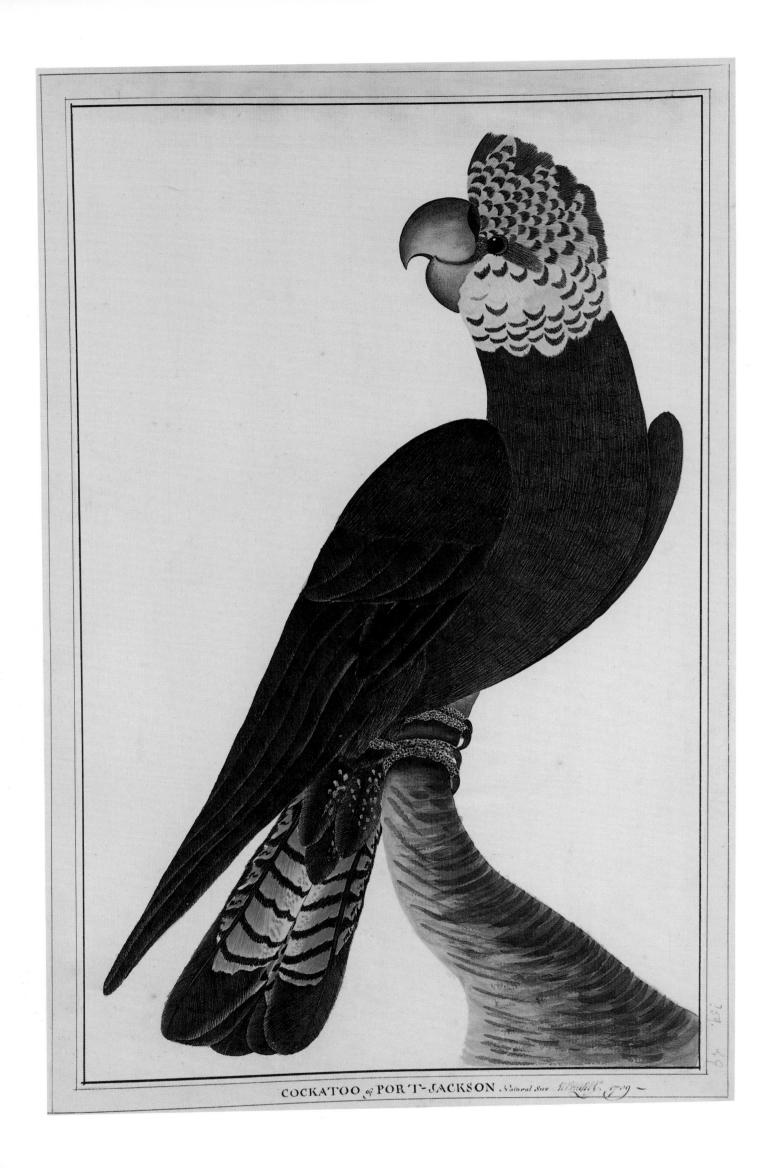

COCKATOO of PORT-JACKSON *Natural Size* *W. Raper. 1789*

174

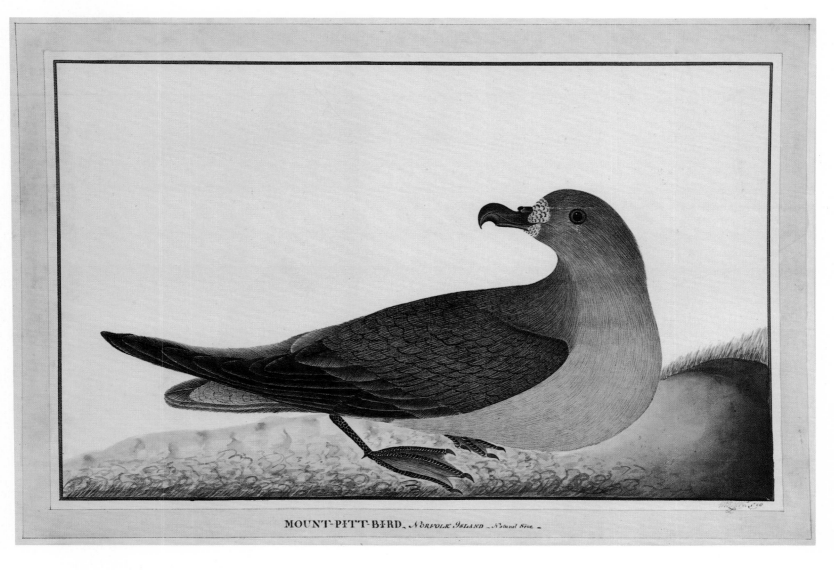

MOUNT-PITT-BIRD. *NORFOLK ISLAND* - *Natural Size* -

Plate 186 [Raper 59]
GEORGE RAPER
Glossy cockatoo, *Calyptorhynchus
lathami* (Temminck, 1807), female
Water-colour, 488 × 314, signed
'Geo Raper 1789'
Inscribed in Raper's hand 'Cockatoo
of Port Jackson Natural Size'. This
cockatoo has not been seen in the
Sydney district for many years.

Plate 187 [Raper 70]
GEORGE RAPER
Providence petrel, *Pterodroma
solandri* (Gould, 1844)
Water-colour, 333 × 491, signed
'Geo. Raper 1790'
Inscribed in Raper's hand 'Mount
Pitt Bird. Norfolk Island. Natural
Size'.
At the beginning of settlement this
bird bred on Norfolk Island in
hundreds of thousands. In the winter
of 1790 the penal colony was
stricken by famine and the easily-
caught breeding petrels were virtually
the only food available. Humans and
pigs eliminated the species by 1800.
In 1985 a small breeding colony was
found on Philip Island a few
kilometres south of Norfolk Island.
This is apparently a new breeding
place, the pioneers coming
presumably from Lord Howe Island,
the only other known breeding place.

Plate 188 [Raper 71]
GEORGE RAPER
Lord Howe Island wood-hen,
Tricholimnas sylvestris (Sclater,
1869)
Water-colour, 482 × 320, signed
'Geo Raper 1790'
Inscribed in Raper's hand 'Ground-
Bird of Lord-Howe-Island. ¼ Less
Natural Size'.
The species, endemic to Lord Howe
Island, was common when the island
was discovered in 1788. Over the
years interference by humans and the
introduced rats and pigs led to a
drastic decline in numbers so that by
1978–81 less than twenty of the
species remained. A vigorous
programme of scientific study,
captive breeding and release, and the
elimination of feral pigs, begun in
1980 by the New South Wales
government, have led to a
remarkable recovery.

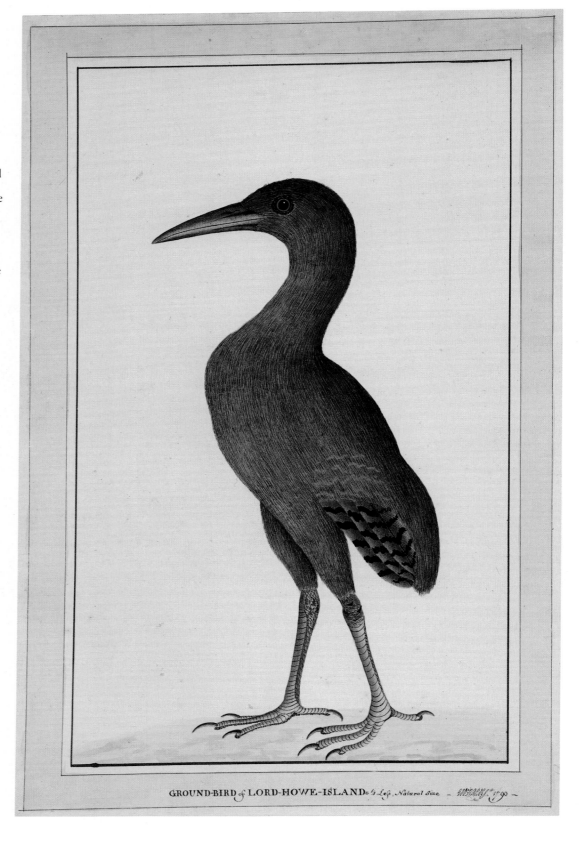

GROUND-BIRD of LORD-HOWE-ISLAND. ¼ Less. Natural Size – *Geo Raper* 1790 –

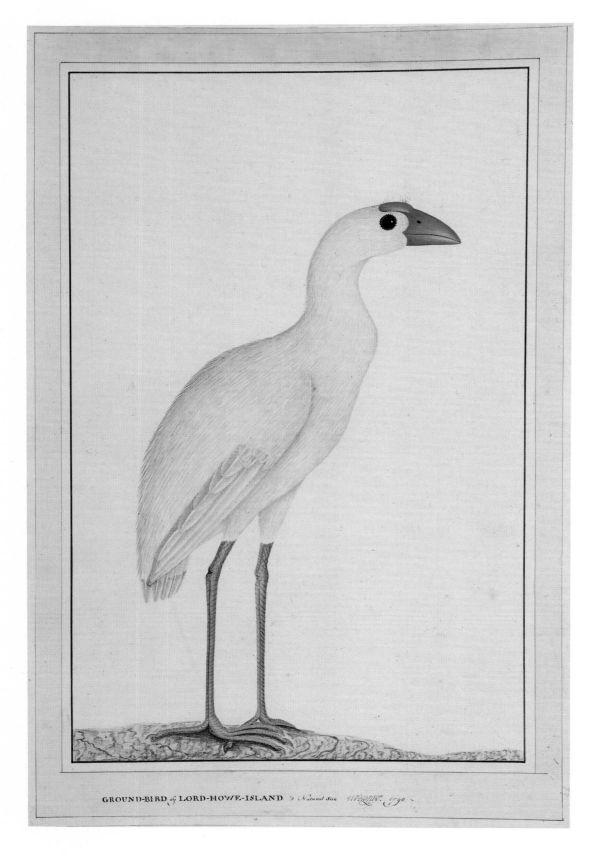

GROUND-BIRD of LORD-HOWE-ISLAND ½ Natural Size Geo Raper 1790

Plate 189 [Raper 73]
GEORGE RAPER
White gallinule (swamp-hen),
Porphyrio albus (Shaw, 1790)
Water-colour, 481 × 317, signed
'Geo Raper 1790'
Inscribed in Raper's hand 'Ground-
Bird of Lord Howe Island. ½
Natural Size'.
The species, endemic to Lord Howe
Island, was apparently reasonably
common when the island was
discovered but became extinct within
fifty years. Hindwood (1940)
summarized all that is known of the
bird and also published coloured and
half-tone photographs of various
drawings of the bird in the Watling
and Raper collections.

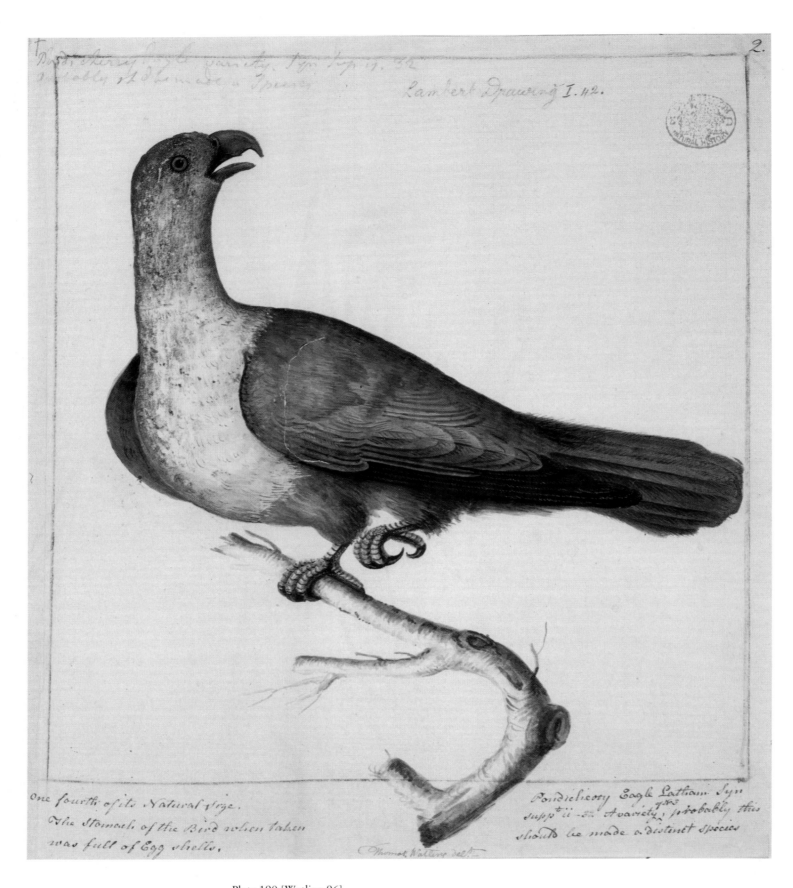

Plate 190 [Watling 96]
THOMAS WATLING
Brahminy kite, *Haliastur indus*
(Boddaert, 1783)
Ink and water-colour, 291 × 259,
signed 'Thomas Watling del!'
Inscribed in pencil 'Lambert
Drawings I. 42', and in ink 'One
fourth of its Natural Size. The
Stomach of the Bird when taken was
full of Egg shells'. In another hand
'Pondicherry Eagle Latham Syn
supp! ii. 32. A variety of No 3
probably this should be made a
distinct species'.
This species has long since
disappeared from the Sydney region.

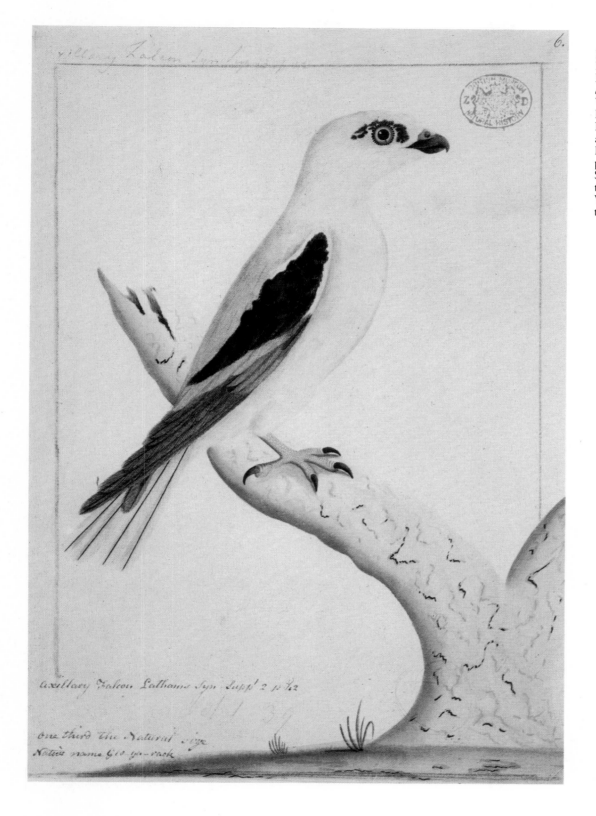

Plate 191 [Watling 100]
PORT JACKSON PAINTER
Black-shouldered kite, *Elanus axillaris* (Latham, 1801)
Water-colour, 262 × 181
Inscribed 'One-third the Natural size. Native name Geo-ga-rack' and in another, later, hand 'Axillary Falcon Lathams Syn, Supp! 2. p.42'. In pencil 'Vol 1 39'.
Schodde and Mason (1980) selected this drawing, one of four in the Watling collection, to represent the type of the species.

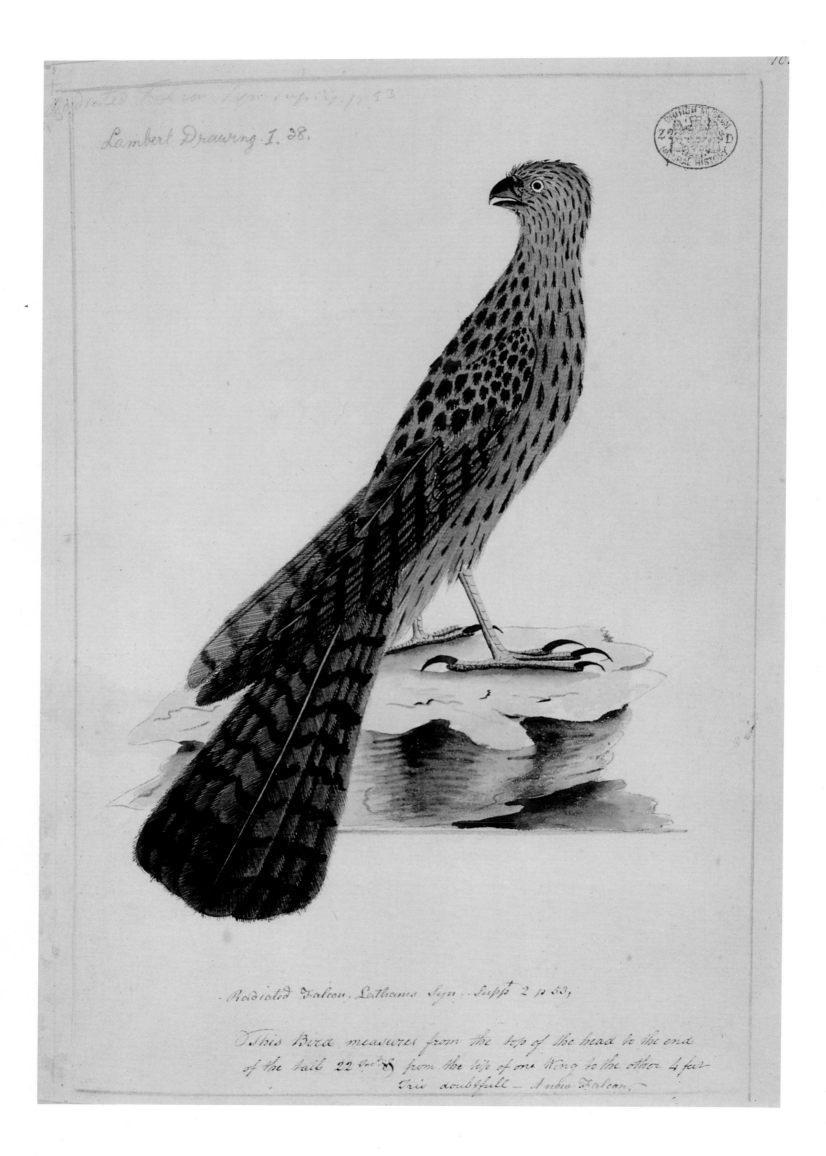

Radiated Falcon. Latham's Syn. Supp. 2 p. 53,

This Bird measures from the top of the head to the end
of the tail 22 inches. from the tip of one Wing to the other 4 feet
This doubtfull — A new Falcon.

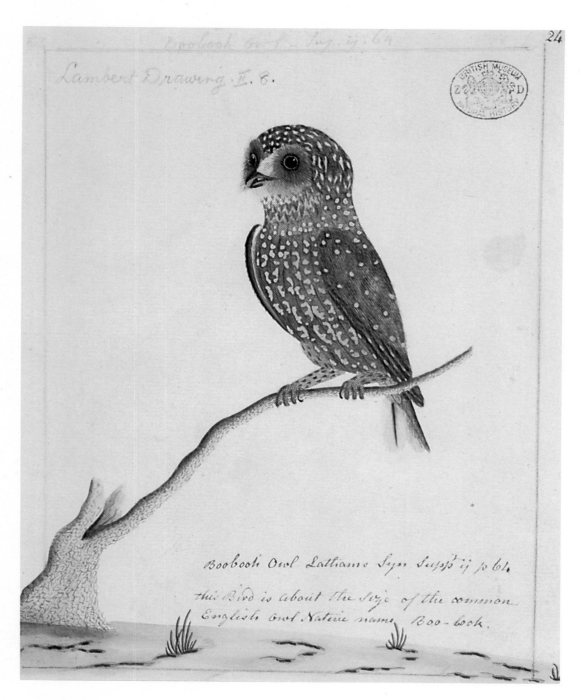

Plate 192 [Watling 103]
PORT JACKSON PAINTER
Red goshawk, *Erythrotriorchis
radiatus* (Latham, 1801)
Water-colour, 310 × 218
Inscribed on the bottom of the sheet
'This bird measures from the top of
the head to the end of the tail 22inc
& from the tip of one Wing to the
other 4 feet Iris doubtfull' apparently
in Watling's hand, and in browned
ink 'A new Falcon'. On a label
pasted on the folio beside the
drawing 'The Skin of this Bird I
found nail'd up to a Settler's Hut, it |
is the only one of the kind ever seen.
The Drawing is a faith | ful Copy.
The Settler who shot it says the Iris
was Brown, | and remarked that he
never saw any Bird fly with such |
Swiftness. Its claws which were long
small & sharp when | he took it up,
it drove quite thro' the end of his
Finger'.
In pencil at u.l. 'Lambert Drawing
I.28' and in ink and also in pencil
'Radiated Falcon Latham Syn . . .
suppt. 2.p. 53'.
The original scientific description
of the species was based on this
drawing.

Plate 193 [Watling 114]
PORT JACKSON PAINTER
Boobook owl, *Ninox boobook*
(Latham, 1801)
Water-colour, 210 × 171
Inscribed 'This Bird is about the Size
of the common English Owl, Native
name Boo-book' and in a later hand
above 'Boobook Owl. Lathams Syn,
Suppt. ii p. 64'. In pencil 'Lambert
Drawing II 8'.
The original scientific description
of the species was based on this
drawing.

Plate 194 [Watling 117]
THOMAS WATLING
Grey butcherbird, *Cracticus torquatus* (Latham, 1801)
Water-colour, 202 × 188, signed 'Tho: Watling del:'
Inscribed 'This Drawing is about half the Natural Size' and in another hand, 'Clouded Shrike Latham Syn Supp¹ ii, p 73'. In pencil 'Lambert Drawing III.32'.
The original scientific description of the species was based on this drawing.

Plate 195 [Watling 162]
THOMAS WATLING
Sittella, *Daphoenositta chrysoptera* (Latham, 1801)
Water-colour, 158 × 178, signed 'T. Watling del:'
Inscribed beneath drawing: '¾' of its Natural size. Native name Mur-ri-gang. Orange winged. Nuthatch very rare. Lathams Syn Supp¹ ii p. 146', and in pencil above the drawing: 'Orange winged Nuthatch. Syn Supp. ii p. 146', and 'Lambert Drawing III. 6'.
The original scientific description of the species was based on this drawing.

Plate 196 [Watling 132]
THOMAS WATLING
Turquoise parrot, *Neophema pulchella* (Shaw, 1792)
Water-colour, 297 × 204, signed 'Thos Watling del:'
Inscribed beneath the drawing in Watling's copperplate hand 'About 1/3 the Natural Size', followed in his informal hand by: 'The feathers of the head, and shoulder of the wing, are of the most brilliant lightest azure. The strongest quill feathers are equal as to cleanness of colour, but of a middling deep mazarine blue, tipped with black. The whole of the birds colours are delightful; but these most especially, the best artist must ever despair of equalling'. Above the drawing is a further inscription: 'The two centre tail feathers are entirely green, the two next have a little yellow on the tips or points, which increases in all the tail feathers, until the two outer ones on each side are perfectly yellow from the centre or two green feathers, the five others on each side regularly decrease in length, this is a rare Bird in N.S. Wales, is of short flight, never seen in more than pairs and oftener seen on the ground than perched on Trees'. In pencil along the top of the drawing: 'Turcosine parrot Sup 2. 19'.

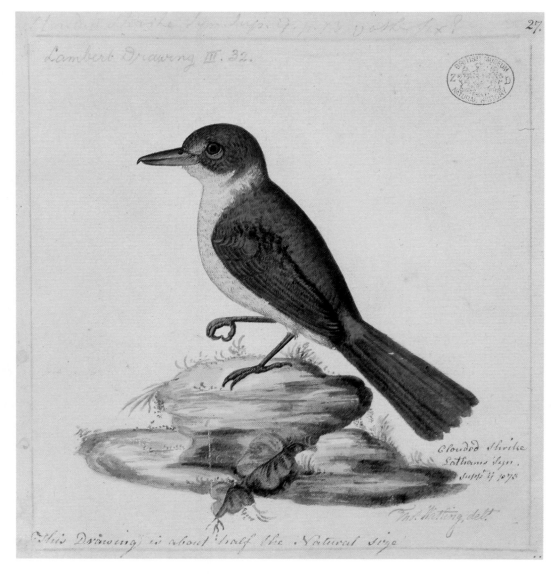

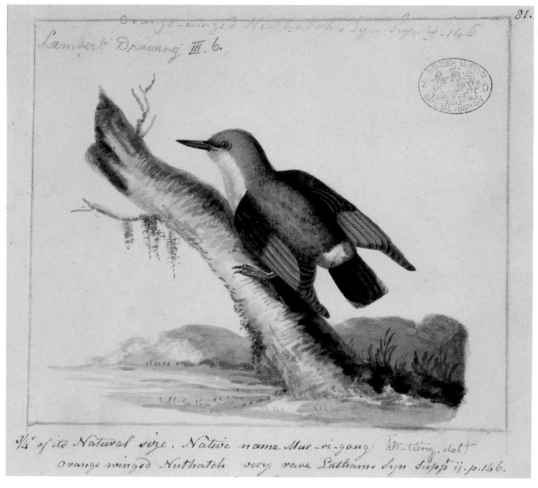

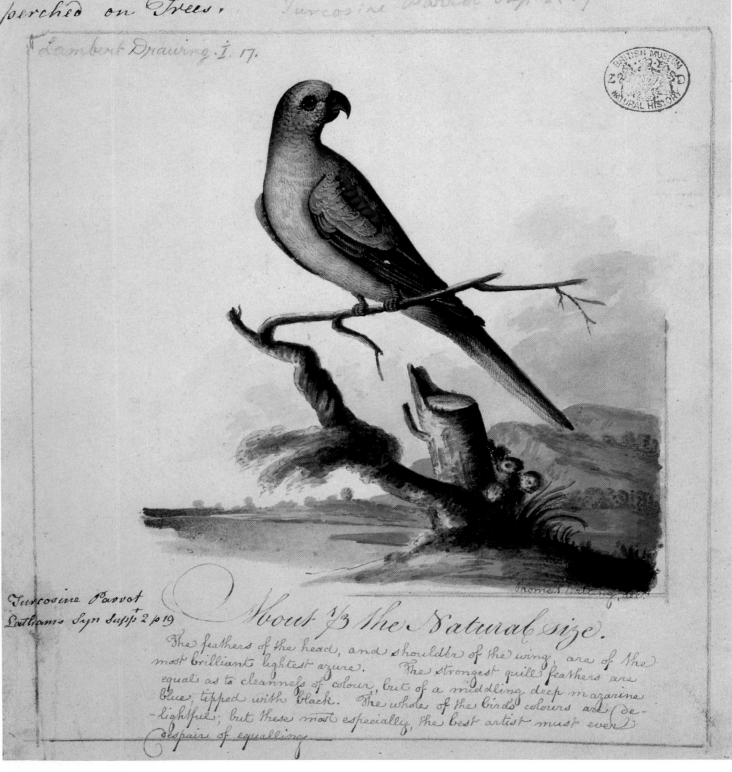

The two centre tail feathers are entirely green, the two next have a little Yellow on the tips or points, which increases in all the tail feathers, until the two out-er ones on each side are perfectly Yellow from the centre or two green feathers, the five others on each side regularly decrease in length, this is a rare Bird in N. S. Wales, is of short flight, never seen in more than pairs and oftener seen on the ground than perched on Trees. Turcosine Parrot Sup 2. 19

Lambert Drawing I. 17.

Turcosine Parrot
Lathams Syn Supp 2 p 19

About 2/3 the Natural size.

The feathers of the head, and shoulder of the wing, are of the most brilliant lightest azure. The strongest quille feathers are equal as to cleanness of colour, but of a middling deep mazarine blue, tipped with black. The whole of the birds colours are de-lightful; but these most especially, the best artist must ever despair of equalling.

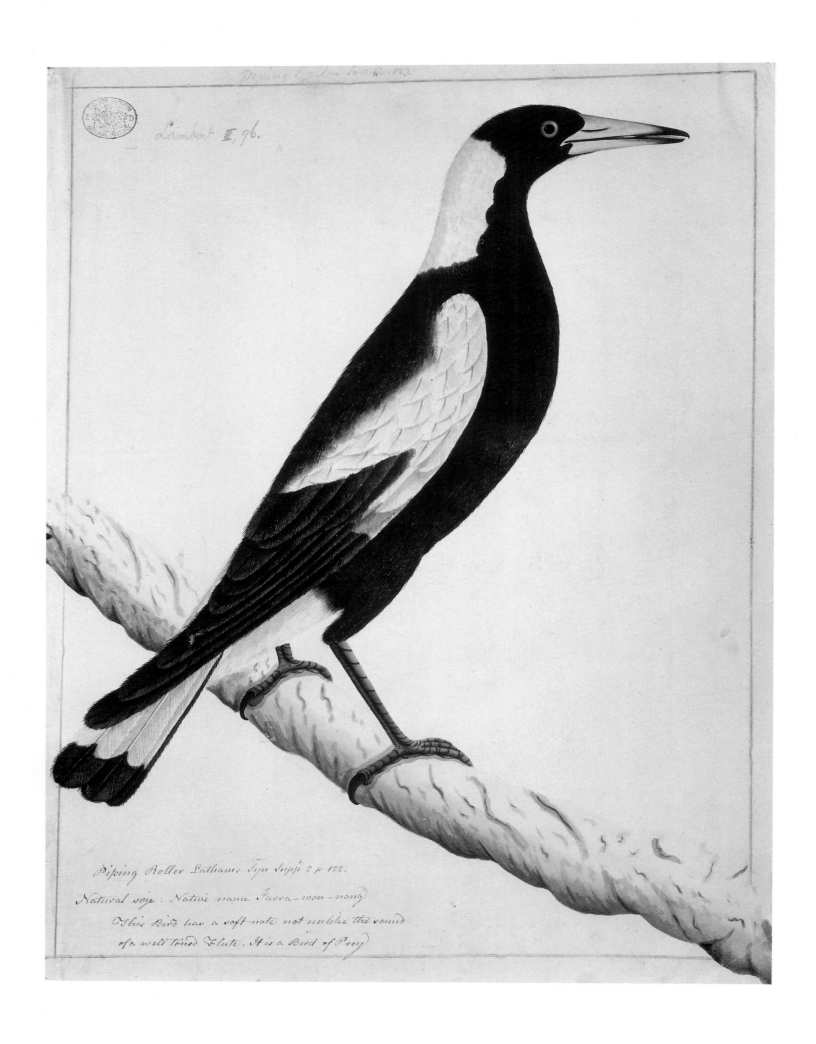

Piping Roller Lathams Syn Supp 2 p. 122.

Natural size. Native name Tarra-wou-nang.

This Bird has a soft note not unlike the sound
of a well toned Flute. It is a Bird of Prey

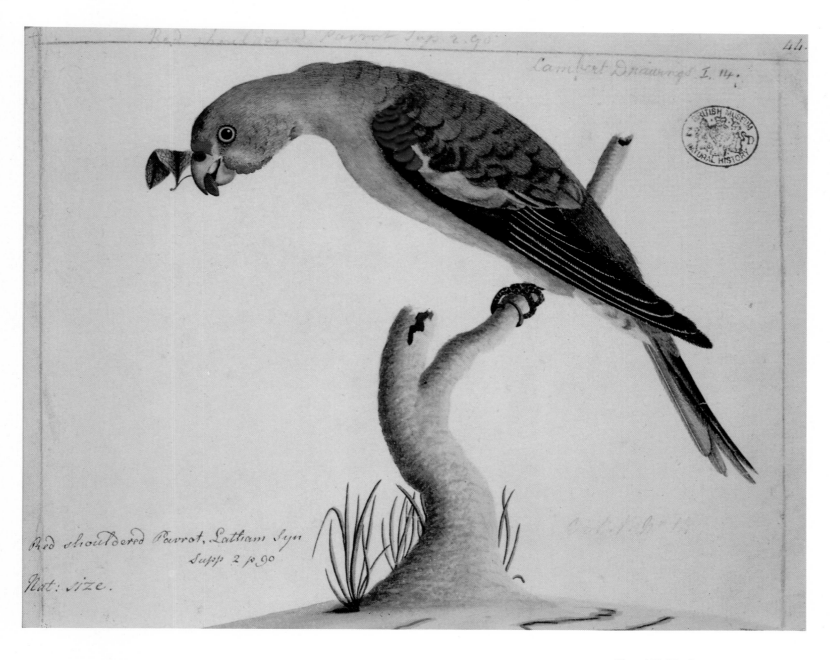

Plate 197 [Watling LS13]
PORT JACKSON PAINTER
Australian magpie, *Gymnorhina
tibicen* (Latham, 1801)
Water-colour, 425 × 328
Inscribed beneath drawing: 'Piping
Roller. Lathams Syn Supp' 2 p 122.
Natural size. Native name Jarra-
won-nang. This Bird has a soft note
not unlike the sound of a well toned
Flute. It is a Bird of Prey'. Above the
drawing in pencil: 'Piping Roller Sup
2 122', and 'Lambert. II. 96'.
The original scientific description
of the species was based on this
drawing.

Plate 198 [Watling 131]
PORT JACKSON PAINTER
Swift parrot, *Lathamus discolor*
(Shaw, 1790)
Water-colour, 186 × 236
Inscribed 'Nat: size.' and in a
later hand above 'Red shouldered Parrot.
Latham Syn Supp 2 p 90'. In pencil
'Lambert Drawings I.14'.
The species was described
scientifically and engraved in White
(1790) plate 29 from an original
drawing by Sarah Stone, which was
distinct from this one and does not
appear in the Banks Ms34.

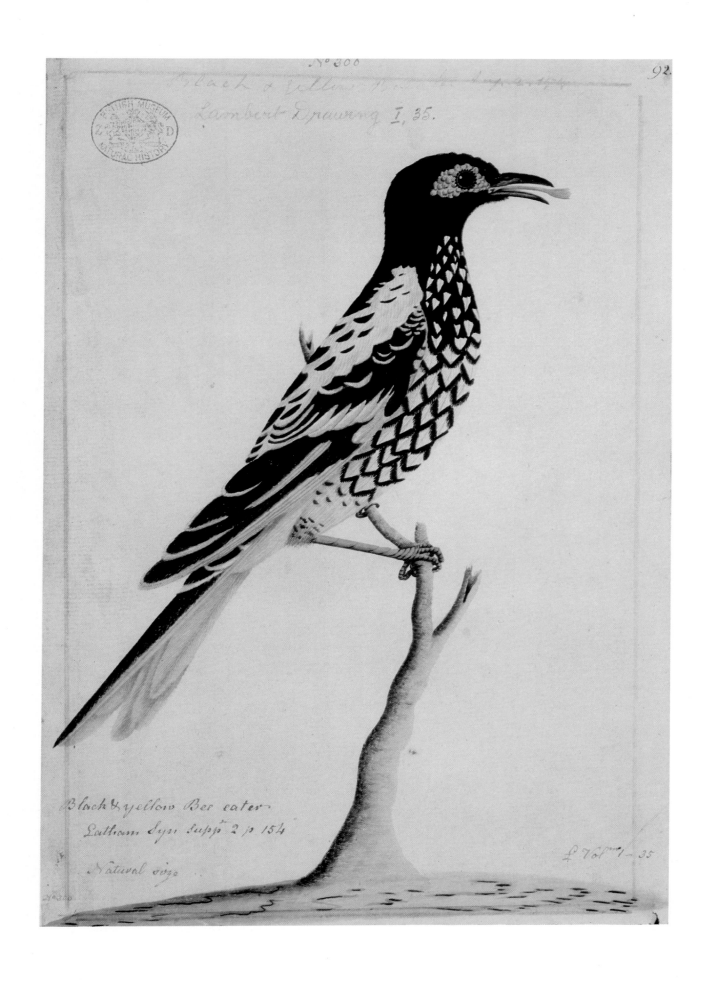

No 300

Lambert Drawing I, 35.

Black & yellow Bee eater
Latham Syn supp 2 p 154

Natural size

L Vol 1 — 35

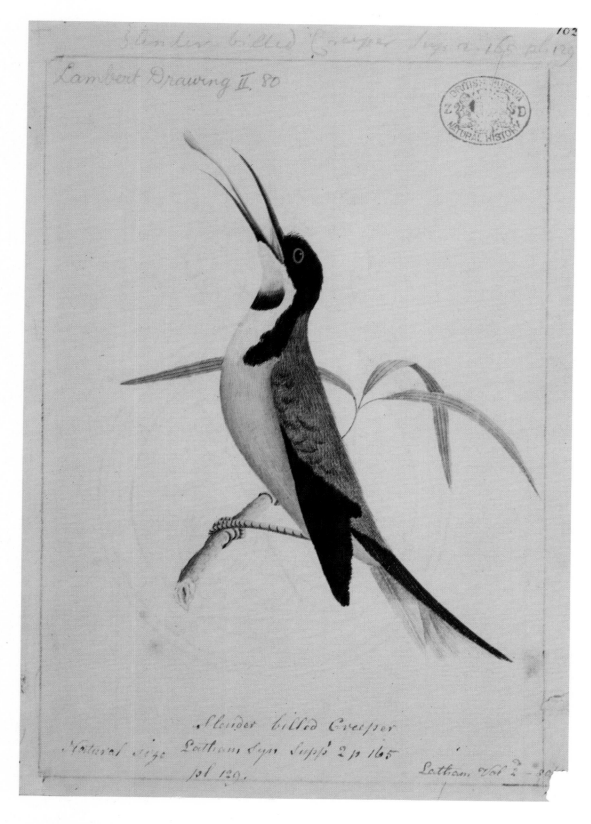

Plate 200 [Watling 181]
PORT JACKSON PAINTER
Eastern spinebill, *Acanthorhynchus tenuirostris* (Latham, 1801)
Water-colour, 210 × 146
Inscribed in pencil across top of the drawing, 'Slender billed Creeper Sup.2. 165 pl 129.', and in another hand 'Lambert Drawing II. 80'. In ink beneath drawing 'Slender billed Creeper, Latham Syn supp! 2 p 165 pl 129', and (l.r.) 'Latham Vol. 2. 80'. Inscribed in ink (l.l.) 'Natural Size'.
The original scientific description of the species was based on this drawing.

Plate 199 [Watling 171] *opposite*
PORT JACKSON PAINTER
Regent honeyeater, *Xanthomyza phrygia* (Shaw, 1794)
Water-colour, 250 × 175
Inscribed in ink (u.c.) 'No 300' and in pencil, 'Black and yellow Bee eater. Supp 2. 154', and beneath in pencil in another hand, 'Lambert Drawing, I, 35'. Also inscribed in ink (l.l.) 'Black & Yellow Bee eater. Latham Syn Supp! 2 p154', and beneath also in ink in another hand 'Natural size', and 'L. Vol^me 1-35'.
The original scientific description of the species was based on this drawing.

187

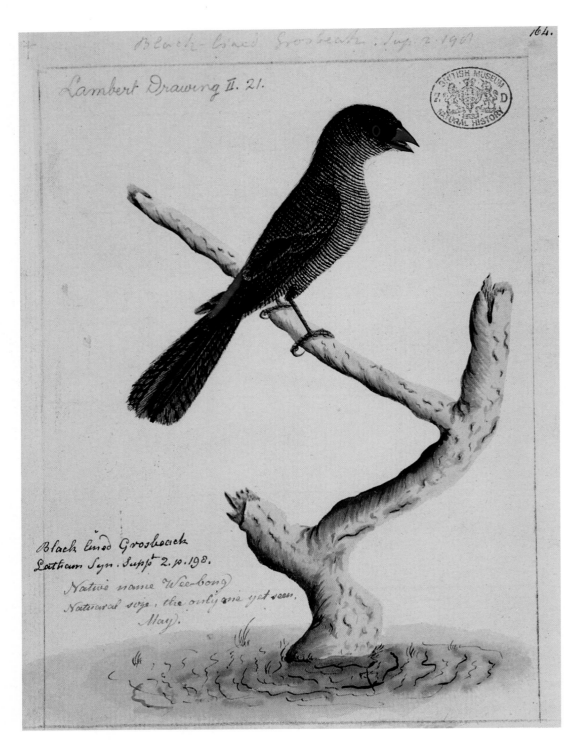

Plate 201 [Watling 243]
PORT JACKSON PAINTER
Beautiful firetail, *Emblema bella*
(Latham, 1801)
Water-colour, 212 × 158
Inscribed in pencil above drawing
'Black-lined Grosbeak Sup. 2.198',
also in pencil (u.l.) 'Lambert
Drawing II. 21'. Beneath (l.l.) in
browned ink, 'Native name Wee-
bong. Natural size, the only one yet
seen. May'; above (also l.l.) in black
ink, 'Black lined Grosbeack Latham
Syn Supp' 2. p. 198'.
The original scientific description
of the species was based on this
drawing.

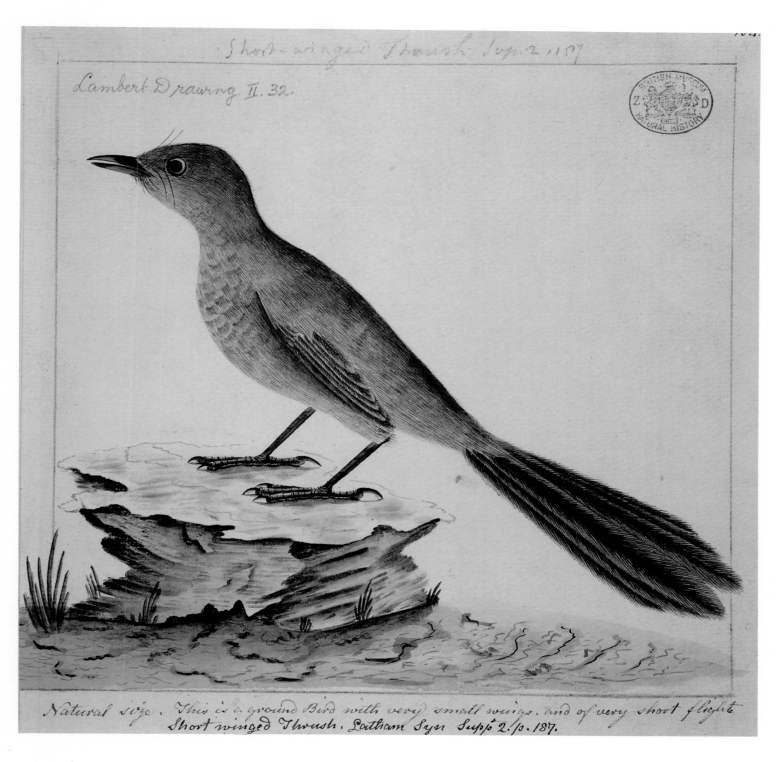

Short-winged Thrush. Sup. 2. 187

Lambert Drawing. II. 32.

Natural size. This is a ground Bird with very small wings. and of very short flight
Short winged Thrush. Latham Syn Supp 2. p. 187.

Plate 202 [Watling 233]
PORT JACKSON PAINTER
Eastern bristlebird, *Dasyornis brachypterus* (Latham, 1801)
Water-colour, 212 × 212
Inscribed in pencil above drawing, 'Short-winged Thrush Sup. 2. p. 187', and also in pencil (u.l.) 'Lambert Drawing II.32'. Beneath drawing in ink, 'Natural Size. This is a ground Bird with very small wings and of very short flight', possibly in Watling's hand in browned ink. Beneath in another hand in black ink, 'Short winged Thrush. Latham Syn supp' 2.p.187'.
The original scientific description of the species was based on this drawing.

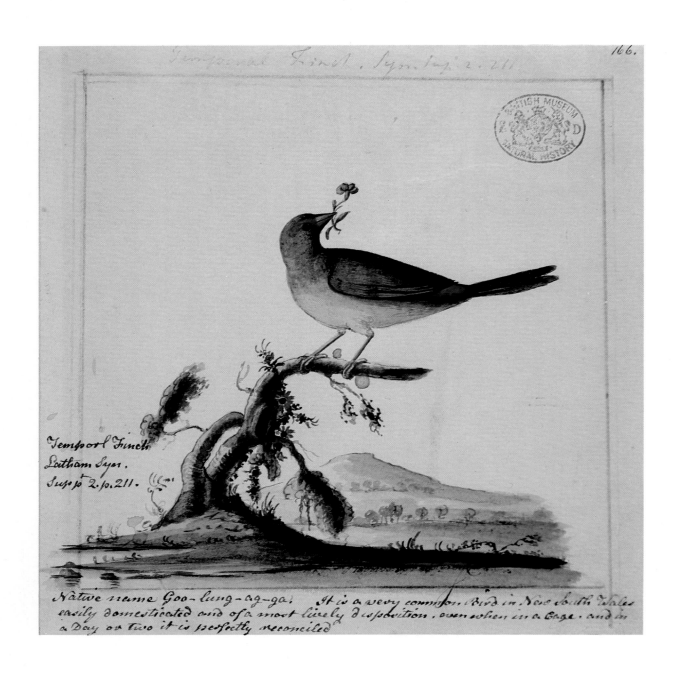

Plate 203 [Watling 245]
THOMAS WATLING
Red-browed finch, *Neochmia
temporalis* (Latham, 1801)
Water-colour, 161 × 159, signed
'Thomas Watling del.'
Inscribed in pencil above drawing
'Temporal finch. Syn. sup 2.211' and
the same information repeated in
black ink (l.l.). Beneath the drawing
in ink: 'Native name Goo-lung-ag-
ga. It is a very common Bird in New
South Wales easily domesticated and
of a most lively disposition, even
when in a Cage, and in a Day or two
it is perfectly reconciled'.
The original scientific description
of the species was based on this
drawing.

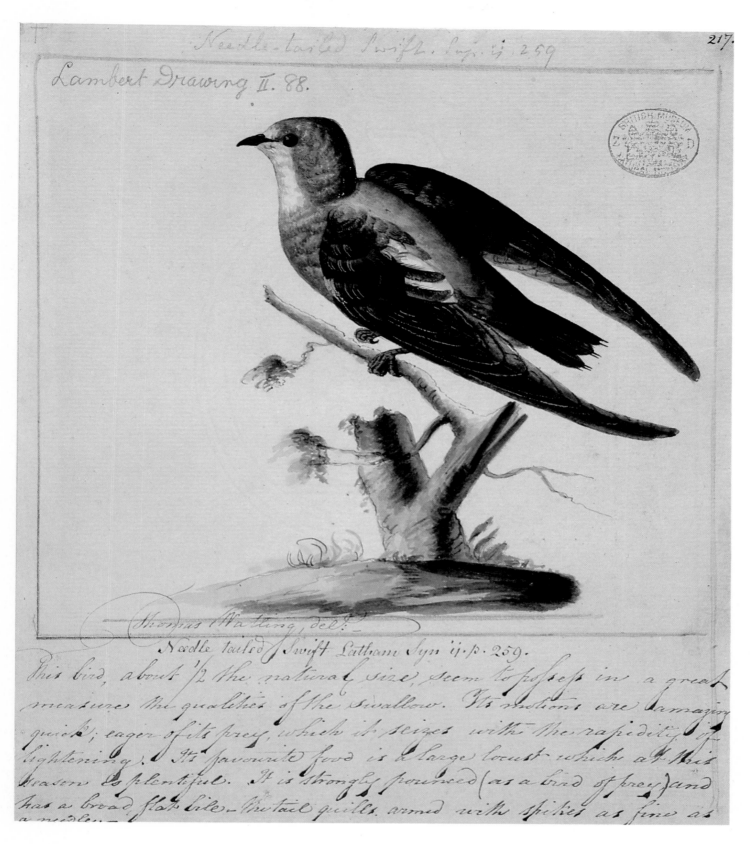

Needle-tailed Swift. Sup. ii. 259

Lambert Drawing II. 88.

Thomas Watling, del:

Needle tailed Swift Latham Syn ij. p. 259.

This bird, about ½ the natural size, seem to possess in a great measure the qualities of the swallow. Its motions are amazing quick; eager of its prey, which it seizes with the rapidity of lightening. Its favourite food is a large locust which at this season is plentiful. It is strongly pounced (as a bird of prey) and has a broad flat bile – the tail quills armed with spikes as fine as a needle.

Plate 204 [Watling 292]
THOMAS WATLING
Spine-tailed swift, *Hirundapus caudacutus* (Latham, 1801)
Water-colour, 220 × 190, signed 'Thomas Watling del.'
Inscribed in pencil above drawing 'Needle-tailed Swift. Sup ii 259' and also in pencil (u.l.) 'Lambert Drawings II. 88'. Beneath drawing in black ink 'Needle tailed Swift Latham Syn ii. p. 259'. Beneath in browned ink: 'This bird, about ½ the natural size, seem to possess in a great measure the qualities of the swallow. Its motions are amazing quick, eager of its prey, which it seizes with the rapidity of lightening. Its favourite food is a large locust which at this season is plentiful. It is strongly pounced (as a bird of prey), and has a broad flat bile – the tail quills armed with spikes as fine as a needle.'
This bird feeds on small insects caught on the wing, and could not handle 'a large locust'.
The original scientific description of the species was based on this drawing.

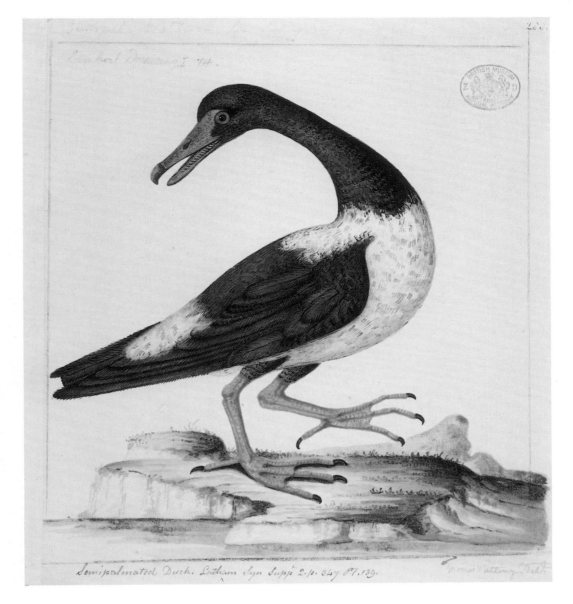

Plate 205 [Watling 355]
THOMAS WATLING
Magpie goose, *Anseranas semipalmata* (Latham, 1798)
Water-colour, 234 × 207, signed 'Thomas Watling del!'
Inscribed faintly in pencil above drawing: 'Semipalmated Duck Syn Supp 2 347 Pl 139' and the same information repeated in ink beneath drawing. Also in ink on a separate label: 'This bird is about the size of our native wild Goose. They are generally found | in flocks and sometimes perching on high Trees. It has been observed by the | Man who sometimes shoots these Birds, that in opening some of them, but not all | that the Wind pipe formed several beautiful circumvolutions on the Breast, under | the Skin before it enters the Thorax. An Officer lately has opened one and | confirms the truth of the Sportsmans observation. It is called by us the New | South Wales Goose, Palminated instead of being Web-footed, because its manner | as well as taste and Flavour resembles that Bird more than any other. | The contours or general likeness is here very well observed. I have been informed | that at times their Note is tunefull and melodius, which appears probable from | the conformation of the Wind pipe. If that Singular circumstance is true. I have | now a Man out attending a Pond where they most frequent, in hopes of | getting one for dissection, they have only lately been observed, and shot principally | on a Pond near the Hawksburgh River, January 2nd 1794. Native name Now-al-Gang'. The species disappeared from the Sydney region long ago.

192

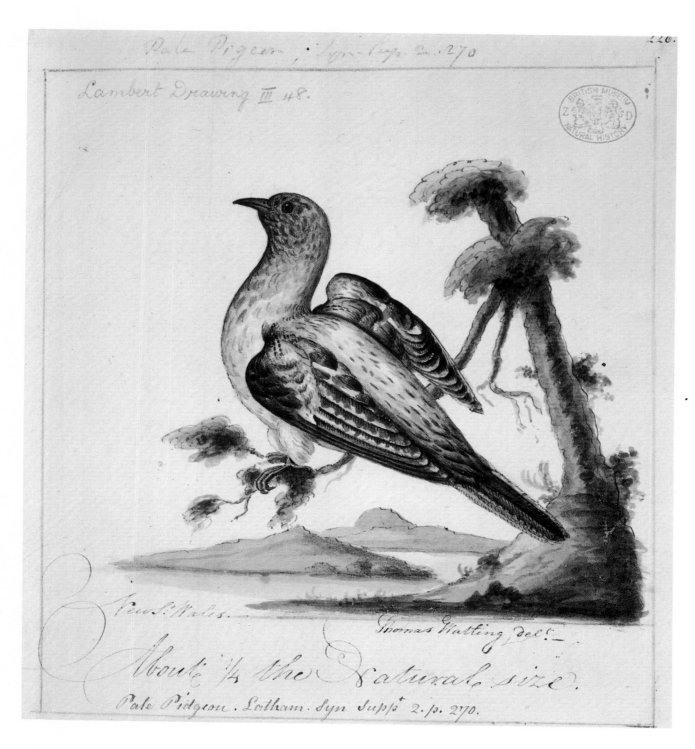

Pale Pigeon, Syn. Sup. 2. 270

Lambert Drawing III 48.

New S. Wales.

Thomas Watling, del.—

About ¼ the Natural size.

Pale Pidgeon. Latham. Syn Supp. 2. p. 270.

Plate 206 [Watling 300]
THOMAS WATLING
Pallid cuckoo, *Cuculus pallidus*
(Latham, 1801)
Ink and water-colour, 220 × 201,
signed 'Thomas Watling, del.'
Inscribed in pencil above drawing
'Pale Pigeon Syn Sup. 2.270', also
in pencil (u.l.) 'Lambert III 48'.
Inscribed below in Watling's
copperplate hand 'New S. Wales'
(l.l.) and 'About ¼ the Natural size'.
Beneath in ink in a later hand 'Pale
Pidgeon. Latham. Syn Supp^t 2 p.
270'.
Latham decided that this drawing
represented a pigeon and described
it as the Pale Pidgeon, *Columba
pallida*. The original scientific
description of the species was based
on this drawing.

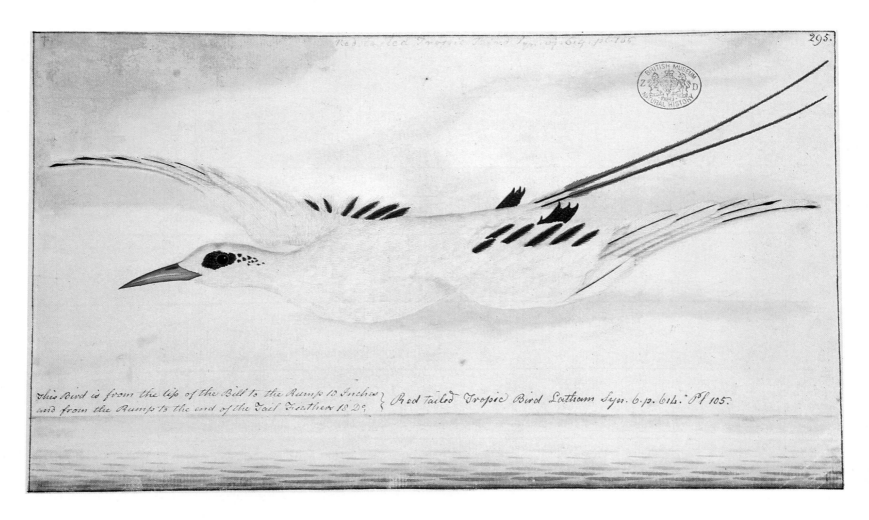

Plate 207 [Watling 360]
PORT JACKSON PAINTER
Red-tailed tropicbird, *Phaethon rubricauda* Boddaert, 1783
Water-colour, 180 × 304
Inscribed in pencil above drawing 'Red tailed Tropic Bird Syn vi, 614, Pl 105'; the information is repeated in ink (l.r.). Inscribed 'This Bird is from the tip of the Bill to the Rump 18 Inches and from the Rump to the end of the Tail Feather 18 D°.'

Plate 208 [Watling 303]
PORT JACKSON PAINTER
Brolga, *Grus rubicundus* (Perry, 1810)
Water-colour, 281 × 153
Inscribed in pencil above drawing 'New Holland Crane' and also in pencil 'Lambert Drawing III. 15' (u.l.), and in ink 'New Holland Crane' (l.l.).
The brolga is no longer seen in the Sydney district.

194

New Holland Crane

Lambert Drawing. III, 15.

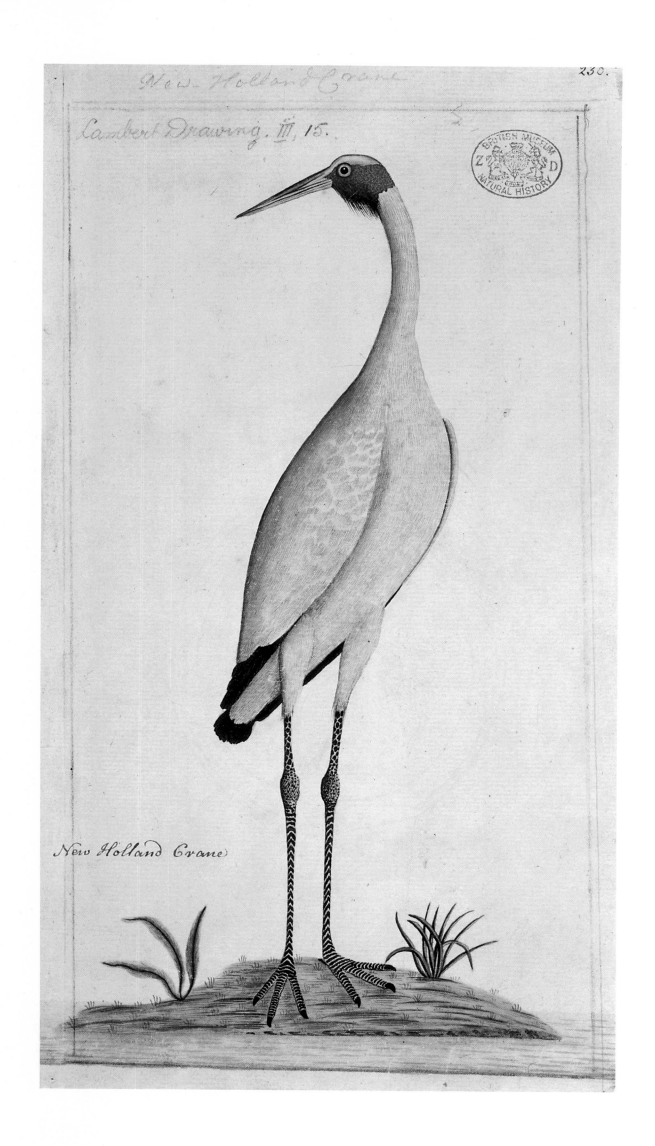

New Holland Crane

Plate 209*a* [Watling 334]
PORT JACKSON PAINTER
Red-necked avocet, *Recurvirostra novaehollandiae* (Vieillot, 1816)
Water-colour, 180 × 148
Inscribed in pencil at top of drawing 'American Avoset Syn 5.295' and beneath the drawing in browned ink '22 Inches from the extremities. This Bird is found along the shores of the Sea coast', followed by 'American Avoset Latham Syn 5. p. 295. Pl 92' in another hand.

Plate 209*b* [Watling 335]
PORT JACKSON PAINTER
Red-necked avocet, *Recurvirostra novaehollandiae* (Vieillot, 1816)
Water-colour, 203 × 147
Inscribed in pencil above drawing 'American Avoset Syn 5. 295', and the information repeated in ink (l.l.) with 'Pl 92' added. Beneath (l.l.) 'Native name Antiquatich'.

Plate 209*c* [Watling 336]
PORT JACKSON PAINTER
Red-necked avocet, *Recurvirostra novaehollandiae* (Vieillot, 1816)
Water-colour, 469 × 265
Inscribed faintly in pencil above drawing 'American Avoset, Syn 5. 295', and also in pencil (u.l.) 'Lambert Drawing, I. 47'. Beneath in browned ink (l.r.) 'The Natural size. This is a rare Bird, only been seen on some Lagoons. A species of the Avocetta' possibly in Watling's hand. Beneath in black ink 'American Avoset. Latham Syn 5. p. 295. Pl 92'.

This is a very rare bird in the Sydney region. Perhaps it always was rare, as the note on the drawing states.

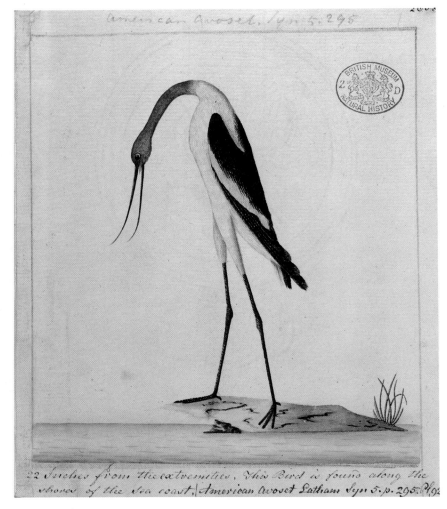

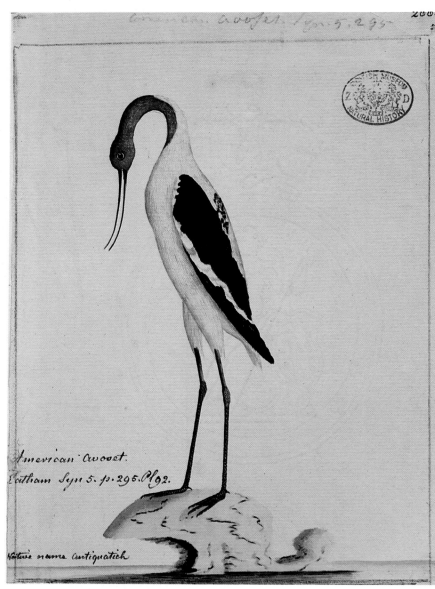

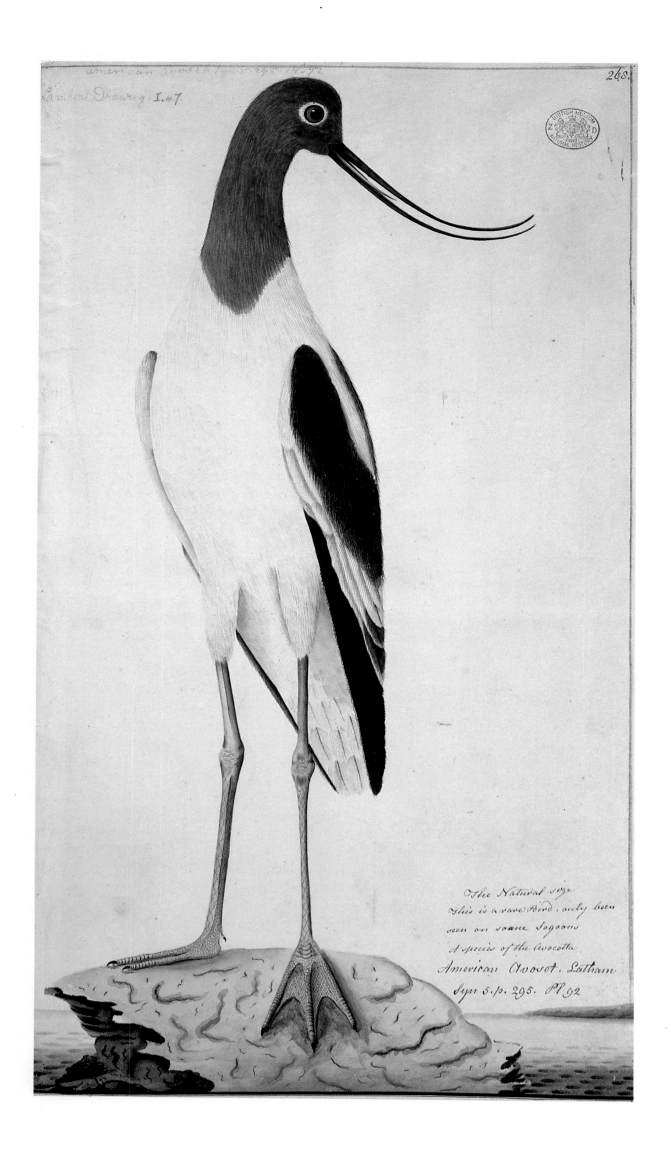

American Avoset Syn 5. 295 Pl. 92

Lambert Drawing. I. 47.

The Natural size
This is a rare Bird, only been
seen on some Lagoons
A species of the Avocetta
American Avoset. Latham
Syn 5. p. 295. Pl. 92

5 / The Artwork

In order to understand the artwork related to the First Fleet a distinction must be made between art drawn on location to record potentially useful information, such as an adjacent coastline from a ship, and work produced to illustrate a text. The latter may draw upon the former but it may also, and often does, draw upon the words of an associated text and upon the memory of the illustrator.

As Dr Perry has noted (p. 72) there were several officers aboard *Sirius* who possessed skills in drawing charts and views, notably William Bradley, George Raper and John Hunter. Manuscript charts drawn at the time exist in several collections but problems arise in distinguishing the individual hands of the chartmakers and the relation of original drafts to copies. The situation with regard to views presents even greater problems. There are at present few, if any, known views drawn by members of the First Fleet during the voyage out to New South Wales that can be said, unquestionably, to be 'field' studies, that is to say drawings made at the time and on the location of the subject depicted. The views that are here ascribed to John Hunter [plates 76–77], for example, may have been painted on the spot or they may have been developed from sketches later. Yet on-the-spot sketches must have been made, particularly at ports of call such as Tenerife, Rio and the Cape. But they have either been destroyed or have not yet come to light.

Bradley, Raper and Hunter, however, have all left signed and dated examples of their work, which may be considered in turn.

William Bradley

Bradley's manuscript, 'A Voyage to New South Wales', in the Mitchell Library, Sydney, contains a number of water-colour drawings that illustrate the outward voyage, such as the Fleet passing Needle Point [plate 90]. But Bradley's 'Voyage' is obviously, from its make-up and presentation, a fair copy of his original journal, now lost or destroyed, and the views it contains are fair copies of what must have been in many but not all cases his own field studies. It is important in this regard not to be misled by the dates Bradley appends to the titles of his views. When he writes 'Sirius, Supply & Convoy: Needle Point ENE 3 miles. Hyena in Company, 13 May 1787' he is referring to the date of the event not the date on which he made the

drawing. In other words the drawing has been made to illustrate his text and inserted in the manuscript to face the relevant text. Since such drawings are clearly illustrations we may ask whether they have been worked up from a lost original either by Bradley himself or an associate, developed with help from an engraving, or even reconstructed from the artist's memory.

The First Fleet was at anchor in Rio Harbour during most of August 1787. The detail and placement of the buildings depicted in Bradley's five illustrations in his 'Voyage' are probably based on sketches he made on the spot at the time. Two are of Rio's fortifications (between 38–9). Such harbour fortifications feature prominently in naval draughtsmanship of the eighteenth century because they provided potentially valuable information for naval intelligence and there was the added excitement of making clandestine drawings from the ship of subjects that were normally forbidden by the local port authorities.

Yet it cannot be assumed that all the illustrations in Bradley's 'Voyage' possess the support of field sketches. Illustrations of events, such as the *Taking of Colbee and Benalon* [plate 210] were of personal importance to Bradley, for he was actively involved in them. It was, he noted 'by far the most unpleasant service I was ever order'd to Execute'.[1] Obviously he could not draw the scene while taking part in it. Nor was there anyone else available who could draw the event. For the First Fleet, unlike voyages of exploration and discovery such as those of Cook and Lapérouse, possessed no official artist. Nor, surprisingly enough, did the British Government ensure, though it sought the advice of Sir Joseph Banks in other matters concerning the planning of the new settlement, that a convict with talent in draughtmanship was included in the first contingent, though one or two may have been by chance.[2] So Bradley, who possessed no training in figure drawing, reconstructed the scene from memory and filled it with his little stick figures.

Plate 210
WILLIAM BRADLEY
Taking of Colbee and Benalon
25 Nov͎. 1789
Water-colour, 135 × 190
From Bradley's manuscript 'A Voyage to New South Wales' in the Mitchell Library, State Library of New South Wales, Sydney, fp. 182.

A View on Port Jackson taken from Goose Island; The Arrow then lying off the Entrance of the Branch five.

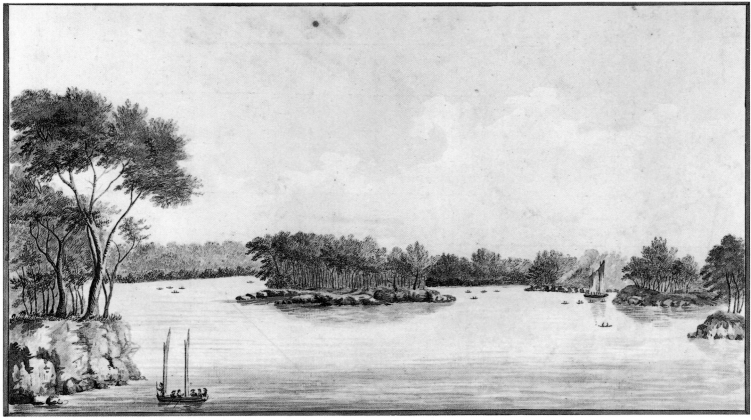

In one case he may have used an engraving to work up an illustration. *Sydney Cove Port Jackson 1788* [plate 116] may be based on the engraving by Dayes in Hunter's *Historical Journal* [plate 115]. There is no item of visual information that is not contained in the engraving. If Bradley did make use of the engraving that would provide us with a useful *terminus a quo* for the completion of his manuscript 'Voyage'. Hunter's book was published on 1 January 1793 but Stockdale had already published plate 115 on 18 October 1792. So the engraving would have been available to Bradley, who returned to England on 22 April 1792, at least from October 1792. We may suppose him to have been completing the fair copy of his journal about this time.

Bradley's *Sydney Cove, Port Jackson*, may not be copied from the Dayes engraving. Both Hunter and Bradley returned to England on the *Waaksamheyd* and it is not unlikely that Hunter would have permitted Bradley to copy Hunter's own original drawing, now lost, on which the engraving was based, during the homeward voyage. On the other hand it is possible that Bradley made the original drawing for the engraving and Hunter made use of it. Hunter, it has been noted (p. 78) incorporated Bradley's plan of *Norfolk Island* [plate 84] in his copy of the *Historical Journal*.

Apart from those in his 'Voyage' Bradley also drew a *View of the Governor's house at Sydney* . . . [plate 117] and two views now in the Mitchell Library. Although the traditional attribution to Bradley has been questioned there is no valid reason to do so.[3] The title of the first, *A View in Port Jackson taken from Sirius Island* [plate 211] is clearly written in Bradley's own hand and the treatment of the eucalypt at the right, with its gently twisting trunk and layered tiers of foliage is very much in the manner used by Bradley in his 'Voyage', such as the *View in Broken Bay* (fp. 90). Such drawings present the first attempts to depict the characteristic ramification of the eucalypt. The second view [plate 212] is probably the original drawing which he later copied into his 'Voyage' as *View in the upper part of Port Jackson, when the Fish was shot* [plate 213].

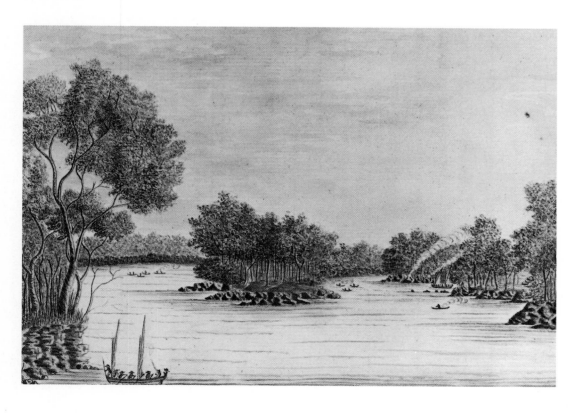

Plate 214
WILLIAM BRADLEY (attributed)
View of the West Side of Arthur's Vale (Norfolk Island) (*c.* 1790)
Pencil, pen and wash, 211 × 299, unsigned and undated
Located in the Banks papers, vol. 15, f. 15, Mitchell Library, State Library of New South Wales, Sydney.

Plate 215
WILLIAM BRADLEY (attributed)
View of the East Side of Arthur's Vale (Norfolk Island) (*c.* 1790)
Located in the Banks papers, vol. 15, f. 14, Mitchell Library, State Library of New South Wales, Sydney.

Plate 216 [Raper 31]
GEORGE RAPER
View of the City Batavia from the Anchorage in the Roades the Church bearing S.S.W. Offshore 1½ Miles
Water-colour, 310 × 475, signed and dated, 'Taken in the Waaksaamheydt by G. Raper Sep.! 1791'

The title refers to a curious incident that occurred on 17 August 1788 which he describes in his 'Voyage'.

As we were coming down the Harbour the Master [James Keltie] shot a fish of 1½ lb weight in a branch of a high Tree which we got & eat, this fish was in the claws of a large Hawk when fired at, drop'd the fish & flew away.

Two views of Arthur's Vale, Norfolk Island, showing the extent of the land under cultivation, are now in the Mitchell Library; they may be attributed on stylistic grounds to William Bradley [plates 214, 215]. He probably drew them to support the general report which he wrote into his 'Voyage' in which he reported, among other things:

The Ground clear'd at Norfolk Island when we left it was 130 Acres from the best accounts I could get, including Gardens, private & public . . . The Ground is certainly capable of producing every thing usually found in the same Climate . . .[4]

George Raper

Geoge Raper also returned on the *Waaksamheyd*. The homeward voyage would have provided Bradley, Hunter and Raper with time to get their papers, charts and drawings in order if not for publication then as a personal record of the preceding five years. In such situations, in the days before mechanical reproduction, it was common practice to exchange notes and drawings and to make copies. This overriding fact constitutes the central problem confronting anyone who seeks to ascribe unsigned and undated drawings related to the First Fleet to individual draughtsmen.

On *Waaksamheyd* Hunter was obviously preparing his *Historical Journal* for publication, for it appeared seven months after his return. This suggests that it was either ready for publication or in an advanced state by the time the ship reached Portsmouth

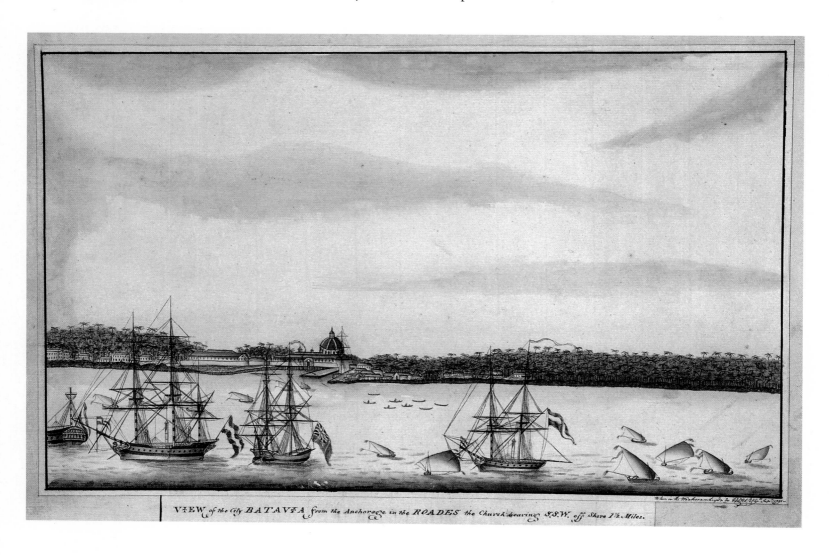

VIEW of the City BATAVIA from the Anchorage in the ROADES the Church bearing S.S.W. off Shore 1½ Miles.

on 22 April 1792. It would seem quite likely that Bradley also wrote up much of his 'Voyage' during the homeward voyage, and that Raper also spent much of the time getting his papers and portfolio of drawings into order.

In Raper's case we are on firmer ground. When he uses a date to record an event he incorporates it into the title. When he records the date he completed a drawing he adds it after his signature. His *Views of the Cape de Verd Islands – Sirius. June 1787* [plate 96], being a finished drawing does not permit us to date it to 1787 – though he probably made the sketches for it then. His *View of the Table–land from the Anchorage in the Bay* . . . [plate 99], signed 'Geo Raper 1792 taken on board the Waaksaamheydt' permits us to date the drawing to January 1792, even though it may not be dated as precisely as his *View of the City Batavia* . . . [plate 216].

The high quality of George Raper's coastal views, from a navigational viewpoint, is exemplified by his *Views of Lord Howe Island* [plate 217]. Here he provides not one view, as was the common practice, but four. As the *Sirius* approached the island in the afternoon of 9 March 1790, John Hunter reported:

we made Lord Howe's Island on the 9th, at four in the afternoon bearing east-north-east, distant about 16 or 18 leagues. The south end of this island is two very high mountains, nearly perpendicular from the sea; those hills are the only land you see until you come within six or seven leagues, when the lower land begins to appear, extending from the foot of the mountains, northward . . . we were enabled to get in with the land by noon of the 10th . . . There is a very remarkable rock, which lies about 12 or 14 miles to the southward of the island, and which is named Ball's pyramid, and has much the appearance of a church steeple at a distance; but as you come near, it is exceedingly high and perpendicular; we passed in the evening between the island and the pyramid.[5]

Plate 217 [Raper 26]
GEORGE RAPER
Views of Lord Howe Island. Disc.d
by Lieu.t Ball. February 1788
Water-colour, 322 × 475, unsigned
Four views in one frame.

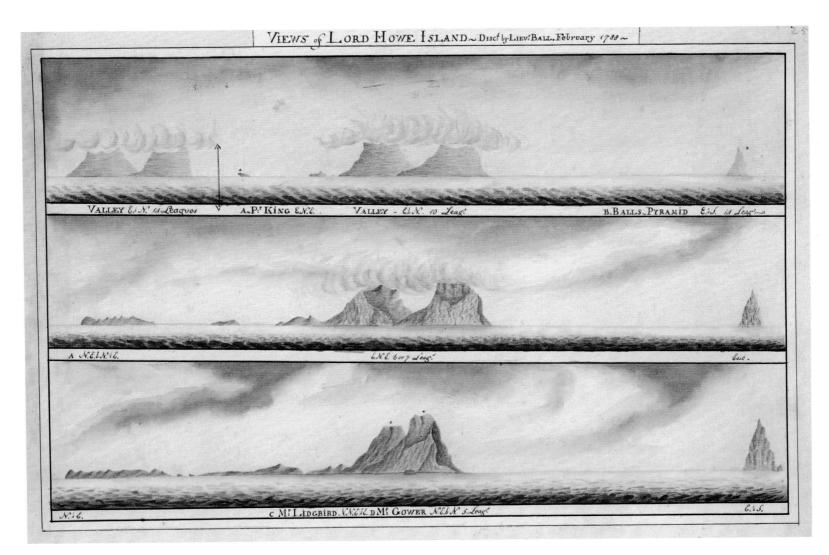

Raper's four drawings made as the ship approached the island illustrate Hunter's text so well that it is to be regretted they were not published with it.

Raper probably began to draw from the time the Fleet left England in May 1787. An unfinished drawing of a partridge of Tenerife [plate 218] is probably his earliest known work. But he does not appear to have gained the confidence to sign and date his finished work until 1789, and from the beginning they leave the strong impression that he was drawing them primarily for his own pleasure and interest, and for his family and friends. The great majority of those dated to 1789 are of birds and flowers of Port Jackson. They reveal a sensitive feeling for linear design and for the relationship of the image to the pictorial space [plates 183, 186, 219], qualities in which his work far surpasses that of all the other First Fleet draughtsmen. There are thirty-five drawings relating to the Sydney neighbourhood dated to 1789 in the British Museum (Natural History) collection and these must have been completed between the return of the *Sirius* from the Cape on 9 May 1789 and its departure for Norfolk Island on 6 March 1790. Raper may have been permitted to draw birds shot by John McEntire and others for Governor Phillip not only for sustenance but also that some might be preserved as specimens for naturalists in England and perhaps also drawn on the spot.[6] But his own drawings reveal no desire to describe and classify. They possess no annotations and only the most general titles. His interest appears to be directed rather towards the shape and colour of the exotic birds and plants before him and their transformation into an effective visual design [plate 219]. In this regard the best of his work will be found in the plant and animal drawings he completed at Sydney and during his enforced stay on Norfolk Island [plates 187, 188, 189, 220], for they convey his immediate response to the exotic and its strange beauty.

Other drawings, doubtless based on lost sketches, belong more closely to the naval practices of the time: those illustrating the southern coast of Tasmania, such as plate 104, for their value to navigation, those of the forts of Rio [plates 94, 97] for naval intelligence, and those that simply record the ports visited on the homeward voyage of *Waaksamheyd* [plates 99, 216]. Still other drawings are conceived as a personal memoir. In Sydney, Raper appears to have decided to compile a folio of drawings illustrating the voyage out to New South Wales and his later adventures, for his *View of the Needles* [plate 91] and *Ice Islands . . .* [plate 102] are both dated 1789. The former may have been worked up from one of his sketches, or one by an associate, or developed in part from an engraving. It was obviously drawn as a retrospective comment on the departure from England.

On the other hand we need not doubt that Raper's *The Melancholy Loss of His Majesty's Ship Sirius . . .* [plate 126], signed and dated 1790, was drawn near the time of the event. The tragic loss of the ship left its company stranded on Norfolk Island for eleven months. In this case there was not only a personal but a general need to record the event visually. Bradley also included two drawings relating to the wreck in his 'Voyage' (between 194–5).

Bradley concludes his 'Voyage' manuscript by informing us that four days after the *Waaksamheyd* arrived in Portsmouth harbour:

A Court Martial was held on board the Brunswick to try Capt Hunter, the Officers and Crew of the Sirius for the loss of the said Ship; when it appear'd that every thing was done, that could be done; to save the ship: Capt Hunter, the Officers & Crew were Honourably Acquitted & removed from the Waaksamheydt to the Admiral's Ship, where they were paid off the 4 May 1797.[7]

Plate 218 [Raper 37]
GEORGE RAPER
Tenerife partridge, *Alectoris rufa*
(Linnaeus, 1758)
Pencil and water-colour, 261 × 408
The title 'Teneriffe partridge' in
pencil on the mount beneath the
drawing.

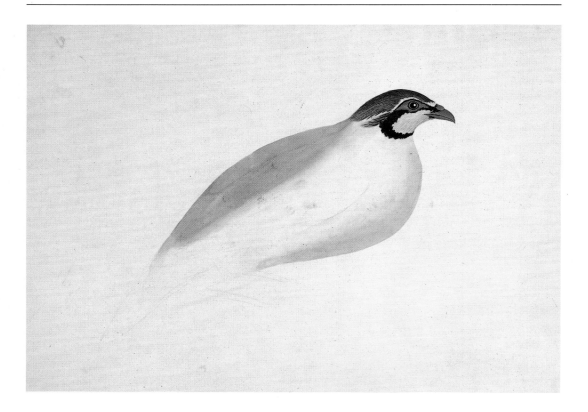

It would be surprising if Hunter, Bradley and Raper did not make use of such charts of Sydney Bay and their drawings of the wreck to make clear to the court the state of the reef, winds and tides that led to the wreck.

Though still only a young man – he was twenty-four when he returned to England – Raper may have had the publication of an illustrated account of his experiences in New South Wales and the Pacific in mind. Apart from the British Museum (Natural History) collection which constitutes the bulk of his known work, there is also signed work by Raper in two other public collections. In the Alexander Turnbull Library, Wellington: a Norfolk Island Pigeon (*Hemiphaga novaeseelandiae spadicea*) (dated 1790), a bird of Port Jackson (1788) the channel-billed cuckoo (*Scythrops novaehollandiae*), a parrot of Port Jackson (1788) the King parrot (*Alisterus scapularis*), and a flax plant (*Phormium tenax*), of Norfolk Island (1790).[8] In the Mitchell Library, Sydney: a pig fish of Norfolk Island (dated 1790), a shark (dated July 1792) and a dolphin (1794) – this last after his return to England.[9] After his return Raper appears to have been placed in charge of a cutter, the *Expedition*, and on being promoted Lieutenant on 27 June 1793 served on the *Cumberland*. While on that ship he probably became ill for on 14 October 1795 he made his will, though he did not die until two years later at the age of twenty-nine or thirty, the date of his birth being uncertain.

Raper's will deserves to be quoted here in full both because he was one of the first European artists to work in Australia and because it provides a glimpse into the life of a young Englishman of the eighteenth century who had joined the navy and developed his talent for drawing while on the high seas:

To my mother Mrs Catherine Raper all my articles of property and possessions with these exceptions:

Plate 219 [Raper 39]
GEORGE RAPER
Noisy friarbird, *Philemon corniculatus* (Latham, 1790)
Water-colour, 450 × 330, signed
'Geo Raper 1789'
Inscribed in Raper's hand beneath drawing 'Bird of Port Jackson Natural Size'. To the left a drawing of the Honey flower, *Lambertia formosa* (Smith), sometimes known as the Mountain devil because of the shape of the fruit.

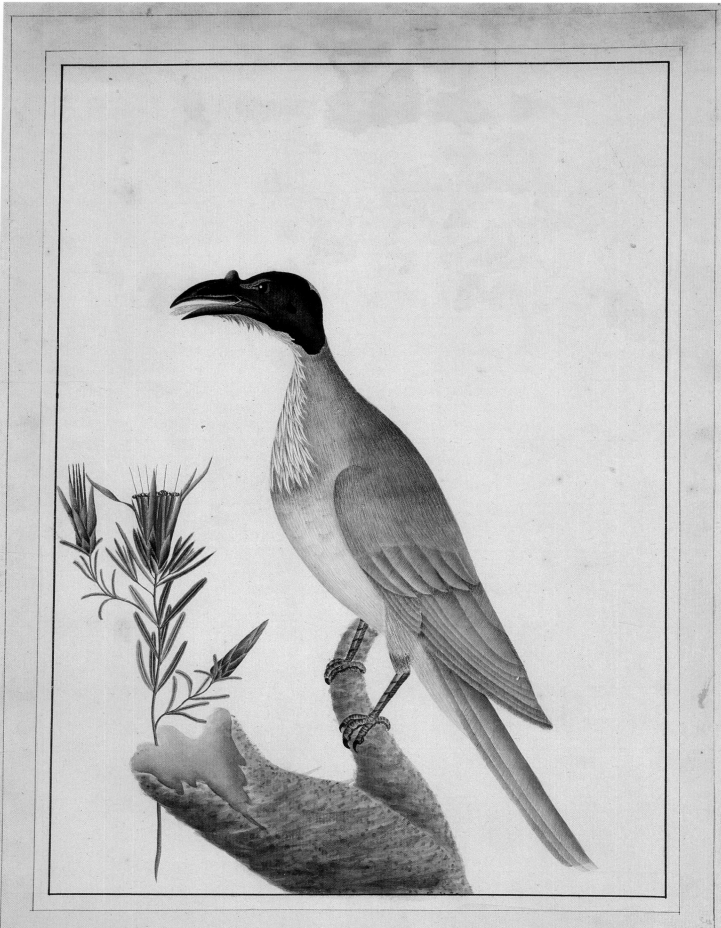

BIRD of PORT JACKSON *Natural Size* 1789

Plate 220 [Raper 54]
GEORGE RAPER
Sweetlip emperor, *Lethrinus chrysostomus* (Richardson, 1848)
Water-colour, 333 × 486, signed 'Geo Raper 1790'
Inscribed beneath drawing in Raper's hand 'Snapper of Norfolk Island, Not more than 2/3ds Grown'.

To Dr Scott my friend whom I appoint sole Executor my large Clock and my Ring. I request my Agent to pay all debts and bills. To my younger Brother Charles Cannier Raper my Gold Repeating Watch and one year's income of my property in the three per cents. To my dearest Sister and Brother who are in the East Indies and well provided (with my best wishes) money sufficient for an Elegant Ring each with my hair. And last to my nephew James at Chelsea £20 sterling to buy something for my remembrance. All other things, Drawings Papers and Books excepted, I desire to be sold at the Mast as is the custom at Sea. For all small debts due to me there is a small Account Book in my Painting Case with everything clear. My charts by former promise with my Glasses are to be delivered as soon as possible to my friend Mr Loveday. All my papers examined by Dr Scott and put in my Painting Case and delivered to my dearest and beloved Mother by him.[10]

John Hunter

On 7 January 1788, the day on which the *Sirius* made its Tasmanian landfall with the rest of the Fleet in convoy, John White, the chief Surgeon, noted in his journal: 'Captain Hunter has a pretty turn for drawing, which will enable him, no doubt, to give such a description of this coast as will do credit to himself, and be of singular advantage, as well to those whose lot it may be to visit hereafter, this extensive coast, as to navigation at large.'[11]

Hunter's original views drawn at the time are no longer known, but it is possible that plates 106 and 107 represent finished drawings made later either by Hunter himself or an associate. The structure of the cliffs presents a degree of skill greater than that normally to be found in the work of the unknown artist here described as the Port Jackson Painter, but the treatment of the sea seems to be closer to his manner than to

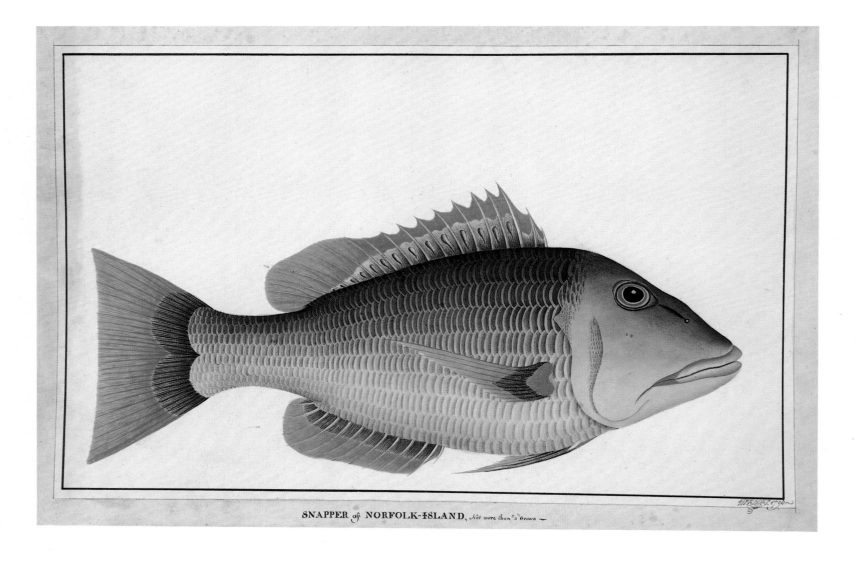

SNAPPER of NORFOLK-ISLAND, *Not more than 2/3 Grown* —

Hunter's, who preferred a more tonal treatment. It is possible that the two drawings represent a collaboration. More importantly the inscriptions on and beneath the drawings appear to be in Hunter's hand. They may therefore be tentatively ascribed to Hunter.

During his first three years in New South Wales, Hunter kept a sketch book, now in the National Library of Australia, acquired by Rex Nan Kivell from a descendant of Hunter's family.[12] It contains a hundred water-colour drawings of birds, plants, flowers, fishes and other marine life, a drawing of a kangaroo and five drawings of native peoples. Two of these last [plates 221, 222] appear to be the originals from which the engravings in Hunter's *Historical Account* (fp. 222, 233) were developed, with some slight alterations by the engraver. They provide us with some idea of Hunter's abilities and limitations as a portrait draughtsman. It will be noted that he places his bust portraits of natives upon a thick base line, a feature also characteristic of some of the portraits of the Port Jackson Painter. Hunter's work however does not reach the stand-

Plate 221
JOHN HUNTER
Man of the Islands call'd Lord Howe's Group
Pencil, ink and wash, 185 × 122
The title as above in Hunter's hand.
Probably the original drawing for the engraving by T. Cook in Hunter (1793) fp. 222.
National Library of Australia, Canberra, NK 2039/98.

Plate 222
JOHN HUNTER
Man of Duke of York's Island
Pencil, ink and wash, 203 × 127
The title as above in Hunter's hand.
Probably the original drawing for the engraving in Hunter (1793) fp. 233.
National Library of Australia, Canberra, NK 2039/97.

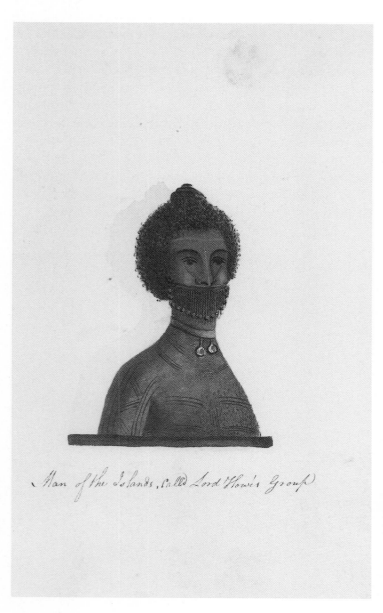

Man of the Islands, called Lord Howe's Group

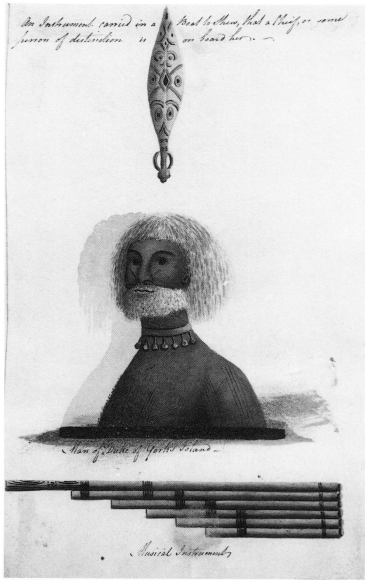

An Instrument carried in a Boat to shew, that a Chief, or some person of distinction is on board her. —

Man of Duke of York's Island —

Musical Instruments

ard of the best portraits of the Port Jackson Painter and it reveals two characteristic features that are not present in the work of the other man, notably the use of two evenly-spreading arcs to depict both nose and eyebrows, and the use of a shadow that repeats the outline of the portrait to strengthen the three-dimensional effect. For these reasons the ascription to Hunter of the sheet of five half-length portraits of Aborigines in the National Library of Australia [plate 51] must be questioned, as must the five other drawings in the same group.[13]

Indeed, because it is so well known, Hunter's name seems to have acquired drawings as a ship of his time acquired barnacles. The only clearly documented views that we possess by Hunter that give us any idea of the way he approached landscape, are the thin strips of navigational views, signed and dated by him, in his own personal copy of his *Historical Account*, now in the Mitchell Library [plate 81].[14] But this has not deterred the ascription of work of a totally different kind to his hand. One such example is the water-colour painting [plate 223] now in the La Trobe Library, Melbourne, which is inscribed, in a later hand, on the back: 'This drawing was made by Captain Hunter, second Governor of New South Wales, A.D. 1793. The old gum tree carried the King's flag hoisted by Governor Phillip. The frigate Sirius was afterwards wrecked in Norfolk Island'.[15] The fact that the *Sirius* was wrecked in 1790 and Hunter was in England during the whole of 1793 must lead us to treat the ascription to Hunter with caution. We have no reason to believe that Hunter ever produced landscapes remotely like this in style. The La Trobe water-colour is most probably the work of a competent draughtsman who copied the engraving by James Heath made from a drawing copied from an unknown original by Watling which was published in David Collins, *An Account of the English Colony in New South Wales* (1798), fp.251. The copyist has lengthened the picture at left adding the large tree and the exotic native group. We know that Watling worked for Collins who probably sent a set of the artist's topographical drawings of Sydney to his publishers Cadell and Davies. Watling's original drawing was

Plate 223
ANONYMOUS
A View of Sydney Cove
Pen, wash and water-colour, 370 × 480, unsigned
Probably copied from a drawing by Thomas Watling. Compare the viewpoint of Plate 135, and of the *View of Sydney* (Mitchell Library, VI/1794 +/1).
La Trobe Collection, State Library of Victoria, Melbourne.

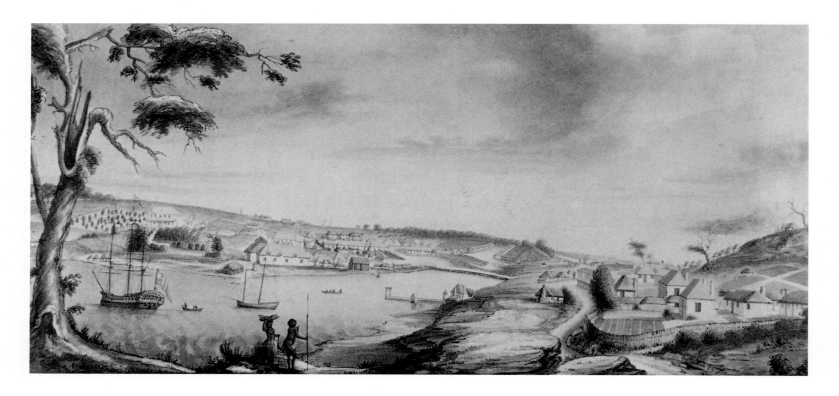

taken from directly behind the hospital, a position from which he seems to have frequently drawn, not surprisingly because as the assigned servant of John White he probably resided in the hospital. What introduces a strong element of doubt about the picture ever being drawn in New South Wales is the odd Aboriginal group in the foreground. He, with his bark shield and spear is credible, but she, with her grass skirt and wooden platter of fish balanced on her head, is certainly not. She is a figment of the exotic imagination and might be compared with that female slave engraved by William Blake for Stedman's *Narrative of a Five Year's Expedition against the Revolted Tribes of Surinam* (1796).[16]

From his letters to his aunt we know that Watling possessed no great affection for Aborigines, he saw them as idle children pampered by government while his own kind were worked to death under a 'burning sun'. Yet when he drew their portraits [plates 3, 4, 19] for White he presented them with sympathy. It is perhaps possible that he developed this topographical painting from one of his own drawings after his return to England and allowed himself the liberty of drawing the 'Aboriginal' couple with a touch of ironic fantasy. Possible, but unlikely. On balance, though the picture is close to Watling's topographical manner, it is more likely to be the product of an English copyist than his own. Hunter, to whom the drawing has been attributed in the past, is not known to have drawn native peoples in this way.

Although we possess no signed drawings by him, another First Fleeter to whom original drawings have been ascribed is Philip Gidley King, Second Lieutenant on *Sirius* and later the third Governor of New South Wales. King's sole claim to being an artist rests on the inscription that appears beneath the plate of William Blake's engraving *A Family of New South Wales*, in Hunter's *Historical Journal* [plate 224] which reads 'From a sketch by Governor King'. But in the absence of any drawings signed by King this must be treated with caution.[17] The inscription could mean that the engraving had been drawn from a sketch received from King but not necessarily drawn by him. It seems to have been a not uncommon practice at this time to accept the unsigned drawings of one's servants and subordinates as one's own. For example, the assertion on the title page of Add. Ms 7085 in the Department of Manuscripts, British Museum, which reads 'Charts, Plans, Views and Drawings, taken on board his Majesty's Bark Endeavour in the Years, 1768, 1769 and 1770 by Lieut James Cook commander' was accepted for many years as sufficient evidence that Cook himself executed the drawings. There would now appear to be incontrovertible evidence that they were drawn by an otherwise unknown seaman, Charles Praval.[18]

Some support for the claim that King made the original drawing for the Blake engraving has been derived from the fact that what indeed seems to be the original drawing for the engraving was found among the Banks Papers in the Mitchell Library in a context that can be loosely associated with King [plate 225]. This does not provide sufficient evidence to ascribe the work with confidence to King.[19] The drawing is one of a group obviously by the same artist [plates 225–228], a person, unlike all the other First Fleet draughtsmen, possessed of some facility in figure drawing. On the other hand they do not look like the work of a man who had ever seen Aborigines; they are ethnographically unconvincing, and do not appear to have been drawn in New South Wales. The heavy-muscled and well-fleshed bodies, the curly hair worn tightly around the head, the oddly shaped woomera held by one man, and the thick negroid lips of another, are unlike any drawings of Australian Aborigines drawn in the colony. They

Philip Gidley King

Plate 224 *far right*
A Family of New South Wales
Engraved by (William) Blake 'From a sketch by Governor King' and dated 15 November 1792.
Published in John Hunter *An Historical Journal of the Transactions at Port Jackson and Norfolk Island* (London, 1793) fp. 414.

Plate 225 *right*
ANONYMOUS
A family of New South Wales
Ink, wash and water-colour, 230 × 158, undated
The drawing has been traditionally attributed to Philip Gidley King because of the resemblance to the engraving (see plate 224), but there is no firm evidence for the attribution.
Located in the Banks papers, vol. 15, f. 12, Mitchell Library, State Library of New South Wales, Sydney.

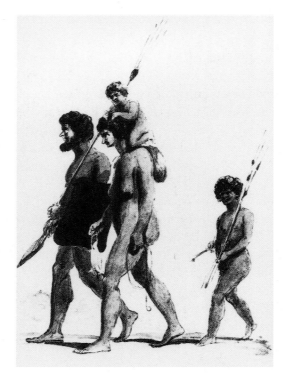

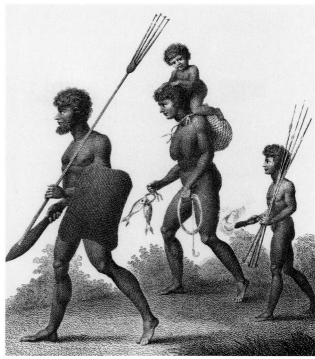

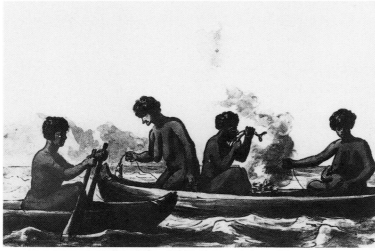

Plate 226 *left*
ANONYMOUS
Aborigines fishing, cooking and eating in canoes
Ink, wash and water-colour, 157 × 230, undated
Located in the Banks papers, vol. 15, f. 10, Mitchell Library, State Library of New South Wales, Sydney.

Plate 227 *right*
ANONYMOUS
An Aboriginal dancing
Ink, wash and water-colour, 230 × 158, undated
Located in the Banks papers, vol. 15, f. 13, Mitchell Library, State Library of New South Wales, Sydney.

Plate 228 *far right*
ANONYMOUS
An Aboriginal throwing a spear
Ink, wash and water-colour, 232 × 158, undated
Located in the Banks papers, vol. 15, f. 12, Mitchell Library, State Library of New South Wales, Sydney.

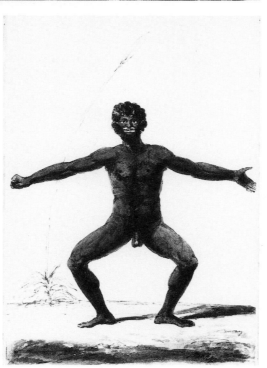

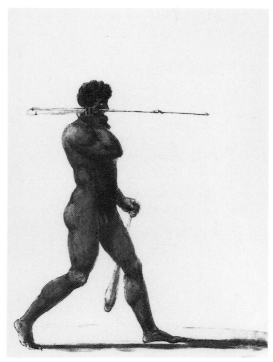

look more like the work of a professional artist called upon to illustrate a text like *The Voyage of Governor Phillip to New South Wales*, but with good reason, rejected. Drawings in this odd neo-classical manner that are signed by King will need to come to light before we can ascribe this group of drawings with confidence to him. Meanwhile it is better to assume that he made no known contribution to the visual documentation of the early years in New South Wales.

The most prolific of all First Fleet draughtsmen has not yet been identified but has become known, for convenience, as the Port Jackson Painter, since most of the work that reveals the characteristic traits of his style is of plants, animals, native peoples, and events that are associated with the Port Jackson neighbourhood.[20]

The Port Jackson Painter

It should be stressed that the Port Jackson Painter should not be considered, until identified, as an individual artist but as a cluster of stylistic traits. That cluster may embrace the work of more than one artist, for example the artist himself and one or more copyists or pupils. At this state of our knowledge it is better to retain the sobriquet until the problem is clarified than to attempt premature attributions to possible or even likely individuals.

The work of the Port Jackson Painter is linked with the traditions of naval topography. He frames his drawings by means of a triple-banded border in ink [plates 75, 105]. Occasionally he will fill the central band with a wash of pink [plates 24, 25, 48, 55, 79], an invariable practice of Raper [plate 67], and at times with pale blue [plates 1, 2]. More often than not he will leave the central band uncoloured or make do with a single, inked framing line. When depicting Aboriginal people he often frames them in tondo [plates 7, 10, 11, 40] or, when presenting half-length portraits especially, make use of a short and thick base line, sometimes doubled or trebled [plates 5, 12, 28] – a practice we have already noted in John Hunter's drawings.

These framing practices, none of which is invariable, are associated with some characteristic stylistic features. The most noticeable is the use of irregular and sinuous brushwork to depict the markings on the bark of trees [plate 33] and the shading of foreground detail on rocks etc. [plate 78]. Shorelines are often rendered by means of a kind of scalloped edge [plate 33]. When painting water the foreground is generally deepened in tone then worked across with horizontal blobs of colour, like a school of small fish swimming in the same direction [plates 40, 75, 78, 105]. Such mannerisms are often accompanied by the use of gradated washes of cobalt blue through lemon yellow to pink or crimson on the horizon when painting skies [plates 25, 35, 37], a process often reversed when painting smooth sheets of water [plates 44, 55].

In depicting Aborigines a silhouette style prevails and profiles are preferred, otherwise portraits are drawn full face, rarely in three-quarter view. Frontal or almost frontal shoulders are commonly joined with profile heads, buttocks and legs, resulting in a twisted perspective [plates 33, 34, 37]. In painting birds the Y-shaped fork of a treeless branch is used for a perch, a fork for one bird, a double fork for two [plates 182, 184]. Leaves are rarely depicted in bird drawings and the ground is indicated by a few dispersed tufts of grass [plates 191, 193]. A branch is usually terminated by a protruding cresting of bark [plate 191].

The drawings are normally accompanied by inscriptions in the Watling collection, but there are no inscriptions on the drawings in the Banks Ms34. Some of these inscriptions on drawings in the Watling collection appear to be in the hand of the Port

Jackson Painter, some in Watling's hand, others in the hand of John White, and still others in the hands of naturalists such as John Latham, made after the drawings had arrived in England.

The most attractive work of the Port Jackson Painter is probably contained in his drawings of plants and animals. Though not depicted with that attention to detail that a taxonomist might desire they do convey an authentic feeling of the surprise and sense of wonder in the presence of the strange and exotic [plates 229, 243]. Many of the drawings eventually became the principal source from which plants and animals were described and determined. Well before that the drawings embodied a sense of the excitement aroused by drawing something that, in most cases, had not been drawn before.

Who was the Port Jackson Painter? Various First Fleet draughtsmen have been nominated from time to time as responsible for the work of the Port Jackson Painter. It will be useful therefore to consider the claims of each in turn and assess the problems associated with each.

I / WT–Watkin Tench or Thomas Watling?

In 1921 Mathews and Iredale first drew attention to the work of the anonymous artist 'W T.'[21] They suggested tentatively, but wisely did not press the case, that possibly he might be Watkin Tench, the captain of Marines who wrote two important books relating to the foundation of the new colony. Their suggestion was based on the fact that no. 124 (old no.) in the Banks Ms34, which is in the manner of the Port Jackson Painter, is signed 'W T' [plate 232]. Tench was interested in natural history and has comments on birds in both his books, but neither contain engravings of birds or anything else, apart from a map in his *Complete Account* (1793). If Tench could have drawn so prolifically we can only assume that he would have seen that his books were illustrated with some of his drawings. That leaves the possibility of some other seaman, marine or convict with the initials W T being responsible for the work. There are a number of such people, including two seamen on the *Supply* and four convicts of the First Fleet, but none of them are known to have possessed, or may be assumed to have learned, any skills in drawing.[22] It is possible that the signature might be a sign of ownership,[23] but we know of no collector of drawings either in the colony or England who, at this time, signed his acquisitions in this way. Again, possibly it might be the work of a draughtsman, perhaps a convict, who signed the drawing after completing it to show his skill and then presented it as evidence of his ability to a potential patron such as Governor Phillip or John White. If employed as a result it is comprehensible that he would not sign any more drawings while in the employ of his patron. We know of only one drawing signed by Charles Praval on Cook's first voyage, and Cook did not hesitate to present Praval's work as if it were his own.[24] Both Parkinson who worked for Banks, and Watling who worked for White, signed their drawings but this did not prevent their patrons failing to acknowledge their names when their drawings were published.[25]

Hugh Gladstone, who first established the basic facts about Thomas Watling's life, noted that WT on no. 124 (now no. 62) of the Banks Ms34 was Watling's initials in reverse. 'I do not think this is anything more than a co-incidence' he added. But the suggestion is worth exploring further.[26]

Is it possible that the linked WT with its curiously bracketed T is an experimental monogram that Watling used once only on a presentation drawing in which he sought to reveal his skill and gain the approval of a patron, perhaps Governor Phillip? After

Plate 229 [Banks Ms34: 40]
PORT JACKSON PAINTER
Diamond python, *Morelia spilota*
(Lacépède, 1804)
Ink and water-colour, 205 × 318
See also plate 163.

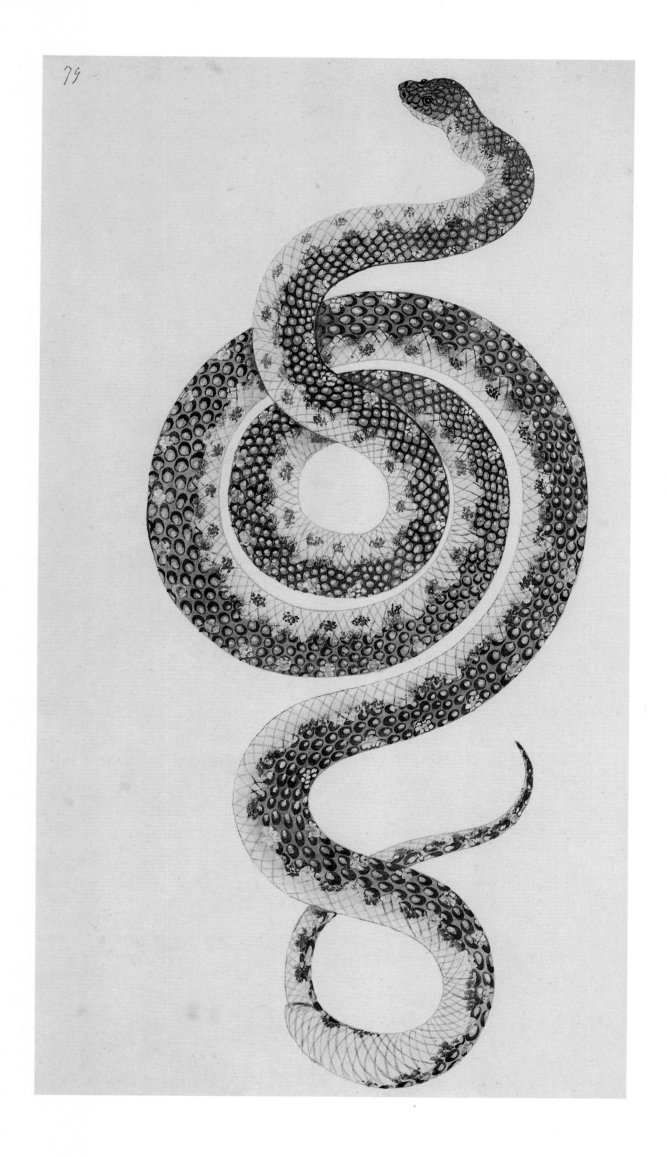

Plate 230*a* [Watling 284]
THOMAS WATLING
Silver eye, *Zosterops lateralis*
Water-colour, 185 × 172, signed
'Thom Watling del!'
Inscribed in pencil, 'Ciliary Warbler
Male La MS', 'Lambert Drawing III,
24' (both u.l.), and beneath drawing
in ink probably in Watling's copper-
plate hand 'One ½ the Natural Size',
and also in ink beneath in another
hand 'Ciliary Warbler Male Latham
MS'.

assignment to White, as a convict he would not, we may assume, be allowed to sign his drawings as if they were his own work. We know that White did not approve of this, for in a note which he later added to the verso of Watling's drawing of the 'Ciliary Warbler', now known as the Silvereye, *Zosterops lateralis*, [plate 230*a*] he wrote: 'The pride and vanity of the draughtsman has induced him to put his name to all the drawings, but should you Publish them I think the name may as well be left out'.[27] There is no doubt that White was addressing his comments on this occasion to his friend the naturalist, Aylmer Burke Lambert (1761–1842), whom he hoped would publish the drawing among others with his own notes for a second book of his on the natural history of New South Wales.

It is not true that Watling signed all his drawings. Many that are clearly by his hand in the 'Watling' collection are not signed. More significantly a great number of those that are signed leave the impression that they were signed at the same time and well after the drawing was completed. Consider for example his signed pencil drawings

[plates 4, 62]. But the question remains: why was it that Watling signed so many of his works despite the obvious disapproval of his master?

Watling himself had every reason for wishing to sign his work because as early as May 1793 he had in mind the possibility of publishing an illustrated book of his own about the colony.[28] The most he succeeded in doing, however, was to have his letters to his aunt published. It is likely that White thwarted Watling's desire to retain any copyright over his own drawings. We know that Watling disliked him and described him to his aunt as 'a very mercenary, sordid person'.[29] How then did he come to sign so many of his own drawings?

White left the colony permanently in the *Daedalus* on 17 December 1794 and arrived in London in August 1795. Between 1796 and 1797 he was serving on various ships. It was not until 11 March 1797 that he sent the rough papers of his proposed second book and an accompanying collection of drawings to his friend Lambert, soliciting his aid in publication:

Herewith you will receive a large rude manuscript, just as it was taken from my common place book by a young man who was my Hospital clerk, which my present situation prevents me being able to throw into any kind of form or even to copy fairly.[30]

Why did White not bring his manuscript to the attention of Lambert when he reached London instead of waiting for almost two years and when already serving on another ship? The likelihood is that he did not bring the manuscript with him but had it sent on. Watling, we may infer, was asked to copy from White's common place book after White had left the colony and have the book with Watling's drawings sent on to him after the work had been completed. In this connection it is interesting to note that Watling received a conditional pardon from Governor Hunter in September 1796, and White sent his manuscript and drawings to Lambert some seven months later. It is tempting to conclude that Watling continued his work for White after he left the colony, transcribing and completing drawings of plants and animals, and that he received his conditional pardon in part for this work. In the letter he sent to Hunter towards the end of his life he expresses his profound gratitude to the Governor for the way he had helped him.[31] With a conditional pardon in view or received it is likely

Plate 230*b*
Separate sheet, originally pasted on p. 74 of the Watling album to the lower left of plate 230*a*. This is a transcription, hand and date unknown, from an inscription in John White's hand on the verso of 230*a*, part of which was cut off when the original drawing was trimmed. (See Gladstone, p. 118.)

that Watling gained a sufficient sense of independence, with White no longer in the colony, to sign much of his own work before seeing it sent off to his former master. This would explain the fact that many of his pencil drawings are signed in ink, perhaps some time after their completion and despite the apparent wishes of his master.

What remains to be explained is why Watling should have used the monogram WT, if it is indeed his, when he normally signed his work in the forms 'Thos Watling', 'Thomas Watling' or 'TW'. It has already been argued above that he may have used the monogrammatic device once only when signing a drawing that served as evidence of his skill, probably shortly after he reached the colony, either to the Governor or to White, then ceased to sign his work during the period when he was under White's direct control. This may sound a somewhat far-fetched explanation – until Watling's handwriting is compared with the initials on the drawing [plate 232]. The first thing to remember was that Watling, an alleged forger, was a skilled calligrapher. This is clear from the several styles of lettering that he inscribed on the plate made to advertise his academy in Dumfries, which was exhibited at his trial [plate 231]. On his own drawings at times he makes use of three distinct styles: a fine copperplate cursive script, a more personal, informal hand, and a form of uncial lettering. Naturally enough, it was his personal, informal hand that he used to sign his work and to annotate many of his drawings. The monogram on plate 232 appears to be in this hand. Note particularly the small looped 'o' flourish that links the two letters. This loop often occurs as a flourish used when forming his capital Ts [plates 16, 17, 60]. Furthermore it may be noted that a large flourish such as the one that precedes 'The Natural Size' on plate 232 will be found on many of Watling's signed drawings [plates 18, 159]. On the basis of this evidence we might conclude that no. 62 of the Banks Ms34 is by Watling.

Plate 231
THOMAS WATLING
Engraved drawing sheet announcing classes for teaching at Watling's Academy, Dumfries
The engraving was produced at Thomas Watling's trial as evidence of his skill as an engraver, and reveals the several kinds of lettering he had mastered as a draughtsman and engraver. Reproduced from 'Thomas Watling Limner of Dumfries' by Hugh S. Gladstone, *Dumfriesshire and Galloway Natural History and Antiquarian Society*, Transactions, 1935–6, third series, vol. xx (Dumfries, 1938) fp. 75.

Plate 232 [Banks Ms34: 62]
ANONYMOUS
Unidentified bird
Ink and water-colour, 204 × 317, signed 'W.T'
Inscribed 'The Natural Size', probably in Watling's hand.
The bird is not determinable. 'It has considerable resemblance to a male Golden whistler (*Pachycephala pectoralis* (Latham, 1801)), however that species does not have a barred tail as the bird in the drawing. The only birds in that size range with barred tails are cuckoos, but the bird has no other characteristics of a cuckoo' (J. H. Calaby to Bernard Smith, *in litt*. 28 November 1986).

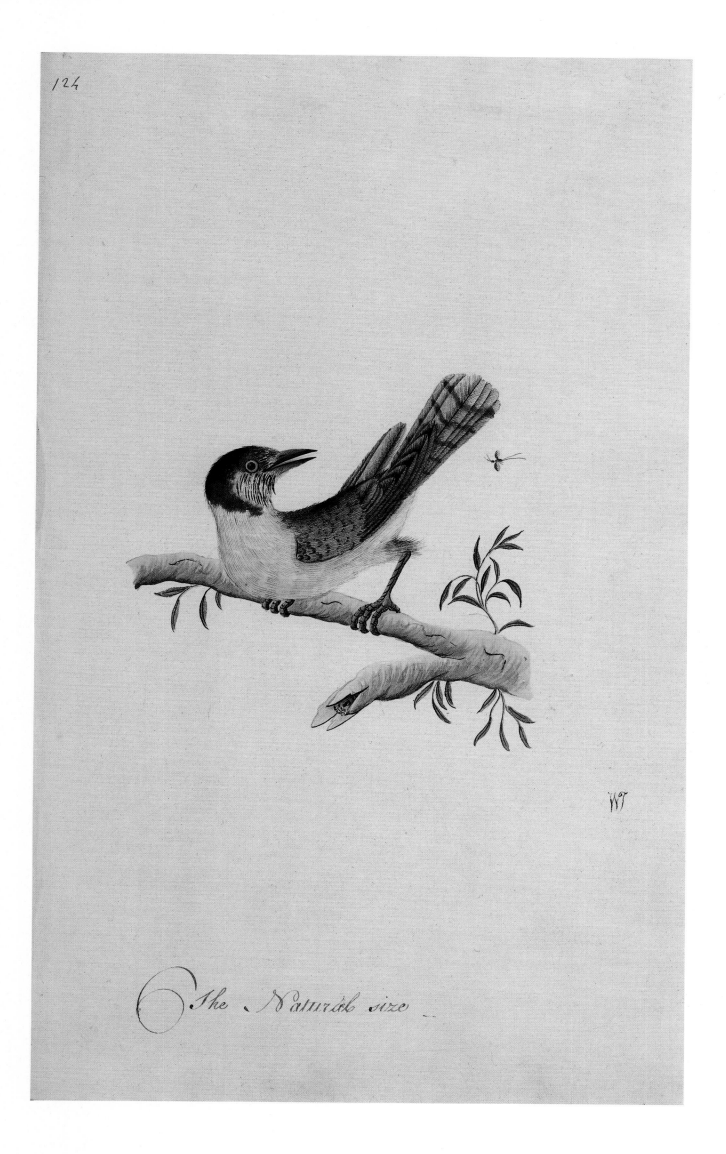

The Natural size

If however we turn to the drawing itself we note that it makes use of two traits of style associated with the work of the Port Jackson Painter: (1) of a sinuous curve to depict irregularities in the bark of the bough on which the bird perches, and (2) that the branch possesses a 'crested' end. But in both cases these mannerisms are deployed with a finesse and delicacy that is not usual in the more robust and naive work of the Port Jackson Painter. Furthermore the branch is modelled tonally and leaves are introduced, neither of which is a feature of the style of the Port Jackson Painter.

Watling had practised as a painter and perhaps also as a teacher of painting in Dumfries and worked briefly as a coach painter in Edinburgh.[32] It is clear from the small landscapes attached to his bird drawings [plates 195, 196, 203, 230a] that he had mastered a picturesque mode of composition, but he had no experience at all, so far as is known, in the quite different genre of natural history drawing. In the circumstances nothing could have been more natural than for either Phillip or White to test Watling's skills, following his arrival in the colony on 7 October 1792, than to ask him to copy some examples of the work of the Port Jackson Painter who had obviously been the most active draughtsman in the colony for some years. Watling was obviously a skilled copyist, and we may envisage him quickly absorbing some of the leading features of the Port Jackson Painter's style in his effort to impress and then soon revealing more sophisticated skills.

There is some evidence of reciprocity: that the Port Jackson Painter himself learned some of Watling's methods, such as the modelling of trunks and branches and the greater use of tone in his work. Watling appears to have developed an interest in depicting evening and night scenes with Aborigines eating fish under rock ledges or dancing. The tonal treatment involved may have inspired the scene depicted in plate 36 by the Port Jackson Painter. In many of the bird drawings, on which both the Port Jackson Painter and Watling may have worked even after White had left the colony, there is a convergence of style that makes it difficult to distinguish between the work of the two men. More documentary evidence and a closer elucidation of the techniques of the two artists may further clarify the problem but at the present state of investigation all work that clearly reveals the Port Jackson Painter's style is here ascribed to him even though, on the arguments advanced above, some of the work may be by Thomas Watling.

2 / Henry Brewer

On the present evidence it is Henry Brewer who possesses the strongest claims to being the Port Jackson Painter.[33] He was an old associate of Arthur Phillip. He had joined Phillip as his clerk at the age of thirty-four, when Phillip was appointed First Officer on the *Alexander* in October 1774, with the designation of a landsman. He was said to have studied architecture and been an architect's clerk but lost his job for reasons he would not discuss. Thereafter he followed Phillip from ship to ship: on the *Basilisk* (1779–80), the *Ariadne* (1781–82) and the *Europe* (1782–84). Edward Spain, who had known Brewer from the time he joined the *Alexander* has left a colourful and not unattractive picture of the man:

Harry Brewer was an excellent scholar and a very great assistant to the Lieutenant [i.e. Phillip] in copying his journals, writing out his watch and quarter bills, so that Harry might be said to be the first lieutenant's clerk ... I verily believe a more disinterested or honester steward is nowhere to be found.[34]

Spain provides a vivid description of Brewer at the time he joined the *Europe* in December 1782:

Figure to yourself a man about fifty years of age [he was in fact about forty-three] of coarse harsh features, a contracted brow which bespoke him a man soured by disappointment; a forbidding countenance, always muttering to himself . . . and wearing . . . a blue coat of the coarsest cloth, a wool hat about three shillings a piece, cocked with three sixpenny nails, a tolerable waist coat, a pair of cordurry breeches, purser's stockings and shoes, a pursers's shirt, none of the cleanest.

It is Spain who also informs us that while the *Europe* was at Madras, Phillip presented Sir Edward Hughes (1720–94), Admiral of the Fleet in India, with 'a couple of Joanna bullocks and some original drawings of places he had visited, done by Henry Brewer'. These drawings have not come to light. From Spain we learn that Brewer was a skilled draughtsman:

Fortune smiles when we least think of it. Who would have thought that Captain P[hillip] a man of no great family, without any connections should be appointed Commodore and Governor of a new Colony to be established in New Holland. So it happened. Now Mr Brewer was just such a man as the Governor wanted. What excellent plans, drafts and views of places he could draw, which I could send home to my patrons. Harry was accordingly appointed and sail'd with his old Captain to New South Wales, where he was appointed Provost Marshall. And there he died. Peace be to his shade. If honesty merits Heaven, Harry is there.[35]

Brewer was entered in the muster book of the *Sirius* as a midshipman on 29 December 1786.[36] On 26 January 1788, Phillip appointed Brewer as his acting Provost Marshall by warrant, though the post was not confirmed until 1792. So Brewer's name remained on the *Sirius*'s muster books until 7 March 1791, though he did not sail in her to the Cape or on the fatal voyage to Norfolk Island. Phillip used Brewer to superintend building operations, because of his earlier experience in a large building firm in England. As Provost Marshall he directed the convict constabulary and was responsible for the maintenance of civil order in the new community. In 1793 he obtained a grant of 50 acres in the neighbourhood of the present suburb of Concord, Sydney.[37] Towards the end of 1795 his health failed and he was relieved of his civil duties in February 1796. He died in July 1796, a few months later.[38]

From Spain's description of him, we might conclude that Phillip would make use of Brewer's skills as a draughtsman, and it has been suggested that he may have been charged with the task of drawing up plans for the first Government House in New South Wales, the first stones of which were laid on 15 May 1788.[39] Unfortunately no drawings are known that can be clearly ascribed to Brewer, apart from copies he made of three of John Hunter's charts: Botany Bay, Broken Bay and Port Jackson [plates 233, 234, 235]. The first is signed 'H. Brewer'. The maps were sent by Phillip to the Home Secretary on 13 February 1790 and ended up in the collection of George III.[40] About twenty-two months later Phillip sent Sir Joseph Banks a drawing of a waratah and mentioned that he had two hundred drawings of plants and animals prepared for Banks's examination.[41] But there is no evidence that Phillip ever sent such a collection of drawings from the colony to Banks or to anyone else. Brewer is the only person resident in the colony known to have possessed the skills to have prepared such a collection, if we exclude as we must, Bradley, Hunter, Raper and King, for the reasons already advanced above. In any case the first three were well on their way back to

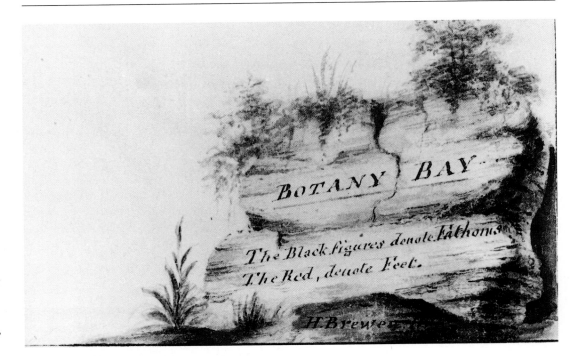

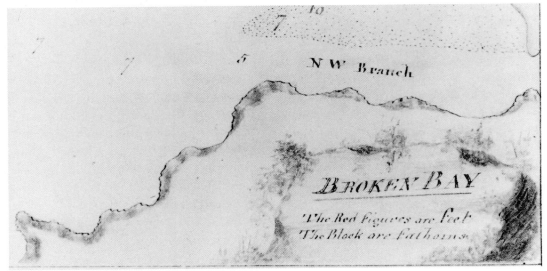

Plate 233
HENRY BREWER
Detail from a chart of Botany Bay
by John Hunter copied by Brewer for
Governor Phillip
The only known drawing signed by
Brewer.
Map Room, British Library, London,
Crown cxvi.

Plate 234
HENRY BREWER
Detail from a chart of Broken Bay
drawn by John Hunter and copied by
Brewer for Governor Phillip
Map Room, British Library, London,
Crown cxvi.

England by December 1791 and would have retained their own drawings, whereas
Brewer had worked for Phillip for years.

A large number of the drawings here attributed to the Port Jackson Painter possess
as we have noted inscriptions in a common hand. Such inscriptions often begin 'The
Natural Size' and often provide the Aboriginal name of a plant or animal. If this hand
could be identified positively as that of Henry Brewer it might be possible to ascribe
much of the work, if not all, of the Port Jackson Painter to Brewer. But no autograph
letter or document by Brewer has as yet come to light, though there exist many logs
and journals of ships on which Phillip and Brewer travelled together, and on Spain's
evidence Brewer acted as Phillip's clerk on the *Basilisk*, the *Ariadne* and the *Europe*.
But lacking an autograph document such evidence is inconclusive.

However, some evidence that Brewer copied drawings, presumably for Phillip, is

provided by a comparison of Raper's *View of the West Side of Sidney Bay, Norfolk Island Shewing the method by which the crew & Provisions etc etc Were saved from the Wreck of H*ˢ *M*ˢ *S*ᵖ *Sirius . . .* [plate 127] with plate 128 here ascribed to the Port Jackson Painter. It is precisely the kind of visual document that would be of interest to Phillip, and Raper's original, we know, remained in the artist's possession.

Raper's view is signed and dated; plate 128 is not. 'The West Side of Sidney Bay Norfolk Island' is an accurate description; 'The West side of Norfolk Island' in the title of plate 128 is not. The copyist has committed a common error of copying, omission. That the copyist was Brewer is suggested by comparing the lettering beneath plate 128 and the lettering on his signed copy of Hunter's plan of Botany Bay [plate 234].

It may well have been Brewer who copied Bradley's plan of Norfolk Island [plates 84, 85, 86] after Bradley's return from Norfolk Island in February 1791. The copies do not include all of Bradley's navigational information.

If Brewer were indeed the Port Jackson Painter we may envisage him working for Phillip during the first two years of settlement, within the naval circle of Hunter, Bradley, and Raper, producing copies of charts, plans and navigational views for the Governor. But from the beginning we should expect him, at Phillip's request, to steadily diversify his work to include drawings of the Aborigines, of native plants, and of animals shot by John McEntire or brought in by others, work for which there was a strong demand from Banks and other naturalists in England. It is likely too that he began to do some work for White who was the most active collector of natural history in the new colony and that when Watling arrived in October 1792 he may have worked with him producing drawings for White. After Phillip's departure in December 1792 Brewer may have worked largely for White before ill-health obliged him to cease. This would help to explain the steady improvement to be observed in the skills of the Port Jackson Painter from the attractive and naive, but somewhat crude drawings of the

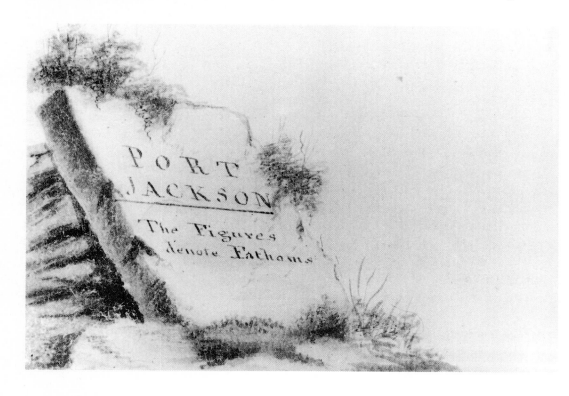

Plate 235
HENRY BREWER
Detail from a chart of Port Jackson drawn by John Hunter and copied by Brewer for Governor Phillip
Map Room, British Library, London, Crown cxvi.

first two years to the increasing delicacy and finesse of the later work. Obviously he would have learned much from association with Watling. But at this point it must be stressed that all this, though plausible, is speculation. Against it we must place the fact that as Provost Marshall Brewer had many other things to do, that apart from Spain's memoir and the copies of Hunter's plans, we have little evidence concerning his skills. From Spain too we know that he drank heavily at times and may have been past his prime by the time he reached Sydney. To have been both Provost Marshall and produce all the work here ascribed to the Port Jackson Painter, though possible would have required the energies of an assiduous worker – and we have no evidence that Brewer was assiduous. We shall not know whether Brewer was the Port Jackson Painter or whether he worked for White after Phillip left the colony until such time as more evidence becomes available.

3 / Francis Fowkes

Dr Perry has drawn attention to the fact that an eye-sketch of Port Jackson in the Watling Collection [plate 71] presents similarities to the representation of Sydney Cove and the settlement as depicted in the engraved *Sketch and Description of the Settlement* . . ., published by Cribb in July 1789 [plate 113]. George Mackaness first suggested that this might be Francis Fowkes on the grounds that he was the only person on the First Fleet convict list bearing the initials F.F.[42] But as Perry notes, the ascription to Fowkes is supported by the fact that he served five years as a midshipman before being convicted of stealing in 1786. If Fowkes was responsible for the eye-sketch [plate 71] then he must be considered as a possible candidate for at least some of the work here attributed to the Port Jackson Painter.

Fowkes was employed as a clerk at Sydney Cove on arrival, served for a time on Norfolk Island and returned to Sydney in October 1792. In 1797 he acquired a grant of land on the Hawkesbury River, through his wife, but in 1800 was also working as a clerk in the office of the Governor's Secretary. His farm was advertised for sale in 1805. It is not known when he died.[43] As a midshipman Fowkes would have learned to draw and his convict status would have ensured that he did not sign his work, but there is no firm evidence that he produced any of the work here attributed to the Port Jackson Painter.

4 / John White

It has been suggested by Rienits and Rienits that John White, the chief surgeon, may have been the Port Jackson Painter,[44] but their case is not convincing. The only ostensible evidence we possess that White ever made drawings derives from the inscription 'I. White delin.' beneath the engraved vignette *View of Port Jackson* which appears on the title page of his *Journal of a Voyage to New South Wales* (1790) [plate 236]. The assertion is bald enough, but until original drawings signed by White, or which can be ascribed to him on firm grounds come to light, it must be treated with caution, like the inscription beneath *A Family of New South Wales* [plate 224] ascribing it to Governor King. It is more likely that White sent the drawing with his manuscript to Debrett, the publisher, and that the publisher simply ascribed the drawing to White as the artist. In Watling's case we know that White was not keen that the name of other artists working in the colony should be credited with work which appeared in his own books.[45]

White, a keen naturalist, certainly bought, commissioned or had someone draw specimens for him in the colony, prior to the arrival of Thomas Watling who, as his assigned convict, completed a great deal of work for him. White probably sent off

drawings to London as early as July 1788 when the *Alexander* left with the first despatches from the colony. It arrived in May 1789. The editor of *The Voyage of Governor Phillip to Botany Bay*, published in November 1789, recorded that the drawing from which the engraving of the kangaroo was cut 'among others, came from Mr White, the surgeon at Port Jackson'.[46] It says plainly enough that they came from White not that he drew them. When White came to publish his own journal a year later he noted in it, as we have seen, that Captain Hunter had 'a pretty turn for drawing' but there is nothing in his book to suggest that he drew too, though it reveals him as a keen collector of natural history. When he sent the manuscript of his journal to London to be published no drawings from the colony were used, so far as we know, for any of the engravings in it except perhaps the one from which the vignette on the title page derives. Perhaps White recalled the criticism of the drawing of the kangaroo that had been published in *The Voyage of Governor Phillip*. London artists were employed to make the drawings from dead specimens sent from the colony.[47]

Rienits and Rienits have drawn attention to the fact that eleven years after White's death, in March 1843, George Gray, the ornithologist, borrowed from the Earl of Derby 'three volumes of drawings which were made by Mr White'.[48] There is a double confusion here. Gray was referring to copies of drawings which Aylmer Burke Lambert made, or had made, from White's collection of drawings and Gray's statement may simply mean that he believed White had assembled the three volumes of drawings not that he had executed them. This opinion is supported by John Gould's statement, which Rienits and Rienits tend to discount, that 'they were made by an artist in the colony for one of the governors'.[49] Gould also thought that the drawings had been presented to Lambert by one of the governors. That was incorrect but the first part of Gould's statement was probably close to the truth. Until firm evidence is produced to the contrary we need not take seriously the suggestion that John White was the Port Jackson Painter.

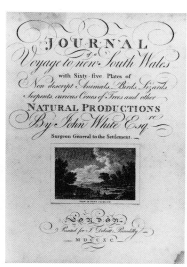

Plate 236
Title-page, John White's *Journal of a Voyage to New South Wales* (London, 1790) with a detail of the engraved illustration

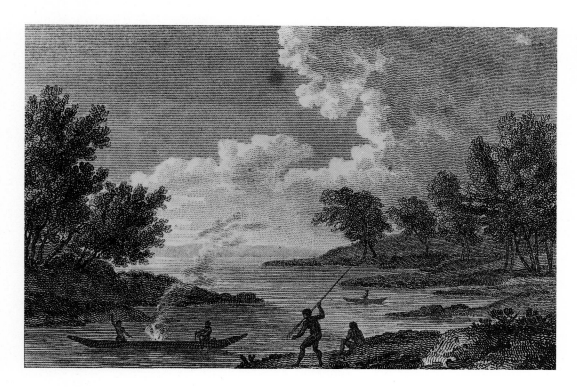

A close examination of the subject matter of what were, in all probability, the earliest drawings of the Port Jackson Painter supports this conclusion. They seem to be clearly the work of a naval man closely concerned with navigation rather than that of a man like White who was more interested in natural history [plates 75, 78, 79, 85, 86, 100, 105]. In all this work there is a close link with the work of Bradley and Raper. If Henry Brewer were the Port Jackson Painter it is likely that he, the older man, would have assisted Raper, who was only nineteen when he joined the *Sirius*, with his drawing and lettering. Such was the custom of the sea and they were both midshipmen on the *Sirius* on the voyage out. If that were the case it is also clear that Raper soon outclassed his teacher in composition and lettering. But it was the Port Jackson Painter – whether or not he was Brewer – who possessed the more robust approach to colour.

This is revealed in *Grotto Point . . . Port Jackson* [plate 78] a work that splendidly reveals most of the features of his style. The drawing may possibly represent one of the earliest attempts to record a personal reaction to Sydney Harbour and its characteristic beauty, perhaps at an impressive moment at sunrise.

It seems possible to document the occasion on which the finished drawing, or at least the sketch on which it was based, was drawn.

In his *Historical Account*, John Hunter records how:

A few days after my arrival with the transports in Port Jackson [I] set off with a six oared boat and a small boat, intending to make as good a survey of the harbour as circumstances would admit: I took to my assistance Mr Bradley, the first lieutenant, Mr Keltie, the master, and a young gentleman of the quarter deck'.[50]

From Bradley's 'Voyage' we know that this survey began on Monday 28 January. On the following day they went over to 'the Middle Branch' now known as Middle Harbour and, towards the end of the day 'went to Grotto Point Moord the boats for the night and made a Tent Fore and Aft the longboat, in which we all slept'.[51]

It would be tempting to conclude, though we have no firm evidence for it, that *Grotto Point* [plate 78] may derive from that occasion though it is not in the style of Bradley or Raper (who was probably the young gentleman of the quarterdeck) and we have no evidence that Brewer was with them; he was probably employed by Phillip on other matters. But he may have developed the drawing made at the time by Bradley or Raper. In any case it may be taken to be an excellent early example of the work of the Port Jackson Painter.

Whoever the Port Jackson Painter was, he was the only person who undertook to represent significant early incidents associated with the beginnings of settlement at Sydney, such as the wounding of Governor Phillip at Manly Cove on 7 September 1790 [plates 63, 64].

A whale had been stranded on the beach there and Bennelong, the only Aborigine at that time to sustain a successful contact with the new settlers, sent Phillip some of its flesh as a present. Keen to renew the acquaintance Phillip rowed across, picking up some muskets at the South Head lookout on the way, for Manly Cove had become crowded with natives attracted by the whale flesh.

None of the published journals contains an eyewitness account of the event that followed. David Collins's is perhaps the most complete:

The cove was full of natives allured by the attractions of a whale feast; and it being remarked during the conference that the twenty or thirty which appeared were drawing themselves into a circle round the governor and his small unarmed party . . . the gov-

ernor proposed retiring to the boat by degrees; but Bennillong, who presented to him several natives by name, pointing out one, whom the governor, thinking to take particular notice of stepped forward to meet, holding out both hands toward him. The savage not understanding this civility, and perhaps thinking that he was going to seize him as a prisoner, lifted a spear from the grass with his foot, and fixing it on his throwing stick, in an instant darted it at the governor. The spear entered a little above the collar bone, and had been discharged with such force, that the barb of it came through on the other side. Several other spears were thrown, but happily no further mischief was effected. The spear was with difficulty broken by Lieutenant Waterhouse, and while the governor was leading down to the boat the people landed with the arms, but of four musquets which they brought on shore only one could be fired.[52]

It is most unlikely that Hunter, Bradley or Raper were responsible for the two drawings which illustrate this event [plates 63, 64] for they were in Norfolk Island at the time and did not return until six months later. At the time of the spearing John White was absent on a natural history excursion to Broken Bay and it was his assistant Balmain who successfully removed the spear. What we know of White suggests that it would be unlikely for him to record an event in which he was conspicuous by his absence. But it was obviously just the kind of event that Brewer, an old and close

Plate 237 [Watling 25]
PORT JACKSON PAINTER
Mr White, Harris & Laing with a party of Soldiers visiting Botany Bay Colebee at that Place when wounded near Botony Bay
Water-colour, 266 × 428
The words 'near Botony Bay' are in browned ink in a variant hand. The name 'Colebee' appears in pencil near the Aboriginal sitting on the log.

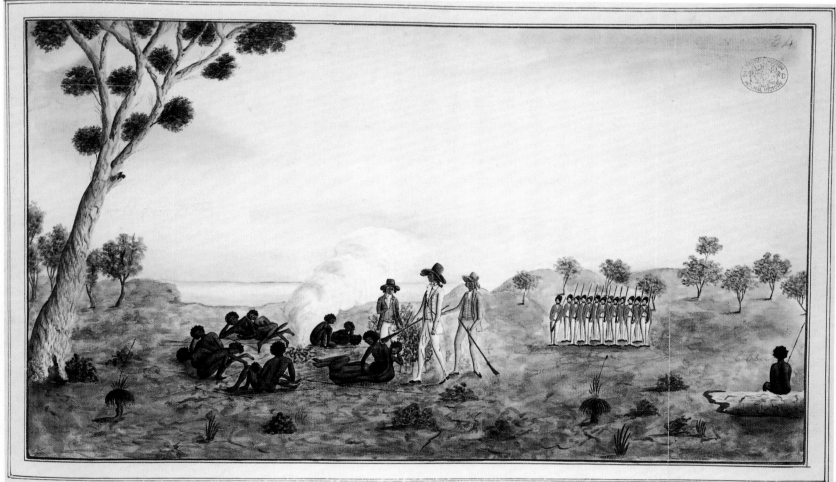

Wr White, Harris & Laing with a party of Soldiers visiting Botany Bay Colebee at that Place when wounded near Botony Bay

friend of the Governor, might want to record, despite his very limited capacity for figure drawing. And despite its innocent *naiveté* the artist, whoever he was, does provide a lively representation of the event: the Aborigines about their huts and fires, or dispersed amid clumps of banksia, or stationed as guards on the outlying rocks – with the one musquet that actually fired being used to some effect.

Another event recorded by the Port Jackson Painter includes White as a participant, but it cannot be identified precisely from the written records [plate 237]. It may refer to some incident that followed the death in December 1790 of John McEntire, the convict licensed by Phillip to carry arms. The natives, Bennelong particularly, had taken a great dislike to him – perhaps for good reason. He was slain by Pemulwuy, an Aboriginal who had consistently opposed the new settlers. John White was a member of the punitive expedition sent out in the direction of Botany Bay to capture Pemulwuy and his associates.[53] The party included some forty members of the New South Wales Army Corps. Near Botany Bay they met Colebee who was unable to help them in their search for Pemulwuy. This drawing may refer to an incident not otherwise recorded that took place at the time.

This completes our consideration of the men associated with the First Fleet who have been nominated from time to time as the artist responsible for the work of the Port Jackson Painter. There remains now to be considered briefly the work of three men who arrived in Sydney in the early 1790s.

William Neate Chapman

William Neate Chapman (1773–1837) was a family friend of both Governor Phillip and Lieutenant Governor King. He returned with King on the *Gorgon* after King's visit to England in 1790–91, arriving in Sydney on 21 September 1791. A few weeks later he sailed with King for Norfolk Island and was appointed storekeeper at Phillipsburgh in the north-east of the island. He remained on the island for ten years and made a few drawings of historical interest relating to the first settlement [plates 132, 145, 147]. In 1801 he was appointed Naval Officer in Sydney under Governor King, and in 1804 left for England not to return. He ended his life in Java as a planter, though apparently not a successful one.[54]

Thomas Watling

We have already discussed some aspects of the work of Thomas Watling in its relation to the work of the Port Jackson Painter, and there are several reasons why his work need not be discussed in detail here. The basic facts of Watling's life were first established as a result of the research of Hugh Gladstone, and his life and work have been discussed in detail by Rienits and Rienits. This book, however, provides the first occasion when it is possible to assess the range of his contribution to the visual documentation of the new colony.

Watling made important contributions not only to our knowledge of the growth of settlement at Sydney in the work that he did for David Collins, the Judge Advocate, but he also made drawings that are invaluable from an ethnographic viewpoint, and the range and quality of his natural history drawings for John White have never been fully appreciated. Fortunately, despite White's displeasure, he signed a good deal of his work and he possesses such a distinctive style that it is not difficult to distinguish his mature work from the work of the naval draughtsmen who preceded him. Watling was obviously trained in the aesthetics of the picturesque and brought a new set of pictorial values to the colony.[55]

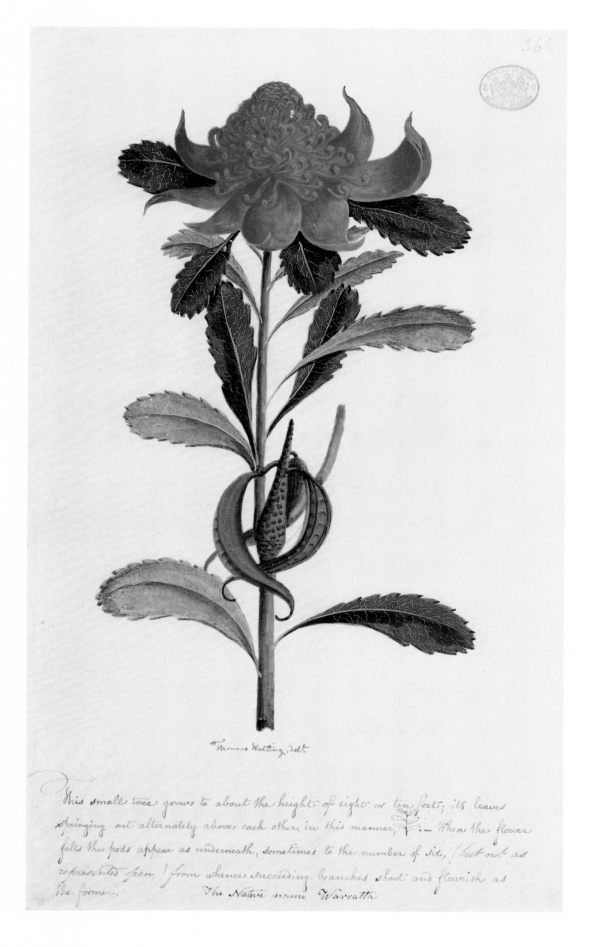

Thomas Watling, del.

This small tree grows to about the height of eight or ten feet; its leaves springing out alternately above each other, in this manner, [diagram] – When the flower falls the pods appear as underneath, sometimes to the number of six, (but not as represented open,) from whence succeeding branches shoot and flourish as the former. The Native name Warratta

Plate 238 [Watling 431]
THOMAS WATLING
Waratah, *Telopea speciosissima*
(Smith) R. Br.
Water-colour, 366 × 218, signed
'Thomas Watling, del!'
Inscribed beneath drawing in
Watling's hand 'This small tree
grows to about the height of eight
or ten feet; its leaves springing out
alternately above each other, in this
manner [diagram] – When the flower
falls the pods appear as underneath,
sometimes to the number of six (but
not as represented open,) from
whence succeeding branches shoot
and flourish as the former', and 'The
Native name Warratta'.

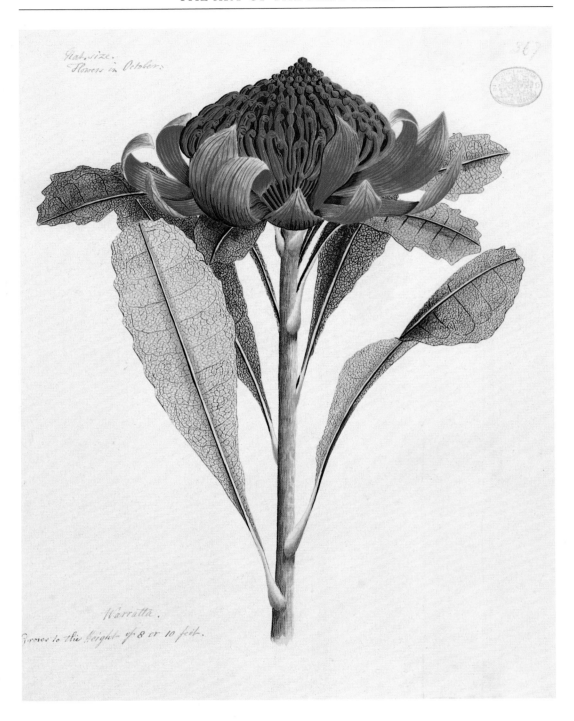

Plate 239 [Watling 432]
THOMAS WATLING
Waratah, *Telopea speciosissima*
(Smith) R. Br.
Water-colour, 339 × 249, unsigned
Inscribed in ink 'Nat. size. Flowers in
October' and 'Warratta. Grows to
the Height of 8 or 10 feet'.

One difficulty, however, does arise that has already been alluded to. It is quite likely that being untrained in natural history drawing and being a skilled copyist he began his work for White by emulating the drawings of the Port Jackson Painter, if only to gain the approval of his superiors. It is also likely that the Port Jackson Painter adopted some of his technical methods. If this is the case then there may be a group of drawings both in the Banks Ms34 and the Watling collection in which features of their respective styles conjoin and are not readily distinguished. For this reason some work that was actually completed by Watling may still here be ascribed to the Port Jackson Painter.

On the present evidence available it has not been possible to separate them conclusively.

Being the more skilful painter it is likely that Watling began to look for more sophisticated models for his natural history drawings than the work the Port Jackson Painter provided. John White's *Journal* was published in 1790 and White probably received copies of the book well before Watling arrived in October 1792. Most of the bird drawings in the book are by Sarah Stone, who worked largely for the Leverian Museum.[56] It is likely that Stone or some other artist hand-coloured the engravings in at least one of the copies of his book that White received. These would provide Watling with better models than the naive work of the Port Jackson Painter.

When preparing the printed catalogue of Sir Joseph Banks's library, his librarian Jonas Dryander catalogued Manuscript 34 as the work of Edgar Thomas Dell. This was later struck out in Banks's own copy of his catalogue and on folio i of the manuscript itself. Dell was not an artist. He was first mate on the *Shah Hormuzear*, a private trading vessel from Calcutta that visited Sydney on 24 February 1793. Dell came again to Sydney as Captain of the *Fancy* on 9 July 1794 and 15 March 1795.[57] It is possible that White sold or bartered the collection of drawings now constituting the Banks Ms34 to Dell on one of his visits to Sydney.

General Thomas Davies (*c.* 1739–1812), an amateur ornithologist, who at one time appears to have made copies of the bird drawings in the Banks Ms34 believed that they came from Governor King.[58] Thomas Dell visited Norfolk Island twice in 1795. Did he there sell the collection of drawings to King, who was then Commandant of the Island? King possessed a close association with Banks and through him the collection may have come into Banks's possession. As a result, the names of both Dell and King, essentially agents of transfer in the matter, may have become attached to the collection as its authors.

While working for White, Watling developed into a highly skilled natural history draughtsman. Some of his paintings such as that of the waratah, *Telopea speciosissima* [plates 238, 239] are comparable to the best work of Sydney Parkinson, Banks's artist on the *Endeavour* voyage.

But as noted above, Watling, so far as we know, had no experience in drawing plants and animals before he reached New South Wales. How did he achieve such skill? It is likely that White gave Watling a copy of his published *Journal*, one with hand-coloured engravings, and asked him to copy the engravings carefully.[59] And this, we may assume, he did with such skill that it has caused some to assume that they are the original drawings for the engravings in White's *Journal*.[60] But this seems most unlikely, since all 69 drawings in the Banks Ms34 appear to be drawn on the same paper stock, and are all on laid paper possessing either Britannia or Floyd and Co. watermarks,[61] and there can be little doubt that the collection originated in New South Wales.

On the basis of the evidence available the most likely conclusion is that all the drawings in the Banks Ms34 collection are by Thomas Watling. They were probably begun shortly after his assignment to White. The first 47 drawings, mostly of birds and animals, are probably copies of drawings by the Port Jackson Painter. This view is reinforced by the fact that no. 42 in the Banks Ms34 [plate 34] is obviously a carefully finished copy of no. 59 in the Watling collection [plate 33], which is most probably an original drawing by the Port Jackson Painter. The drawings from nos. 49 to 59 are careful copies by Watling [plates 151, 152, 154, 155] of hand-coloured engravings in White's *Journal* made from original drawings by Sarah Stone and other

May

Natural size

Natural size

This Plant grows about 4 or 5 feet in height and generally found in dry sandy soil

English artists. The following two drawings of birds, nos. 60 [plate 182] and 61, are again closely in the style of the Port Jackson Painter. The last eight drawings in the collection are unlike the others in that they are all inscribed in what certainly appears to be Watling's copperplate hand. It has already been noted that the first drawing in this sequence with inscriptions is signed 'W.T.' and I have argued above that this is a monogram adopted by Watling, but on one occasion only. White, probably, did not approve. It may also be noted that the two bird drawings which contain inscriptions are no longer in the manner of the Port Jackson Painter. They are much closer to Sarah Stone's style for presenting birds. In this regard nos. 63 and 69 in the Banks Ms34 may be compared with the engraving in White's *Journal* (1790), of *The Crested Cockatoo* (pl. 17), from a drawing by Stone.

We may conclude therefore that Watling began working on the collection now known as the Banks Ms34 shortly after he was assigned to White; that he began by copying drawings of the Port Jackson Painter, proceeded to copy engravings from White's *Journal*, and completed the series with drawings inscribed by himself which reveal the influence of Sarah Stone and the other artists who made original drawings for the engravings in White's book.

Original drawings of plants and animals from New South Wales continued to be sought during the early 1790s. In 1793 James Sowerby (1757–1822), artist, naturalist, member of the Linnean Society and author of *An easy Introduction to drawing flowers according to Nature* (1788), decided to publish two small books (initially in parts): *A Specimen of the Botany of New Holland* (1793) by Sir James Edward Smith (1759–1828), the President of the Linnean Society; and *Zoology of New Holland* (1794) by George Shaw (1751–1813), also a member of the Linnean Society and at that time Keeper of the Department of Natural History of the British Museum.

Sowerby developed his drawings for these books from the original drawings and

Plate 240
ANONYMOUS
Styphelia tubiflora Smith
Water-colour, 469 × 305
Inscribed 'This plant grows about 4 or 5 feet in height and generally found in dry sandy soils'.
Private collection, Australia.

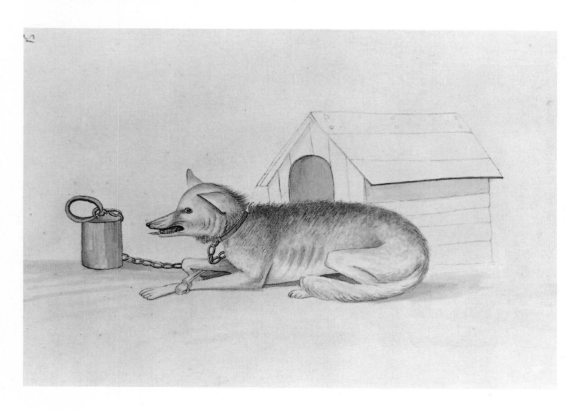

Plate 241
THOMAS WATLING
Dingo, *Canis familiaris dingo* Meyer, 1793
Pencil, pen and wash
Inscribed on verso apparently in Watling's hand 'A wild dog or Dingo of N.S. Wales the Property of J. White Esq Surgeon General to the Territory'.
Private collection, Australia.

specimens sent from Sydney by White and others. Two sets of drawings that may have assisted Sowerby's venture are now in an Australian private collection. James Smith informs us that the illustration of *Styphelia* which appears in *A Specimen of the Botany of New Holland* (p. 45) was taken 'from a drawing obligingly communicated to us by the late Major Ross and assisted by very magnificent specimens from Mr White'.[62] The drawing referred to may be that illustrated in plate 240, for it appears to have been drawn and annotated by either the Port Jackson Painter or Thomas Watling. A second set of drawings in the same private collection includes twelve drawings of plants from New Holland, four of which are on sheets containing Britannia watermarks. These drawings certainly seem to be associated with Thomas Watling, for one is of a dingo [plate 241], probably the earliest known drawing of a dingo in captivity. It is inscribed on the verso 'A wild dog or Dingo of N.S.Wales the Property of J. White Esq. Surgeon General to the Territory'. The handwriting appears to be Watling's; 'N.S.Wales' seems to have been an abbreviation he favoured.

Watling also possessed considerable potential as a landscape painter. The small landscapes which he attached to many of his bird drawings are surprisingly fresh and attractive [plates 195, 196, 203, 230a]. They reveal his skill at landscape far more clearly than the topographic views of Sydney that he drew for White and Collins. He

Plate 242
THOMAS WATLING
A Direct North General View of Sydney Cove, the chief British Settlement in New South Wales as it appeared in 1794, being the 7th year of its establishment
Oil on canvas, 915 × 1296, unsigned, date not known
The title is inscribed on the back of the canvas in black paint, apparently in Watling's hand.
Dixson Gallery, State Library of New South Wales, Sydney.

234

complained about the unpicturesque character of New South Wales landscape yet aspired to produce a set of picturesque views of the colony.[63] Unhappily the project came to nothing. The small vignettes beneath his bird drawings provide a glimpse of what he might have achieved had he been permitted to extend his considerable talents into landscape.

Although not as aesthetically attractive, the topographical views which Watling completed for White and Collins are of great historical importance. Those he drew for White [plates 134–142] are here published in a sequence suggested by Dr Frost. Though not all of them are signed, perhaps because he considered them to be sketches or unfinished work, they may all be ascribed to him. Taken together with the engraved views in Collins's *Account* which were redrawn from Watling's originals by Edward Dayes, they constitute a significant topographic survey of Sydney's urban development in the mid-1790s, seven or eight years after settlement. It is conceivable that they were completed over a comparatively short period of time at the suggestion (or requirement) of Collins in order to provide a co-ordinated view of the settlement from several points of the compass, in the manner of the Italian *vedute* painters, the series providing a three-dimensional picture of the growing town.

One final question however must be raised. The very well-known painting *Sydney Cove . . . in 1794* [plate 242] in the Dixson Gallery, State Library of New South Wales, is usually regarded as a work that Watling completed in the colony. But this view is open to question. There need be little doubt that the work is by Watling. The inscription on the back of the canvas reads 'A Direct North general View of Sydney Cove the chief British Settlement in New South Wales as it appears in 1794 being the 7th Year from its Establishment. Painted immediately from Nature by T. Watling'.[64] It thus repeats the first part of the inscription beneath Watling's wash drawing at plate 141 and the inscription, though done with a brush in thick white paint, appears to be in Watling's own hand.

Watling's assertion that the picture was 'painted immediately from Nature' requires consideration and interpretation. If we take it literally, are we to assume that Watling set up his canvas in the open air somewhere behind the general hospital and painted a *plein-air* view of the town? This would mean that *plein-air* oil painting in oils in Australia began not with the Heidelberg school in the 1880s but with Watling almost a century before! William Dixson, when he purchased the work in 1919, noted that it had cracked vertically down the middle and suggested that this was probably due to its being folded for transport to England.[65] But that implies that the painting was not on a stretcher. If so it would have been much safer to have folded the painting. The vertical crack is in fact more likely to have been caused by the central vertical strut of its original stretcher.

Rienits and Rienits have noted that John White, in 1791, bought 'one chip box containing colours and brushes' and 'one marble stone for preparing colours' from David Burton, a gardener whom Sir Joseph Banks had sent to the colony, and assumes that this was a box of oil colours.[66] But painters of plants working for naturalists like Banks and the artists associated with him invariably coloured their drawings with transparent water-colour or gouache. The box Burton sold to White probably contained pigments in cake or powdered form to be mixed with water on a china or marble slab. In 1801 Ackerman, who specialized in providing materials for water-colour painters advertised 'Neat Mahogany boxes, containing a marble slab, brushes etc., and colours ranging from twelve to thirty-six'.[67] This is the kind of unit Burton may have possessed.

The problem may be stated thus: if White purchased oil paints for Watling's use, why did Watling make this single unique use of them in *Sydney Cove in 1794*? An oil painting in Sydney at that date would be quite exceptional. It is not until the 1820s in the work of Richard Read senior and Augustus Earle that oil painting comes into common use in Sydney.[68] It must be questioned therefore whether *Sydney Cove in 1794* was painted in the colony. It is more likely that it was painted from wash drawings in Watling's possession after his return to Dumfries around 1804, from drawings similar to those in plates 135 and 141. The fact that the picture first came to light in the Oldham Fine Arts and Industrial Exhibition of 1883 suggests a provenance originating in the north of Britain, one it retained until Sir William Dixson purchased it in 1919.

David Burton arrived in Sydney in the *Gorgon* on 22 September 1791 as a superintendent of convicts. Banks had recommended his appointment because he possessed a knowledge of gardening and surveying and he also commissioned him at a rate of £20 a year to collect seeds and specimens for him privately, on condition that he collected for no one else.

Burton sent tubs of plants and boxes of seeds back to Banks when the *Gorgan* left Sydney in December 1791, and also on the *Pitt*, early in March 1792. On 13 April 1792 he died as the result of mishandling his own gun while shooting ducks on the Nepean River. As noted above, he had brought a box of colours with him to the colony and some sketches are said to have been found among his effects. It is unlikely, however, that the young man had much time to make drawings during the five and a half months he was in New South Wales, where he was responsible for superintending convicts, reporting on the quality of the land in the Parramatta area for Governor Phillip and collecting seeds and specimens for Banks.[69]

In a letter Phillip wrote to Banks, dated 3 December 1791 and probably despatched in the *Gorgan* when it sailed on 13 December, Phillip noted that 'Burton will be useful & in his idle hours shall collect seeds, he has got specimens of the plants sent home, & I send you a drawing of the War-re-teh, several plants of which are in the tubs. I am getting drawings of all the plants & animals, they are done correctly, & about two hundred are finished.'[70]

On the basis of the evidence already considered above it is unlikely that the collection of drawings mentioned by Phillip ever became part of either the Banks Ms34 or the Watling collection. What happened to the drawings Phillip refers to? Who drew them? The mystery remains.

Plate 243 [Watling 351]
PORT JACKSON PAINTER
Black swan, *Cygnus atratus* (Latham, 1790)
Water-colour, 241 × 191
Inscribed beneath the drawing in browned ink 'The black Swan, the size of an English Swan Native name Mulgo'.

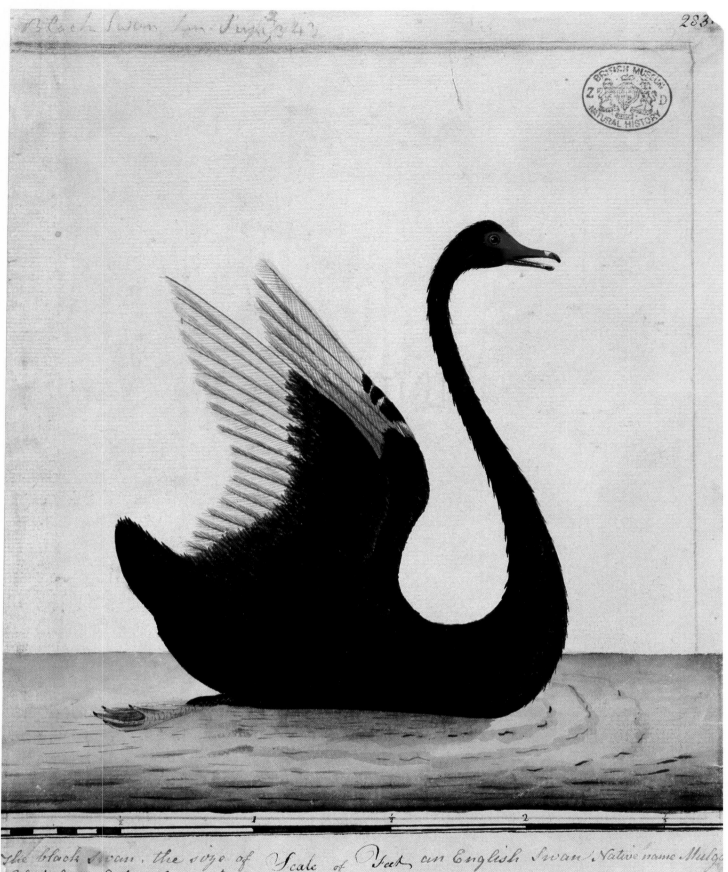

the black Swan. the size of Scale of Feet an English Swan Native name Mulga
Black Swan Latham Syn Supp 2. p. 343.

APPENDIXES

Appendix 1: Engraved charts and nautical views published in *The Voyage of Governor Phillip to Botany Bay,* John Hunter's *Historical Journal of the Transactions at Port Jackson and Norfolk Island*, and John Hunter's charts published by Alexander Dalrymple

THE VOYAGE OF GOVERNOR PHILLIP TO BOTANY BAY

Plate 7 'Norfolk Island' and 'S. End of Norfolk Island';

Plate 12 'Sketch of Sydney Cove, Port Jackson . . . The Coastline by W. Dawes; the Soundings by Capt. Hunter';

Plate 14 'Plan of Port Jackson . . . By Capt. John Hunter';

Plate 31 'A View of Lord Howe Island' and 'A Chart of Lord Howe Island Discovered by Lieut. Henry Lidgbird Ball . . .';

Plate 32 'Ball's Pyramid' (view);

Plate 34 'A Chart of the Track of the Alexander . . . on Her Homeward Passage from Port Jackson . . . by Thomas George Shortland';

Plate 35 'A Chart of a Track of Land . . . Discovered by Lieut. John Shortland . . . by Thomas Geo.ᶜ Shortland . . .' (New Georgia);

Plate 36 'View of Curtis's Islands';

Plate 37 'View of Macaulay's Island';

Plate 38 'A Chart of the Track of the Scarborough . . . from Port Jackson . . . towards China, by Captain John Marshall' (Port Jackson to the Ladrone Islands with 17 small views).

The second edition of the *Voyage* published in 1790 contained an additional plate, 'A New Chart of New Holland on which are delineated New South Wales, and a Plan of Botany Bay' dated '1 Jany 1787'. This first appeared in *The History of New Holland . . .* published by Stockdale in 1787. It was abridged as an appendix to the second edition of the *Voyage*. The 'Plan of Botany Bay' is an adaptation of Captain Cook's sketch published in Hawkesworth's *Account of the Voyages . . .* (1773).

AN HISTORICAL JOURNAL OF THE TRANSACTIONS AT PORT JACKSON AND NORFOLK ISLAND

Plate 3 'A Map of all those Parts of New South Wales which have been seen by any Person belonging to the Settlement established at Port Jackson . . . By . . . William Dawes';

Plate 5 'Southern Hemisphere Shewing the Track of His Majesties Ship Sirius, from the Equator to the Compleating the Circle';

Plate 6 'Chart of the Coast between Botany Bay and Broken Bay . . . by Captain John Hunter';

Plate 12 'Chart Shewing the Track of the Waaksamheyd Transport from Port Jackson . . . to Batavia, in 1792';

Plate 13 'Plan of Norfolk Island . . . By W. Bradley'.

HUNTER'S CHARTS PUBLISHED BY ALEXANDER DALRYMPLE

1 A sheet of three charts of easterly outliers of the Solomon Islands, published 20 March 1794:

(a) 'Plan of Lord Howe's Group of Islands Discovered in the Waezamehydt by Capt. John Hunter 1791', with a view signed 'J. Hunter 1791' (Ontong Java);

(b) 'Plan of the Islands seen the 18th May 1791 in the Waezamheydt by Capt. John Hunter' (Kilinailau or Carteret Island); and

(c) 'Sketch of Stewart's Islands discovered in the Waezamheydt by Capt. John Hunter 1791' with two views one of which is signed 'J. Hunter'.

2 A sheet with one chart and two views published 15 April 1794: 'Sketch of the Anchorage off Hummock Island and the islands which lye between It and Po. Sanguey by Capt. John Hunter 1791', with two views both signed 'J. Hunter 1791' (Tinaca Point, Mindanao, and the islands to its south as far as Sangihi; Hummock Island is Balut). See Plate 81.

3 A sheet with two charts and two views of islands in the western Carolines:

(a) 'Sketch of part of the New Carolinas Islands seen 17th July 1791 in the Waezamheydt by Capt. John Hunter', with a view initialled 'J.H.' (Yap Island and Hunter Bank); and

(b) 'Sketch of Phillip Islands. Seen 14th July 1791 in the Waezamheydt by Capt. John Hunter', with a view initialled 'J.H.' (named by Hunter in honour of Arthur Phillip, now Sorol).

Compiled by T. M. Perry

Appendix 2: Manuscript charts pasted into John Hunter's copy of the *Historical Journal of the Transactions at Port Jackson and Norfolk Island*

1 Copies of Bradley's plans of Port Hunter (Balanawang) and part of the north-west coast of Duke of York's Island in St George's Channel between New Britain and New Ireland, signed 'J. Hunter 1791';

2 A plan of the harbour of Rio de Janeiro, unsigned, probably a copy of a printed plan, but not the one published by Dalrymple in 1785;

3 A plan of 'Johnstone's Cove', Port Jackson, by Bradley where *Sirius* was refitted (also called Great Sirius Cove and Careening Cove, now Mosman Bay);

4 A plan of the landing places, Sydney Bay, Norfolk Island by Bradley;

5 A view of the Isle of Pines signed 'J. Hunter 1791', and a chart of the islands off the south end of New Caledonia;

6 A plan and view of Lord Howe's Group (Ontong Java) signed 'J. Hunter 1791', and a plan and view of Stewart's Island, signed 'J. Hunter 1791';

7 An unsigned plan of 'Islands seen 18th May 1791' (Kilinailau or Carteret Island);

8 A view and plan of Sandwich Island (Djaul) and a view and plan of Portland Islands (Tingwon Group); signed 'J. Hunter 1791';

9 A plan and view of part of the Admiralty Islands, signed 'J. Hunter 1791';

10 An untitled and unsigned chart showing parts of the Bismarck Archipelago between Lord Anson's Island (Buka) and the Admiralty Islands;

11 Views of 'Poulo Sanguy' (Sangihi) and 'the South part of Mindanao' (Tinaca Point), and a sketch of the anchorage at Hummock Island (Balut) and the islets between Tinaca Point and Sangihi with *Waaksamheyd*'s track, signed 'J. Hunter 1791'.

Compiled by T. M. Perry

Appendix 3: A chronology of events mentioned in chapter 2

This table has been compiled principally from the *Historical Journal* (1793) and *The Voyage of Governor Phillip* (1789), with additional information from Bradley's journal, *A Voyage to New South Wales*, and J. S. Cumpston, *Shipping Arrivals & Departures, Sydney 1788–1825* (Canberra, 1977). There has been no attempt to reconcile variant dates in these sources. Some variations arise from the use of naval rather than civil time in some sources, and some from copyist's errors. On the whole, dates given in the *Historical Journal* are preferred, and at the beginning of the table 'Fleet' dates are really those of *Sirius*.

1787	13 May	The First Fleet sailed from Spithead.
	3 to 10 June	Fleet at Santa Cruz, Tenerife.
	6 August to 4 September	Fleet at Rio de Janeiro, Brazil.
	14 October to 13 November	Fleet at Cape Town.
1788	8 January	Fleet off Mewstone, Van Diemen's Land.
	20 January	Fleet anchored in Botany Bay.
	26 January	Fleet moved to Sydney Cove.
	13 February	*Supply* sailed for Norfolk Island.
	17 February	*Supply* discovered Lord Howe Island.
	19 March	*Supply* returned from Norfolk Island.
	6 May	Transports *Charlotte*, *Scarborough* and *Lady Penhryn* sailed from Port Jackson.
	6 to 24 May	*Supply* went to Lord Howe Island.
	14 July	Transports *Prince of Wales*, *Friendship* and *Alexander*, and storeship *Borrowdale* sailed from Port Jackson.
	17 July	*Supply* sailed for Norfolk Island.
	26 August	*Supply* returned to Port Jackson.
	1 October	*Sirius* sailed for Cape Town and *Golden Grove* sailed for Norfolk Island.

1789	2 January	*Sirius* anchored in Table Bay, Cape Town.
	18 February	*Alexander* in Table Bay to 16 March.
	20 February	*Sirius* sailed from Table Bay for Port Jackson.
	9 May	*Sirius* arrived in Port Jackson.
	28 May	*Alexander*, carrying first despatches from New South Wales, off Isle of Wight.
	19 June to 7 November	*Sirius* refitted in Careening Cove (Mosman Bay) Port Jackson.
1790	6 March	*Sirius* and *Supply* sailed for Norfolk Island.
	19 March	*Sirius* wrecked in Sydney Bay, Norfolk Island.
	24 March	*Supply* sailed from Norfolk Island.
	4/5? April	*Supply* returned to Port Jackson.
	17 April	*Supply* sailed for Batavia.
	19 September	*Supply* returned to Port Jackson.
	17 December	*Waaksamheyd* arrived in Port Jackson from Batavia.
1791	22 January	*Supply* sailed for Norfolk Island.
	11 February	*Supply* sailed from Norfolk Island with *Sirius*'s company on board.
	27 February	*Supply* returned to Port Jackson.

	26 March	*Waaksamheyd* sailed for England with *Sirius*'s company on board.
	22 to 27 May	*Waaksamheyd* in Port Hunter, Duke of York's Island.
	10 to 14 August	*Waaksamheyd* off Hummock Island, near south point of Mindanao.
	22 September to 22 October	*Waaksamheyd* in Batavia Road, Java.
	26 November	*Supply* sailed from Port Jackson for England via Cape Horn.
	17 December	*Waaksamheyd* anchored in Table Bay (*Providence*, William Bligh, there from 7 November to 23 December).
1792	19 January	*Waaksamheyd* sailed from Table Bay.
	4 to 13 February	*Waaksamheyd* at St Helena.
	20 April	*Supply* passed Lizard at entrance to English Channel.
	22 April	*Waaksamheyd* anchored in Portsmouth Harbour.
	27 April	Court martial on loss of *Sirius*; Captain Hunter, officers and crew honourably acquitted.
	4 May	*Sirius*'s company paid off.

Compiled by T. M. Perry

Appendix 4: A table of drawings in the British Museum (Natural History) contained in the Watling, Banks Ms34 and Raper collections

The tables that follow show the relationship between the post-1984/7 and pre-1984/7 British Museum (Natural History) numbering systems. The new (post-1984/7 mount) numbers are given in the first column; the old (pre-1984/7 drawing) numbers are given in the second column; the plate number, where represented in this book, in the third column, and the type of subject-matter of the drawing in the last column.

The collection of drawings known as the Watling Drawings were, until 1984, bound in one folio volume, containing 120 folios. The collection consisted originally of 512 numbered drawings of which 24 (all of birds) were never received by the British Museum, leaving a total of 488 drawings.

In 1984 the volume was taken apart and the drawings conserved and individually mounted in window-mounts. These mounts have been numbered 1–472 and Large Series (LS) 1–16. These are the numbers used in the captions of this book. Drawings signed by Watling are marked with an asterisk.

post-1984 mount no.	old folio and drawing no.	plate no.	type of drawing	post-1984 mount no.	old folio and drawing no.	plate no.	type of drawing
1	4/4	85	topography	73	28/82	41	ethnography
2	4/5	86	topography	74	28/83	47	ethnography
3	6/7	105	topography	75	29/84	48	ethnography
4	6/8	75	topography	76	29/85	56	ethnography
5	7/9	76	topography	77	29/86	43	ethnography
6	7/10	77	topography	78	30/87	52	ethnography
7	7/11	78	topography	79	30/88	–	ethnography
8	7/12	79	topography	80	32/90	168	mammal
9	8/13	106	topography	81	32/91	169	mammal
10	8/14	107	topography	82	33/92	170	mammal
11	8/15	109	topography	83	33/93	171	mammal
12	8/16	110	topography	84	33/94	172	mammal
13*	9/18	–	topography	85	34/95	175	mammal
14	12/21	134	topography	86	34/96	176	mammal
15	13/24	137	topography	87	34/97	177	mammal
16*	14/25	136	topography	88	34/98	178	mammal
17	14/26	139	topography	89	35/99	153	mammal
18	14/27	120	topography	90	35/100	173	mammal
19	15/28	118	topography	91	35/101	174	mammal
20*	15/29	140	topography	92	35/102	166	mammal
21	15/30	121	topography	93	35/103	179	mammal
22	16/31	128	topography	94	36/104	180	mammal
23	16/32	63	ethnography	95	37/1	–	bird
24	17/33	64	ethnography	96*	37/2	190	bird
25	17/34	237	ethnography	97	37/3	–	bird
26*	18/35	39	ethnography	98	38/4	–	bird
27	18/36	45	ethnography	99	38/5	–	bird
28*	19/37	19	ethnography	100	38/6	191	bird
29	19/38	37	ethnography	101	39/7	–	bird
30*	19/39	16	ethnography	102	39/8	–	bird
31	19/40	17	ethnography	103	40/10	192	bird
32*	20/41	18	ethnography	104	40/11	–	bird
33*	20/42	61	ethnography	105	40/12	–	bird
34*	20/43	58	ethnography	106	40/13	–	bird
35	20/44	3	ethnography	107	41/14	–	bird
36*	20/45	62	ethnography	108	41/15	–	bird
37*	21/46	4	ethnography		[41/16 & 41/17 never received]		bird
38*	21/47	60	ethnography	109*	41/18	–	bird
39	21/48	59	ethnography	110	41/19	–	bird
40	21/49	66	ethnography	111*	41/20	–	bird
41	21/50	7	ethnography	112	41/21	–	bird
42	21/51	22	ethnography	113*	42/22	–	bird
43	22/52	38	ethnography		[42/23 never received]		bird
44	22/53	10	ethnography	114	42/24	193	bird
45	22/54	11	ethnography	115	42/25	–	bird
46	22/55	24	ethnography	116	42/26	–	bird
47	23/56	25	ethnography	117*	42/27	194	bird
48	23/57	20	ethnography	118	43/28	–	bird
49	23/58	36	ethnography	119	43/29	–	bird
50	24/59	23	ethnography	120	43/30	–	bird
51	24/60	32	ethnography	121*	43/31	–	bird
52	24/61	26	ethnography	122	43/32	–	bird
53	24/62	30	ethnography	123	43/33	–	bird
54	25/63	35	ethnography	124	44/34	–	bird
55	25/64	12	ethnography	125*	44/35	–	bird
56	25/65	28	ethnography	126	44/36	–	bird
57	25/66	49	ethnography	127*	44/37	–	bird
58	26/67	1	ethnography	128	44/38	–	bird
59	26/68	33	ethnography		[44/39 never received]		bird
60	26/69	2	ethnography		[44/40 never received]		bird
61	26/70	5	ethnography	129*	45/41	–	bird
62	27/71	27	ethnography		[45/42 never received]		bird
63	27/72	9	ethnography	130	45/43	–	bird
64	27/73	50	ethnography	131	45/44	198	bird
65	27/74	21	ethnography		[45/45 never received]		bird
66	27/75	14	ethnography		[45/46 never received]		bird
67	27/76	13	ethnography	132*	45/47	196	bird
68	27/77	46	ethnography	133	45/48	–	bird
69	28/78	15	ethnography	134*	45/49	–	bird
70	28/79	55	ethnography	135	46/50	–	bird
71	28/80	44	ethnography	136	46/51	–	bird
72	28/81	40	ethnography	137*	46/52	–	bird

post-1984 mount no.	old folio and drawing no.	plate no.	type of drawing	post-1984 mount no.	old folio and drawing no.	plate no.	type of drawing
138	46/53	–	bird	207	62/129	–	bird
139	47/54	–	bird	208	63/130	–	bird
	[47/55 never received]		bird	209	63/131	–	bird
140	47/56	–	bird	210*	63/132	–	bird
141	49/58	–	bird	211	63/133	–	bird
142*	49/59	–	bird	212*	63/134	–	bird
143*	49/60	–	bird	213*	63/135	–	bird
144	49/61	–	bird	214	63/136	–	bird
145	49/62	–	bird	215	64/137	–	bird
146	50/63	–	bird	216	64/138	–	bird
147	50/64	–	bird	217*	64/139	–	bird
148	50/65	–	bird	218	64/140	–	bird
149*	51/67	–	bird	219	64/140A	–	bird
150	51/68	–	bird	220	64/141	–	bird
151	52/69	–	bird	221	64/142	–	bird
152	52/70	–	bird	222	65/143	–	bird
153*	52/71	–	bird	223	65/144	–	bird
154*	53/72	–	bird	224	65/145	–	bird
155	53/73	–	bird	225	65/146	–	bird
156	53/74	–	bird	226	66/147	–	bird
157	53/75	–	bird	227	66/148	–	bird
158	53/76	–	bird	228*	66/149	–	bird
159	54/77	–	bird	229*	66/150	–	bird
160	54/79	–	bird	230	66/151	–	bird
161	54/80	–	bird	231	66/152	–	bird
162*	54/81	195	bird	232	67/153	–	bird
163*	55/82	–	bird	233	67/154	202	bird
164*	55/83	–	bird	234*	67/155	–	bird
165	55/84	–	bird	235	67/156	–	bird
	[55/85 never received]		bird	236*	67/157	–	bird
166	55/86	–	bird	237	67/158	–	bird
167*	55/87	–	bird	238	67/159	–	bird
168	55/88	–	bird	239	68/160	–	bird
169	56/89	–	bird	240	68/161	–	bird
170	56/91	–	bird	241	68/162	–	bird
171	56/92	199	bird	242	68/163	–	bird
172*	57/93	–	bird	243	68/164	201	bird
173	57/94	–	bird	244*	68/165	–	bird
174*	57/95	–	bird	245*	68/166	203	bird
175*	57/96	–	bird	246	68/167	–	bird
176	58/97	–	bird	247	68/168	–	bird
177	58/98	–	bird		[69/169 never received]		bird
178	58/99	–	bird	248	69/170	–	bird
179	58/100	–	bird	249	69/171	–	bird
180	58/101	–	bird	250	69/172	–	bird
181	58/102	200	bird	251	69/173	–	bird
182	59/103	–	bird	252	69/174	–	bird
183*	59/104	–	bird	253	69/175	–	bird
184	59/105	–	bird	254*	69/176	–	bird
185	59/106	–	bird	255	70/177	–	bird
186*	59/107	–	bird		[70/178 never received]		bird
187	59/108	–	bird	256	70/179	–	bird
188	59/109	–	bird	257	70/180	–	bird
189	60/110	–	bird	258	70/181	–	bird
190	60/111	–	bird	259	70/182	–	bird
191	60/112	–	bird	260	70/183	–	bird
192	60/113	–	bird	261	70/184	–	bird
193	60/114	–	bird	262*	70/185	–	bird
194*	60/115	–	bird	263	71/186	–	bird
	[60/116 never received]		bird	264	71/187	–	bird
195	60/117	–	bird	265	71/188	–	bird
196	61/118	–	bird	266*	71/189	–	bird
197	61/119	–	bird	267*	71/190	–	bird
198	61/120	–	bird	268	72/191	–	bird
199	61/121	–	bird	269*	72/192	–	bird
200*	61/122	–	bird	270	72/193	–	bird
201	61/123	–	bird	271	72/194	–	bird
202	62/124	–	bird		[72/195 never received]		bird
203	62/125	–	bird	272	72/196	–	bird
204	62/126	–	bird	273	72/197	–	bird
205*	62/127	–	bird	274	72/198	–	bird
206*	62/128	–	bird		[72/199 never received]		bird

post-1984 mount no.	old folio and drawing no.	plate no.	type of drawing
275	72/200	–	bird
276*	73/201	157	bird
277*	73/202	–	bird
278*	73/203	–	bird
279	73/204	–	bird
280	73/205	–	bird
281	73/206	–	bird
282	73/207	–	bird
283	74/208	–	bird
284*	74/209	230	bird
285*	74/210	–	bird
286	74/211	–	bird
287*	74/212	–	bird
288	74/213	–	bird
289	74/214	–	bird
290	75/215	–	bird
291*	75/216	–	bird
292*	75/217	204	bird
293*	75/218	–	bird
294	75/219	–	bird
295	75/220	–	bird
296	76/221	–	bird
297	76/222	–	bird
298	76/223	–	bird
	[76/224 never received]		bird
299	76/225	–	bird
300*	77/226	206	bird
301	77/227	–	bird
302	77/228	–	bird
	[77/229 never received]		bird
303	77/230	208	bird
304	77/231	–	bird
305*	78/232	–	bird
	[78/233 never received]		bird
306*	78/234	–	bird
307	78/235	–	bird
308	78/236	–	bird
309	78/237	–	bird
310	79/238	–	bird
311	79/239	–	bird
312*	79/140 [=240]	–	bird
313	79/241	–	bird
314	80/242	–	bird
315	80/243	–	bird
316*	80/244	–	bird
317	80/245	–	bird
318	80/246	–	bird
319	81/247	–	bird
	[81/248 never received]		bird
320*	81/249	–	bird
321*	81/250	–	bird
322*	81/251	–	bird
323	81/252	–	bird
324*	81/253	–	bird
325	81/254	–	bird
326*	82/255	–	bird
327	82/256	–	bird
328	83/257	–	bird
329	83/258	–	bird
330	83/259	–	bird
331	83/260	–	bird
332	83/261	–	bird
	[83/262 never received]		bird
333*	84/263	–	bird
	[84/264 never received]		
334	84/265	209a	bird
335	84/266	209b	bird
[No 267. This number written on the flap holding 268]			
336	84/268	209c	bird
337	84/269	–	bird
338*	84/270	–	bird
339*	85/271	–	bird
340	85/272	–	bird
341	85/273	–	bird
342*	85/274	–	bird
343*	85/275	–	bird
344	85/276	–	bird
345	86/277	–	bird
346*	86/278	–	bird
347	87/279	–	bird
348	87/280	–	bird
349	87/281	–	bird
350	87/282	–	bird
351	87/283	243	bird
352	88/284	–	bird
353*	88/285	–	bird
354	88/286	–	bird
	[88/287 never received]		bird
355*	88/288	205	bird
	[88/289 never received]		bird
	[89/290 never received]		bird
356*	89/291	–	bird
357	89/292	–	bird
358	89/293	–	bird
359	89/294	–	bird
360	89/295	207	bird
361	90/296	159	reptile
362	90/297	158	reptile
363*	90/298	160	reptile
364	91/299	–	reptile
365*	91/300	161	reptile
366*	91/301	162	reptile
367*	91/302	163	reptile
368*	91/303	165	reptile
369*	92/304	164	reptile
370	92/305	–	fish
371*	92/306	–	fish
372	92/307	–	fish
373*	92/308	–	fish
374*	93/309	–	fish
375*	93/310	–	fish
376*	93/311	–	fish
377	94/312	–	fish
378	94/313	–	fish
379	94/314	–	fish
380*	95/315	–	fish
381*	93/316	–	fish
382	95/317	–	fish
383	95/318	–	fish
384	95/318A	–	mollusc
385*	96/319	–	mollusc
386*	96/320	–	mollusc
387*	96/321	–	mollusc
388*	96/322	–	mollusc
389*	96/323	–	mollusc
390	97/324	–	mollusc
391	97/325	–	mollusc
392*	97/326	–	mollusc
393	97/327	–	mollusc
394	97/328	–	mollusc
395*	97/329	–	mollusc
396*	98/330	–	mollusc
397	98/331	–	mollusc
398*	98/332	–	mollusc
399	98/333	–	mollusc
400	99/334	–	mollusc
401	99/335	–	mollusc
402*	99/336	–	arthropod
403	100/337	–	arthropod
404	100/338	–	arthropod
405	100/339	–	arthropod
406	100/340	–	arthropod
407	100/341	–	arthropod
408*	100/342	–	arthropod

post-1984 mount no.	old folio and drawing no.	plate no.	type of drawing
409*	100/343	–	arthropod
410	101/344	–	arthropod
411	101/345	–	arthropod
412	101/346	–	arthropod
413	101/347	–	arthropod
414*	101/348	–	arthropod
415	103/350	–	plant
416	103/351	–	plant
417	104/352	–	plant
418	104/353	–	plant
419	104/354	–	plant
420*	104/355	–	plant
421	105/356	–	plant
422	105/357	–	plant
423	105/358	–	plant
424	105/359	–	plant
425	106/360	–	plant
426	106/361	–	plant
427	106/362	–	plant
428	106/363	–	plant
429*	107/364	–	plant
430*	107/365	–	plant
431*	107/366	238	plant
432	107/367	239	plant
433	108/368	–	plant
434	108/369	–	plant
435	108/370	–	plant
436	109/371	–	plant
437*	109/372	–	plant
438	109/373	–	plant
439	109/374	–	plant
440	110/375	–	plant
441	110/376	–	plant
442	110/377	–	plant
443*	110/378	–	plant
444	111/379	–	plant
445	111/380	–	plant
446	111/381	–	plant
447	112/382	–	plant
448	112/383	–	plant
449	112/384	–	plant
450	112/385	–	plant
451	112/386	–	plant

post-1984 mount no.	old folio and drawing no.	plate no.	type of drawing
452	113/387	–	plant
453	113/388	–	plant
454	113/389	–	plant
455	113/390	–	plant
456	114/391	–	plant
457	114/392	–	plant
458	114/393	–	plant
459	114/394	–	plant
460	115/395	–	plant
461	115/396	–	plant
462	115/397	–	plant
463	115/398	–	plant
464	116/399	–	plant
465	116/400	–	plant
466	116/401	–	plant
467	116/402	–	plant
468	117/403	–	plant
469	117/404	–	plant
470	118/405	–	plant
471	119/406	–	plant
472	120/407	–	plant
LS1	1/1	72	topography
LS2	2/2	71	topography
LS3	3/3	69	topography
LS4	5/6	111	topography
LS5	9/17	100	topography
LS6*	10/19	135	topography
LS7*	11/20	141	topography
LS8	12/22	142	topography
LS9	13/23	138	topography
LS10	31/89	167	mammal
LS11	39/9	–	bird
LS12*	48/57	–	bird
LS13	51/66	197	bird
LS14*	54/78	–	bird
LS15	56/90	–	bird
LS16	102/349	–	plant

The number of items in the collection by subject: Topography and ethnography 88, mammals 16, birds 271 (plus 24 never received), fishes 15, reptiles 9, molluscs 17, arthropods 13, plants 59. Total 488 (plus 24 never received).

This collection of 69 drawings which came to the British Museum (Natural History) in 1827 was a part of Sir Joseph Banks's collection. It was originally bound in one volume, each sheet being numbered recto and verso, 1–137. In 1984 the volume was taken apart, the drawings conserved and then individually mounted in window-mounts numbered 1–69. These new mount numbers are used in the captions of this book.

post-1984 mount no.	old drawing no.	plate no.	type of drawing
1	1	–	bird
2	3	–	bird
3	5	–	bird
4	7	–	bird
5	9	–	reptile
6	11	–	bird
7	13	–	plant
8	15	–	plant
9	17	–	bird
10	19	–	plant
11	21	–	plant

THE BANKS MS34 COLLECTION

post-1984 mount no.	old drawing no.	plate no.	type of drawing
12	23	–	plant
13	25	–	plant
14	27	–	bird
15	29	–	plant
16	31	–	bird
17	33	–	bird
18	35	–	plant
19	37	–	plant
20	39	–	plant
21	41	–	plant
22	43	–	bird
23	45	184	bird
24	47	–	bird
25	49	–	plant
26	51	–	bird
27	53	–	bird
28	55	–	bird
29	57	–	bird
30	59	–	bird
31	61	–	bird
32	63	–	bird
33	65	–	bird
34	67	–	bird

post-1984 mount no.	old drawing no.	plate no.	type of drawing
35	69	—	bird
36	71	—	bird
37	73	—	bird
38	75	—	bird
		—	
39	77	—	reptile
40	79	229	reptile
41	81	—	reptile
42	83	34	ethnography
43	85	31	ethnography
44	87	65	ethnography
45	89	29	ethnography
46	91	—	arthropod
47	93	—	mammal
48	95	—	bird
49	97	151	bird
50	99	—	fish
51	101	152	reptile
52	103	155	mammal
53	105	—	reptile

post-1984 mount no.	old drawing no.	plate no.	type of drawing
54	107	—	fish
55	109	—	reptile
56	111	—	reptile
57	113	—	reptile
58	115	—	fish
59	117	154	mammal
60	119	182	bird
61	121	—	bird
62	124	232	bird
63	126	—	bird
64	128	—	fish
65	130	—	plant
66	132	—	fish
67	134	—	plant
68	135	—	plant
69	137	—	bird

The number of items in the collection by subject: Ethnography 4, mammals 3, birds 32, fishes 5, reptiles 9, arthropods 1, plants 15. Total 69.

THE RAPER COLLECTION

The collection of water-colour drawings by George Raper, midshipman in H.M.S. *Sirius*, was presented to the British Museum (Natural History) by Miss Eva Godman in 1962. It consists of 72 drawings plus a hand-coloured title-piece also by Raper. In 1987 they were removed from the volume in which they had been bound, and were conserved and individually mounted. All but 10 of the drawings are signed by Raper. Signed drawings are marked with an asterisk.

post-1987 mount no.	old drawing no.	plate no.	type of drawing
1	title-piece, not numbered		title
2	1	—	gun on carriage
3*	2	67	ethnography
4	3	92	topography
5*	4	91	topography
6	5	93	topography
7	6	96	topography
8*	7	95	topography
9*	8	94	topography
10*	9	97	topography
11*	10	98	topography
12*	11	99	topography
13*	12	104	topography
14*	13	68	topography
15*	14	74	topography
16	15	119	topography
17	16	73	topography
18*	17	42	ethnography
19*	18	102	topography
20*	19	124	topography
21*	20	125	toptography
22*	21	126	topography
23*	22	127	topography
24*	23	129	topography
25*	24	131	topography
26	25	217	topography
27*	26	88	topography
28*	27	83	topography
29	28	—	ethnography
30*	29	—	ethnography
31*	30	216	topography
32*	31	—	mammal
33*	32	—	fish
34*	33	—	mammal
35*	34	—	fish

post-1987 mount no.	old drawing no.	plate no.	type of drawing
36*	35	149	bird
37*	36	218	bird
38*	37	—	bird
39*	38	219	bird
40*	39	—	fish and reptile
41*	40	—	bird
42*	41	—	reptile
43*	42	—	bird
44*	43	—	fish
45*	44	—	bird
46*	45	—	bird
47*	46	—	fish
48*	47	—	plant
49*	48	183	bird and plant
50*	49	—	bird and plant
51*	50	—	bird and plant
52*	51	—	bird and plant
53*	52	—	bird
54*	53	220	fish
55*	54	—	bird and plant
56*	55	150	mammal and plant
	[No drawing 56]		
57*	57	—	bird and plant
58*	48[=58]	—	bird
59*	49[=59]	186	bird
60*	60	—	bird
61*	61	—	bird and plant
62*	62	—	fish
63*	63	—	bird and plant
64*	64	—	fish
65*	65	—	bird
66*	66	—	bird and plant
67*	67	181	bird
68*	68	—	bird
69*	69	185	bird
70*	70	187	bird
71*	71	188	bird
72*	72	—	bird
73*	73	189	bird

The number of items in the collection by subject: Topography and ethnography 30, mammals and plants 1, mammals 2, birds and plants 9, birds 20, fishes 8, reptiles 1, plants 1. Total 72, plus title-piece.

Compiled by Dorothy Norman and Bernard Smith

NOTES

I thank various colleagues with whom I discussed sections of this chapter: Mr J. Kohen (Macquarie University), Dr B. Meehan and Dr D. Losche (Australian Museum).

1 Kohen and Lampert (1987)
2 Tench (1793), 178
3 Collins (1798), 549
4 White (1790), 160; Tench (1793), 180; Collins (1798), 550
5 Smith (1960), 128
6 Tench (1789), 70; (1793), 179
7 Collins (1798), 553
8 Howitt (1904), 747
9 Tench (1793), 182
10 Collins (1798), 552
11 Ibid., 551
12 Ibid., 551
13 Ibid., 551
14 Ibid., 552, 563
15 Ibid., 554
16 Lampert (1966)
17 Collins (1798), 567
18 Ibid., 562
19 Ibid., 582
20 White (1790), 156
21 Plomley (1966), 137
22 B. Meehan, pers. comm.
23 Dutton (1974)
24 Rao (1966)
25 Tench (1793), 194
26 Ibid., 194
27 Kohen and Lampert (1987), 351
28 Collins (1798), 546; Tench (1793), 193
29 Collins (1798), 562
30 Ibid., 559
31 Berndt and Berndt (1977); Howitt (1904)
32 Collins (1798), 590
33 White (1790), 161
34 Collins (1798), 591
35 Tench (1793), 190
36 Collins (1798), 586
37 Ibid., 587
38 Ibid., 590-2
39 Tench (1793), 182; Collins (1798), 598

40 Tench (1793), 193
41 Ibid., 185
42 Ibid., 192
43 Webb (1984), 180–1
44 Collins (1798), 601
45 Ibid., 603; see also Lycett water-colour in the National Library of Australia
46 Collins (1798), 607
47 Ibid., 605
48 Ibid., 547
49 Cf Stanner (1965), 210
50 Collins (1798), 556
51 Barratt (1981)
52 Lampert (1966), (1971)
53 Lampert and Hughes (1974)
54 Collins (1978), 589
55 Tench (1793), 28
56 Ibid., 125
57 McBryde (1984)
58 Ross (1976); Kohen and Lampert (1987)
59 Collins (1798), 585
60 Tench (1789), 87
61 Lampert (1971), 49
62 Lampert (1966)
63 Binns and McBryde (1972)
64 Dickson (1981)
65 Collins (1798), 585
66 White (1790), 294
67 McBryde (1978)
68 Collins (1798), 612
69 Ibid., 612
70 Ibid., 585
71 Tench (1793), 191
72 Collins (1798), 585
73 Ibid., 555
74 Ibid., 16
75 Ibid., 175
76 Willmot (1985), 47
77 Collins (1798), 136
78 Tench (1793), 61
79 Smith (1960), 119, fig. 84
80 White (1790), 132
81 Tench (1793), 35
82 Collins (1798), 251
83 Kohen and Lampert (1987)
84 Collins (1798), 581
85 Reinits (1962), 19

1 For an outline of the history of maritime cartography and the evolution of sea atlases see Bagrow (1964); Crone (1962); and Tooley (1961)
2 In *Waaksamheyd* Hunter seems to have had copies of some of Carteret's and Cook's charts (but not the account of Cook's second voyage, which suggests that his source was Hawkesworth's *Voyages*), and to know of Bougainville's and de Surville's voyages, accounts of which had been published in 1771–72 and 1783, and some of whose charts had been reissued by Alexander Dalrymple

[3] See, for example, Hooper (1975); Bradley (1969) discussed here; and Captain Hunter's own copy of his *Historical Journal*, also discussed here

[4] These are reproduced in the folio of Charts and Views, edited by R. A. Skelton and published with the Hakluyt Society's edition of Cook's journals (Cambridge, 1955)

[5] The volumes of the *Australia Pilot*, published by the Hydrographic Department of the UK Ministry of Defence, contain both drawings and photographs supplementing the information given in the *Pilots* and on the charts published by the department and by the Hydrographic Service of the Royal Australian Navy

[6] See Appendix 1 [7] See Appendix 1

[8] Public Record Office, C.O. 201/3. It has been photographed by the Australian Joint Copying Project on Reel 1546

[9] See Appendix 1

[10] The charts of Sydney Cove, Broken Bay and Botany Bay are items 1, 2 and 3 in Australia Folio 2 (C581a), and that of the coast between Botany Bay and Broken Bay is d89 Xc

[11] See Appendix 2

[12] See the letters from Phillip to Stephens 14 March 1791, and Bradley to Nepean 23 April 1792, *Historical Records of New South Wales*, I, II (1892), 475–6 and 616

[13] George Raper's Papers 1787–1824, have been photographed by the Australian Joint Copying Project, Reel M.1183. They contain: an astronomical observation book made in *Sirius* between May 1787 and April 1789, in *Speedy* in 1793, and in *Commerce de Marsailles* in 1794; a certificate of his naval service from 1783 to 1796 (containing some obvious errors) dated 1824; nine charts and plans; five sheets of views; a copy of his will; and the Deed of Administration of his estate issued to his mother in 1799

[14] For examples of the use of chevrons in the letters A and H, see Robinson (1962), pl. 34 and pl. 35;

Blewitt (1957), 75; and Lysaght (1971), pl. 40 and 91

[15] The five unsigned charts in the Dixson Library, Sydney, copied by Raper, are:
An untitled chart of the North Atlantic Ocean showing the tracks of *Sirius* in 1787 and *Waaksamheyd* in 1792 (Cb 79/6);
'A Chart of the Southern Hemisphere Shewing the Track of His Majesty's Ship Sirius compleating the Circle' (Cb 78/5) (A copy of pl. 5 in the *Historical Journal*);
Norfolk and Phillip Islands and the 'South Coast of Norfolk Island' (Cb 79/5) (two charts on one sheet similar to plates 85 and 86);
'Chart of the Track of the Waaksamheidt from Port Jackson by the Northern Route to Batavia' (Cc 79/4) (a version of pl. 12 in the *Historical Journal*);
'Chart of the Three Harbours Botany-Bay Port-Jackson & Broken Bay on the Coast of New South Wales as Survey'd by Captn. Iohn Hunter 1788 & 1789' (Cc 78/4) (a copy of pl. 6 in the *Historical Journal*)

[16] For accounts of *Supply*'s voyage to Batavia see the letters from Newton Fowell to Evan Nepean, 30 July 1790, and to his father, 31 July 1790, in *HRNSW* (1892), I, 2, 372–86. Booby Shoal and Tench Island are still marked on charts and described in the *Pilots*: Booby Reef in vol. III of the *Australia Pilot*, and Tench Island in vol. I of the *Pacific Islands Pilot*

[17] Sharp (1960) offers some firm conclusions on pages 152–5

[18] Cox's voyage is described in Mortimer (1791). Dalrymple's 'Plan of Oyster Bay' is included as one of the plates in this volume

[19] *Salamander*'s call at Port Stephens and Grimes's survey of it whilst in the *Norfolk* are both described in volume I of Collins (1798), 191, 408–9. A redrawn copy of Grimes's plan is printed in the *HRNSW*, vol. II, fp. 286.

3: THE GROWTH OF
SETTLEMENT

[1] Cook, ed. Beaglehole (1955–68), I, 397

[2] *St James Chronicle*, 16–18 January 1787

[3] See Frost (1987), 170–1

[4] See below, section on Norfolk Island

[5] Collins, ed. Fletcher (1975), 25

[6] Ibid., 5

[7] Ibid

[8] For a discussion of models and analogues, see Frost (1987), 7–8, 65, 68–9, 120–3, 199–200

[9] Waterhouse to his father, 11 July 1788, Mitchell Library FM 4/63

[10] Phillip to Banks, 22 August 1790, Mitchell Library, Ms C213:66

[11] Waterhouse to his father, 11 July 1788, Mitchell Library FM 4/63

[12] Phillip to Sydney, 24 September 1788, Dixson Library Ms Q 162:14; to Banks, 26 September 1788, Mitchell Library Ms C213:37

[13] Phillip to Nepean, 9 July 1788, *Historical Records of New South Wales* (1892–1901), I,ii, 152; to

Sydney, 28 September 1788, ibid., 189

[14] Collins (1975), 20

[15] Phillip to Sydney, 15 May 1788, *HRNSW* I,ii, 123; Worgan (1978), 35–6

[16] Collins (1975), 35

[17] These details are drawn mostly from Perry (1963), 6–22

[18] The two bulls and four cows which Phillip intended to breed into a government herd wandered away and were lost, and of 'the livestock purchased at the Cape, part died on the passage, and the greatest part of what remained since landing' – Phillip to Sydney, 9 July 1788, *HRNSW* I,ii, 149

[19] Tench, ed. Fitzhardinge (1979), 135

[20] Phillip to Sydney, 15 May 1788, *HRNSW* I,ii, 133

[21] Ibid.; Phillip to Sydney, 23 September 1788 and Ross to Stephens, 1 October 1788, ibid., 189, 198; and cf. Collins (1975), 37

[22] Phillip to Sydney, 12 February 1790, *HRNSW* i,ii,

296; to Banks, 26 July 1790, Mitchell Library Ms C213:55

23 Phillip to Banks, 26 July 1790, Mitchell Library Ms C213:55

24 Tench (1979), 264

25 Ibid., 193; and [?] to [?], 24 March 1791, *HRNSW* II, 775

26 Phillip to Sydney, 24 March 1791, Mitchell Library Ms C213

27 Collins (1975), 75; see also Tench (1979) 197–8

28 For his intention, see Phillip to Sydney, 13 February 1790, *HRNSW* I,ii, 306

29 Burton to Phillip, with Phillip's annotations, 24 February 1792, Sutro Library, Banks papers SS 1:45

30 Francisco Xavier de Viana, 'Diario', in *The Spanish at Port Jackson: The Visit of the Corvettes 'Descubierta' and 'Atrevida'* (Sydney 1967), 26

31 Luis Nee and Antonio Joseph Cavanelles, 'Observations on the Soil, natives and Plants of Port Jackson and Botany Bay', Mitchell Library docu. 2337:4

32 White to Skill, 17 April 1790, *HRNSW* I,ii, 333

33 Cook (1955–68), II, 565–6, 868–9

34 King, ed. Fidlon and Ryan (1980), 43, 46, 47

35 Ibid., 129, 135

36 For details, see Frost (1980), 150–3

37 King, 'Description of Norfolk Island', 10 January 1791, *HRNSW* I,ii, 429

38 King (1980), 70, 72

39 Ibid., 85–111, 129, 131, 135

40 Ibid., 145 ff., 165–71, 213, 221, 237

41 Ibid., 201–3

42 Ibid., 228; and King, 'Description of Norfolk Island', *HRNSW* i,ii, 420, 431

43 King (1980), 43

44 Ross, 'Remarks and Observations on Norfolk Island', *HRNSW*, I,ii, 416–20

45 Ross to Grenville, 29 August 1790, ibid., 403; Ross, General Order, 8 January 1791, ibid., 445–7

46 King to Nepean, 23 November 1791, *HRNSW* I,ii, 563; Phillip to Grenville, 15 December 1791, ibid., 571; King, '[Description of Norfolk Island]', 29 December 1791, in Hunter (1793) ed. Bach (1968), 382

47 King to Phillip, 19 September 1792, *HRNSW* I,ii, 656–9 48 Ibid., 660

49 Grose to Dundas, 29 April 1794, *HRNSW* II, 208

50 Macarthur to his brother, August 1794, ed. Onslow (1914), (1973), 45–6

51 Grose to Dundas, 29 April 1794, *HRNSW* II, 210

52 Paterson, Return, 15 June 1795, ibid., 311

53 King to Grose, 20 July 1794, ibid., 240

54 For details, see Frost (1980), 160–1

55 Paterson to Banks, 17 March 1795, Dixson Library Ms Q158:185; and Return, 15 June 1795, *HRNSW* II, 311

56 King, 'Condition of Norfolk Island', 18 October 1796, *HRNSW* III, 150–2; and Return, 8 June 1795, ibid., II, 301

57 In March 1795, there were 3,400 Europeans in the mainland colony – see Palmer, Return, 21 March 1795, *HRNSW* II, 289

58 Hunter to Portland, 10 June 1797, ibid., III, 221

59 Hunter to Portland, 28 April 1796, ibid., 38

60 Hunter to Portland, 10 June 1797, ibid., 220

61 (A colonist), August 1799, quoted in *Colonial Australia 1788–1840*, Crowley ed. (Melbourne, 1980), 92

62 In March 1795, there were 946 persons on the island, and 875 at the end of 1797 – King, Return, 4 March 1795, *HRNSW* II, 283, and Return, 30 November 1797, ibid., III, 311

63 King, 'Condition of Norfolk Island', 18 October 1796, ibid., III, 159–60

64 14 September 1798, ibid., 486

65 Hunter to Portland, 12 November 1796, *HRNSW* III, 175

66 8 April 1800, quoted in *Colonial Australia 1788–1840*, Crowley ed. (Melbourne, 1980), 92

67 Quoted in Scott (1910), 196

1 See Allen (1976), 45–6 2 Whitehead (1969)

3 Whitley (1938), 291–304

4 Watling (1794), 20

5 In John Hunter's Sketchbook, National Library of Australia, Canberra, RNK 2039

6 Hindwood (1965); Schodde *et al.* (1983)

7 Hindwood (1964), 32–57

8 Rienits and Rienits (1963), 47

9 Smith (1960), 121

10 The seven species of mammals described in White and their modern names are as follows: plate 54 (Kangaroo) Eastern grey kangaroo, *Macropus giganteus*; plate 56 (Wha Tapoua Roo) Brushtail possum, *Trichosurus vulpecula*; plate 57 (Dog of New South Wales) Dingo, *Canis familiaris dingo*; plate 58 (Tapoa Tafa) Brush-tailed phascogale, *Phascogale tapoatafa*; plate 59 Eastern native cat, *Dasyurus viverrinus*; plate 60 (Poto Roo) Potoroo, *Potorous tridactylus*; plate 61 (Hepoona Roo) Yellow-bellied glider, *Petaurus australis*

11 Chisholm (1962), 199

12 Waterhouse (1841), 177, 287

13 Poignant (1965), text to fig. 70

14 Tench (1789), 83

15 Smith (1960) 260; Rienits and Rienits (1963) 225

16 The Latham list was originally mounted on p.36 of the album containing the Watling Drawings (British Museum (Natural History)) and is now kept at the end of the renumbered series of the Watling Drawings in the Zoology Library, Department of Library Services, British Museum (Natural History)

17 Gray (1843), 189–94

18 Strickland (1843), 333–8

19 Sharpe (1906), 79–515

20 Gladstone (1938)

21 Hindwood (1970), 16–32

22 Iredale (1958), 162–9

23 Tench (1789), 128

24 Morrison-Scott and Sawyer (1950)

4: THE NATURAL HISTORY DRAWINGS

I have been assisted considerably by Dr J. H. Calaby, Dr Alan Frost, Dr T. M. Perry, Dr R. J. Lampert and Mr Alwyne Wheeler, all of whom read and commented upon earlier drafts of this essay. I wish to acknowledge also the assistance of Ann Bickford, Emma Hicks, Helen Proudfoot and Dr Adrienne Kaeppler. None of them are of course responsible for any of the views expressed. The research involved was assisted by a small grant from the University of Melbourne.

1 Bradley (1969), 183
2 For example, Francis Fowkes, see Chapman (1981), 88
3 By Rienits and Rienits (1963), 21, 25
4 Bradley (1969), 220
5 Hunter (1793), 172
6 On McEntire, see Chapman (1981), 128
7 Bradley (1969), 302
8 See Hindwood (1964), 32–57
9 *Australian Fishes*, M.L., PXD 18
10 Somerset House, PCC 1799. 222 Howe. 'Made aboard H.M.S. *Cumberland* at sea off Minorca 20 leagues west. 14 Octover 1795'
11 White (1790), 107–8
12 NLA, NK 2039
13 NLA, NK 144 A–F
14 ML, Z/C 689
15 La Trobe Collection, State Library of Victoria
16 Plate 68, reproduced in Smith (1985), 118
17 See Smith (1960), 128 and (1985), 172; also King and King (1981), 50, where it is claimed that King visited William Blake and 'gave some of his own water-colours to Blake'. No evidence for this assertion is provided
18 See Joppien and Smith (1985), 55–9
19 As in King and King (1981), where the five drawings are ascribed to King (fpp. 55, 102)
20 See Smith (1960), 117–19
21 Mathews and Iredale (1921), 114–22
22 See the lists published in *The Voyage of Governor Phillip to Botany Bay* (1789) and in Chapman (1981)
23 Suggested in discussion by Jörg Schmeisser
24 Joppien and Smith (1985), 1, 55–9
25 Ibid., 54 for Parkinson; for Watling see fn. 27
26 Gladstone (1938), 107
27 Ibid., 118
28 Watling (1794), 26 29 Ibid., 20
30 BL Add Ms f. 204
31 Kent family papers, ML vol 11.f.9, quoted in Rienits and Rienits (1963), 74
32 Gladstone (1938), 72, 75
33 The suggestion that Brewer was the unknown artist was first made by Mackaness (1937), 356
34 Edward Spain, Ms. Reminiscences, 1774–1802. ML c.266
35 Ibid.
36 PRO. Kew. *Sirius* Muster books, ADM 36/10978
37 Index to Register of Land Grants 1792–1807, New South Wales archives
38 See article on Brewer by A. J. Gray, ADB, 1, 149–50
39 Proudfoot (1983), 21
40 Map Room, BL Crown cxvi, 60–2
41 Phillip to Banks 3 December 1791. ML Banks papers. A 81. v. 18, 33–44
42 Mackaness (1937), fp. 128
43 Chapman (1981) 88 where his name is spelt Fokes
44 Rienits and Rienits (1963), 55
45 Douglas Anderson (1933) noted that White may have sought to take the credit for the discovery of the medicinal value of eucalyptus oil from his assistant Surgeon, Denis Considen, following 'the time-honoured custom of assuming the credit for his subordinate's discovery', 188. Quoted in Rienits and Rienits (1963), 66
46 Phillip (1789), 290
47 Artists such as Sarah Stone, Charles Catton junior, Frederick Polydore Nodder, Edward Kennion and [?] Mortimer
48 Rienits and Rienits (1963), 55 49 Ibid.
50 Hunter (1793), 52
51 Bradley (1969), 66
52 Collins (1798), 134 53 Ibid., 143–5
54 On Chapman see *Australian Dictionary of Biography*, I, 218
55 The sources of his art training in Dumfries have not yet been researched
56 On Sarah Stone see Dr Adrienne Kaeppler's forthcoming book on the Leverian Museum
57 Collins (1798), 270, 410–11, 419
58 On Davies see Gladstone (1938); Mathews and Iredale (1921), 114–22; Sawyer (1949), 175
59 Rienits and Rienits (1963) first suggested that the drawings in the Banks Ms34 which relate to the engravings in White (1790) are copies after them.
60 It was a view that I once held myself, see Smith (1960), 121
61 I am indebted to Emma Hicks for this information, 18 March 1987
62 Smith (1793), 46
63 Watling (1794), 18
64 A photograph of the back of the painting is reproduced in Gladstone (1938), fp. 70
65 Sir William Dixson to Sir Sidney Harmer, 6 July 1920, Dixson Library, Sydney
66 Rienits and Rienits (1963), 78
67 Hardie (1966), 24
68 Recent research reveals that John William Lewin was working in oils in Sydney in 1812. See *First Views of Australia 1788–1825*, ed. T. McCormick, (Sydney 1987), 277
69 On Burton see A. J. Gray in the *Australian Dictionary of Biography*, 1, 183; and C. M. Finney, *To Sail Beyond the Sunset*, (Adelaide, 1984), 57, 59, 60
70 Phillip to Banks, 3 September 1791, Banks papers, Mitchell Library, Sydney, A 82, c. 18. p. 37 (page 5 of the letter)

BIBLIOGRAPHY

Allen, D. E. *The Naturalist in Britain, A Social History* (London, 1976)

Anderson, Douglas, 'John White, Surgeon-General to the First Fleet', *Medical Journal of Australia* (February 1933)

Anon, *The History of New Holland, from its first discovery in 1616 to the present time* (London 1787)

Bagrow, Leo, *History of Cartography,* revised and enlarged by R. A. Skelton (London, 1964)

Barratt, G., *The Russians at Port Jackson 1814–1822* (Australian Institute of Aboriginal Studies) (Canberra, 1981)

Berndt, R. M. and Berndt, C. H., *The World of the first Australians* (Sydney, 1977)

Bewick, Thomas, *A General History of Quadrupeds* (London, 1790)

Binns, R. A. and McBryde, I., *A petrological analysis of ground-edge artefacts from northern New South Wales* (Australian Institute of Aboriginal Studies) (Canberra 1972)

Blewitt, Mary, *Surveys of the Seas* (London, 1957)

Bonnemains, J., Forsyth, E. and Smith, B. (eds.), *Baudin in Australian Waters* (Melbourne, 1988)

Bradley, William, *A Voyage to New South Wales. The Journal of Lieutenant William Bradley R.N. of H.M.S. Sirius 1786–1792* (Sydney, 1969)

Chapman, Don, *1788, The People of the First Fleet* (Sydney, 1981)

Chisholm, A. H. (ed.), *Journal of a voyage to New South Wales,* by John White (Sydney, 1962)

Clark, Ralph, *The Journal and Letters of Lt. Ralph Clark 1787–1792,* edited by P. G. Fidlon and R. J. Ryan (Sydney, 1981)

Cogger, H. G., Cameron, E. C. and Cogger, H. M., *Zoological Catalogue of Australia,* vol. 1. *Amphibia and Reptiles,* (Canberra, 1983)

Collins, David, *An Account of the English Colony in New South Wales . . .* (2 vols., London, 1798 and 1802)

Collins, David, *An Account of the English Colony in New South Wales* [1798], edited by B. H. Fletcher (Sydney, 1975)

Cook, James, *The Journals of Captain James Cook on his voyages of discovery . . .,* edited by J. C. Beaglehole (3 vols., Cambridge, 1955–68)

Crone, G. R., *Maps and their Makers* (London, 1962)

Crowley, Frank (ed.), *Colonial Australia 1788–1840* (Melbourne, 1980)

A Documentary History of Australia, I: Colonial Australia, 1788–1840, edited by Frank Crowley (Melbourne, 1980)

Cumpston, J. S., *Shipping Arrivals & Departures Sydney, 1788–1825* (Canberra, 1977)

Dalrymple, Alexander, 'East India Pilot', Two guardbooks into which are pasted 526 charts and plans published by Dalrymple between 1762 and 1801 (2 vols., National Library of Australia, Canberra, Ra 42)

Dickson, F. P., *Australian Stone Hatchets: a study in design and dynamics* (Sydney, 1981)

Dutton, G., *White on Black: the Australian Aborigine Portrayed in Art* (Melbourne, 1974)

Evans, Susanna, *Historical Sydney as seen by its Early Artists* (Sydney, 1983)

Fabricius, J. C., *Systema Entomologiae* (Flensburg, 1775)

Finney, C. M., *To Sail Beyond the Sunset* (Adelaide, 1984)

Flinders, Matthew, *A Voyage to Terra Australis . . . 1801, 1802, and 1803 in His Majesty's Ship the Investigator . . .* (2 vols and atlas, London, 1814)

Freycinet, Louis, *Voyage de Découvertes aux Terres Australes . . . Atlas* (Paris, 1812)

Frost, Alan, *Convicts and Empire: A Naval Question, 1776–1811* (Melbourne, 1980)

Frost, Alan, *Arthur Phillip, 1738–1814: His Voyaging* (Melbourne, 1987)

Gilbert, Thomas, *Voyage from New South Wales to Canton, in the year 1788 . . .* (London, 1789)

Gladstone, H. S., 'Thomas Watling Limner of Dumfries', *Dumfriesshire and Galloway Natural History & Antiquarian Society Transactions and Journal of Proceedings 1935–36,* 3rd Ser. (1938), 20, 70–133

Gray, G. R., 'Some rectification of the nomenclature of Australian birds', *Annals and Magazine of Natural History* (1843), 11, 189–94

Hardie, Martin, *Water-colour Painting in Britain,* edited by D. Snelgrove and B. Taylor (3 vols, London, 1968)

Hawkesworth, John, *An Account of the Voyages undertaken . . . by Commodore Byron, Captain Wallis, Captain Carteret and Captain Cook . . .* (3 vols, London, 1773)

Hindwood, K. A., 'The birds of Lord Howe Island', *Emu* (1940), 40, 1–86

Hindwood, K. A., 'George Raper: an artist of the First Fleet', *Journal and Proceedings of the Royal Australian Historical Society* (1964), 50, 32–57

Hindwood, K. A., 'John Hunter: a naturalist and artist of the First Fleet', *Emu* (1965), 65, 83–95

Hindwood, K. A., 'The "Watling" drawings with incidental notes on the "Lambert" and the "Latham" drawings', *Proceedings of the Royal Zoological Society of New South Wales for the years 1968–69* (1970), 16–32

Historical Records of New South Wales (7 vols., Sydney, 1892–1901, reprinted 1979–80)

Hooper, Beverley, *With Captain James Cook in the Antarctic and Pacific: the private journal of James Burney . . . 1772–1773* (Canberra, 1975)

Howitt, A. W., *The Native Tribes of south-east Australia* (London, 1904)

Hunter, John, *An Historical Journal of the Transactions at Port Jackson and Norfolk Island . . .* (London, 1793)

Hunter, John, *An Historical Journal of Events at Sydney and at Sea, 1787–1792* [1793], edited by John Bach (Sydney, 1793)

Hydrographic Department, U.K. Ministry of Defence, *Australia Pilot* (5 vols., 4th edn, Taunton, 1948–56); *Pacific Islands Pilot* (vol. I, 9th edn, Taunton, 1970)

Iredale, T., 'History of New South Wales Shells Part III.: The settlement years (continued): Thomas Watling, Artist', *Proceedings of the Royal Zoological Society of New South Wales* for the year 1956–57 (1958), 162–9

Joppien, Rüdiger and Smith, Bernard, *The Art of Captain Cook's Voyages* (3 vols., Melbourne, 1985–7)

King, Jonathan and King, John, *Philip Gidley King, A biography of the Third Governor of New South Wales* (Melbourne, 1981)

King, Philip Gidley, *The Journal of Philip Gidley King: Lieutenant, RN 1787–1790*, edited by P. G. Fidlon and J. R. Ryan (Sydney, 1980)

Keulen, Johannes Van, *De Nieuwe Groote Lichtende Zee-Fakkel, Het Sesde Deel Vertoonende de Zee-Kusten, Eyelanden en Havens van Oost-Indien . . .* part VI of the *Zee-Fakkel* (Amsterdam, 1753)

Kohen, J. L. and Lampert, Ronald, 'Hunters and Fishers in the Sydney Region' *Australians to 1788*, edited by D. J. Mulvaney and J. Peter White (Sydney, 1987), 342–65

Lampert, R. J., 'An excavation at Durras North, New South Wales', *Archaeology and Physical Anthropology in Oceania* (1966), 1, 83–118

Lampert, R. J., *Burrill Lake and Currarong. Terra Australis I*, (Department of Prehistory, Research School of Pacific Studies, Australian National University), (Canberra, 1971)

Lampert, R. J. and Hughes, P. J. 'Sea level changes and Aboriginal coastal adaptations in southern New South Wales', *Archaeology and Physical Anthropology in Oceania* (1974), 9, 226–35

Latham, John, *A General Synopsis of Birds* (8 vols., London, 1781–85)

Latham, John, *Index Ornithologicus sive Systema Ornithologiae* (2 vols., London, 1790)

Latham John, *A General History of Birds* (11 vols., Winchester, 1821–28)

Lysaght, A. M., *Joseph Banks in Newfoundland and Labrador, 1766* (London, 1971)

McBryde, I. (ed.), *Records of times past: Ethnohistorical essays on the culture and ecology of the New England tribes*, (Australian Institute of Aboriginal Studies), (Canberra, 1978)

McBryde, I., 'Exchange in south-eastern Australia: an ethnohistorical perspective', *Aboriginal History* (1984), 8, 132–53

Mackaness, George, *Admiral Arthur Phillip, founder of New South Wales, 1738–1814* (Sydney, 1937)

Mathews, Gregory M. and Iredale, Tom, 'Forgotten Bird-Artists and an old-time ornithologist', *The Austral Avian Record* (December 1921), iv, 114–22

Morrison-Scott, T. C. S., and Sawyer, F. C., 'The identity of Captain Cook's kangaroo', *Bulletin of the British Museum (Natural History) Zoology* (1950), 1(3), 45–50

Mortimer, George, *Observations and Remarks made during a Voyage to the islands of Teneriffe, Amsterdam, Maria's Islands Near Van Diemen's Land . . . in the Brig Mercury, commanded by John Henry Cox Esq. . . .* (London and Dublin, 1791)

Neptune des Côtes Orientales et du Grand Archipel d'Asie (Paris, 1803)

Onslow, S. M. (ed.), *Some Early Records of the Macarthurs of Camden* (1914) (Adelaide, 1973)

Paine, Daniel, *The Journal of Daniel Paine*, edited by R. J. B. Knight and Alan Frost (Sydney, 1983)

Parkinson, Sydney, *A Journal of a Voyage to the South Seas* (London, 1773)

Peron, F. A., *Voyage de Découvertes aux Terres Australes . . .* Atlas per M. M. Lesueur et Petit (Paris, 1808–11)

Perry, T. M., *Australia's First Frontier* (Carlton, 1963)

Phillip, Arthur, Collections of manuscript letters, Mitchell Library Ms C213, Dixson Library Ms Q 162

Phillip, Arthur, *The Voyage of Governor Phillip to Botany Bay; with an account of the Establishment of the Colonies of Port Jackson & Norfolk Island . . .* (London, 1789, 3rd edn. 1790)

Plomley, N. J. B., *Friendly mission: the Tasmanian journals and papers of George Augustus Robinson 1829–1834* (Kingsgrove, NSW, 1966)

Poignant, A., *The Improbable Kangaroo and other Australian Animals* (Sydney, 1965)

Proudfoot, Helen, 'The First Government House, Sydney', *Heritage Australia* (Summer 1983), 21–5

Rao, P. D. P., 'Squatting facets on the talus and tibia in some Australian Aborigines', *Archaeology and Physical Anthropology in Oceania* (1966), 1, 51–6

Rienits, R., 'Introduction' in White, J. *Journal of a Voyage to New South Wales* (London, 1790), edited by A. H. Chisholm (Sydney, 1962)

Rienits, R. and Rienits, T., *Early Artists of Australia* (Sydney, 1963)

Robinson, A. H. W., *Marine Cartography in Britain, a history of the sea chart to 1855* (Leicester, 1962)

Ross, A., *Inter-tribal contacts – what the First Fleet saw.* (B.A. (Hons) thesis, Department of Anthropology, University of Sydney, 1976.)

Sawyer, F. C., 'Notes on Some Original Drawings of Birds used by Dr John Latham', *Journal of the Society for the Bibliography of Natural History* (1949), 2, 173–80

Schodde, R. and Mason, I. J., *Nocturnal Birds of Australia* (Melbourne, 1980)

Schodde, R., Fullagar, P. and Hermes, N., *A Review of Norfolk Island Birds: past and present* (Australian National Parks and Wildlife Service, Special Publication (no. 8), (Canberra 1983)

Scott, Ernest, *Terre Napoleon* (London, 1910)

Sharp, Andrew, *The Discovery of the Pacific Islands* (Oxford, 1960)

Sharpe, R. B., 'Birds', *The History of the Collections contained in the Natural History Departments of the British Museum*, (London, 1906)

Shaw, George, *Zoology of New Holland* (London, 1794)

Shaw, George and Nodder, F. P., *The Naturalist's Miscellany* (24 vols., London, 1789–1813)

Skelton, R. A., *Charts and Views drawn by Cook and his Officers and Reproduced from the Original Manuscripts* (with the Hakluyt Society's edition of *The Journals of Captain James Cook on his Voyages of Discovery* edited by J. C. Beaglehole), (Cambridge, 1955)

Skelton, R. A. See Bagrow, Leo

Smith, B., *European Vision and the South Pacific 1768–1850,* Oxford, 1960 (2nd edn., London, 1985)

Smith, James Edward, *A Specimen of the Botany of New Holland* (London, 1793)

Smyth, Arthur Bowes, *The Journal of Arthur Bowes Smyth*, edited by P. G. Fidlon and R. J. Ryan (Sydney, 1979)

Stanner, W. E. H., 'Religion, totemism and symbolism', in *Aboriginal Man in Australia* edited by R. M. Berndt and C. H. Berndt (Sydney, 1965) 207–37

Strickland, H. E. 'Remarks on a collection of Australian drawings of birds, the property of the Earl of Derby', *Annals and Magazine of Natural History* (1843), 11, 333–8

Tench, W., *A Narrative of the Expedition to Botany Bay: with an account of New South Wales, its productions, inhabitants to which is subjoined, A List of the Civil and Military Establishments at Port Jackson* (London, 1789)

Tench, W., *A Complete Account of the Settlement at Port Jackson, in New South Wales, including an accurate description of the Situation of the Colony; of the Natives and of its natural productions: Taken on the spot, by Captain Watkin Tench of the Marines* (London, 1793)

Tench, W., *Sydney's First Four Years*, ed. L.F. Fitzhardinge (Sydney, 1979)

Tooley, R. V., *Maps and Map-Makers* (London, 1961)

de Viana, Francisco Xavier, in *The Spanish at Port Jackson: The Visit of the Corvettes 'Descubierta' and 'Atrevida'* (Sydney, 1967)

Waterhouse, G. R., *Marsupialia or pouched animals*. Vol. 11, *The Naturalist's Library Mammalia* (Edinburgh, 1841)

Watling, Thomas, *Letters from an Exile at Botany Bay to his Aunt in Dumfries* (Penrith, 1794)

Webb, S., 'Intensification, population and social change in south-eastern Australia: the skeletal evidence', *Aboriginal History* (1984), 8, 154–72

White, J., *Journal of a Voyage to New South Wales* (London, 1790), edited by A. H. Chisholm (Sydney, 1962)

Whitehead, P. J. P., 'Zoological Specimens from Captain Cook's voyages', *Journal of the Society for the Bibliography of Natural History* (1969), 5, 161–201

Whitley, G. P., 'Naturalists of the First Fleet', *Australian Museum Magazine* (1938), 6, 291–304

Willmot, E., 'The Dragon Principle', in *Who Owns the Past?* edited by I. McBryde (Melbourne, 1985), 41–8

Worgan, George, *Journal of a First Fleet Surgeon* (Sydney, 1978)

INDEX